# VICTORIAN CULTURE AND
# CLASSICAL ANTIQUITY

# MARTIN CLASSICAL LECTURES

❀ ❀ ❀ ❀ ❀ ❀ ❀ ❀ ❀ ❀ ❀ ❀ ❀ ❀ ❀ ❀ ❀ ❀ ❀ ❀ ❀ ❀ ❀ ❀ ❀

The Martin Classical Lectures are delivered annually at Oberlin College through a foundation established by his many friends in honor of Charles Beebe Martin, for forty-five years a teacher of classical literature and art at Oberlin.

John Peradotto, *Man in the Middle Voice: Name and Narration in the* Odyssey

Martha C. Nussbaum, *The Therapy of Desire: Theory and Practice in Hellenistic Ethics*

Josiah Ober, *Political Dissent in Democratic Athens: Intellectual Critics of Popular Rule*

Anne Carson, *Economy of the Unlost: (Reading Simonides of Keos with Paul Celan)*

Helene P. Foley, *Female Acts in Greek Tragedy*

Mark W. Edwards, *Sound, Sense, and Rhythm: Listening to Greek and Latin Poetry*

Michael C. J. Putnam, *Poetic Interplay: Catullus and Horace*

Julia Haig Gaisser, *The Fortunes of Apuleius and the Golden Ass: A Study in Transmission and Reception*

Kenneth J. Reckford, *Recognizing Persius*

Leslie Kurke, *Aesopic Conversations: Popular Tradition, Cultural Dialogue, and the Invention of Greek Prose*

Erich Gruen, *Rethinking the Other in Antiquity*

Simon Goldhill, *Victorian Culture and Classical Antiquity: Art, Opera, Fiction, and the Proclamation of Modernity*

# VICTORIAN CULTURE AND CLASSICAL ANTIQUITY

❀ ❀ ❀ ❀ ❀ ❀ ❀ ❀ ❀ ❀ ❀ ❀ ❀ ❀ ❀ ❀ ❀ ❀ ❀ ❀ ❀

*Art, Opera, Fiction, and the Proclamation of Modernity*

Simon Goldhill

PRINCETON UNIVERSITY PRESS

PRINCETON AND OXFORD

Copyright © 2011 Princeton University Press

Requests for permission to reproduce material from this work should be sent to Permissions, Princeton University Press

Published by Princeton University Press, 41 William Street, Princeton, New Jersey 08540

In the United Kingdom: Princeton University Press, 6 Oxford Street, Woodstock, Oxfordshire OX20 1TW

press.princeton.edu

All Rights Reserved

Library of Congress Cataloging-in-Publication Data

Goldhill, Simon.
    Victorian culture and classical antiquity : art, opera, fiction, and the proclamation of modernity / Simon Goldhill.
        p. cm. — (Martin classical lectures)
    Includes bibliographical references and index.
    ISBN 978-0-691-14984-4 (acid-free paper)   1. Great Britain—Intellectual life—19th century.   2. Great Britain—Civilization—19th century.   3. English literature—19th century—Classical influences.   4. Art, Victorian—Great Britain.   5. Art, British—Classical influences.   6. Opera—Classical influences.   I. Title.   II. Series.

    DA550.G65 2011
    941.081—dc22                                                                    2010049711

British Library Cataloging-in-Publication Data is available

This book has been composed in Janson Text LT STD
Printed on acid-free paper. ∞
Printed in the United States of America

10   9   8   7   6   5   4   3   2   1

# CONTENTS

❀ ❀ ❀ ❀ ❀ ❀ ❀ ❀ ❀ ❀ ❀ ❀ ❀ ❀ ❀ ❀ ❀ ❀

# ILLUSTRATIONS

❁ ❁ ❁ ❁ ❁ ❁ ❁ ❁ ❁ ❁ ❁ ❁ ❁ ❁ ❁ ❁ ❁ ❁

## Figures

## Plates

# Introduction

❀ ❀ ❀ ❀ ❀ ❀ ❀ ❀ ❀ ❀ ❀ ❀ ❀ ❀ ❀ ❀ ❀

# DISCIPLINE AND REVOLUTION:
# CLASSICS IN VICTORIAN CULTURE

*Victorian Culture and Classical Antiquity* is intended to make a contribution to three major areas of scholarship, nineteenth-century studies, Classics, and what is often called Reception Studies. A short version of the agenda will seem straightforward enough: Victorian culture was obsessed with the classical past, as nineteenth-century self-consciousness about its own moment in history combined with an idealism focused on the glories of Greece and the splendor of Rome to make classical antiquity a deeply privileged and deeply contested arena for cultural (self-)expression. This is, or should be, a fundamental area of concern for nineteenth-century scholars. Classics as a discipline has always been interested in its own development, and it has supported the history of classical scholarship as a small but lovingly tended genre within the field; and there are few centuries as important for classicists' self-awareness as the nineteenth, whether we focus on scholarship itself or on the classicists' complicity with imperialism, racism, and nationalism. This is, or should be, highly pertinent for working classicists, explaining how we have come to be who we currently are. Reception Studies—often called by classicists the history of the classical tradition—has become in recent years both a growth field and an area where methodological issues central to the very idea of classics are hotly debated: where better to test the waters then in the Victorian engagement with Classical Antiquity?

My dull title inevitably threatens such apparently self-evident delineations of my project's questions. But this book also sets out to produce some new questions and new understandings in each of these areas. For example, let us think for a moment about the discipline of Classics and its place in Victorian culture.

One lasting icon of the nineteenth-century's new organization of the discipline of Classics is Benjamin Jowett, Master of Balliol College, Oxford, instigator of the tutorial system of teaching, translator of Plato, and public intellectual who articulates as strongly as anyone the connection between university education and public life.[1] As Classics itself took a turn away from the high and dry philological training toward political philosophy, with Plato becoming a central subject, so Jowett's one-on-one Socratic classes,

prepared the young men of class to become the administrators of British power. The Oxford man knew when he walked down the Broad that he ruled the world (the Cambridge man, of course, when he walked down King's Parade, didn't care who ruled the world: different style, same arrogance). Classics has found it hard to shake off the connection between itself as a discipline and the power structures of empire ever since. Jowett placing his men, well-read in Virgil, in the India Office, is too strong an image. Classics has a reputation of being the imperial subject par excellence, despite geology, encyclopedias, and even botany playing catch-up in recent decades of scholarly analysis.[2]

It is not hard to see why Classics has this reputation. At least it is not hard to see why this has become the standard story, and why Classics functions as the paradigmatic discipline for thinking through the relations between disciplinarization and the ideological and institutional structures of authority, privilege, and education, especially in the Victorian era. By the nineteenth century, Classics—by which is meant primarily the learning of Greek and Latin, the reading of the great texts of the canon, and the study of ancient history—took up a major part of the curriculum in the burgeoning public schools. According to the Clarendon Report, the average public school spent eleven of its twenty weekly lessons, every week, on classics (compared to two for drawing and two for science, say). Most pupils who passed through elite education learned reams of Greek and Latin poetry by heart. Classics was simply the furniture of the mind for the Victorian upper classes, often somewhat shabby or threadbare furniture, sometimes thrown out on the rag-and-bone cart, but always a recognizable style of decoration, whether homely or grand.[3] In defense of this curriculum, J. K. Stephen could argue that it was not whether you actually knew Greek or Latin that counted, but whether you had once learned it: to have forgotten Greek and Latin was, for him, a better education than knowing science.[4] Virginia Woolf's cousin had his own version of (not) knowing Greek. The great arguments about education in the nineteenth century were always integrally and essentially arguments about the place of classics, and since the great arguments about educational reform were also arguments about political enfranchisement, the study of Classics had an inevitable political formation. Part of the justification of the continuing study of Classics was that it formed, as well as informed, the mind, and formed the mind not just for a gentleman but for a figure of authority. A training in how to rule. So, paradigmatically, Macaulay on his way to a colonial position in India reads Virgil, Livy, Homer, and the other classics. And this training is fully institutionalized: there were twice as many points available in the civil service exams for the classical papers. For ruling India, it was more valued to know ancient Greek than modern Hindi or Urdu.[5]

So Classics can easily be seen as the archetype of discipline formation in the nineteenth century, and so it has been discussed by some very fine modern studies: Classics was central to the curriculum, its place as a subject was publicly and extensively discussed, its increasing institutional structures were debated and a major part of educational reform, it proved itself capable of absorbing new sciences like archaeology or art history into its learning, and it provides the perfect example of the connection of education and privilege mutually supporting each other, as the classically educated moved into the church, the government, and the arts of empire. The anecdote, as ever, is the clincher: the famous one word message of triumph sent by Napier back home read just "peccavi"—"I have sinned," that is, "I have captured the Indian province of Sindh." The point is not whether the punning message was really sent, but its loving circulation, from *Punch* in 1844 onward, among generations of guys to indicate how the gentleman soldier of empire does witticism—which articulates precisely enough the iconic and complicit image of Latinist as imperialist.

This story of the discipline is standard, and much beloved of anyone who feels like attacking Classics to make themselves feel modern or self-satisfied in their own political stance. And it is a story that is easy to tell because it does accurately represent one strand of classics as a nineteenth-century discipline. But there are some very strong challenges to it as a story, which constitute a need for a major redrafting of the account. I want to express three of these first, before moving on to what I will argue is a major gap in the current versions of the disciplinary formation of Victorian Classics.

The first challenge is familiar especially to those working in the early decades of the nineteenth century. When Shelley said "We are all Greeks," it was a battle cry of a philhellenic Romantic to join the revolution.[6] The idealism associated with classicism was for many at the turn of the nineteenth century a clarion call to change the world—beginning with a revolution in contemporary Greece to overthrow their Ottoman rulers. Bernard Shaw described Plutarch as a "handbook for Revolutionaries." This may seem like Shaw's customary overstatement, but Rousseau, the intellectual godfather of the French revolution, claimed to have learned all of Plutarch by heart by the age of eight. Now that certainly is Rousseau's self-serving exaggeration—there are twenty-four volumes of Plutarch in the Loeb edition—but he did write "Ceaselessly occupied with Rome and Athens, I lived, so to speak, with these great men"—he is talking of Plutarch's *Lives*—"myself born the citizen of a Republic and the son of a father whose love of fatherland was his strongest passion, I caught fire with it. . . . I became the character whose life I read." So Madame Roland, no doubt with half an eye on Rousseau, wrote from prison that "at the age of eight I used to take Plutarch to church instead of my prayer book." Charlotte Corday, too, or

so the story goes, read her beloved Plutarch all the day before assassinating Marat. For the luminaries of the French Revolution, reading Plutarch fired the imagination, provided exemplars, and stimulated revolutionary zeal.[7] When Marx wrote that the French Revolution was conducted in Roman dress, he was referring primarily to the Republican political theory that underlay so much of the principled action, as well as the neoclassical stances adopted by so many figures of the period (all those letters and tracts signed by "Brutus," "Cincinnatus,". . .). But one shouldn't forget that it also involved the reading of classical texts with revolutionary fervor. It is simply not the case that Classics is inevitably linked to empire or to conservative values in the nineteenth century. Rather, for many, especially at the beginning of the century, Classics was a visionary, revolutionary subject. Indeed, it might be better to say that the increasing institutionalization of Classics, followed by its association with the corridors of power, was a response to the challenge provided by Romantic philhellenism. What should the immense popularity of Byron and the Byronic mean for the study of Classics? It is not clear in the first years of the century where Classics will end by the last years of the century. The history of Victorian Classics as a discipline could benefit from a comparative history with European Classics, as it weaves in and out of the years around 1848—and a comparative history between the discipline—school, university, publishing—and the role of Classics within a broader cultural milieu. One strand of the story of Classics in the nineteenth century would tell how its revolutionary force was tamed, *disciplined* by the subject becoming a discipline—or rather how its revolutionary potential was redirected away from the radical politics associated with Romantic philhellenism. For, despite the regulation of becoming a fully institutionalized discipline, Classics never wholly lost its power for disruption. As we will see when we turn to the religious arguments of the second half of the century, there was another, passionately felt and contested revolution fueled by classical study.

The second area of challenge will also be familiar, especially to those working in the later decades of the century: sexuality—the empire of the senses. Although Payne Knight may have privately circulated his work on the ancient phallus as a pagan challenge to a dominant Christianity at the end of the eighteenth century, by the end of the nineteenth century, Classics and sexuality were linked in fascinating ways within the discipline as an institution.[8] Hellenism and homosexuality went together like a horse and carriage in the Victorian university, and the trial of Oscar Wilde brought it into the limelight of public scandal. Again, this has been very well discussed by modern scholarship. From the use of Greek philosophy as an alibi for male desire for males, to the idealization of the classical male body, to the artistic and literary fantasies of a pre-Christian sexuality, Greek writing became a way of constructing a revolutionary sexual world, a world of

change from the mundane realities of Victorian Britain.[9] Deliberately and self-consciously counter-cultural, using the privilege of cultural value against the dominant cultural models. (So, too, Virginia Woolf or H. D. or Michael Field turned to Greek in particular for their intellectual feminism but also for their sexual self-definition.) This sexual turn has had a long heritage. The Uranians were only one of the groups who linked male desire for males with a Greek idealism, which thus set Greek pederasty at the center of its self-presentation—and one might say that the contemporary popular association of homosexuality with child abuse is one offshoot of the Victorian marriage of convenience between Greek idealism and homosexual self-presentation.[10] From another angle, Freud's revolutionary sexual understanding is informed throughout by his classical training, not just in the naming of complexes, but in his models of analysis, the archaeology of the self. As scholars from Rudnytsky to Gere have shown, Freud, seated at his desk surrounded by his figures of classical sculptures, used Classics as much more than a metaphor in his science.[11] The point is a simple one: From Freud to Foucault, Classics has been central to modern sexual revolutions particularly—though not only through the analysis of male sexuality via the example of Greece. Again, there is a history waiting to be written of how the institutionalization of Classics, especially in the public school system, dealt with the troubling picture of the bearded man pursuing the youth in the gym.

The third area of challenge is in the history of democracy. One of the best-selling books in the middle of the nineteenth century, and certainly one of the most renowned, was Grote's *History of Greece* (as I will further discuss in chapter 5). Grote was a banker, and an MP, and wrote as a private individual. But his impact on the discipline was huge. If Wolf debunked the status of Homer, and Niebuhr the status of the legends of Rome, Grote's history turned the first fully critical eye on the legends of Greece.[12] But for my purposes in this introduction, what matters about Grote is that his history was written self-consciously against the historical stance of his predecessors, in opposition to Mitford's History, and as a sharper version of Thirlwall's—and was perceived to be so by his contemporaries. This was not just a question of historiography or of accuracy, but of politics. Grote was seen as—and wrote as—a defender of democracy, and of Athenian democracy at that.[13] In the controversy over his publications, both sides agreed that history was written to exemplify a political view, and that Grote supported democracy. In short, in these years of political reform, ancient Greek history, rather than being the conservative force that the traditional story of the history of the discipline would seem to require, was the means and matter of challenging modern conservative historiography. Again, the disciplinarization of the field needs to be seen in and against the anti-establishment, anti-conservative political potential of its study. A potential

activated most strikingly in the field of political history in the century where political and historical self-consciousness is a defining characteristic of a cultural identity.

The standard account of the development of the discipline of classics, then, with its drive toward political conservatism and its role as the educator of imperial gentlemen needs some serious qualification. Alongside, interwoven with this narrative, runs a political challenge to which the discipline is responding: political revolutionary idealism; sexual counter-culturalism; the authority of the past in service of a democratic political vision. These are not minor or simply marginal trends. From Rousseau and Shelley through Grote to Wilde, we are talking of major cultural icons for whom Classics is the opposite of a conservative or imperialist educational resource or cultural value.

What I have offered so far is in many ways the standard response to the standard story, for all that there is still a need for much of this challenge to be worked out in detailed research. I want now to look at a much underresearched and under-appreciated topic. My discussion aims to do two things: first, to explore another, and to my mind, absolutely crucial way that Classics played a role in what we could call the most important revolution of the nineteenth century; and second, to question the boundaries of the idea of a discipline in what might at first sight appear to be the clearest case of disciplinarization.

So what, then, is the most important revolution of the nineteenth century, and how does this affect our understanding of a discipline as a discipline? The revolution has different names, and the choice of what we call it is highly politicized, but for the moment I will call it the loss of the dominant place of Christian religion in Britain. I need hardly emphasize that this loss is often connected to Darwin and the growth of scientific disciplines. But I want to start with a telling comment by the novelist Mrs. Humphry Ward. This starting point is not random. Not only was she connected with many of the luminaries of trendy thinking in Victorian Britain, including Benjamin Jowett with whom I started, but she also wrote *Robert Elsmere*, perhaps the most celebrated and widely circulated novel of loss of faith ever written. It is a long, serious book about an Anglican vicar who gradually loses his faith in the church and in church history, and it was a passionately debated bestseller in England and America for a decade following its publication in 1888.

Mrs. Humphry Ward wrote that it was not science, as our contemporary academy tends to think, but *"the education of the historic sense* which is disintegrating faith."[14] That is, the greatest challenge to religion, to faith, is not Darwin, but the work of critical history. This is the process she represents in her novel, where her hero's crisis of faith is prompted precisely by the study of ancient history. As she wrote to a friend, "What convinced *me* fi-

nally and irrevocably was two years of close and constant occupation with materials of history in those centuries which lie near the birth of Christianity."[15] And she depicts Robert Elsmere going through the same process in her novel. Ancient history as a subject proved a profound threat to the self, the religious self.

*Robert Elsmere* was a hugely successful novel in part because it summed up perfectly a current trend, which will be discussed in detail in chapter 5. Wolf's work on Homer had suggested at the beginning of the century that Homer's texts were the result of a long oral tradition, and that the legends and myths it included had the most fragile of historical status. Niebuhr had challenged Roman originary legends from Livy, the great historian of the early Roman Empire. But it was perhaps the work of David Strauss in Germany, and above all Ernest Renan in France, which had the biggest impact. Strauss's *Life of Jesus*, translated into English by Marian Evans, soon to be the novelist George Eliot, looked with care at the historical evidence for Jesus and applied standards of historical plausibility to the accounts of early Christianity. Renan was read very broadly in England (and Mrs. Humphry Ward had met him in Oxford). His *Life of Jesus* combined a romantic travelogue with critical history to suggest a very human Jesus in a non-Jewish Galilee. The humanity of Jesus—as opposed to his divinity as the son of God—became a watch word of the opponents of conservative, institutional Christianity, and was bitterly contested by Anglicans and Catholics alike. Together with the sniffy dismissal of miracles as impossibility—God does not interfere with the laws of nature—this move away from the traditional evidences of the church depended on a careful, critical, historical reading of the Greek and Latin sources of the first centuries. So Robert Elsmere's crisis of faith is summed up in one climactic line: *miracles do not happen*. Cardinal Newman and the Tractarians wrote saints' lives, complete with extraordinary tales, to bolster precisely the belief in the early church's authoritative truth. The Catholics claimed unbroken apostolic succession from these early figures. Even the lowest of Anglicans had studied the miracles of Jesus as an evidence of divinity. So Gladstone, obsessed with *Robert Elsmere*, invited Mrs. Ward to breakfast in Oxford, where in defense of social order and the British system, he stated with passion: "if you sweep away miracles, you sweep away *the Resurrection!*"[16] But the historical study of early church texts, as texts of their own time and designed for their own audience, led Elsmere and many others to conclude that *miracles do not happen*. The study of Classics was, as opponents of Erasmus had feared back in the sixteenth century, the beginnings of heresy.

Between 1834 and 1843, fully 93 percent of all clerics were graduates, almost all (84.6 percent) educated at Oxford or Cambridge, and the majority in Classics, before theology. In the same period, over 70 percent of all graduates were ordained. As late as 1906, some 65 percent of all British

clerics were still graduates, mostly educated at Oxford and Cambridge.[17] From 1864–73, still over half of all Oxford and Cambridge graduates were ordained into the church. The connection between the university and the church was profound. The texts of the early church—the ones that mattered at least—were mostly in Greek and Latin. So T. S. Eliot as late as the 1930s wrote, justifying a continuing educational focus on classics, "It is only upon readers who wish to see a Christian civilization survive . . . that I am urging the importance of the study of Greek and Latin."[18] For similar reasons around the end of the nineteenth century, out-of-town clerics duly voted to keep compulsory Latin and Greek at Cambridge and swung the vote for many years of failed educational reform.[19] But in the very same period, it was precisely the study of the texts of the classical past that was undermining the church's own history and, with it, its historical authority. Classics, at this level, proved very dangerous indeed to the Christian order of things. Kept because it was essential, in its modern disciplinary form it was still essentially a profound threat.

So starting within the discipline of Classics with Wolf in the German research university, or in a theology department with Strauss, moving through public intellectuals such as Renan or novelists such as Mrs. Humphry Ward, into the general intellectual world of newspapers and journals where ideas were circulated and contested in a broader arena, the study of ancient Greek and Latin sources was an essential element in the most insistent challenge to the institutional and ideological structures of Victorian Britain—the Anglican Church itself. The truth of the Gospels and the truth of the saints' lives were scrutinized and found wanting by new historical, critical methods. The loss of the historical truth of the texts of early Christianity was a crisis in self-understanding, religious authority, and the institutional structures of the communities of Britain. To assert *miracles do not happen* was a deeply destabilizing claim. By 1899, in the hands of the satirical novelist W. H. Mallock (who deliciously parodies Mrs. Humphry Ward amongst other notables), it has become a recognizable stereotype of crisis: his hero, Tristram Lacy, once very religious, "came in contact with the criticism and scientific thought of to-day" at Oxford, "forgot an appointment at a house of a highly reprehensible character, in reading a German history of the growth of the early Church," and became a "disbeliever in everything."[20] It is striking that Benjamin Jowett, icon of Classics as a training for imperialism, at the center of the institutional structures of Oxford, had his professorial salary withheld by the fellows of Christchurch for several years because they regarded his critical views on ancient history, and thus religion, unacceptable to their Anglican vows. Jowett was to them a disgraceful, unwanted heretic.[21] It is essential to (re)build the image of Jowett the religious renegade into the image of Jowett the standard-bearer of imperialism and the Classics.

This very brief and necessarily oversimplified account of how Anglican Christianity and Classics interweave shows just how hard it is to limit the boundaries of the discipline of Classics. It is not just that Mrs. Ward was marginal to institutions, or Renan kept outside the standard university networks. (He was appointed Professor at the College de France but suspended because of the religious views of his first lecture. . . .) Nor is it just that Victorian intellectual luminaries could move between classics and theology, novels and preaching, school teaching and the church. Nor is it that the work of scholars and artists cross-fertilized and influenced each other. Rather, we haven't quite yet been able to write a history of the disciplinary formation of classics that can take account of how the discipline appears sometimes to move in complete separation from work outside the discipline, but sometimes acts in opposition to it, in an attempt to control it, in earnest or angry or anxious response to it. The interface of classics and theology is precisely the place to conduct such an enquiry into the dynamics of disciplinary formation, one which is, I suggest, essential to understanding how we have arrived at where we are.

This book takes a very broad view of the dynamics of Classics in the nineteenth-century, not just in looking at art, opera, and fiction but also in seeing how these different areas interact, and how each area, severally and collectively, can be properly understood only within multiple frames of cultural reference, multiple questions of cultural significance. Several micro-histories lie in this volume—detailed examples are integral to its exposition—but whether it is a classical picture on the walls of the Royal Academy or an opera performance by amateurs at Cambridge, or a blockbuster novel about the Roman Empire, in each case we need to scrutinize *what we need to know* in order to understand the artwork in its historical context—and how such multiple social, intellectual, aesthetic, political frames together form an image of Victorian culture. The first contribution that this book sets out to make, then, is to our understanding both of the development of Classics as a subject in the nineteenth century, and of the integral and essential place of classical antiquity in Victorian culture.

Now, it will be immediately clear from a glance at the contents page that although this book is called *Victorian Culture and Classical Antiquity* the time scale is broader than the reign of Victoria, and the geographical area much wider than Britain. Every historian these days wants their century to be "the long century"; but the range of this book is actually from around 1760 to today, which is longer even than any normal claims for the "long nineteenth century." There are two points of justification, beyond the standard resistance to arbitrary dating boundaries, which I hope will at least deflect worries about the title being too misleading. (*The Long Nineteenth-Century and Its Dynamic Engagement with the Past of Classical Antiquity* seemed

a bit too clunky for a title.) First, there is a specific focus in the book on the last two decades of the nineteenth century, together with the first few years of the twentieth century, a period when there is a major revival of classicizing art in London in particular (on which chapters 1 and 2 are concentrated), when Gluck's operas, the subject of chapter 3, were revived in London, and when the majority of the novels discussed in chapters 5–7 were published for the first or second time, many of them in London. The center of this book is located in the culture of Victorian (and just post-Victorian) London between 1880 and 1910. These decades were a period of particular cultural and material richness, and an era when the practice and arguments about classical education, a fascination with ancient sexuality as a counter-culture to contemporary behavioral patterns, and an aesthetic engagement with antiquity, combined to make a perfect storm around the classical. The word "Victorian" appears in the title to indicate that the book focuses here (rather than on Romantic philhellenism, say), but no reader should be surprised or complain that the argument ranges much wider in space and time than the term indicates.

Second, and to my mind more importantly, I am particularly interested in the role of cultural forgetting, on the one hand, and on the myths of cultural tradition, on the other. That is, I am fascinated at one level by what has to be *forgotten* in the construction of a past. As we will see in chapter 3, the revolutionary aesthetic and political force of Gluck in the eighteenth century had to be forgotten for the cultural impact of his revival in 1890 in Cambridge or in 1910 in London to work as it did. In the same way, as we will see in chapter 4, the first production of Wagner's *Ring* in Bayreuth after the Second World War had to be blind to the nineteenth-century connotations of Richard Wagner's Hellenism, linked as it was to his fervent nationalism and, indeed, racism. Chapter 1 strives to rehabilitate Waterhouse from modernist scorn, which has made his pictures so unappreciated by contemporary art criticism, where a teleological art history has determined Waterhouse as no more than a failed harbinger of the modern. To hear these silences, to observe these failures of cultural memory, we need to move some way at least beyond the boundaries of a delimited Victorian era. Cultural tradition, that is, depends on the circulation of myths, of constructed charters, icons, and stories of the significance of the past. When the Victorians deploy narratives and images of the classical past, to appreciate the deployment we need to look back or forward beyond the Victorians to gain a perspective—just as we need to maintain as best we can a self-awareness of our own deployment of our images of the Victorians today. There is inevitably a set of contemporary political and cultural agendas in the much trumpeted but rather unnuanced recent discovery that Victorian classicists were racist, imperialist, and sexist—agendas which need careful analysis rather than simple concession or dismissal. *Victorian Cul-*

*ture and Classical Antiquity* has to take account of the complicities, mis-recognitions, and hopefulness of both their and our contemporary gaze backward.

One word for this shady and shifting dynamic between past and present is "reception." In literary studies, reception as a term is used first and foremost to indicate the self-conscious adaptation of the work of one artist, thinker, or writer by another artist, thinker, or writer: how, as it were, George Eliot reads, adapts, plays with Greek tragedy in her own fiction; or Shakespeare's Ovid; Shakespeare and the Classics.[22] Or, starting with an ancient text rather than a modern author, how Sophocles's *Antigone*, say, or even a phrase like *thalassa, thalassa* ("the sea! the sea!") has been adapted and appropriated by later writers.[23] There are long-running arguments over how "reception" is to be distinguished from related terms such as "(classical) tradition," or "intertextuality," or even "literary history." I stated above that I intend this book to be a contribution not just to Classics and Victorian Studies but also to Reception Studies, and I would like briefly to indicate *how* here.

The most important contribution is in the chapters themselves, where most of my detailed test cases have barely entered contemporary discussion of nineteenth-century classics, despite their importance and popularity at the time. There has been no study of the reception of Waterhouse, a major celebrity of Victorian painting—nor, more surprisingly, any systematic analysis of his art (although there is now at least the catalogue of the first full-scale retrospective exhibition to add to the fine critical biography by Trippi).[24] Nor has the reception of Gluck been studied in any depth, nor, despite his evident importance in the history of opera, are there any detailed discussions of his performance tradition (though many treatments of the music exist). A good number of the novels I explore in chapters 5–7 have no critical bibliography at all, and most of the bestsellers I discuss, even Nobel Prize–winning works, are now languishing in obscurity. This history of the genre of novels of antiquity (if it can properly be called a genre), both in scope and in argument, opens a fresh perspective on nineteenth-century classics within literary and popular culture. *Victorian Culture and Classical Antiquity* intends in this way to broaden the view of what is understood by Victorian Classics. It brings together grand themes—desire, cultural politics, religion—with major genres—art, opera, fiction—to explore the role of classical antiquity in Victorian culture through sources whose importance for the nineteenth century has been undervalued in more recent years.

Beyond the range of material and genres, however, I also hope that each of the chapters is exemplary in its practice, and I would like to take the opportunity of this introduction to suggest at least in lapidary form some ways in which my work takes a position within current Reception Studies.

It would be strange, after all, *not* to attempt to place my book's work on an intellectual map. Let me begin positively with four areas where I hope these studies build on what I regard as the most valuable current work in this field.

The first area concerns time. In each of these chapters, I am interested in how meaning comes into being over time, and as a process. We can see this on three interconnected levels. First, and most obviously, the making of the artwork, and the response of even the first audience to the artwork, take place as a process over time. So, to start with a particularly clear example, each of Gluck's operas that I discuss is composed over several years in a collective creative project, changing in response to rehearsals, reviews, new cities, new performance possibilities, and restrictions. The audience response to these performances is not just for the duration of the performance, but also develops in anticipation and retrospect, in response to reviews, in the production of reviews, in discussions, in the shimmer of memory's tricks, as part of the process through which the operas become successful, popular, significant (or forgotten). At a second level, the artwork is re-performed—re-viewed, reread—at different moments across (in the case of Gluck again) the long nineteenth century. His operas dropped out of the standard repertory after 1810 and were barely performed in Europe, but did have stunning revivals, each perceived to be a major cultural event, in 1847 in Germany under Wagner, in 1859 in France under Berlioz, and in 1890 and 1910 in England under Stanford. Each revival changed the sense of Gluck for contemporary audiences, and redrafted what Gluck's classicism meant. So, too, we will look at the changing senses of Wagner's Hellenism between the first performance of the *Ring* at Bayreuth and its first performance after the Second World War. Or the changing perspectives opened by the republication of a book such as Croly's *Salathiel*, published first in the 1820s, reissued in the 1850s, and then repackaged with a new title and published again in 1901. This "re-performance history" repeatedly changes what the classicism of an artwork means—and forms a necessary part of what we can understand by "reception." But—and this is my third and most complex level—the antiquity of the settings of classicizing art, as well as the recognition of older lost performances or readings, is part of the artists' and audiences' self-aware reflections on the modernity of the experience of the artwork. Classicizing art is haunted by memories or projected memories of a lost past—a classical past and a past of earlier performances. The question of whether one can experience Gluck's classical tragic opera as a classical Greek experienced his tragedy, or even as an earlier audience felt Gluck, is explicitly part of the emotional response to Gluck's music. The self-consciousness of modernity, of seeing oneself within a literary tradition or a performance tradition, runs through both the composition of these artworks, and the response to them. When

Dorothy L. Sayers complains that Wilkie Collins's "Goths and Romans alike hail from Wardour Street,"[25] she is not just mocking or lamenting Collins's anachronism as a flaw in characterization. She is also performing a gesture of a rather anxious self-awareness we see repeated throughout the critical tradition of classicism: Is this art Greek or Roman enough? Is my response authentic or modern? Is this re-performance true to the original? Was the original true to its model? I indicated earlier that I was particularly interested in *cultural forgetting*. We can now be more precise: classicizing art has an integral and heightened temporal self-awareness, but we need to appreciate how the acts of affiliation to the past, the gestures of appropriation, the proclamation of ancient models—typical marks of classicism—are in dynamic and creative tension with acts of repression. The reinvention of the Greeks is both a discovery and a forgetting—and the forgetting too needs its place in Reception Studies.

For all our love of epiphany, meaning takes time—and, I would add, flirts with its own temporality, its status as lasting or fleeting, its temporariness. Reception studies are most nuanced, I would suggest, when they are most aware of how meaning takes shape over time, and when they are most sensitive both to the dynamics of "re-performance history" and to the dynamics of temporal self-consciousness, integral to classicizing artworks. This book tries to follow such an agenda.

The second area concerns the space of meaning: where does meaning take place? This question is designed to draw out an argument implicit in the discussion of temporality, where I included audiences in the model of reception. This book is concerned with how artworks have an effect, a meaning, in society. Once meaning is conceived as a public event, as it were, the audience becomes a key part of what could be called the scene of reception. This is most pressing in a staged performance, of course, where Gluck's response to Greek tragedy, say, takes place with and for an audience, and, indeed, the audience's response takes place, as we will see, acutely aware of other audience members and their responses (an audience in the theatre always watches itself watching). In the Victorian art gallery, too, especially in the context of the circulation of reviews, the scandals over particular exhibitions, and the public debate over display, viewers are aware that their judgments and responses are like or unlike other viewers' judgments and responses—and are performed as such. Gallery goers look at each other as well as at the pictures. (Which is why scenes at the art gallery are so often scenes of falling in love at first sight. . . .) Even the private act of reading a novel is triangulated through other projected audiences, other readings. Ruskin is exemplary when he deposits in his diary the thought that "Everybody has a spite at Bulwer because the public thinks him clever and they don't"[26] (a remark that will be further discussed in chapter 5). As he reads and reflects on the novels of Bulwer Lytton (author of *The Last*

*Days of Pompeii*), his response is articulated through his perception of what "everyone"—a self-appointed elect—believes, in contrast to the mere "public," and how he himself fits onto this map. Imagined, denied, hoped for, despised audiences crowd in on the act of composition and the act of being in an audience (including reading). Artworks have power, value, status to the degree that audiences engage with them. Thus, in this book I am interested in meaning as a (messy) social process not as an imagined private (pure) communion between an artist and an artwork of the past. Not so much Gluck's reading of Greek tragedy, then, as the meaning of the performance of Gluck's operas, which certainly includes Gluck's personal engagement with the classics, but only as one element in the production of a cultural event. We will see many difficulties in evaluating and utilizing an audience's response, but nonetheless, it is, I would suggest, potentially a damaging oversimplification to exclude audiences from Reception Study. Audiences are part of the cultural event of restaging the past for the here and now.

One consequence of this paradigm—and this is my third area—is that each chapter is best seen as a form of cultural history as much as an aesthetic project. Or rather, I am concerned to locate aesthetics as one historically specific element in a series of frames in which any particular public display of art, performance in a theatre, or publication of a novel, needs to be comprehended. Now, for many literary scholars (let alone cultural historians), to raise a banner for cultural history will scarcely seem a provocative or even interesting gesture. It has no claim to novelty: much of the best literary criticism of Victorian fiction, for example, happily deploys science, psychology, glass, physiognomics, things—any aspect of cultural history—as an informative framework or cultural interface to help locate and appreciate the meaning of written texts. Yet, despite the predominance of cultural history in many domains, there is nonetheless one compelling reason to underline my commitment to cultural history in this book—namely, the resistance to cultural history in some popular styles of Reception Study within contemporary Classics. At one level, this is often just because of what could be charitably called the narrow focus of many a work of *Rezeptionsgeschichte*; or called, less charitably, "positivist history, often of a rather amateurish nature."[27] It would be easy here to list books, which list translations of Aristotle (*vel sim*), as if such a *catalogue raisonée* could ever constitute a *history*. But at a more interesting level, the so-called new aesthetics, with its roots in Kantian thinking, has repeatedly *opposed* reception as an *aesthetic* project to cultural history, and indeed uses the term "historicist" as a sneer.[28] My starting point is with artworks that have made a significant difference by virtue of their public impact—these seem to me to be particularly worth our attention as historians and critics; this leads inevitably to thinking about meaning as a public event, which leads inevitably to cul-

tural history. I would be happy for this book to be seen as a positive and productive rejoinder to "the new aesthetics."

One marker of public impact is the size and volubility of an audience. The paintings I discuss in chapters 1 and 2 were seen by audiences of hundreds of thousands in London, and these numbers expanded as the paintings toured England, Europe, America, and the works were also discussed in the widely circulated press. Gluck's operas produced hundreds of pages of polemical pamphlets in Paris, as well as huge audiences of emotionally overwhelmed Parisians. They were produced all over Europe. Wagner's operas were discussed across Europe and America, and, while they, like Gluck's, changed the aesthetics of opera in the West, it was also the overheated audiences and commentators in the press that made Wagner's music such a European *événement*. Many of the novels discussed in chapters 5–7 were sold in enormous numbers, and were read by many more—and many of the novels became plays, films, and paintings, which further spread their recognition. The subject of this book hovers between high and popular art. What's more, the circulation of popular images of Classics introduces particular hermeneutic problems for reception studies: How are we to evaluate the impact of *Ben Hur* when it reaches an audience whose cultural knowledge is so different from the usual educated audience envisaged by Reception Studies? How are we to appreciate the circulation of the trivial use of classical icons—Venus de Milo in a corset in a newspaper advertisement? And, most interestingly, how are we to understand the imagery or ideas or representations that slip *between* the elite world of high culture and more popular exposure—when, for example, one generation's provocation becomes another's cliché? This book does not merely consider works of high culture or works of popular culture, but also focuses on the relation *between* high and popular cultures, and the awkward transitions and tensions between the elite and the demotic, which constantly provoke the unsettling question of *how shared* culture is. Here, then, is my fourth area of concern with regard to Reception Studies: the slippage between elite and popular culture of classical motifs or narratives, and the effect on both elite and popular culture of such slippage.

Now, it is no doubt a foolhardy hostage to fortune to attempt to locate one's work in so varied and invested a field as Reception Studies in three pages, and each of these four areas could certainly be expanded to make a full-scale methodological exposition, especially now when Reception Studies is so absorbed with the theory of its own practice. But I hope enough has been said to indicate something of my slant on reception theory. I am interested in the messy business of how meaning or significance—and specifically the various responses of Victorian culture to classical antiquity—takes shape in society, over time, and between genres. I focus on the construction of cultural value in and through cultural performance, and how

the development of nineteenth-century media and mass audiences alters
not just the circulation of images of antiquity, but also the interplay be-
tween high culture and popular culture—a topic of special purchase for
Classics, with its constant patina of privilege. How this plays out in prac-
tice, the chapters will demonstrate. I have tried—without complete suc-
cess, I know—to avoid polemic in positioning my approach to Reception
Studies, but it will not hurt to indicate, for the sake of clarity at least, that
part of the drive behind this book is my dissatisfaction with one particular
model of Reception Studies that, at least in its most aggressive form, privi-
leges the unilinear response of the artist to a previous artwork—Milton's
reading of Virgil, or Titian's reworking of Ovid—at the cost of severely
downplaying the importance of historical contextualization, audience en-
gagement, and cultural power. For me, reception Studies is most produc-
tive and interesting when we move away from the great man communing
in his study with the great work of the past, toward the cultural significance
of the representation of the past for a here and now.

I am now in a position to underline the force of my subtitle, ". . . and the
Proclamation of Modernity." In each of my chapters, there is a specific
focus on how the artworks in question come to stand for a self-aware state-
ment about modernity—through the classical past. Waterhouse and Alma-
Tadema are very much artists of the moment, fashionable, of course, and
engaged, as I will show, in contemporary discussions and anxieties about
sexuality. Waterhouse's *St Cecilia* was hailed precisely as "one of the most
brilliant and essentially modern performances of this eclectic age," and as
an epitome of "the moderates of modernity."[29] But both artists, in their
reception through the twentieth century (and beyond), have been criti-
cized, often with considerable vitriol, precisely for not being modern
enough. In contrast to the art of their European contemporaries, neither
Waterhouse nor Alma-Tadema reaches the illustrious status of being a har-
binger of modernity. What is at stake here is partly a formalist teleological
critique, where art must be seen to move toward abstraction (through im-
pressionism and cubism and so forth), and thus the lush realism of these
Victorian artists is seen as stylistically retrograde. But also at stake is our
modern view of how modernity is to be conceptualized.[30] What place for
Classics, for narrative, for representation in a realist mode—*today*, in a
*modern* aesthetics? The word "Victorian" is still often used as a dismissive
negative adjective to contrast with the self-definitions of contemporary
culture. *They* were the Victorians, but *we* are. . . . The lack of appreciation
for how Waterhouse and Alma-Tadema have serious contributions to make
in the heady arena of sexuality, narrative, and viewing—the epicenter of
modernity's self-recognition—may be laid at the door of such historical
oversimplification. The fact that Waterhouse and Alma-Tadema have been
so popular as poster art may suggest that the images they put in circulation

have a greater hold on the cultural imagination than the dismissiveness of art historical criticism would suggest.

In a similar manner, Gluck was taken first to be a revolutionary figure of modernity in an age of revolution, and then became the icon of tradition set fast against modernity's inroads. Wagner was recognized—most famously by Nietzsche—to "sum up modernity." But, as we will see in chapter 4, the narrative of Wagner as the modern or as the unacceptable and rejected past, becomes again a more complicated act of self-definition in Bayreuth after the Second World War. The novels I discuss in the final chapter are concerned with how the modern contemporary world understands itself as the endpoint of a historical development—and with how fiction can be new, or let us see the new for what it is ("new foes with old faces" or "old foes with new faces," to quote a chapter and subtitle by Charles Kingsley). In each case, this is not just a question of changing fashion, but a question of how modernity reinvents itself as modern, and how classical antiquity has played a role in that act of self-definition. As Marx famously put it in the *Eighteenth Brumaire*: "And it is just when they appear to be revolutionizing themselves and their circumstances, in creating something unprecedented, it is in just such epochs of revolutionary crisis that they nervously summon up the spirits of the past, borrowing from their names, marching orders, uniforms, in order to enact new scenes in world history."[31] Marx is concerned primarily with political change, of course. But his sense of the paradox of the revolutionary reaching for the past captures an essential strand of the Victorian turn to the classical—which with a further twist of the paradoxical becomes itself the basis for the (even more modern) criticism of Victorian conservatism. The subtitle ". . . and the Proclamation of Modernity" indicates this repeated rhetoric of historical self-awareness and self-definition within the narrative of reception.

It may seem simply overweening to have attempted not only to study art, opera, and literature, but also to do so between Classics and Victorian England, two subject areas with fiercely defended and hard-earned specialisms. But the image of antiquity in Victorian Britain is one topic where intermediality (to borrow a term currently very fashionable in German cultural criticism) and interdisciplinarity (a term fashionable everywhere) seem sensible requirements. Even at a superficial level, it is evident that what antiquity means for the British in the nineteenth century will be constructed over a range of fields—education, art, literature, music, history, theology, at the very least—and that these fields will cross-reference each other. As we will see, many paintings proclaim they are based on poetry or novels, and contemporary criticism has commented on this extensively; both art and fiction borrow from scholarship; opera takes its plots from other fictional narratives; fiction imitates the tableau of art (and vice versa);

art is part of the construction of a historical imagination—and so forth. Interdisciplinarity is integral to the Victorian engagement with Classics. One thing I have learned painfully from this project, however, and particularly from the members of the Cambridge Victorian Studies Group, is how hard it is to do interdisciplinary work seriously, and what level of knowledge of both Classics and Victorian studies is necessary in order to make a respectable contribution. Because of the interstitial space the book inhabits, all readers will need to be generous toward one or another aspect of the glossing that it has seemed foolish not to include. Not all Victorianists will know why Synesius is an especially riveting father of the church; not all classicists will know that Froude is Kingsley's brother-in-law. And especially in chapter 5, there are books discussed that have been read by very few modern scholars of any discipline.

But despite the vast and clumsy title of the book, and the subtitle's paraded range of disciplines, there is in this volume no attempt at being exhaustive in any of these areas, let alone in the complete range of Victorian engagements with the classical past. I have looked just at some central issues and a few central figures (alongside the lesser characters who frame their centrality). Each chapter is designed to be exemplary of a version of how Classics and Victorian Studies can engage with each other. So in the first section, I look at the art of J. W. Waterhouse, who has just had his first major retrospective in Europe and Canada, and then in chapter 2 at one painting of Alma-Tadema. In both chapters, the relation between desire, classical imagery, and nineteenth-century projections is paramount. In the second section on opera, I look only at Gluck in performance from the eighteenth to the twentieth century, and then, in a shorter chapter, at what we can learn from comparing the first production of Wagner's *Ring* with the first production at Bayreuth after the Second World War. Here my concern is primarily with the relation between Hellenism and nationalism, or the use of opera in the construction of an image of political citizenship: what one might call "the politics of cultural performance" or "the performance of cultural politics." In the final section made up of three closely interrelated chapters, I look at novels about the Roman Empire written in the nineteenth century, of which there are more than 200 on the bookshelves: Here the connections between fiction, the classical past, historical self-consciousness, and in particular religion, come to the fore. So this book aims to explore desire, cultural politics, and religion, through art, opera, and fiction.

To cover the whole subject of Victorian Culture and Classical Antiquity would take more than one lifetime, I fear. I am by no means the first to dip my toes into these waters, of course. Frank Turner's marvelous *The Greek Heritage in Victorian Britain* is superb, particularly on historiography and political writing—I have learned from this hugely, but felt no need to go

over the same ground again. He barely mentions art, opera, or literature in what remains a magisterial study. Richard Jenkyns's *The Victorians and Ancient Greece* and his later *Dignity and Decadence*, well ahead of the game in their choice of subject and interdisciplinarity, certainly cover enough examples from art, architecture, poetry, and fiction, but because of the sheer range of material have had to sacrifice a certain depth of argument. Our questions sometimes overlap, but more often are aimed in quite different directions. Several books have also been hugely influential on specific areas—and again I have been happy to learn liberally from them. Risking invidiousness for exemplarity, one could name Yopie Prins's *Victorian Sappho*, Linda Dowling's *Hellenism and Homosexuality*, Norman Vance's *The Victorians and Ancient Rome*, and, on education and science, Christopher Stray's *Classics Transformed*, and for the micro-history of a subject, Suzanne Marchand's *Down from Olympus: Archaeology and Philhellenism in Germany 1750–1970* (as well as her more recent work on Orientalism). It is to the understanding of Victorian culture and the classical world mapped by these books that *Victorian Culture and Classical Antiquity* will, I hope, also make its contribution.

It is a pleasure to be able to thank Liz Prettejohn for invaluable help for chapters 1 and 2, Michael Sonenscher, Karen Henson, Ben Walton, and John Deathridge on chapters 3 and 4, Miriam Leonard, Michael Ledger-Lomas, Peter Mandler, Mary Beard, and David Gange on chapters 5, 6, and 7. Sally Shuttleworth and Yopie Prins have allowed me to chatter away and learn from their expertise, and Yopie read the whole manuscript in a really instructive manner. I have, as ever, benefited throughout from the generous intellectual engagement of Helen Morales and Miriam Leonard. Versions of chapters have been delivered as lectures in the universities of Oxford, Melbourne, Yale, Princeton, Pennsylvania, Bristol, Columbia, Miami/Ohio, Glasgow—and the whole as the Martin Classical Lectures in Oberlin, a wonderful stay in the snow of Ohio. Thanks to the audiences in each place for what were always stimulating and enlightening discussions. But it is to the members of the Cambridge Victorian Studies Group, generously funded by the Leverhulme Trust, that I owe my most general and profound debt for five years and more of seminars, discussions, and generous commenting on drafts of work: Peter Mandler, Clare Pettit, Mary Beard, Jim Secord, Michael Ledger-Lomas, David Gange, Adelene Buckland, Sadia Qureshi, Anna Vaninskaya, and Astrid Swenson.

PART 1

❀ ❀ ❀ ❀ ❀ ❀ ❀ ❀ ❀ ❀ ❀ ❀ ❀ ❀ ❀ ❀ ❀

Art and Desire

# Chapter 1

❀ ❀ ❀ ❀ ❀ ❀ ❀ ❀ ❀ ❀ ❀ ❀ ❀ ❀ ❀ ❀ ❀ ❀

## THE ART OF RECEPTION:
## J. W. WATERHOUSE AND THE PAINTING
## OF DESIRE IN VICTORIAN BRITAIN

IN THE 1880s and 1890s, the art galleries of London flared with a burst of painting on classical subjects. Alma-Tadema, Poynter, Leighton, Waterhouse, and a host of less celebrated figures, produced an extraordinary profusion of classicizing canvasses, especially for the Royal Academy, but also for other galleries in London and for exhibitions around the country—pictures which were gazed at by hundreds of thousands of visitors, discussed intently in the press, and which helped form the visual imagination of a generation.

This excitement over imaging classical antiquity takes to a particular height the embracing fascination with ancient Greece and Rome, so much in evidence throughout the broader cultural milieu of nineteenth-century Europe. Classics was an integral part of the furniture of the Victorian mind, bolstered through the elite education system, spread parodically and aspirationally through popular culture, visible in the physicality of the architecture and sculpture of the capital; disseminated in opera, in theatre, in literature, and even in the battles over religion that dominated the spiritual crises that commentators loved to descry in the final years of the century.[1] After the First World War, Virginia Woolf could still write, "it is to the Greeks that we turn when we are sick of the vagueness, of the confusion, of the Christianity and its conclusions of our own age."[2] Romantic poets had long longed for the "isles of Greece, the isles of Greece where burning Sappho loved and sung." The Renaissance was precisely the rebirth of the privilege of the classical. But, for all the long backstory of neoclassicism, and the still unending history of the classical tradition, the 1880s and 1890s in London were a special time for the Greek gods and the Roman emperors. And the art of these decades was a sign and a symptom of this passion for antiquity.

Nineteenth-century commentators, especially from the middle of the century onward, turned out essay after self-conscious essay on "the girl of the period," "the signs of the times," the "art of the age," the perils and delights of "the modern era." It was a commonplace of nineteenth-century

writing that Victorian England was a great age of progress and was acutely aware of it. Yet it is also striking just how intensely and repeatedly the rapidly changing culture of Britain expressed its concerns, projected its ideals, and explored its sense of self through images of the *past*. Ye olden days of medieval England, the Renaissance glories of Elizabethan imperialism—Shakespeare and the Armada—and, above all, biblical times and the past of Greece and Rome, provided a repertoire of narratives and images whereby modernity found its ancestors, explanations, and alibis. In the first section of this book, I want to look at how paintings depicting the classical past became a way of talking about—or not talking about—sexual desire, in a period that has become celebrated for its (modern) discovery of sexual science, from the invention, as we say, of homosexuality to Freud's archaeology of the psyche. How did the passion for antiquity depict and explore passion through antiquity? How did images of ancient desire find a privileged place amid the loud claims of modernity to a new vision of sexuality? These paintings, which became and have remained deeply unfashionable, will be shown not only to reach the heart of a Victorian discourse of erotic desire, but also to raise profound questions about how we see ourselves within the history of sexuality.

In the second chapter of the section, I will look in detail at a single painting by Lawrence Alma-Tadema, which concerns the space of desire—a Greek scene, the gap between a man and a woman, the touch of a girl and a woman—and how this space is traversed by critics and viewers, then and now. In this first and longer chapter, I want to make a broader survey of the art of J. W. Waterhouse, a figure who has suffered markedly from shifts in taste in the twentieth century. His paintings are among the most reproduced of all Victorian art: as posters, postcards, and Internet images, Waterhouse's work has been for forty years, again, hugely popular (and populist). At the same time, his lush classical realism has been largely ignored (at best) by critics, and (more often than not) despised as the epitome of sentimentality—chocolate-box art—or as dubious lasciviousness by a modernist teleological narrative that privileges nineteenth-century impressionism in the move toward abstraction. Yet Waterhouse was at the very center of the turn toward classicizing art in the 1880s and 1890s. His pictures were highly valued, critically and financially, and were triumphantly successful across Europe and America. His art is paradigmatic of later Victorian London's visual imagination.

My interest in Waterhouse, however, is not just because he epitomizes the fashion of the last decades of the nineteenth century, and the perils of fragile reputation. One complaint frequently aired against Waterhouse's art by twenty-first-century critics—both in journalistic jibes and from within a more extended and politically informed discussion—focuses on his representation of female figures as sexually available teenagers, dream-

ily exposing their underdeveloped bodies through flimsy silks. Indeed, from the 1880s until today, Victorian nudes, as we will see, have repeatedly provoked such moral qualms, centered on the prurience or false innocence of a viewer's response to the art of exposure. It must be right to worry about such images: It is not as if the inheritance of Victorian modeling of gender has simply or cleanly passed away from our cultural or visual imagination, let alone from contemporary social behavior. But one claim of this chapter is that Waterhouse's engagement with the undoubtedly patriarchal regime of the visual in Victorian Britain is more sophisticated and engaged than the standard critical denigration suggests. In particular—and in part by tracing the critical anxiety about the erotic in Waterhouse's painting—I shall be exploring how Waterhouse represents the male subject of desire, and how his representational devices position, manipulate, and implicate the viewer—a topic that has been largely ignored in the scant discussions of his work, and is strikingly absent from the most influential attempts to see Waterhouse's art in its Victorian context.[3] This discussion will place Waterhouse at the center of a Victorian worry about male self-control and erotic openness, in which the imaging of the classical world plays an integral role. My point is not simply that Waterhouse is a more complex and provocative artist than is customarily thought. His case is also a telling example of how one strategy of modern self-definition loves to oversimplify "the Victorians" as a contrastive other to today—and nowhere more obviously than in the field of sexuality. Waterhouse's visualization of the classical becomes a paradigm of how viewers place themselves within a history of sexuality.

My second aim in turning to Waterhouse is to contribute specifically to current debates about art and text within the general arena of Reception Studies. Waterhouse's classical subjects are not just the familiar icons of tradition—Hercules, the Sirens, Venus, and so forth—from the familiar masters of classics—Homer, Virgil, and Ovid. He also depicts far less familiar figures—Mariamne, St. Eulalia—taken from far less familiar authors—Josephus, Prudentius—and often explicitly so: Many of Waterhouse's paintings come with titles and catalogue entries which announce that their subjects are taken from specific classical texts. Where a work of art explicitly cues a text in this way, scholars have inevitably been tempted to offer a formalistic analysis, which focuses on how the individual artist has taken a (verbal) image from the classical past and turned it into a (pictorial) image in the present. Art is conceptualized as illustration, and (thus) reception as a unilinear process—where the artist reads a text and then transforms it into an image: Titian's version of Ovid, Waterhouse's Prudentius.[4] There are some obvious ways in which this seductively simple model immediately needs nuancing. Images are constructed also within iconographic traditions: Waterhouse's Prudentius may be formulated through

Caravaggio's St. Paul, say, as much as through the Latin poem. Readings of texts also always need their historical, intellectual, and political contextualization: The depiction of a martyr is inevitably formed within a religious agenda. Artists also work within frames of cultural polemic, technical experimentation and limitation, and market forces, all of which mold the creative act. Part of this chapter's work will be to provide the elements of the cultural history that Waterhouse's pictures require, if their richness as cultural products is to be appreciated.

But the citation, explicit or indirect, of specific classical sources, attached to a picture, exhibited in a gallery in Victorian London, also establishes a wonderfully layered scene for the performance of cultural authority—as the viewer reads and evaluates the painter's allusive reference to a privileged classical source, in relation to the image of the classical world on display, in the light of his or her own differing levels of classical knowledge and interest, and with an eye, too, on other viewers' and critics' expressed or projected opinions—and on the dictates of propriety in the public domain.[5] And the painter's title or catalogue entry for the painting anticipates this scene. The exhibition of the painting in the gallery becomes a site where classical knowledge is deployed in response to an image of the classical world—arrogantly, foolishly, desperately, longingly, knowingly, mistakenly, brilliantly (etc.)—and this deployment is part of the cultural performance of reception. Viewing, said the late Michael Baxandall famously, is "a theory-laden activity": viewing classicizing art in the Victorian gallery comes laden with particularly heavy baggage; and the interplay of citations of classical texts with depictions of the classical world brings the artist's and viewer's purchase on antiquity—the baggage—into the limelight. Waterhouse's text-labeled and text-laden images are a paradigmatic site for reflecting on the complexity of the circulation of classical knowledge in Victorian culture—reception in action.

## Fleshliness and Purity

I shall begin my argument with a painting that will put the representation of erotics, the place of an artwork within cultural history, and the relation of art and text, firmly on the agenda. Plate 1 is one of Waterhouse's first great successes, his painting *Saint Eulalia*, first exhibited at the Royal Academy in 1885, and now in the Tate in London. The painting is huge—six feet tall—and it is a very striking theme, strikingly depicted. The subject is novel and bold: there are no other modern pictures of Eulalia that I have been able to trace, although there is one formulaic mosaic image of her in the procession of virgin martyrs in the basilica of S. Apollinare Nuovo at

Ravenna.[6] Immediately after the exhibition of this canvas, Waterhouse was elected to the Academy, and critics wrote at length on the technical skills of the work. These same critics, however, remained surprised and even confused by the choice of topic—and their surprise cues a question of its choice and treatment. Eulalia is taken from Prudentius's *Peristephanon*, a fourth-century collection of religious poems about martyrs that, even in the heady days of Victorian classicism and religious fervor, was not a text he could expect his audience to recall immediately and fully. Hence he adds a brief comment in the catalogue: "Prudentius says that the body of St Eulalia was shrouded 'by a miraculous fall of snow when lying exposed in the forum after martyrdom.'"[7]

The third poem of the *Peristephanon* tells the story of Eulalia with Prudentius's customary combination of blood, torture, and verbal pyrotechnics.[8] Eulalia is a twelve-year-old girl who lives in the country. She willfully flees her mother's control, to go to town in order to refuse to do a sacrifice, so she can bear witness to Christ. The Romans duly punish her. The executioners slice her breasts with an iron claw, and cut her sides to the bone. She revels in her triumph (*Perist.* 3.136–40): "Look Lord, your name is being written on me. How I love to read these letters, which record your victories, Christ, and the purple of the blood itself as it is drawn forth speaks your holy name." As she dies, her hair covers her nakedness, and a white dove, her pure spirit, escapes from her mouth, and finally a sudden heavy fall of snow covers her body from prying eyes. It is a poem that revels in violence to the female body as a vindication of Christian suffering—both an image of Christ's suffering and a witness to it.

It should be immediately clear that Waterhouse's summary of Prudentius for the catalogue is remarkably thin—or, rather, seems deliberately to remove the bloody violence and verbal exuberance of Prudentius's narrative. Prudentius's fervid enthusiasm becomes the barest of identifications—and the sentence that Waterhouse puts into inverted commas as a quotation from the Latin does not actually occur in the poem: it is Waterhouse's own summary of some glorifying and highly charged expressions of the early Christian poet.

Waterhouse's construction of the visual image is equally distinctive. The picture is, first of all, a remarkable exercise in foreshortening,[9] technically expert, and the construction is sophisticated, with the cross on the right, reminding us of the ideological background to the death, set against the upright pillars and upright soldier of Roman rule. The tiny group of Christians look on, one kneeling in prayer, as three white doves fly above her body, while others peck around: the miracle is set firmly within a naturalistic frame, a pointed gesture, as we will see, within Victorian religious polemics. A child in this background group points up at the highest of the three doves, attesting to the miracle. None of these Christians, intent

though they are, look at the dead saint. Nor do the Romans. Everyone's gaze is elsewhere. When we look at Eulalia, we are setting ourselves apart from the dramatic scene, doing what no one in the image does, and stare at the bared body of the girl. But the body leaves us with a problem. There is no sign of how this martyr dies, certainly no sign of the torture of her breasts and sides. She lies in the position of a crucifixion, and there is the large cross to her right, with a sign that may contain her name, but there is no indication that Eulalia has been crucified on it, barring, perhaps, a broken cord on her right wrist. She seems older than twelve. Her hair flows out like blood from the body—and thereby *un*covers the naked torso. As in many paintings by Waterhouse, he captures the moment of crisis, the point of transition, a juncture of suspended narrative: this is the precise and mysterious instant of the death of the saint, the flash of recognition of the dove, the first flakes of the miracle of snow. The snow is beginning to fall, but there is no question of it preserving her modesty. Her young body is open to the gaze of the viewers. Against the greys and white of the background, the flesh tones draw the eye instantly to the front of the canvas. The strange angle of the body to our gaze requires us to readjust and focus hard: to stare at the naked flesh. It is, in all senses, a sensational picture.

The title and catalogue entry of this painting announce it to be taken from a poem in the ancient world, and the painting's imagery is located within a naturalistic tradition of the depiction of antiquity. It might seem that we are strongly encouraged to view *St Eulalia* as a self-conscious illustration—reception—of Prudentius. Yet Waterhouse's markedly circumscribed version of Prudentius's poem, and strikingly idiosyncratic construction of the visual image, do not merely direct us to a classical authority of the early church, but also raise a question for us of how to view and comprehend the representation of the Christian saint. Why does Waterhouse show Eulalia as older than twelve, naked, and unmutilated? In trying to answer this question, at least three levels of reception will be brought into play—Waterhouse's reading of Prudentius; contemporary critical and popular receptions of the painting; and a later, modern tradition of looking back at Waterhouse's visualization of the martyr's bared body.

Now it is impossible to answer any question about the painting from the writings of Waterhouse himself. His biographical material is thinner than any other major painter of the period.[10] Unlike Alma-Tadema, Burne-Jones, Watts, or Leighton, say, he has not left significant caches of letters or other writings, and does not even appear in the letters and diaries of others. (It's perhaps a personal joke on Waterhouse's reticence about public life that his friend, Logsdail, painted his portrait as just one face on a bus—in the background, still.[11]) Although he taught, and his own art was successful, and he worked in a celebrated artists' commune in Primrose Hill, his aesthetic and

religious attitudes can only be evaluated by viewing his paintings in context and from the reaction they provoked.

Nor can we easily set *St Eulalia* in a context of Waterhouse's religious art. It is something of a surprise for such a widely commissioned nineteenth-century artist that he painted scarcely any religious art in his long career. Apart from one undistinguished and flowery scene of the Annunciation from 1914, right at the end of his career, an exercise painted in the style of much earlier Pre-Raphaelite imagery, there is only one explicitly Christian painting, the superb portrait of the recumbent St. Cecilia, with kneeling angels playing stringed instruments in front of her (1895) (plate 2). This image is explicitly based on Tennyson—the catalogue cited a condensed stanza from Tennyson's poem "Palace of Art"; Tennyson was a particularly favorite source for Waterhouse, and his image of *The Lady of Shallot* has in turn become the cover of many a book—and it is strongly aware of how Burne-Jones, Strudwick, and Rosetti had each treated this subject as an allegory of music/art. It is, in other words, a finely modernist *mise-en-abime* of representation—the painting of a poetic description of a painting: an image of an ecphrasis—which is an allegory of the creative act, set self-consciously within an artistic tradition of modern art. The saint's eyes are closed, as if she is snoozing over the music book on her lap. Is what she sees a dream or a vision? However, it is a nice touch that we can see the angels with our mundane eyes, which she, patron saint of art, sees inwardly. The painting was praised in contemporary criticism precisely for its modernist technique—its blocks of color, the wet-on-wet application of paint that created such soft and nuanced flesh tones. *St Cecilia* is a deeply sophisticated image that is concerned more with the imaginative process of art and vision than with a profound Christian message—and it should encourage us to read *St Eulalia* with care: it is another painting based on a poem, transformed by citation and visualization, that provokes self-conscious reflection beyond the iconography of sainthood.

*St Eulalia* was widely reviewed on its first exhibition, and we have access now to the reviewers' comments (although I have not been able to trace any private reactions, as we do have for some paintings from this period). The broad initial favor demonstrates the success of Waterhouse's repackaging of Prudentius. There were some slightly bewildered attempts to understand what attracted Waterhouse to the story, and a good deal of praise for the technical achievement of the painting, which as Armstrong noted "not many English painters would have brought off so successfully."[12] Two strands of response are worth emphasizing. First, the beauty of the saint: The *Magazine of Art* commented that "Its whole force is centred on the pathetic dignity of the outstretched figure, so beautiful in its helplessness and pure serenity."[13] The beauty of "helplessness" fits more easily into the

Victorian erotics of femininity than into the rhetoric of the triumphs of martyrdom—we can expect such an aesthetic bias in the *Magazine of Art*, aligning Eulalia with other naked, pitiful maidens in the period's art (as well as with the ideals of classical aesthetics as mediated by Winckelmann, high priest of serenity). But the adjective "pure" marks a different potential. There is no term more charged in Victorian religious thinking on sexuality. It is an invitation to view Eulalia's body without erotic stain—an invitation that cannot fully repress the desire that motivates it. There is a suppressed question here about Eulalia's beauty.

Second, critics declared that its vigor, boldness, and striking effect was positively French in conception—"more at home in the Salon"—but, at least for Armstrong, "the torn sides, the scorched breasts and head, all these, of course, as Mr Waterhouse paints not in the Boulevard Clichy but at Primrose Hill, are left out."[14] Armstrong knows his Prudentius (or at least has gone back to the text, following Waterhouse's lead) and expects his readers to appreciate his learning, and uses it to underline the choices Waterhouse has made in his depiction of the saint. The rest of Armstrong's piece would suggest that his comment is positive, exhibiting distaste for lurid continental taste. Waterhouse is part of a critical argument about nationalism and art. His "conservatism of reverence," and his "moral qualities," surrounded his work with the precious values of propriety and dignity.[15] His martyr involves no extremism in representation or belief: The French Catholic taste for mutilated saintly bodies is distasteful to the British public eye.

Modern critics are less likely to be as sanguine as Armstrong or Blaikie. Peter Trippi, in the best modern book on Waterhouse, is blunt enough. In the painting itself and in the critics' very language of beauty, he sees a disturbing sexuality, grounded in a modern stereotype of national perversion: Eulalia reveals "the erotic implications of martyrdom, which endured in the sado-masochistic sexual practices of many Englishmen"; like Kestner, he sees a lurid voyeurism in the display of female flesh, designed to bolster the Victorian patriarchal ideology.[16] Should we be more knowing than the Victorian critics who showed nothing but respect for Waterhouse's delicacy and reticence? Or are their statements that there is nothing untoward, a sign and signal that they did feel some nervousness about the image? Is it possible to analyze how Waterhouse reads Prudentius *without* modern concerns invading our approach? That is, when we look at the reception of Prudentius by Waterhouse, do we not inevitably overlap the three levels of reception I separated, and use both contemporary critical response and our own conceptual assumptions to construct Waterhouse's process of composition?

We need here, then, to develop further the framing of *St Eulalia* within Victorian debates on religion and sexuality, if we are going to go beyond

the rather too self-serving rhetoric of Victorian hypocrisy and modern en-
lightenment. In the 1880s, there was, of course, considerable turmoil within
organized religion. The impact of Darwin (and of science in general), of
the Oxford Movement, and of evangelical groups made the sphere of reli-
gion a shrill and contested arena, as the consequences of the bitter theo-
logical and political fights of the 1850s and 1860s unfurled.[17] The ques-
tioning of the miraculous in the Bible stories (which we will discuss in
detail in chapter 5) led to a string of archaeological missions to prove the
truth of the biblical narrative and a profoundly critical study of the re-
ported miracles of the early church, of which Prudentius is a typical ex-
ample. Waterhouse here seems to have hedged his bets. The boy at the
back of the painting is pointing toward the white dove rising, which in
the poem is the sign of the miraculous rising of Eulalia's spirit. But the
dove is also only one of a flock of doves who flutter and strut around the
body. The gesture can be read either as a demonstration of the child's sim-
ple faith as proof of the story, or as a more defensive response, naturalizing
the miracle as a child's perception of a normal and natural event. (So
St. Cecilia is depicted as asleep, and the angels thus can be seen as figures of
her dreaming/vision.) The very separation of the group of Christians from
the martyr, their failure to look at her, raises the question of how to relate
the pathetic victim to the religious response to her. There is an implicit
engagement with the historical, critical understanding of the early church
in this painting.

For our purposes here, the role of the classical world in such arguments
needs specifying. On the one hand, the classical world could be presented
as a pre-Christian haven, closer to nature, innocence, and simplicity. This
was particularly the case with ancient Greece, and for the sexual politics of
characters such as Symonds, this Greece was a fundamental idealism—as it
was for the cultural politics of Wagner, say, or the aesthetic credo of
Winckelmann.[18] On the other hand, the Roman world could appear as a
model for thinking through empire—How like Rome was Britain? What
lessons did Rome bequeath Britain?—and as a privileged image of deca-
dence and degeneracy, through which the overheated Victorian fascination
with such topics could be represented.[19] Christianity emerged here as a
triumphant purity opposed to a collapsing and immoral state (an image
supported by a string of influential novels of Roman life filled with wicked
emperors and pious Christian heroes). Alma-Tadema's ancient world in-
fluenced the young Waterhouse deeply. In Alma-Tadema's many pictures
of the Greek and Roman world, there is barely a hint of any Christian
motif: It is another place, pagan, and untouched by theological aggression.
Gérôme, however, who was also a major influence on Waterhouse, set his
Christian martyrs in the boldest frame of Roman decadent power. His
painting of Christians in the Circus Maximus, *The Christian Martyrs' Last*

*Prayer* (1883, now in the Waters Gallery, Baltimore) has a large lion (followed by a tiger) approach a group of Christians who kneel in prayer around a patriarchal figure. Behind them, and stretching across the canvas, is a line of martyrs crucified and being burned to death. The focus on fear and violence, the contrast between the wild animal, the praying Christians (all fully dressed), and the barbaric sight of the burning human flesh in front of a massive crowd, create a shockingly emotive image of the fight of Christianity in the Roman Empire. How Christianity is conceived to fit into the ancient world from which it came is an ideological issue of some import. Waterhouse's archaeological realism and his precisely naturalistic account of Prudentius's miracles seem to draw him back toward Alma-Tadema; the slaughtered saint under the guard of the Roman centurion links him closer to the tradition epitomized by Gerôme. Waterhouse's response to the story from Prudentius is poised within arguments about how Christianity and paganism interrelate, and between competing models of the ancient world for the Victorian imagination.

This ideological self-positioning is itself framed by the pictures with which Waterhouse's canvas was viewed by his contemporary audiences. In the exhibition of 1885 itself, there were paintings of Christian martyrs (F. Hamilton Jackson's diptych *St Dorothea* and A. W. Bayes's *Dream of a Christian Martyr*, for example, both of which appear to have shown fully clothed saints in pious garb).[20] More striking is Charles Mitchell's *Hypatia*, shown at the Grosvener Gallery at the same time (plate 3), his only widely successful painting. This image also announces that it has a precise literary model—Kingsley's novel *Hypatia*—a violently anti-Catholic novel, set in fifth-century Alexandria, which went through eleven editions in the 1880s, although first published in 1853. As Hypatia, the pagan philosopher, was stripped and dragged to her violent death by a mob of fanatical Christian monks, she "rose for one moment to her full height, naked, snow-white against the dusky mass around—shame and indignation in those wide clear eyes, but not a stain of fear. With one hand she clasped her golden locks around her; the other long white arm was stretched upward toward the great still Christ, appealing—and who dare say, in vain?—from man to God."[21] This is the moment captured by Mitchell, and the tense musculature around the raised arm is particularly emphatic in a female model—to such a degree that the image may even be seen as de-eroticized, despite the bared breast.[22] Kingsley's novel made the pagan a martyr to monkish Christians, and—an even more shockingly polemical gesture for a member of the church—toys at this moment of her death with the idea that she was a pagan received by Christ—unlike the disgustingly violent professed Christians who murder her. Tennyson, a friend of Kingsley's, was upset that the author had used the word "naked" in his description. That his heroine should be stripped and humiliated seemed too brutal. It is this shocking

moment that Mitchell vividly depicts. It is against such religious polemic too that *St Eulalia* should be viewed.

Looking at the displayed fleshliness of saints' bodies had the potential for sectarian polemic as early as the 1840s. William Sewell was a classicist and a divine, who was a member of the Oxford Movement, but strongly opposed to Roman Catholicism, rejecting vehemently the move that Newman so scandalously made. He was a founder of Radley School near Oxford, precisely in order to institutionalize his High Church principles. Sewell famously took a pupil's copy of Froude's *Nemesis of Faith*, tore it in pieces, and burned it in front of the class. His two-volume novel *Hawkstone; A Tale of and for England in 184-*, is a luridly anti-Catholic novel, published when he was Whyte's Professor of Moral Philosophy at Oxford. It begins "It was a dark, stormy night. . . ," echoing Bulwer Lytton's famous opening, and ends with a plea that "the vengeance of heaven" might fall on "those miserable men, who, under the name of religion, are rendering asunder, in this country, the ties which God has joined, and tearing the children of this empire from their Father in the State and in the Church"[23]— a plea which sums up the book's view of Catholicism as a violent threat to all the sacred bonds of England. The staunchly Anglican hero visits the city of Rome with a friend who tries to convert him to Catholicism (he is saved by his powers of textual criticism, which allow him to detect the frauds and interpolations in the texts of the early church he is shown).[24] They visit churches together where they see men "lounging on sofas to gaze, through opera glasses, on the sufferings of saints, and admire the anatomy of muscles in the form of a crucified Redeemer."[25] The corruption of Catholicism is visualized with a shudder as the degenerate and lascivious staring at the flesh of saints. This scene—perhaps without the sofas and opera glasses— haunts the gallery even in the 1880s, with the fear that the image of a suffering saint stimulates awful desires—to "Dream hours before her picture, till thy lips / Dare to approach her feet" as Kingsley puts it with customary horrified fascination.[26]

"The theme of religious bigotry," particularly focused on a naked female form, "would have been especially pertinent" this year, as Allison Smith has wonderfully uncovered,[27] since a group of religious men, led by J. C. Horsley, and promoted by Lord Haddo (George Gordon), actively led protests against the immorality of nudes in art, and especially the use of nude models in art schools.[28] One of the more distinguished paintings in the Academy exhibition of 1885 was Poynter's *Diadumene* (figure 1.1). This painting is a wonderful example of just how multilayered the game of classical quotation could be—and of how such an image could enter the cultural politics of the time. The painting is a larger version of his own first image called *Diadumene* exhibited at the Academy in the previous year. The earlier picture was smaller, but the girl is completely naked (figure 1.2). The second

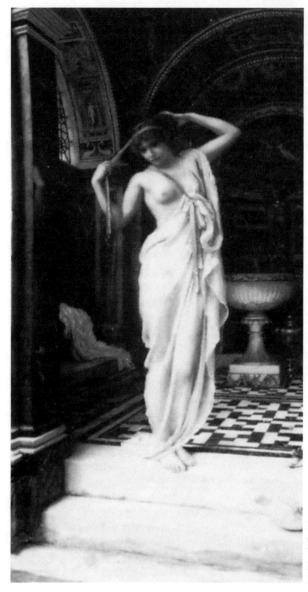

Fig. 1.1. *Diadumene*
(clothed) (1885–1893)
by Edward John
Poynter (1836–1919).
Private collection

image covers up part of the girl's nudity, and thus also draws attention to
the (added) veil.[29] The picture is itself a version of the recently discovered
(1874) Esquiline Venus, a Roman marble that recalls a Greek original (or
so it was debated at the time). Yet the title, *Diadumene*, is a feminine version
of the title of a famous Greek sculpture, the Diadoumenos of Polycleitus,
a paradigm of male beauty for ancient art. Alma-Tadema in 1877 had ex-

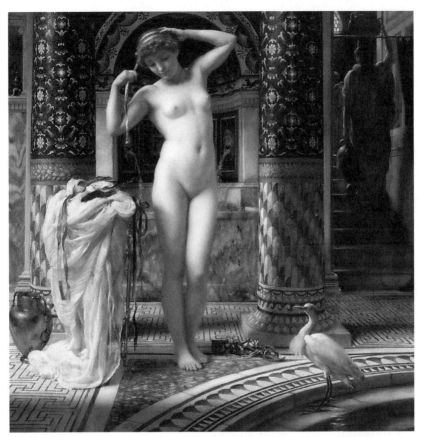

Fig.1.2. *Diadumene* (c. 1883) by Edward John Poynter (1836–1919), oil on canvas. Royal Albert Memorial Museum, Exeter, UK. Photo: The Bridgeman Art Library. Image reference: EX232729

hibited in the Academy a full-scale nude painting of a woman in exactly the same pose, called *A Sculptor's Model* (plate 4), where the combination of a life-size female nude with a male figure staring at her from behind (and thus facing the viewer with an image of a viewer) helped make the painting a *cause célèbre*—it was seen by over 89,000 people when exhibited in Liverpool, and was much discussed in the press there (as we will explore in chapter 2).[30] Poynter's *Diadumene* quotes a Roman Venus quoting a Greek model; quotes a male Greek model; and quotes his colleague Alma-Tadema's work. For all this sophisticated, self-conscious construction of artistic imagery, the Press made this painting the focus of the controversy over the display of nude figures, and in reply, Poynter defended himself in *The Times* (with what might be thought studied disingenuousness) as being really interested in reconstructing with archaeological authenticity Roman bathing customs.[31]

Poynter was responding to a lengthy debate in *The Times* prompted in the first instance by a letter signed by a "British Matron," who wrote in disgust at the Royal Academy Exhibition: "To show an utter want of delicacy when selecting a subject painted for no purpose but to testify to the painter's skill is an insult to that modesty which we should desire to foster in both sexes. Is it not a crying shame that pictures are flaunted before the public . . . which must lead many visitors to the gallery to turn from them in disgust and cause only timid half glances to be cast at the paintings close by however excellent they may be, lest it should be supposed that the spectator is looking at that which revolts his or her sense of decency."[32] The British Matron's[33] letter has some very strong expressions of revulsion ("crying shame," "disgust," "flaunted") and she sees herself as taking part in "a noble crusade of purity to check the rank profligacy that abounds in our land." But even so, she represents the spectators as half-glancing at pictures, lest their eyes fall on a painting that will offend a sense of decency. How can one know which paintings not to look at without having at least glanced? Despite the strong emotions of revulsion, there is still a play of timid glances around the gallery. This attraction and repulsion, this half-looking, captures perfectly the anxiety about modesty and desire that will recur throughout the responses to classical nudes in this period.

It would be easy for a modern reader to see the British Matron as a caricature of "outraged Victorian prudery," but it would be wrong to underestimate the seriousness of her remarks. Her phrase "noble crusade of purity" unmistakably refers to the Campaign for Social Purity, which was reaching a climax in 1885 with the passing of social purity legislation, after a long campaign to repeal the Contagious Diseases Acts.[34] She is aligning herself with major social reformers such as Josephine Butler and Jane Ellice Hopkins, and bringing the art gallery into the arena of national debate on the morality and control of society. It should be no surprise then that the British Matron's letter prompted extremely heated debate for a week.

Some women wrote in support: "After some years in the colonies I visited the Royal Academy recently in company with my husband and was shocked, not only at the 'nudities' referred to, but at the ease and apparent nonchalance with which young girls, evidently of the higher classes of society, stood regarding the same side by side with men and boys . . . I, matron that I am, could not remain without a burning sense of shame. I am sure that hundreds—nay, thousands—of other British Matrons also have like feelings with myself in this respect."[35] As with the first matron, the combination of anxieties about class, age, the state of the nation ("from the colonies"), as well as moral purity, make for a heady brew of outrage. But the majority of the response was highly critical of the British Matron's stance. "An English Girl" wrote in to say that she thought the emotions of shame experienced by the Matron would be "new and unknown sensations to

pure-minded women who see no harm (where none is intended) in any simple representation of nature."[36] The Girl, for all her attempt to reclaim purity as a term ("pure-minded"), found herself dismissively ridiculed as naïve and uncultured, along with the Matron, by a string of aggressive and patronizing male responses ("Much is due to the prejudices of well-meaning but uncultured people, in whose name the 'British Matron' is privileged to talk nonsense"; "her letter is damning evidence of the morbid imagination of the writer"; "the distorted and unhealthy attitude of mind which she displays is far more shameful than any fidelity to nature in a work of art").[37] But other women also wrote in response. "An English Woman" reversed the opinion of the matron from the colonies, with a mildly daring allusion to art theory, as well as the necessary claim to pure-mindedness: "There are, I trust and believe, very few cultured and pure-minded women, loving art for art's sake, who share the virtuous indignation of a 'British Matron' regarding nude studies."[38] A mother ("UMB") noted that her seventeen-year-old daughter, reading the letters' pages after visiting the Grosvenor Gallery, was amazed: "Why, mother, we did not see anything indecent there."[39] Many of the male comments reveal a familiar misogynistic rhetoric. John Brett, an artist, assumed the woman's outrage was because she was "so sad to think how hopelessly less beautiful her own figure is than that in the lovely picture which enchants her masculine friend."[40] Jerome K. Jerome chipped in with his characteristic sense of fun, agreeing that the "human form is a disgrace to decency and that it ought never to be seen in its natural state. . . . It is God Almighty who is to blame in this matter for having created such an indelicate object."[41]

This is a public debate, and not material from any more intimate sources such as diaries or letters, but nonetheless it gives a rare opportunity to see a set of female responses to an exhibition (when so many responses are marked as male). It is clear, first, that the women write self-consciously as women, even when demanding a shared sense of decency between the sexes; that they write without the strong commitments to theorization seen in the male writers (who often indicate their status as artists or religious leaders, where the women are identified through familial position; it is this separation from theorization that makes the one woman's comments on "art for art's sake" seem daring); and, above all, that they not only reflect the conflicted response we see in the male writers, but also, despite their differences, they agree that the debate is about decency and the desires of the viewer. As one writer put it, who was trying to articulate the difference between acceptable and unacceptable nude pictures, there must be "a manifest appeal to the love of beauty, and not to appetite"—a distinction which might be hard to police.[42] The asymmetry of expectations about female desire and female language means that women in these letters do not talk explicitly of the paintings' erotic content or effect, but the male response

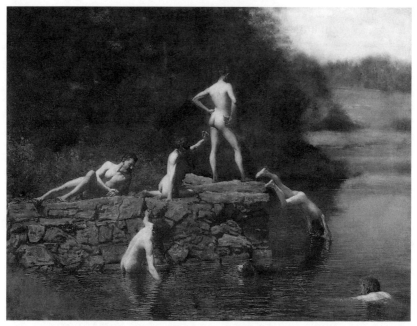

Fig. 1.3. *The Swimming Hole* (1885) by Thomas Eakins (1844–1916), oil on canvas, 27 3/8 ×
36 3/8 in. Amon Carter Museum of American Art, Fort Worth, Texas. Purchased by the
Friends of Art, Fort Worth Art Association, 1925; acquired by the Amon Carter Museum,
1990, from the Modern Art Museum of Fort Worth through grants and donations from the
Amon G. Carter Foundation, the Sid W. Richardson Foundation, the Anne Burnett and
Charles Tandy Foundation, Capital Cities / ABC Foundation, Fort Worth *Star-Telegram*,
The R. D. and Joan Dale Hubbard Foundation and the people of Fort Worth. 1990.19.1

to the women viewers leaves little doubt about where the threat to decency
lies at the scene of viewing "nudities."

This was not only an issue for British matrons. In 1885 in the Pennsyl-
vania Academy of Fine Arts, a different painting of bathing was also caus-
ing a scandal in its annual show. Thomas Eakins's (now) well-known pic-
ture, *The Swimming Hole*, depicts the artist and five other men—students
and friends of his—naked by a swimming pond (figure 1.3). The picture
had been commissioned by Edward Coates, a businessman, who was also
the Chairman of the Committee on Instruction at the Pennsylvania Acad-
emy of Fine Arts. He returned it to the artist, and in 1886 Eakins was dis-
missed from the Academy in a row precisely over the study of nudes. Men
could swim naked without shame or disquiet it seems, but this everyday
activity could not be represented in figural form. (Eakins did not help
his cause by taking off his own clothes at the drop of a hat, asking his
models, friends, and even his society portrait subjects to do the same, and
then touching his subjects in too intimate a way in trying to arrange their

poses: at least one lady fled from the studio.)[43] Despite the long tradition of representing the human form, in the English-speaking world in the mid-1880s the display of the painting of a nude body could always flare into controversy.

The nude form also entered religious debate in an overheated manner. In 1891, Calderon's painting *St Elizabeth of Hungary's Great Act of Renunciation* caused debate up to the Prime Minister himself. Elizabeth, wife of the king of Hungary, who died while on the Crusades, chose under the guidance of her confessor Conrad of Marburg to follow a life of charity, seclusion, and prayer (plate 5). Calderon in the Catalogue of the Exhibition cited as his authority for the story of his picture a medieval life of Elizabeth ("*see* Dietrich's 'Life of St Elizabeth'"[44]), but once again Charles Kingsley provided the most relevant source text with his poem "The Saint's Tragedy" (1848), a lengthy verse drama in which Saint Elizabeth indeed tears off her clothes and swears to go "naked and barefoot through the world to follow / my naked Lord." It was almost certainly through Kingsley that Calderon encountered the tale (and Kingsley included sixteen pages of footnotes with special attention to Dietrich the Theologian's eight-volume biography of the saint, to defend his stridently anti-Catholic portrayal).[45] Kingsley's poem—the first draft, which was presented to his wife on their wedding day, complete with his own drawings, which his university colleagues thought inappropriate at best—was not only anti-Catholic, it was also stridently opposed to celibacy and fasting, which the Oxford Movement had idealized. Kingsley was long dead by the 1890s, and no longer regarded as a hot-headed radical—he had been Professor of Modern History at Cambridge, Chaplain to Queen Victoria, and published *Waterbabies*, after all. But "the extreme anti-Catholic bias of Kingsley was read into Calderon's painting"—and a huge row broke out in the letters pages of *The Times*.[46]

The suggestion that Elizabeth would have "voluntarily stripped herself naked to imitate [Christ's] involuntary and most pitiful nakedness" outraged the Jesuit R. F. Clarke as an "idea utterly repulsive to Christian feeling." It would, he declared, "make her a madwoman, not a saint."[47] "Naked" (*nudus*) was, he said, obviously a metaphor for humble submission. The (Catholic) Duke of Norfolk finally wrote on behalf of the Catholic Union of Great Britain to complain that it was "an indecent travesty of a sacred incident" which attributed a "sinful act of gross immodesty to a canonized saint" and to demand that the picture not be purchased for the nation.[48] T. H. Huxley, part of the scientific community around Darwin, which was repeatedly slurred with the accusation of immorality for its views on sexuality and religion, joined in with a letter that quoted a medieval Latin source that described Conrad as flagellating Elizabeth in her shift, and pilloried the confessor as being "*capable de tout*" (French, as ever, is the proper

language for scandal).[49] Dr. Abbott wrote in with a lengthy analysis of the
Latin life of Elizabeth to suggest Calderon might have been right in his
representation of a naked penitent; R. F. Clarke replied with an even lon-
ger defense of the metaphorical sense of "nudus," even and especially in
the crucial phrase "omnino se exuit et nudavit ut et nuda nudum pauperta-
tis et charitatis gressibus sequeretur," "she completely divested herself and
bared herself, so that she could naked follow Him naked in the steps of
poverty and charity." (Scholarship was a crucial flag in this debate from the
beginning. I suspect that the days when the correct translation of a medi-
eval Latin religious text could fill the pages of a national newspaper for two
weeks have passed.)[50] Many others chipped in with scholarly observation,
too, on the heinous or admirable nature of Conrad, as well as on the issue
of understanding the Latin.

We can sense something of the outrage this picture evoked by compar-
ing it with the image world of a bastion of social propriety, Mrs. Gladstone.
Her memorial in the Gladstone family church at Hawarden, a shrine of
piety if ever there was one, is a large marble tomb, flanked by a pair of
stained glass windows, which show us, the inscription declares, the icons
of feminine goodliness that Mrs. Gladstone took as models to live by.
There stands St. Elizabeth, fully clothed in Pre-Raphaelite medieval drap-
ery, in protective and exemplary care of the Prime Minister's wife. St. Eliz-
abeth was the personal patron of Mrs. Gladstone—how could she be the
naked, starved, and humiliated victim of a manipulative Catholic confessor?

Even when *The Times* leader wrote a summary of the letters and a careful
conclusion, and thus tried to bring an end to the debate, nonetheless it
rumbled on.[51] (The editorial's poised judiciousness—a combination of sexism
and anti-Catholic sneering—reads less comfortably today: "there is . . . no
limit to the absurdities which women may commit when they put them-
selves under priestly control.") The *Pall Mall Gazette* had no doubt what
was going on in this modern art: "You have nothing particular to say; no
particular light even to throw on the human figure and you are just a little
afraid of the British Matron. . . . You therefore pretend that so far from
choosing a subject in order that you may introduce the nude, you have
drawn your inspiration from a scene in some past epoch of nakedness
which forces the nude upon you."[52] Calderon's image of the cowled Con-
rad looming over and staring at the naked female saint, even with the chap-
erone of a kneeling nun, prompted strong suspicions of an unhealthy voy-
eurism, associated not just with disturbing (Catholic) religious rites, but
also with the contemporary exploitation of women. *Punch* and other maga-
zines linked it to a trivial scandal of the moment involving (male) officials
of the London County Council who insisted in inspecting a female acro-
bat's body for signs of mistreatment. *Punch's* cartoon "The Penance of
Zaeo in the presence of some members of the County Council" is a striking

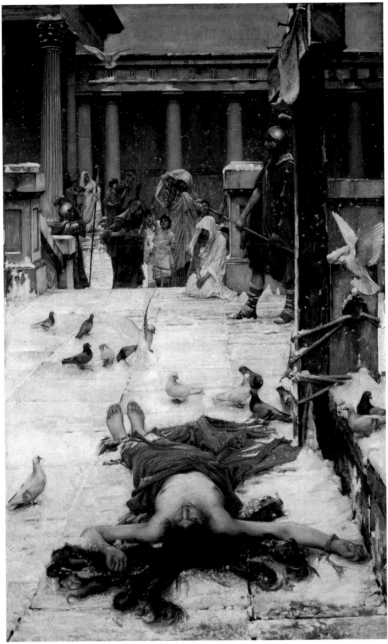

Plate 1. *Saint Eulalia* (exh. 1885) by John William Waterhouse (1849–1917), oil on canvas, 188.6 × 117.5 cm. Tate Gallery, London, Great Britain. Photo: Tate, London / Art Resource, NY

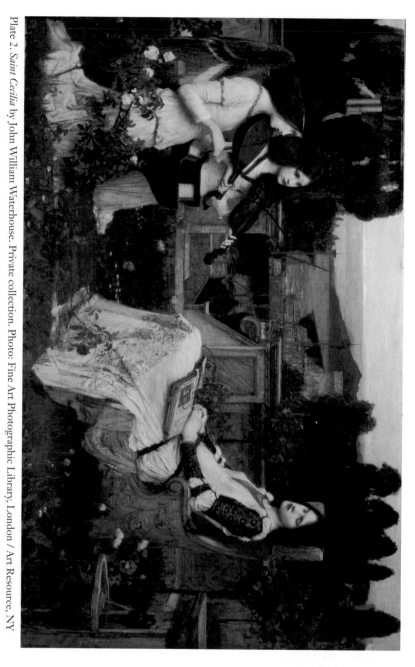

Plate 2. *Saint Cecilia* by John William Waterhouse. Private collection. Photo: Fine Art Photographic Library, London / Art Resource, NY

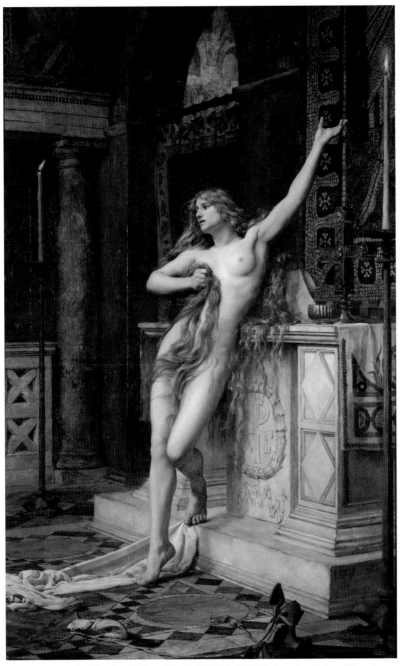

Plate 3. *Hypatia* by Charles William Mitchell (1854–1903). Laing Art Gallery. Tyne & Wear Archives & Museums

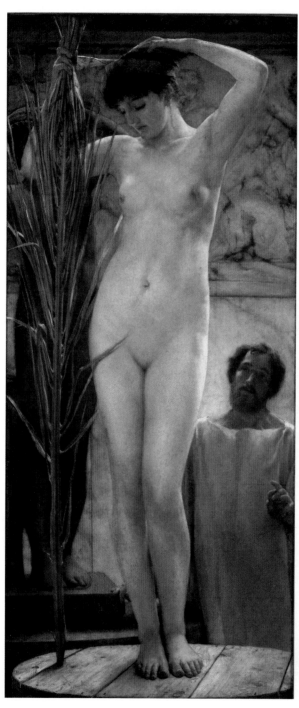

Plate 4. *A Sculptor's Model* (1877) by Lawrence Alma-Tadema (1836–1912), oil on canvas, 195.5 × 86 cm. Private collection. Photo © Christie's Images / The Bridgeman Art Library. Image reference: CH35179

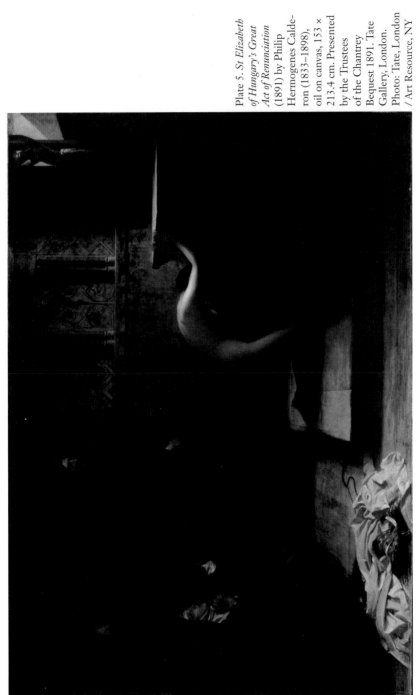

Plate 5. *St Elizabeth of Hungary's Great Act of Renunciation* (1891) by Philip Hermogenes Calderon (1833–1898), oil on canvas, 153 × 213.4 cm. Presented by the Trustees of the Chantrey Bequest 1891. Tate Gallery, London. Photo: Tate, London / Art Resource, NY

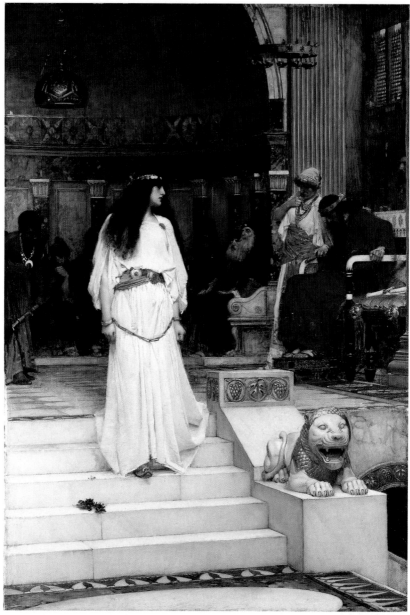

Plate 6. *Mariamne* (1887) by John William Waterhouse, oil on canvas, 267 × 183.5 cm. Private collection. Photo © Christie's Images / The Bridgeman Art Library. Image reference: CH368191

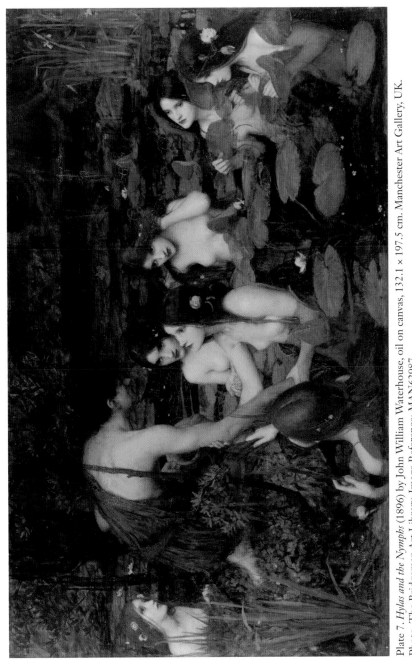

Plate 7. *Hylas and the Nymphs* (1896) by John William Waterhouse, oil on canvas, 132.1 × 197.5 cm. Manchester Art Gallery, UK. Photo: The Bridgeman Art Library. Image Reference: MAN62987

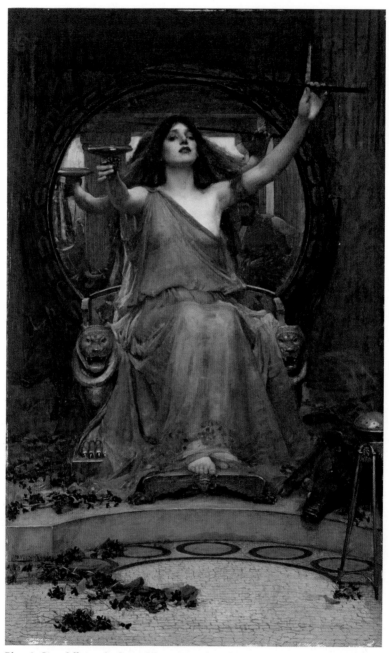

Plate 8. *Circe Offering the Cup to Ulysses* (1891) by John William Waterhouse, oil on canvas, 146.4 × 90.2 cm. Gallery Oldham, UK. Photo © Gallery Oldham, UK / The Bridgeman Art Library. Image reference: OLD36956

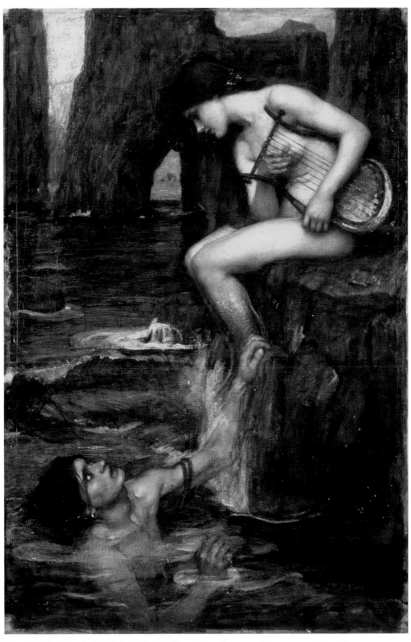

Plate 9. *The Siren* (c.1900) by John William Waterhouse, oil on canvas, 81 × 53 cm.
Private collection. Photo: The Bridgeman Art Library. Image reference: NUL121285

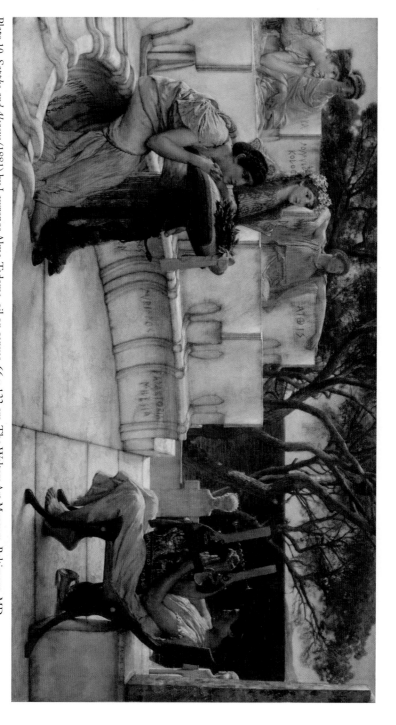

Plate 10. *Sappho and Alcaeus* (1881) by Lawrence Alma-Tadema, oil on canvas, 66 × 122 cm. The Walters Art Museum, Baltimore, MD

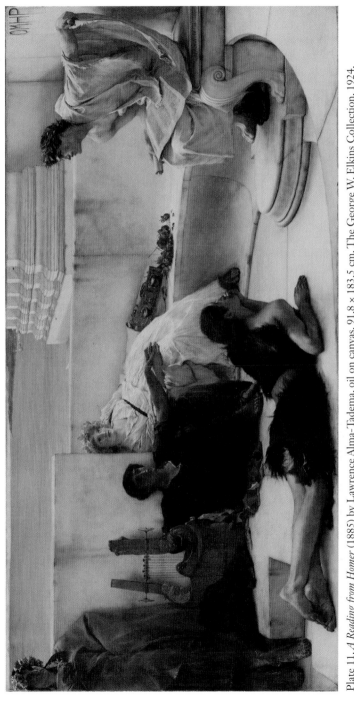

Plate 11. *A Reading from Homer* (1885) by Lawrence Alma-Tadema, oil on canvas, 91.8 × 183.5 cm. The George W. Elkins Collection, 1924, Philadelphia Museum of Art, Philadelphia. Photo: The Philadelphia Museum of Art / Art Resource, NY

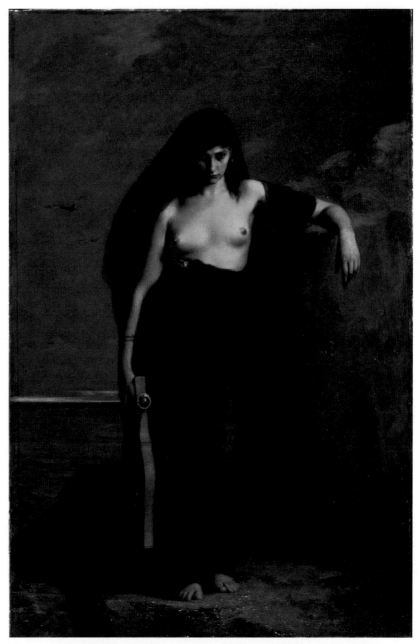

Plate 12. *Sappho* (1877) by Charles Auguste Mengin (1853–1933), oil on canvas, 230.7 × 151.1 cm. Manchester Art Gallery, UK. Photo: The Bridgeman Art Library. Image reference: MAN75576

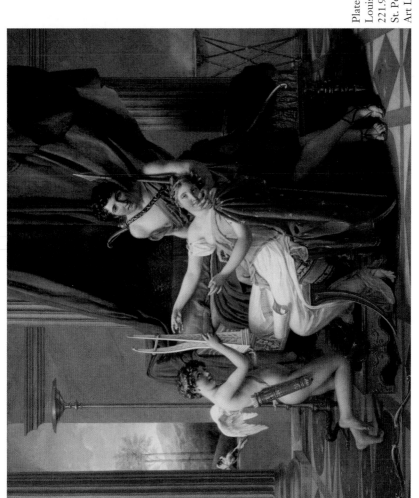

Plate 13. *Sappho and Phaon* (1809) by Jacques-Louis David (1748–1825), oil on canvas, 221.9 × 261 cm. State Hermitage Museum, St. Petersburg, Russia. Photo: The Bridgeman Art Library. Image reference: MEL48925

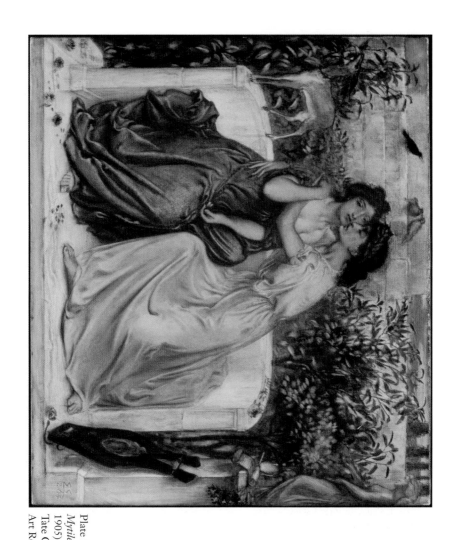

Plate 14. *Sappho and Erinna in a Garden at Mytilene* (1864), by Simeon Solomon (1840–1905), watercolor on paper, 33.0 × 38.1 cm. Tate Gallery, London. Photo: Tate, London / Art Resource, NY

Plate 15. *The Kiss of the Sphinx* by Franz von Stuck (1863–1928). Szépművészeti Múzeum, Budapest

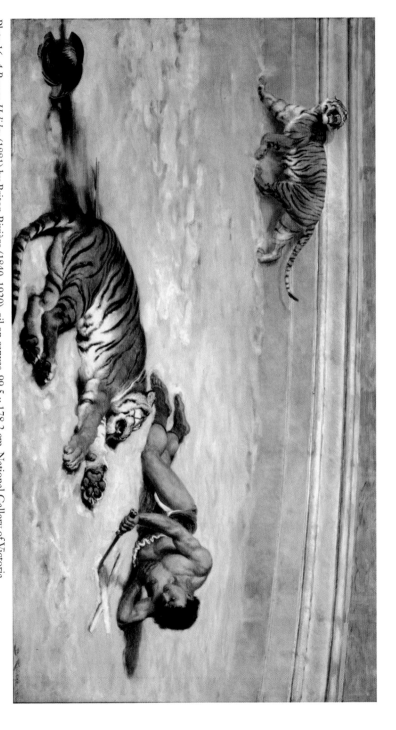

Plate 16. *A Roman Holiday* (1881) by Briton Rivière (1840–1920), oil on canvas, 99.5 × 178.2 cm. National Gallery of Victoria, Melbourne, Australia. Photo: The Bridgeman Art Library. Image reference: NGV114845

parody of the Calderon picture, with a (scantily clothed) acrobat kneeling and being leered at by a besuited civil servant.[53] The implication that a male viewer could be smuttily implicated by his gaze—even with religious art—is clear enough. For many viewers of Calderon's picture, the holiness and chastity of Elizabeth was not enough to shield her—and the viewers— from the disturbing sexuality of looking at a (priest looking at) the naked female saint.

In July in the House of Lords, Lord Stanley again raised the issue of the unseemliness of the picture and the insult to Catholics. The Prime Minister Lord Salisbury replied with a speech that drew much laughter (a "not unsuitable retort to the solemn pedantry of Lord Stanley," as *The Times* noted).[54] There was no need to worry, he told the House, because in the public collection it was exhibited in a corner, and when he visited the gallery no one was there anyway. If it had been in a private collection, on the other hand, it might actually be seen every day "by all kinds of persons, including maidservants and others." It is an irony of the history of British attitudes to sexuality that what could be already in 1891 a winning joke by the Prime Minister, should become the kind of serious remark around which the most famous post-war trial for obscenity—the *Lady Chatterly's Lover* case—should turn: "is this the sort of book you would allow your wife or servants to read?" In the 1860s and 1870s, there had been few political topics as divisive and aggressive as anti-Catholic feeling: Murphy, a hot-headed lecturer, caused riots in Birmingham with his lectures on the impropriety of the confessional, and eventually died after being beaten viciously by a Catholic mob; a good deal of public fuss was focused pruriently on what happened inside convents, and on priestly influence on young women, fomented in particular by the county squire and conservative MP Charles Newdigate Newdegate.[55] The case of Barbara Ubryk, "the nun of Cracow," who was found naked and without heating in a convent, caused a brief but intense scandal in 1869: *The Tablet* explained that she was insane and destroyed any clothing or furniture in her surroundings, a defense that did not wholly defuse the situation.[56] Artistic depictions of nuns and novices reflected this deep-seated anti-Catholic feeling.[57] But by 1891, the intensity of these political rows had calmed down—to the degree that the Prime Minister could now afford to joke in the House about such sensitivities (however strongly felt by the Duke of Norfolk and others). But nonetheless, Calderon's picture did become a lightning rod for anxieties about sexuality and religion, anxieties articulated with increasing fervor concerning the propriety of representing a naked medieval saint.

The strength of response in the later decades of the nineteenth century is interesting to compare with a rather different response from the middle of the century. Edward Frost exhibited in 1849 a picture of the Sirens (and we will be turning to Waterhouse's Siren shortly). Frost gives us a painting

of three beautiful naked young women, sitting on the seashore, in the most seductive poses, singing. *The Art Journal's* reviewer had no doubt that this was a most alluring image, and with wry humor playfully records the spectators' response: "These three ladies are seated on the shore of their isle, singing to lure the luckless crew of some passing craft. Whatever may be their success with these coasting amateurs we know not, but it is signal with the throng of spectators now around them; none can pass by their isle without stopping to listen." And he leaves us in little doubt why: "The expression of their features is voluptuous. . . . The skin textures are warm, soft, yielding."[58] The classical nude here has a capability of turning the decent Victorian into a "coasting amateur," and the reviewer rather enjoys both the watching and his light-hearted observations on that pleasure of the gaze. The threat of such casual enjoyment—which is not limited to the middle of the century, of course—also hardens the moral fervor of those who object to such art. And reminds us of the multiple responses to the sexuality of art in this age of conflicted purities.

The nudity of Saint Eulalia, then, may seem a more charged element of the painting in such a context. Is the question of a viewer's prurience, raised by modern critics, and raised in general about the exhibition of 1885 by the correspondents in *The Times*, a question—silenced but present—for Waterhouse's contemporaries, faced by this picture? Eulalia is noticeably thinner than most nude women in the art of the time (as is Hypatia also), and it has been suggested that this "ascetic" body takes it beyond the erotic gaze (even toward "androgyny").[59] Yet she is still older than 12 and naked. . . .

Perhaps the greatest scandal and the greatest debate of 1885 was prompted by a long report in the *Pall Mall Gazette* (it stretched over four days), which was discussed in journal after journal throughout Britain, Europe, and America, and which led to a rally in Hyde Park attended by up to 200,000 people. It was instrumental in a change of the law, which has affected British citizens ever since. The report, by William Thomas Stead (a crusading journalist who died on the Titanic and who now makes an appearance in Tom Stoppard's play *The Invention of Love*), was entitled "The Maiden Tribute of Modern Babylon," and it was an enquiry into prostitution and in particular the supply of young virgins to upper-class men by brothel-keepers and other procurers.[60] The report was set in motion at least in part by Josephine Butler of the Social Purity movement and Catherine Booth of the Salvation Army—the same milieu from which the complaints against the Royal Academy exhibition emerged.[61] It makes for horrific reading even today, with frightening first-hand tales of girls as young as thirteen, who are wholly ignorant of sex, being drugged and raped. The report helped make sure Parliament raised the age of consent from thirteen to sixteen (where it has remained ever since). The issue dom-

inated public discussion for weeks (though not as much as the *Pall Mall Gazette* itself boasted). Waterhouse began thinking about Eulalia several years before the *Pall Mall Gazette* report. He had exhibited a watercolor sketch, a preliminary study, in the Dudley as early as 1881. (And the report, though not, of course, the debate on the age of consent, appeared after the Summer Exhibition had opened.) But for the audience of the Summer Exhibition—and over 300,000 attended the show, as they did each year of the decade—the "The Maiden Tribute of Modern Babylon" would have become an issue of considerable vividness. The young virgin, half-naked, murdered but with her purity intact, and exposed before the grim soldiers of the state, spoke perhaps all too precisely to contemporary concerns. Should the age of the martyr be viewed within the frame of this controversy?

It could plausibly be claimed that three areas of debate have claims to be the dominant, or at least obsessive concerns of the complex, public, cultural discourse of Victorian Britain in the 1880s: first, the "woman question"—the discussion around gender roles, desire, and sexuality; second, religion—the clash between forms of Christianity, and between Christianity and other forms of spirituality as well as materialism; third, the role of the past and in particular the ancient past of Greece and Rome. Waterhouse's picture of Saint Eulalia speaks to each of these.

It is not the case that Waterhouse's response to Prudentius is prior to the discursive fields in which his response is formulated. The construction of the picture of Eulalia fully participates in the politics—intellectual, aesthetic, cultural—that I have been outlining, and the receptions of his picture are likewise integrally and fully embroiled within a matrix of socially formed expectations and arguments. "The reception of the classical in art" needs to be comprehended as such an engagement. This is why the simpler unilinear model, with its focus on the direct contact of the artist with a predecessor, can be so distorting. As we have seen, even when the artist tells us precisely what his ancient source is, the artist's contact with it, the form that the contact takes, the dissemination of the contact through the artist's work, are all constituted in and by these intricate discursive fields. That's what makes art a social, historical, and *effective* medium. The only way we can adequately understand why Waterhouse produces the image he does from his engagement with Prudentius, and the only way we can adequately explore a Victorian audience's reaction to this painting, is by investigating the frames of comprehension—the social, political, intellectual contexts—in which the image was produced and viewed. Cultural history is not "background" to the processes of reception, but constitutive of them.

We are now in a better position to try to answer the question of how to understand Waterhouse's representation of St. Eulalia. With only a title, the painting would be rather difficult to comprehend with any degree of

assurance for most viewers, for whom St. Eulalia is a murky figure, not least because Prudentius is unlikely to be a regular or even an irregular read. With the catalogue entry as guide, Waterhouse begins to add a narrative explanation for the image of the Roman town and the half-naked girl. But to any reader who did know Prudentius well, Waterhouse's brief summary of the poem is extraordinarily thin—or rather it demonstrates a deliberate and drastic removal of the torture of martyrdom, along with a careful restraint about the miraculous, limiting God's work to the barely depicted and naturalizable event of a snowfall. For a viewer who has only Waterhouse's catalogue summary, the martyrdom remains unexplained and unexplored, while the impending snow promises to provide a yet unachieved veil of modesty. The catalogue entry opens the painting to narrative comprehension, but also draws attention to the remarkable version of the poem that Waterhouse provides, both in his catalogue and in his picture. It would seem that Waterhouse's response to Prudentius is intimately tied up with his artistic response to genre and to religion—to his theological and painterly values. The catalogue entry is read differently according to how much knowledge of Prudentius is brought to bear—and the more knowledge of Prudentius the viewer deploys, the more it seems that Waterhouse is rejecting the violence both of the most extreme Catholic imagery, and of the polemical anti-Catholic imagery. With a readily assimilable Protestant aesthetic, he turns to realism in his depiction of the classical world as a response to the problematic and extreme stories of the early church. A "moderate modernist," then, as one contemporary critic sharply called him:[62] modernist in his critical engagement with a difficult source of the early church, and moderate in his realistic depiction of the classical world and the saint's last minutes in it.

Prudentius's poem is a long way from Victorian ideals of decorum, for all its status as a classical Latin authority of the early church, but Waterhouse's picture would not be out of place in a novel of the 1880s, which treat martyrdom precisely in this manner—as a reasonable story of remarkable heroism—and which repeatedly revel in the chaste death of a beautiful Christian woman. The paintings of Calderon, Mitchell, and even Poynter prompted the moralists to see purity outraged, and the *Pall Mall Gazette* to sneer at the hypocrisy and the voyeurism of such displays of nudity (thus anticipating twentieth-century critics, quick to believe that the Victorians did not know what they were doing). But Waterhouse seems to have escaped such censure. His exposure of St. Eulalia allowed critics to insist on purity—the purity of his imagery, and (thus) of their viewing.

The success of this canvas, I would suggest, is not just because of its technical expertise, expert though the painting is, nor just because of the thrilling construction of the fleshly saint's body against the Roman background, but because its realistic Roman surrounding, and its particular

model of a beautiful death, articulated for its contemporary viewers a pre-
cise place within religious polemics, conflicted ideals of purity and desire,
and critical engagements with classical antiquity—a place that was exciting
without being too uncomfortable, provocative without being too danger-
ously extreme. A success, then, but *pas de scandale*. . . .

We will see the passion for archaeological accuracy return not just in
other paintings of the 1880s and 1890s, but also in the theatrical perfor-
mances of Greek tragedy and in the classicizing operas of Gluck. We will
see the naturalism of miracles and the wonder of martyrdom become a
theme of theology, history, and the novels of the same decades. We will see
the erotic lure of the classical body, and its dodgy implications exciting
Christian spectacle haunt many a novel and painting. *St Eulalia* catches the
crest of a moment, which is what is meant by calling it a very fashionable
painting. It is a paradigm of classical reception in the 1880s.

## Visualizing Desire, Elsewhere

The reading of classical literature and its redeployment in art runs through-
out Waterhouse's paintings, and many examples and trends could be inves-
tigated. I want to concentrate in the remainder of this chapter on just three
more pictures, each of which raises issues of how specific classical texts can
enter a visual medium, and each of which raise questions of how desire is
pictured through classical models. I also have chosen these three because
they will allow me to extend my argument about the nature of the recep-
tion of the classical in and through Waterhouse's art.

The first is the monumental painting *Mariamne* (plate 6), exhibited at
the Academy in 1887, two years after *Saint Eulalia*. (It is nearly nine feet
high and six feet wide, larger than anything Waterhouse had yet painted,
and some critics at the first showings wished it were smaller.) It was sold at
the exhibition to William Cuthbert Quilter, a corporate capitalist who in-
vested in the nascent telephone system, became an MP, and who was
knighted in 1897. The painting was exhibited eighteen times in twenty-
two years across America and Europe, and won prizes at the 1889 Paris
Exposition Universelle, the 1893 Chicago World's Columbian Exposition,
and at the 1897 Brussels Exposition Internationale. (It was for many years
suitably enough in the Forbes Magazine Collection, New York, but was
sold at auction in February 2003.[63]) It was an image that was widely seen,
discussed, and valued: one of the best known contemporary paintings of its
time. The painting depicts Mariamne, the wife of Herod the Great. She
has been convicted falsely of adultery, and is progressing to her punish-
ment of death. Herod is dissuaded from commuting the sentence by his

sister Salome, who hated Mariamne. Mariamne treads down a white marble stairway toward a dark underground cell (in the bottom right corner of the painting, significantly placed below the threatening and gaping jaws of the lion statue). The judges, elderly bearded Jewish sages, sit behind, shrouded in shadow. The king himself on his throne is bent toward Salome, who whispers sideways into his ear (their two heads emphatically highlighted against the soaring gold pillar: the room, with a surprising playfulness for such a painting, appears to be a recognizable version of Alma-Tadema's studio-house, which was decorated in the style of one of his own classicizing paintings). All gazes in this picture of deceit and foulplay are sidelong and indirect. The queen looks back half in the direction of her husband and accuser over her shoulder, and round her loosened hair. The king looks down, while Salome's head is turned forward away from the man she is talking to. The judges' gazes are directed anywhere but squarely upon the victim. The black slave has bowed in the direction of his erstwhile queen, Mariamne, but glances over at the powerful figure of Salome. No one looks at the person with whom he or she is communicating: the breakdown of trust in the court of Herod is vividly embodied. Mariamne's tale is criss-crossed with rumors, false accusations, and the power of corrupt communication in the environment of the Eastern court. The body language here eloquently captures this distorted world of fear, plotting, and danger. The early canvas, *The Favourites of the Emperor Honorius* (1883), shows a similar dramatic dislocation of gazes, and from the preparatory sketches, we can see how each version of this early masterpiece worked to increase this sense of aggressively uneasy, askance looking.[64]

Mariamne, like St. Eulalia, is a subject taken from a classical text, and, again, Waterhouse used the catalogue to direct viewers toward his source, and again his reading of the classical text is pointedly oversimplifying. The story is taken from Josephus, and it is another topic that has barely been treated by modern artists. There is a poem by Byron, a rather lackluster three-stanza "Lament of Herod," from his *Hebrew Melodies* of 1815;[65] a little known tragedy by Voltaire, called *Mariamne*; an equally obscure play by Pordage (*Herod and Mariamne*, produced in 1673 and not since); and a German tragedy by Hebbel in the nineteenth century.[66] But I have been unable to trace any significant visual representation of Mariamne before—or after—Waterhouse. There is no indication that Waterhouse knew any of these modern texts (an awareness of Byron is most likely, of course). He cites Josephus in his Catalogue entry, and reminds the viewer that Mariamne was falsely accused by Herod's sister:

> Mariamne, wife of King Herod the Great, going forth to execution, after her trial for a false charge brought against her by the jealousy of Salome, the King's sister, his mother, and others of his family. After Mariamne's trial and condemna-

tion by the judges appointed by her husband, Herod, who had been passionately
attached to his wife, was about to commute the sentence to imprisonment for
life, but was urged by Salome to have the sentence carried out, which was ac-
cordingly done—*see Josephus.*[67]

Peter Trippi, following this note, calls the painting tellingly the "martyr-
dom" of Mariamne. Waterhouse, he writes, "implicitly encouraged viewers
to admire Mariamne's endurance of suffering under masculine power. . . .
Mariamne's defiance is signalled by her scornful gaze, her untamed hair so
unlike the tightly bound hair of dutiful Victorian women, and the violets
symbolizing fidelity and early death that she has cast on the steps."[68] Like
Waterhouse's contemporary critics, he notes the theatrical dominance of
the scene by the white clad diva, despite the smoldering emotions of the
femme fatale and the weak-willed king in the rear.[69]

Yet it is far from clear that Trippi or any other critic of this painting has
read Josephus. Josephus actually tells the history of Mariamne *twice*, once
in the *Jewish War* and once in the *Jewish Antiquities* (a fact no critic, Victo-
rian or modern, mentions). The stories do not agree with each other in
many significant details. But both versions tell a story that makes martyr-
dom a surprising term to apply to Mariamne. The account in the *Jewish
War* is short and sharp, but it is stressed that Mariamne is the cause of
Herod's disastrous, tragic life: "His ill-fortune stemmed from a woman, to
whom he was passionately attached" (I. 432). The story—with its rapa-
ciousness and salaciousness—needs to be briefly recounted to appreciate
exactly what Waterhouse has achieved. Mariamne was the daughter of Al-
exander, Aristoboulus's son, and thus the grand-daughter of Hyrcanus—
that is, the royal family of Judaea. This is how Herod, an Idumenean, en-
ters the royal family. He killed Hyrcanus (and her brother Jonathan) as
rivals for the throne. But Herod felt "an overwhelming passion for Mari-
amne which burned more fiercely day by day, so that he failed to recognize
the disasters that came from his beloved" (436). To feel such *eros* for a wife
is bound to lead to horrors (as the paradigmatic tale of Gyges and Candaules
in Herodotus Book I lays out). In terms of the expectations of Greek histo-
riography, Herod's passion is bound to lead him to the abyss.

But in this case it is even worse, since Mariamne hated him as much as
he desired her. She took advantage of his desire by speaking out constantly
against him (though, as Josephus also notes, she had good enough reason
since Herod had killed her grandfather and brother). She then proceeded
to abuse his mother and sister violently—*exhubrizen loidoriais* (438). But
Herod was "muzzled by his infatuation" (438) (*pephimōto*, "muzzled" is a
term normally applied to animals and is a very striking term for the king's
weakness). So the women fought back in the way they knew would get to
Herod most painfully: they accused Mariamne of adultery. In particular,

they said she had brazenly sent a portrait of herself to Mark Antony, whose lust was likely to lead to violence (439). Herod became increasingly jealous. He had to go to Antony on state business. He left instructions with Joseph, the husband of his sister, Salome, that if he were to die at the hands of Antony, then Mariamne should be put to death. Joseph, wishing to convince Mariamne of the king's continuing love for her, told her of the instruction, in order to prove that the king could not bear to be separated from her even in death. When Herod returned from Antony, and as usual professed his passion for her. Mariamne replied "You make a fine demonstration of love when you instruct Joseph to kill me" (442). Herod was convinced that the only way the faithful Joseph would have confessed such an order was if he had slept with Mariamne, and he was overcome with jealousy. He had them both put to death immediately. But remorse followed, and his love endured. He would still talk to her as if she were alive and in his presence (this is the *mise-en-scène* of Byron' s poem), and, as Josephus grimly concludes, "his grief was as profound as his feelings for her when alive" (444).

It is easy to see how this tale of intrigue, sexual passion, and royal crime could make a fine Renaissance tragedy or a baroque opera. But it should be clear that the story is focused on the corrupting effect of desire on a man, especially a ruler; and on the powerful and dangerous impact of beautiful, scheming, and ambitious women in the court. Mariamne is violent and full of hate toward Herod and his family; even though she has cause for her feelings, her behavior is marked as transgressive. She may not have committed adultery, but she contributes wilfully to her own downfall, and is a catalyst for the miserable collapse of Herod, the leading figure of the book. It is hard to see her simply as a martyr.

The second time Josephus tells the story in the *Jewish Antiquities* it is surprisingly different (which causes great difficulties for historians). In this story, it is a character called Soemus rather than Joseph who reveals the instruction of Herod, when Herod is away visiting Augustus (rather than Antony), and Soemus is immediately put to death. Mariamne, however, is tried and condemned to death. The judges saw how out of control the king was and how he was too angry for judgment, and because of this they found her guilty, comments Josephus—driving home the point of the corrupting effect of a king's lack of temperance [*JA* XV 229]. The presence of the shifty judges in Waterhouse's painting may suggest that it is likely he was working primarily from this version of Mariamne's tale from the *Jewish Antiquities*. When the king repented, he was nonetheless dissuaded by Salome and her friends from commuting the sentence. The final straw is when Alexandra, Mariamne's mother, trying to save her own skin, accused her daughter of outrageous behavior ("she played her part of accuser in such an unseemly way and was so bold that she grabbed her daughter by

the hair. . . " [234]). In this story, Herod is tortured by passion, and Mariamne takes full advantage of his weakness, but she is given a more ambivalent character. Josephus introduces her in this way (219): "she was in most respects decent [*sōphrōn*] and faithful toward him, but at the same time there was something at once feminine and harsh in her nature. She luxuriated in the fact that he was a slave to his passion; she ignored that he was her king and master and often treated him outrageously [*hubristikōs*]; he put on a mask of bearing this with self-control and strength. She openly jeered and foul-mouthed his mother and sister for their low birth" [219–20]. Salome starts her campaign against Mariamne when one afternoon Mariamne refuses to go to bed with her husband (despite his entreaty) and instead expresses contempt for him and reviles him to his face [222]. Her snobbery, sexual manipulation, and aggression toward her own husband take her far from the standard ideals of Greek womanhood.

Josephus, in the typical style of ancient historiography, also ends with a brief summary of her character and role. It too is studiedly balanced. "She was a woman of the very highest order with regard to self-control and greatness of spirit. But she lacked decency and was by nature overly fond of dissension. In the beauty of her body and dignity of bearing she excelled her contemporaries more than can be said. This was the main reason for the lack of grace and pleasure in her life with the king. Because of his desire for her, he paid court to her; she expected no harsh response from him. So she developed an excessive freedom of speech" [237–38]. Mariamne again emerges as a complex, aggressive, difficult character, who is instrumental in the king's emotional turmoil, though it is primarily his lack of self-control because of his erotic desires that Josephus relentlessly exposes. Mariamne may be a victim, but innocence cannot be ascribed to any character in the story.

Three initial points emerge from this rehearsal of Josephus's lurid accounts of the violent sexual politics of Herod's court. The first is that there is good reason to see a more complex emotional dynamic in Waterhouse's painting than the rather simplistic account of Mariamne as chaste martyr to a false accusation would suggest. Mariamne has clenched fists (a very rare gesture among female figures in Victorian art, and unparalleled in Waterhouse), a sign of the effort of controlling her emotion; her loose hair recalls her own lack of restraint, as does her expression, whether it is seen simply as scornful, as Trippi suggests, or a more mixed sense of anger, grief, and regret. The scornfulness recalls her treatment of Herod prior to the trial. Her bearing—her actress-like dominance of the picture's space on which so many of the Victorian critics commented—recalls both Josephus's judgment on her "dignity of bearing" and also her arrogance and dismissiveness toward Salome that has led to this moment. The gold chain binding her wrists (which suggests luxury as well as bondage) not only marks

her status as prisoner, but may also—along with her white dress like a bride—evoke the symbolic chains of her marriage, and the king's lust—overlapping regimes of failed (self-)control. How rich the representation of Waterhouse's Mariamne is recognized to be depends on how rich a reading of Josephus underpins it.

The second point concerns the position of the viewer and the role of desire at the scene of reception. The figure of Herod is a character crushed by his enslavement to desire. The narrative moment of the painting holds him caught between his jealousy, his repentance, and the persuasion of his sister, another female force leading him astray from the path of a proper ruler. He sits in the picture as a failed model of masculinity, his "profound grief" about to start. Finding Mariamne attractive is "the source of the king's disasters." So where does that place the (male) viewer of this painting? The painting offers a moral exemplum of the dangers of male desire, and sets a beautiful woman center stage and open to the viewer's gaze and sympathy. As with the half-naked, youthful Saint Eulalia, this picture requires a controlled viewing. Or, through its narrativized moment of the display of female beauty, it puts the proprieties of male desire at stake.

Third, the painting raises a foundational question for the notion or the practice of reception. Waterhouse through the unfamiliar topic and his Catalogue entry encourages a turn back toward Josephus, but it seems clear that a detailed understanding of Mariamne's story is *not* brought to bear by most viewers and critics. Nor can her story be said to be part of the general cultural imagination, in the way Hercules or Venus could be said to be constantly encrusted with half-remembered stories and images. "Educated viewers knew that Mariamne disdained the low birth of her in-laws, that Herod's guilt drove him wild, and that Salome later plotted against her brother," writes Trippi.[70] It is far from clear who these educated viewers are, why they know those three facts about the story (and not, say, the memorable vignette of Herod's lust and her refusal to make love with the king in the afternoon);[71] nor, indeed, is it clear the degree to which detailed knowledge slips into generic narrative stereotypes before the canvas—the wrongly accused wife, the guilty husband, a *Winter's Tale* for the Middle East. If the story was indeed well known, it is surprising that Waterhouse added the comments he offers in the catalogue.[72] It's even more surprising that he specifies that Salome's "jealousy" was the motivation for the accusation, when the cause in Josephus is specifically anger at an insult about low-birth and resentment of Mariamne's *hauteur*. We do know that Josephus was not a regular school or even university text. Where Virgil, say, was learned by heart in large chunks by most elite school children, most students would have only a nodding recognition of the name and scope of Josephus. At the same time, the archaeology and history of the Holy Land

was a booming and contentious field, and Josephus, especially the *Jewish Antiquities*, is a prime source for Palestine at the time of Jesus. Josephus was read, most widely in translation, in this context. This, however, is constructing a fairly narrow sense of "educated viewers"—those who had read Josephus and not only the parts relevant to archaeology or to Jesus's life. Waterhouse's catalogue entry may have the paradoxical effect of encouraging a thin reading of the painting by giving enough information to enable a superficially satisfying account of the scene according to a well-worn pattern of narrative cliché about jealous husbands, pure wives, and the anguish of guilty remorse. The painting may be the product of an encounter with a single ancient author, but its reception as a painting—the understanding of the image—takes place through different levels and applications of knowledge, different interplays of generic and detailed narrative expectations. The use of the term "educated viewers," typical in Reception Studies, downplays the complexity of such engagements.

The catalogue entry enjoins us, with an archetypical ecphrastic gesture, to "*see* Josephus." When you look at the canvas, you should indeed *see* the privileged ancient tale with all its biblical and classical resonances. See the past, historically grounded in an authoritative source, visualized before you. Yet the text of the catalogue offers to our sight a distortingly simplified version of Josephus. Once again, there is a dynamic and productive interplay between Waterhouse's textual version of an authoritative source, the source itself (in this case, unrecognized as double), and the image. As with Eulalia, the more engaged with the ancient text a viewer is, the more multilayered and manipulative the picture appears.

The art of reception here has, then, two quite different vectors which may be in tension with each other. On the one hand, we are encouraged to go back to the text of Josephus (and how else would Waterhouse have known of this story without reading Josephus? "*See Josephus*"). This produces a rich interaction between a complex ancient story and a modern representation of that text, which encourages the viewer to explore the violent and conflicting characterization of Mariamne, the political and psychological weakness of King Herod, a central figure in biblical narrative, and the corrupt physicality and rumor-mongering of an Eastern court (which cues in turn the intricate imperial politics of the late Victorian response to the Ottoman Empire as much as to biblical history). On the other hand, Waterhouse's own brief catalogue entry, combined with a less informed encounter with Josephus, draws the image toward a more stereotypical set of terms—where Mariamne appears as innocence falsely accused, and where Salome is motivated by an unexplained "jealousy." Here, the melodramatic plots of Victorian sexual narrative lead toward the sentimental understanding of Mariamne as a martyr. Her white dress becomes

the sign and symbol of an imagined purity, lacking in Josephus's account, but all too easily assimilable to a cultural imagination mapped by Coventry Patmore.

Both of these vectors are located within the frames of contemporary discourse, and it would certainly have been possible here to offer a more detailed account of these frames of understanding, especially the imperial view of the Middle Eastern court, the image of Herod as biblical figure, or the role of excessive desire in marriage (in the way that I attempted to sketch a set of frames for "Saint Eulalia")—this is a picture clearly deeply implicated in what we would call orientalist fantasy, and with the specific dynamics of such orientalism when it is concerned with the privileged Eastern world of the Bible. But what I wish to stress here is how these vectors suggest importantly different senses of "reception." First of all, it is quite unclear how sophisticated or full a reading of Josephus informs Waterhouse's art. Even though we are directed to Josephus by the artist himself, it is uncertain whether he would recognize the sentimental or the complex Mariamne—or both (or neither). We cannot even tell if Waterhouse knew both accounts of Mariamne. He may or may not have thought of Mariamne as a martyr. This uncertainty cannot be written out of the scene of reception. Second, there is likely to be a range of responses to this painting dependent on an engagement not merely with Josephus but also with the contemporary discourses of gender, the Bible, Eastern power, corrupt sexuality, and so forth—and these responses not only may clash, as contemporary controversy indicates, but also will change over time. When Stephen Hinds writes (with whatever irony) that he doubts whether the "*entire* community of [Ovid's] first readers"[73] responded in such or such a way to an Ovidian line, he reveals the idealist fiction of the unilinear model—that the criterion of evaluation should be what all readers certainly and clearly agree upon. What Waterhouse shows by contrast is that reception should be seen as a variegated and conflictual space of engagement rather than a neatly bounded moment of comprehension. The question for Reception Studies is how to assimilate into its methodology and practice this multiplicity of response without retreating into ceaseless fragmentation and uncertainty.

Waterhouse's most famous painting these days, thanks to thousands of posters on student walls, and my second example, is *Hylas and the Nymphs* of 1896 (plate 7).[74] It shows seven languishing and enticing nymphs, barebreasted, all taken from two models, about to draw the pretty Hylas into the water. Its intricate composition and classical evocation made it a hit in Victorian Britain, too. The story is taken from Theocritus 13, and after Theocritus in particular, it becomes a commonplace reference in Latin poetry, a reference that evokes the rape of a youth, the lover of Hercules,

whose beauty leads the nymphs to pull him into the water, and who is searched for in vain by his erstwhile lover and the sailors of the Argo. Lost love, lost youth, and rapacious females, emerging out of the water . . . a perfect subject for the *fin de siècle*.[75] Where *St Eulalia* and *Mariamne* cued individual texts with specific citations attached to the paintings through the catalogue, with *Hylas* we are dealing with a more diffuse (though still limited) range of references, and a far more familiar set of texts—and consequently there is no additional catalogue entry.

Waterhouse captures the moment of female desire—the eyes of all the nymphs are focused on Hylas—but leaves the rape and disappearance of the boy to our imagination. Hylas's face, shaded and hidden, betrays no reaction to their enticement. The male body is pictured as the image of female desire, and female desire is imaged more as a dreamy hopefulness than the sexually predatory. For all that, this is a scene of abduction. It is a picture of desire, but carefully framed as classical, pastoral, mythic, and poised at the moment before desire is fully acted out.

The term "nymph" itself has a fascinating range of reference in Victorian culture, from the elegant pastoral to the medical handbook, which is worth considering here. "Nymph" was a familiar sexualized term for prostitute or other enchanting women at this time, and the water lilies in this picture are actually of the genus "Nymphaea": The long creeping tendrils of plants were repeatedly used in symbolist art, such as that of Aubrey Beardsley, to suggest the deadly entrapments of seductive and frightening female sexuality.[76] The connection of the nymphs and the Nymphaea in which they are set invokes a world of threatening and entangling beauty. The term "Nymphomania" as a term for uncontrolled female desire had already entered both the technical language of medical science and a more popular cultural understanding. Although Bienville in 1775 was the first to use the term in a full-scale treatise (in the same medical milieu that produced Tissot and his work on masturbation),[77] it was through Victorian medical writers such as Acton that the term became an important sign of personal anxiety.[78] Writing in the *Cincinnati Medical Journal* of 1895, L. M. Phillips (an obscure physician), in an article entitled "Nymphomania: Reply to Questions," asked "what influence does nude statuary, exposed in our public museums and *fin-de-siècle* theater, have on susceptible minds," a question he answers in dire terms through the case of Mrs. L., who dated her attacks of acute sexual desire from seeing a *tableau vivant* of beautiful women as statues in New York. This is a story which takes the anxiety of Hadot and others about the nude in art into the murkier world of the burgeoning new scientific field of sexology. What's more, "nymphae" is also a term for the labia minora, though no one uses "nymphae" in such a sense today, I think, and it was perhaps already obscure in Victorian usage. Freud, for one, thought his patient "Dora" had come across it

in her reading.[79] ("Nympholepsy" too by the time of Waterhouse's picture has become a technical term for the seizing of young men by nymphs—bringing mythic narratives under the banner of new scientific language.)[80] Like Sirens, women lead men to drown, caught in their liquid desires; and the term "nymph" in different ways—science, myth, slang—is part of this burgeoning, nervy concern about the dangers of excessive sexuality.

Yet Waterhouse's nymphs were described by one contemporary critic, A. G. Temple, as showing a "sweet and winsome expression . . . not without a touch of wonder."[81] Indeed, *The Studio* devoted a whole article to this painting, which is very keen to see no suggestion of rape or any sexual threat in the nymphs. It declares that "no hint of strong emotion, no suggestion of strife or violent action, mars the classical repose of the picture"; "He has seen it with the eyes of a Greek"—and it compliments the artist on the "subdued and mysterious reserve" of the picture and the "childish purity" of the nymphs. Waterhouse is "an apostle of a delightful paganism."[82] "Delightful repose" recalls the Winckelmannian "calm serenity" of classical art; "purity" is once again an invitation. And to achieve purity, to control any of the erotic impulse hinted at in such vocabulary, you must look "with the eyes of a Greek"—and not thus as a corrupt modern? There is a tension, that is, in the responses to the painting between the looming sexual violence, and the winsomeness of the girls, made worse by the fact that, as J. Phythian, the director of Manchester's municipal art gallery, noted, Waterhouse's picture had a disturbing realism for such a mythic subject.[83] If the representation of Victorian femininity is polarized around opposed categories of virgin and whore, "angel in the house," "siren on the street" (as Joseph Kestner amongst others has argued),[84] the nymphs who are sweet and threatening, winsome and dangerous, blur those categories, worryingly.

Where, then, is the viewer in the play of gazes here? Some critics saw this as an image of women dragging a man into their dark watery grotto—a threatening, engulfing fear. Some wondered whether Hylas, like a *fin-de-siècle* decadent, was about to wallow in pleasure. Spielmann thought the nymphs had such "wistful and delicate forms" that we wonder if we pity Hylas, as if slipping into the arms of these nymphs would be a bliss devoutly to be desired. The *Art Journal* saw "a sad and sympathetic welcome, tinged with . . . aesthetic mournfulness," and, in a similar vein, *The Studio* was keen that nothing was to disturb the "exquisite purity and dignity" of Waterhouse's vision: "no hint of strong emotion, no suggestion of strife or violent action, mars the classic repose of the picture."[85] The viewer is caught between desire and fear, between pleasure (always touched by decadence) and danger. Hylas's face cannot direct a viewer's response, and becomes thus a blank mirror where the viewers' responses to female sexuality

are reflected. The eroticism of the painting, the tension between its delicate winsomeness and its narrative of seduction or seizure is like an extended gloss on the word "ravishing": rape or ecstasy, dangerous lack of control or sweet abandonment? In short, is Hylas here a victim? How this question is answered will inevitably implicate the critic's own ideological self-positioning. This painting is a place where female desire is represented—but male desire is set at stake. It is here that this classical image speaks most directly to contemporary Victorian concerns about self-control and abandonment.

In this light, the use of only two models to represent seven nymphs raises a more general question about desire and repetition. Is the object of desire unique? Or is desire always for an image (ideal, fantasy, model), which can only be repeated through a series of encounters? The 1885 *Pall Mall Gazette* report described a group of men who required a new child virgin repeatedly (as often as once a week for their sexual pleasure); the now celebrated pornographic autobiography *My Secret Life* records the obsessive repetitions of the pursuit of prostitutes in Victorian London. How important is it to try to tell these nymphs apart—or to see them as the same as each other? Much as Narcissus looking into the reflective water becomes an image for a psychological account of the desiring subject, so Hylas being eased into the water by a series of desiring females, who are hard to tell apart from each other, also constructs a provocative image of the processes of desire.

"Hylas and the Nymphs" takes a well-known classical narrative: Theocritus was a school text in the elite public schools and universities; the story was told briefly but memorably in Virgil's *Eclogues*, and touched on in Propertius's *Monobiblos*, as well as in Apollonius of Rhodes and Juvenal. It had been represented in visual media before, including a striking statue by John Gibson in 1837 in London. It was a story retold by William Morris and others. Both the familiarity and the classical authority of the myth are integral to Waterhouse's painting. The classical authority of myth allows the representation of female sexual desire in a more direct and alluring manner than a realist painting could countenance (hence Phythian's anxiety about the picture's realism). The myth also demands we recall the danger and violence that lurks beneath the "winsome" representation of femininity. The familiarity of the ancient story is also essential to the effect of the painting. As Sketchley, one of Waterhouse's most astute Victorian fans, noted, the narrative is held at a "pictorial and emotional equilibrium."[86] The narrative is poised at a moment of crisis, and thereby encourages the viewer's engagement. In this engagement, the reader's desire is implicated. Waterhouse's use of a classical model here is a veil, which drapes and exposes the viewer's longing look. I described the process of reception as a

"space of engagement": in the case of Waterhouse's *Hylas and the Nymphs*, we see it is specifically a space of engagement for the desire of the viewer— a desire conceptualized through contemporary frames of reference.

This dynamic is fully realized in the last painting on which I wish to focus attention, namely, Waterhouse's Homeric image of 1891, *Circe Offering the Cup to Odysseus*, another monumental painting of nearly 6 feet in height (plate 8). The story is most familiar from *Odyssey* 10, which was very well known not only as a school text, but also from its many retellings in Latin and later literature, and from the visual arts. Odysseus's men come to Circe's house in the wood. They accept the drink and food she offers them, are turned into pigs, and then led into a sty and fed on acorns and mast. One man, Eurylochus, returns in desperate fear to Odysseus. The leader must save his men. So off he goes. On the way, he meets Hermes, the god who gives him a drug called *moly*. Protected by this defense, Circe's drugs have no effect on him. So she immediately says, "come to bed, so that we can trust each other." This is still a threat to Odysseus—he fears he will be unmanned when naked—but after she swears an oath not to harm him, they do sleep together. At dinner afterward, he asks for his men to be released, and they all stay a year, feasting and, in Odysseus's case, sharing Circe's bed. Circe's island is the only place on his travels where Odysseus has to be reminded by his crew about the trip home, and from the classical era onward, the story has been read as an allegory of lust. Give into desire, and a man will be turned into a bestial creature, and even if everything seems a feast of pleasure, to enjoy such pleasure can only be a delay on the proper journey toward a homecoming into marital bliss.

   In Victorian Britain, Circe was an easy metaphor. The Report on Child Prostitution in the *Pall Mall Gazette* of 1885, "The Maiden's Tribute of Modern Babylon," begins with an impressionistic account of the author's trip to the awful underground of vice: "You wander in Circe's Isle," he writes (3), "where the victims of the foul enchantress's wand meet you at every turn."[87] It is not by chance that James Joyce in *Ulysses* made his Circe, Bella Cohen, a brothel keeper. Acton, the doctor who wrote so influentially on sexual dysfunction and disease, used the same image: "Kings and philosophers and priests, the learned and the noble, no less than the ignorant and simple, have drunk without stint in every age and every clime of Circe's cup."[88] John Ruskin, the art critic whose views were central to the development of the Pre-Raphaelites, was slightly more sanguine. He compared the Sirens with Circe, and found in Circe "frank and full vital pleasure, which if governed and watched, nourishes men; but unwatched, and having no 'moly' or bitterness or delay mixed with it, turns men into beasts, but does not slay them."[89] For Ruskin, typically enough, it is only when there is bitterness and no unseemly rush into things, that there could be a chance that

some pleasure will not make you an animal. There is a long history of allegorizing the tale of Circe, which takes a very particular turn in Victorian Britain.

Waterhouse's *Circe* was first exhibited in 1891 by choice at the Grosvener Gallery rather than the Royal Academy—a more intimate and challenging space, which chose self-consciously more provocative art than the Academy. Circe sits enthroned in majesty as befits a goddess, and reaches out the cup of her poisons toward the viewer, and holds her wand raised high, ready to complete the process of transformation that follows from accepting the cup. Her sexuality is pronounced. She is naked beneath her flowing robes, and her breasts, belly, and legs are clearly visible through the shimmering cloth. One nipple has slipped out of her dress; and there is a slit in the right side of the cloth, revealing her flank. She is leaning back in the seat, or at least her head is slightly upturned, with half-open mouth and hooded eyes and loose hair—encouraging, leading the viewer on. (Her loose hair and translucent dress is a stronger version of the image of Mariamne, which helps emphasize the danger embodied in Herod's wife.) Her throne has two lions' heads as arm rests: open mouthed and growling, a sign of threat and aggression. (Mariamne too was flanked by such a lion.) By her feet, there is a snoozing boar, presumably one of Odysseus's transformed crewmen (sated from the pleasures of Circe's hall). Parallel to Odysseus on the left side of the mirror are two pigs, looking up at their human leader. The color of their pelts echoes the coloring of Odysseus's robes, underlining the alternate fates of the visitors of Circe. One foot in particular pokes out from under her dress, and rests above a small Gorgon's head, which adds to the threat of dangerous transformation through female power—and through the power of the gaze. In the middle of the foreground, however, amid the purple grapes and dark vine-leaves (obvious markers of luxurious pleasure), there is a toad. A toad is not mentioned in Homer's story of Circe's animals, but is familiarly associated with witches and poison from medieval literature onward. But the toad is also associated with holding out a surprising hope of cure, since, as the story goes, a toad has a magic jewel in his head that acts as an antidote to poison. As Shakespeare put it, "Sweet are the uses of adversity, which like the toad, ugly and venomous, wears yet a precious jewel in his head."[90] So perhaps the toad here, which has a bright point of light on its head, suggests both the poison and the cure—the lure of and the resistance to desire.

Behind Circe is a large circular mirror, and reflected in it, is an extraordinary image of Odysseus. As many scholars have noted, the grandeur of the seated goddess with a massive circular decoration behind her, recalls Louis Chalon's picture *Circé et les compagnons d'Ulysse* of 1888 (figure 1.4). In Chalon's image, the circle is a large sun (Circe is descended from Helios, the Sun god), and the pigs in the forefront of the picture serve as a dark

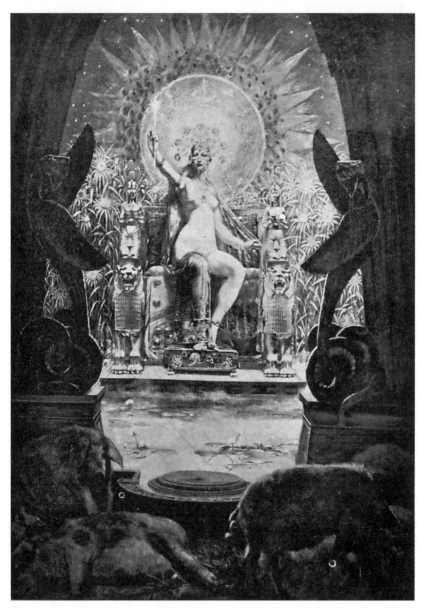

Fig. 1.4. *Circe and the Companions of Ulysses* by Louis Chalon (1866–1940). Reproduced from *Famous Pictures Reproduced from Renowned Paintings by the World's Greatest Artists*, Stanton & Van Vliet Co., 1917

frame to her splendor. Waterhouse's picture may have some formal similarities to Chalon's, but he has turned it to a quite different and particularly fascinating use, which goes to the heart of his use of Classical images to approach male desire. The image of Odysseus in the mirror is far smaller than Circe and his head is awkwardly framed by her massive arm and breast (as if she already has him in a kind of embrace). It is relevant to the effect of the painting that Circe's image is itself the size of a statuesque woman, whereas Odysseus is shrunk to a smaller frame. He is not a heroic nude, but dressed. His fists are clenched, his right arm around the sword strap, it seems. He looks with twisted and hunched body nervously at the huge figure of Circe, and is clearly marked as frightened or at least apprehensive. Like Mariamne, the clenched fists indicate his struggle with his emotions. Unlike the mirror of self-obsession and longing in *Marianna in the South* (1897), and unlike the mirror in *The Lady of Shalott* (1894) which shows only the back of Lancelot's head, and unlike the mirror in *Gather Ye Rosebuds While Ye May* (1908), where the girl's erotically inviting look finds no viewer but us, this mirror sets up an exchange of looks, triangulated through us as spectators.

The lines of sight are again crucial to this canvas. Circe looks directly out toward the viewer and her hazy gaze embraces us. Unlike the other images of femininity we have considered, she looks directly out of the canvas toward us, from her elevated position. Odysseus, although he is set to the right of the canvas, is staring at Circe and thus via the mirror's angled reflection, directly at the viewer in front of the picture. As we look at the sexually enticing and dangerous figure of Circe, our gaze is mirrored by the look of Odysseus, whose fear, caution and physical hesitation, direct our response. It is significant that the image of Odysseus looks like the painter and has been taken as a self-portrait.[91] What is imaged here is not just an image of corrupt female desire—the poison of female enticement, as the moral tracts of the time regularly put the threat of the prostitute—but also male fear and hesitation before this female sexuality. At one level, this might make this painting seem like a simple moral statement—watch out for corrupt feminine wiles and sexuality!—a message which many writings of the period would parallel. But, as we know, the fearful Odysseus in the mirror *will* sleep with Circe for a year (and have a son by her who will grow up to kill his father, as the later epic tradition records). Odysseus will step forward into the scene and drink the offered cup.

Again what is unsettling about this painting is the tension created by the precise freezing of the narrative moment. We are again caught in a moment of uncertainty about male desire. Surprisingly, Peter Trippi, in his sophisticated treatment of Waterhouse, singles out Odysseus as the only male figure in Waterhouse's work who does not succumb to temptation.[92] As if in *Circe Offering the Cup to Odysseus* Waterhouse was imaging his own

propriety. This quite underplays the threat of this picture. It is true that Odysseus is not turned into a pig, nor will be, and that he transcends the errors of his companions. But he is on the point of drinking the offered cup, and will indeed sleep with the beauty in front of us and him. Is the viewer to see himself in Odysseus, as the picture, putting the hero in the position of viewer, encourages? If so, where does that put the male viewer? Resistant, or about to fall into the arms of Circe—or both? How strongly do you stand before the temptation of Circe's embrace? Herod in *Mariamne* offered an image of a man whose weakness in desire is a weakness in political rule and personal self-control; not being like Herod means not succumbing to the beauty of Mariamne, whose shimmering clothes and physical beauty dominate the canvas. Here, Waterhouse has gone one stage further by having the dangerous beauty look enticingly at the viewer and by inscribing an image of the viewer in the picture—a viewer who is terrified to succumb but will do so. We are mirrored by Odysseus—and, as ever, looking in the mirror poses a question about the self. How will the hero Odysseus become an example for us?

We find a more simple image of desire in Arthur Hacker's *Circe Enchants Odysseus' Companions* (figure 1.5) from 1893, which provides a pointed contrast for Waterhouse's painting. Here, Circe is depicted from the rear in the familiar pose of a nude model, with her hands raised to her hair: She is beautiful and sexually charged but there is no (other?) sign of her witchcraft. The setting is apparently an unmarked rocky patch of ground. But the crew are depicted as staring at her exposed beauty and in the process of being transformed into hogs. Without any drugs or wand visible, it appears that it is the lascivious stare of the crew members that is making them bestial (an idea that is a cliché of the allegorizing tradition). The crew members warn of the brutishness of lust, as Circe offers both them and the viewer the stimulus to that lust. Hacker demonstrates again how Circe is for Victorian discourse a way of talking about the perils of male desire (and the threat of female seductiveness), but by focusing on the crew members and not the hero Odysseus, Hacker avoids the more disturbing ambiguities of Waterhouse's image.[93] It is easier for the viewer to distance himself from the nameless line of ill-fated sailors, who will here at least be rescued by Odysseus. There is an easier alibi for gazing at the naked body of Circe. Hacker's picture, another moment of Homeric reception, helps highlight the carefully constructed positioning of the viewer in Waterhouse's art. Thomas Spence exhibited his *The Temptation of Odysseus by Circe* in 1897: This depicts a tired and depressed-looking Odysseus sitting on a huge throne, while Circe, fully clothed stands slightly behind him, decorously clothed and haughtily holding out a drink. Here, the threat seems strangely formalized and without evident sexual charge. (It is almost as if the world-weary Odysseus is being offered one too many drinks by his importunate

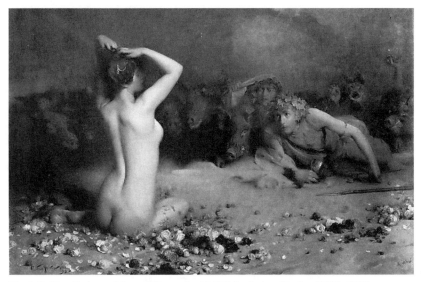

Fig. 1.5. *Circe Enchants Odysseus' Companions* (1893) by Arthur Hacker (1858–1919)

hostess.) So too Briton Rivière painted his *Circe and the Friends of Odysseus* (1871) where a young and relaxed Circe sits for all the world like a pastoral shepherdess on a porch while a herd of pigs snuffles around the porch. W. Armstrong, writing twenty years later, was surprised *and* defensive about the extremely decorous nature of the picture, where all sexual threat seems to have been removed.[94] Each of these paintings emphasizes how striking Waterhouse's composition is, and how it puts the viewer in the frame.

Waterhouse returned to the Odyssean world of female seduction more than once, and the connection between water and women, sex and death, was for him, as for so many *fin-de-siècle* artists, an interconnected system of images. By way of contrast with *Circe*, plate 9 is a smaller canvas from 1901, called simply *The Siren*. This is a different imagistic world from the Homeric narrative of *Circe Offering the Cup to Odysseus* (and from Waterhouse's earlier *Odysseus and the Sirens*, which showed the Sirens as represented on Greek pots—namely, as grotesque bird-like creatures with female heads, images Waterhouse probably found by reading Jane Ellen Harrison).[95] A beautiful naked young woman sits with a lyre on a rock. Her legs melt almost imperceptibly into a fish tail, which blends in color and outline into the rock. She emerges from the rock and water like a natural force. She looks languorously down at a beautiful young man hanging onto the rock from within the ocean. He has strongly muscled arms, but soft facial features and long hair, and what seems to be an earring. The sea is calm—as in the Homeric narrative, where an uncanny calmness indicates the ship's

approach to the Sirens' rocks—but there is a smashed mast floating behind the sailor in the sea. The background is an haute-romantic landscape of massive rock formations and receding indistinct mountains in the distance.

The two figures look at each other like lovers with deep longing. They are both traditionally beautiful, and from the faces one could see them as the shipwrecked lovers of a Shakespearian romance. The Siren holds a lyre, but her mouth is shut. She may have sung before, but now she needs no verbal enticement. The look is enough. The boy looks up with an awe-struck expression. We have here entered a symbolist world—for which the Shakespearian romance is a misleading frame of reference. The Siren, even more than Circe, is a familiar image for the prostitute, or the enticing female who leads astray the desiring male. Ruskin again gives a neat summary: "The deadly Sirens . . . promise pleasure but never give it. They nourish in no wise; but slay by slow death." "They are not pleasures but *desires*."[96] This is an image of desire. And the threat of desire to the male self.

What continues to worry, however, is again the poised moment of narrative. The victims of the Sirens die; their bones are strewn around their island, as Homer tells us. This boy is on his way to death. But there is no indication of how he is going to die. Will he slip beneath the waves, watched by the cool gaze of the Siren? Will he die on the rock, deserted? Will he die in the arms of the Siren? (Each of these readings could be expanded into further symbolic or social associations.) But perhaps most importantly, the picture captures the moment of the locked gaze. The artist seems to be suggesting that it is the moment of the passionate gaze that is the prelude to the loss of self in death. What sort of artistic self-consciousness or even despair is that?

## Off the Chocolate Box

Waterhouse was not a scandalous artist, and he is usually regarded as representing the polite Victorian world of a gentle and genteel sexuality—"English roses"—where even tortured saints can appear unblemished. Even when he is involved with French art and responds to the more difficult art of the continent, he is described in contemporary sources as quintessentially English. Ironically enough, his astounding brushwork is increasingly influenced by French artistic technique, and his blocks of color, as well as his use of mirrors and self-aware manipulation of literary sources, tie him more closely to modernist aesthetics than his easy appropriation to an English naturalistic artistic tradition would suggest. It was, however, at the end, his *moderateness* that was found memorable, as he slipped into the dis-

missive category of the unfashionable. As one memorial piece recalled, he had a "dainty melancholy, which, however, was not allowed to degenerate into morbidity"; he was "wholesome"—not a word to endear him to the ferocious liberalness of modern art.[97] But in the pictures I have analyzed here, the view of male subjectivity reveals something more dark and difficult that goes beyond the ideology of virgin and whore, toward something closer to Degas's *Interior*, which has now come to be seen as the exemplary painting of male desire in the continental art of this period. His images of females and female desire can usually be fitted easily into a patriarchal model, for sure. But in his pictures, the male viewer, always the privileged viewer in Victorian art, even when the British Matron was cajoling her friends, is placed in a more complex position, where male desire is seen as a threat to the security of the male self. It is not by chance that so many of the paintings I have discussed have a strongly marked male viewer in the frame—unlike other more obviously salacious pictures of female nudes, offered up to the viewer's gaze. This implication of the viewer is strikingly different from the more standard academic voyeuristic classicism of, say, Herbert Gustav Schmalz's victims in the Roman arena, bared, humiliated, and exposed to our gaze (where the spectators are just a blur), or Jules Joseph LeFebvre's airbrushed classical girls, naked, eroticized, with their bodies inviting the stare of the spectator.[98] With Waterhouse, patriarchy's subject is exposed, exposed at the moment of frozen narrative as uncertain, slipping, and struggling, and this affects—infects—the viewer. Desire needs veils to speak. The classical world provides those veils. Waterhouse provides a strong paradigm for us to see, for the most traditional-seeming Victorian art uses its classics to find a route into a more worrying world where male desire is a source of anxiety and struggle.

With *St Eulalia*, *Mariamne*, *Hylas and the Nymphs*, *Circe Offering the Cup to Odysseus*, and *The Siren*, we have moved from two images that refer to single and specific classical texts, each with strong religious importance, to Hylas, a classical subject anchored in a privileged classical text, but which is disseminated as a mythic reference throughout classical and classicizing literature, then on to Circe, a figure that has a privileged origin in Homer, but which has become a familiar metaphor in the sexual discourse of Victorian society, and then finally to the Siren, which may have an origin in Homer, but which can be used without any recognition of a classical source to indicate the threats and delights of female allure. These offer different potential models of reception, and provoke different artistic responses: The familiarity and dissemination of a classical figure changes the potential strategies of reception, both by the painter and by his audience. "Classics" is not a single block of cultural knowledge shared by educated viewers, but a multiform construction, criss-crossed by ignorance as much as knowledge, pretension as much as privilege, anxiety as much as idealism. Reception

Studies need to take due account of this fissured engagement with the past. But perhaps most importantly, with each of these pictures the position of the viewer—implied in the case of *Hylas*, imaged in *Circe*, thematized in the paintings *Mariamne*, *St Eulalia*, and *The Siren*—is integral to the process of reception. The viewer as victim of desire runs through Waterhouse's artistic vision. Classical desire is a way of talking about contemporary desiring: Classical subject painting "shaped the [Victorian] discourse about sexuality."[99] Paintings are designed to have an effect. With a recognition of the role of the viewer at the scene of reception, we pay due regard to the *performativity* of the artwork.

As critics from that era to today have repeatedly demonstrated, looking at such pictures of the past encourages us as viewers to use these images of a lost world to articulate one's own self-positioning within the history of sexuality, here and now. (A detour through the past is the alibi of self-projection.) Waterhouse's pictures interweave art and text together—images of antiquity, texts from antiquity—and this dynamic, intermedial response to the past makes the exhibition of his paintings an event that invites and entices the viewer into such an engagement. Waterhouse's paintings explore male desire in a more provocative way than his reputation as a pious, wholesome Victorian suggests.[100] This discussion of Waterhouse's classicism, however, my attempt to get him off the chocolate box and back into the center of the cultural excitements of 1880s and 1890s London, has also underlined a general point of how important it is, when discussing reception as a process, to look at the full range of discursive fields involved in the act of representation, and to explore the engagement of the viewer whose knowledge, knowingness, and ideological self-positioning are fundamental to the scene of reception in the gallery. In this way, we can build the historical and cultural contexts of the production of meaning as well as the triangulated interactions between artist, artworks, and audiences, into our models of reception—and, consequently, begin to appreciate what made Waterstone's art paradigmatic of the Victorian cultural fascination with classical antiquity.

## Chapter 2

❁ ❁ ❁ ❁ ❁ ❁ ❁ ❁ ❁ ❁ ❁ ❁ ❁ ❁ ❁ ❁ ❁ ❁

# THE TOUCH OF SAPPHO

THIS CHAPTER PICKS UP from my discussion of Waterhouse some of the most insistent and difficult questions facing reception theory, via the small scope of a single picture. It is concerned first with a double process, which, I argued in chapter 1, is integral to classical reception. An artist (or writer) produces a work, which engages with the classical past. Such productions are often the focus of author-centered *Rezeptionsgeschichte*, and how an artist (or writer) recognizes and treats the classical is a traditional topic of scholarly discussion. But viewers (or readers) also respond to such a work as part of their own engagement with the classical past (and with the present). The picture becomes the site of an ongoing and active response to the classical past. This reception is multiform at the time of the work's production, and also changes over time. Our contemporary understanding of a Victorian painting's view of the classical past necessarily passes through the prism of such layered receptions, as viewing in the here and now performs its own gestures of appropriation, (mis)recognition and revelation. Putting the viewer back into *Rezeptionsgeschichte* reminds us that reception is best seen as a continuing, dynamic process, where our object of study is not the picture as a static and stable receptacle of meaning, but rather the viewer's engagement with the picture as a cultural event.

A viewer is not simply an abstract construct, however, even though art history often makes a generalization out of the multiform subject positions from which art is viewed. To focus on a viewer's reception is to broach not just constructions of class, gender and education, but also of the relation between the margins and the center of cultural life, and how such mapping affects the comprehension of a cultural work. A picture on display in the Royal Academy is not the same event as a privately circulated image. A picture viewed by 90,000 people in a gallery in Liverpool has a different cultural significance from a picture seen and debated by the London critics. A picture may be viewed differently by a man and by a woman. What's more, as viewers change over time, what can be seen alters over history.

A version of this chapter appeared as chapter 20, "The Touch of Sappho," in Charles Martindale and Richard F. Thomas eds., *Classics and the Uses of Reception* (2006 ), Wiley-Blackwell.

This is nowhere more pertinent than with texts and images that treat the expression, recognition, and regulation of desire, the second major area I began to discuss with Waterhouse. Desire cannot be expressed without its veils, feints, and silences. As Freud teaches us, it *always* cannot speak its name, at least its clear and real name; it cannot *stop* speaking of its aliases and alibis. There are always silences in the exchange that makes up the recognition of desire, and the reception of silence is inevitably a hermeneutic crisis.

My interest in this chapter, then, is the shifting recognition of desire in readers' receptions of a Victorian image of the classical past—and the interpretative lures and snags of such an enquiry. How does desire speak and silence its name in art? Where with Waterhouse I focused on figures of classical literature and myth, here I will turn not just to the image of a poet from antiquity, but the most famous female poet of ancient Greece, whose name has become synonymous with the expression of female desire, Sappho.

## Viewed in the Light of Greece

The picture in question is a painting exhibited in the Royal Academy by Lawrence Alma-Tadema in 1881, first titled *Sappho* (plate 10), though now usually called *Sappho and Alcaeus*.[1] I want to use this image as a route into the more general questions of the contours of cultural normativity that I have been outlining. It is a most striking canvas, which immediately attracted a good deal of attention in the press. It is one of Alma-Tadema's larger works, measuring 26 inches by 48 inches (66.1×122 cm), and is now in the Walters Art Gallery, Baltimore. The setting is a marble terrace, an *exedra*, where the Mediterranean glistens in the background, and a bright sky can be glimpsed through a canopy of pines. On the right, a beautiful young man, Alcaeus, the poet, is playing on the cithara (a type of lyre) and his mouth is slightly open, perhaps singing. Across the performance space—the empty center of the painting—sits Sappho, staring intently at him. On her lectern is a laurel wreath, a victor's crown awaiting a head, and under the lectern stands a statue of Winged Victory, holding out a laurel wreath, too. Behind Sappho, arranged on the marble benches, are three girls in various states of concentration, rapture, critical observation, and concert-goer's inattention. The middle girl of the three looks out at us the viewers, enforcing a self-conscious sense of looking: It is in part a picture that represents gazing and listening: acts of interpretation, appreciation, and performance. A fourth girl stands behind Sappho. She alone is crowned with brightly colored daisies, which match her decorated dress, and while she looks at Alcaeus, her arm is draped across Sappho's shoulders in an affectionate and protective manner. The stone benches are scratched with

graffiti, the clearest of which spell out in Greek the names of the girls named in Sappho's love poetry—Anactoria, Atthis, Gongyla, Gyrinnos, as well as some less clear syllables.[2]

Now, Alma-Tadema painted a series of well-known paintings of *exedrai* which are often peopled by young lovers. In *Pleading* (1876), a young man lies prone on the marble bench and looks up at a seated girl, who with her hand to her mouth is poised in the moment of doubtful hesitation. The same pose is adopted by the two figures in *Xanthe and Phaon* (1883). *Ask Me No More* (1906) has a young man kiss the hand of a woman, who turns her head and body away from his approach. *Amo te, ama me* (1881, the same year as *Sappho and Alcaeus*) shows another courting couple against a Greek backdrop.

In *A Reading from Homer* (1885) (plate 11), a full-scale canvas now in the Philadelphia Museum of Art, four listeners, posed around the *exedra*, are held transfixed by a poet reciting from a scroll: a young man with a lyre and a young woman leaning on the marble bench with a tambourine hold hands, in front of them, a youth dressed incongruously in animal skins, as if in satyr costume, languishes on the floor. A fourth figure, shrouded in a cloak and garlanded stands in the shadows behind them. In all of these pictures of *exedrai*, the sea can be glimpsed, blue against the white marble, and the figures are caught in a moment of longing and looking and listening.[3]

The image of reading in Victorian art is often constructed as a private moment—of incipient desire, the longing poem, the amorous letter, lost in a novel.[4] Such scenes offer to the viewer the voyeuristic fascination of capturing an unguarded moment of inward emotional life, the truth of feeling, unseen. (To view a woman—naked or clothed—when she does not know that she is being observed, is the paradigmatic subject position for the male subject in Western patriarchal regimes of the visual—though the sight of a woman with a *book* has been a niche excitement for the cultivated intellectual since ancient Greek times.) In *A Reading from Homer*, however, Alma-Tadema gives us reading as performance. There is a barely concealed eroticism in the audience—they look as if they have just been dancing in some Dionysiac show, with tambourine, hairy shorts, and all.[5] But they are now transfixed by the poet—as we gaze at their gazing. As with Waterhouse's *St Cecilia*, this painting is carefully self-reflexive, not just in its focus on the enthralled gaze of artistic appreciation, but also with its interplay between the sister arts of poetry, music, dance, and painting. In *Sappho and Alcaeus*, then, the scenery of the *exedra*, as well as the title of the painting, cue an eroticized scene of poetic performance.

There is a long tradition linking Sappho and Alcaeus erotically (as well as a less well-defined tradition that has them share in ill-judged political activity against Pittacus, the tyrant of Lesbos).[6] According to one story,

usually taken back to the authority of Aristotle [*Rhet.* 1.9.20], Sappho rejected an indecent proposal from Alcaeus.[7] For Madame de Stael, Alcaeus was a lover of Sappho, who later, as a friend, became the preserver of her literary record.[8] For others, he was the jealous rival of Phaon, the man for whose love Sappho leapt to her death.[9] The discovery of a fifth-century Greek pot in 1822 with paired images of Sappho and Alcaeus gave their relationship the romance of an apparently authentic material embodiment.[10] (On the pot, both Alcaeus and Sappho carry lyres, as if in competition or for a duet; on another early fifth-century vase, discussed later, Sappho is seen reading from a scroll to her companions.) Alma-Tadema's image looks back through the long history of modern representations of Sappho as poet and lover.

The physical tensions of the painting seem carefully calibrated. Sappho, leaning on her arms, is intent and fully focused in her gaze at Alcaeus— across the central gap of the *exedra* and the painting. Is this poetic appreciation? Or even rivalry? The laurel wreath is set between them, as is the little statue of Victory, reaching out toward him. The girl with her arm on Sappho's shoulder, and the girl on the seats behind them to the left also stare at the poet, creating a trio of shared attention, and a strong line of sight between them and the man on the other side of the *exedra*: a transfixed audience. As in *A Reading from Homer*, the intensity of gazes links the enthrallment of poetic performance with the concentration of art's visual experience. And the wood of the lectern set against the marble matches the wood of the chair and lyre of Alcaeus, visually linking the two poets. It is a scene, then, of poetic appreciation, a captured moment of performance.

Or is the tension between the protagonists of the painting (also) a sexual tension, as one might expect in such a setting and from the tradition of these two characters? The drinking cup casually discarded underneath the chair of Alcaeus suggests a certain decadence. Alcaeus, depicted as a very beautiful young man, seems to stare past the lyre directly toward Sappho's eyes. Sappho and Alcaeus, who are the only two figures not to have their bodies largely obscured by the seating and the dais, are dramatically foregrounded, both dark-haired and olive-skinned, both intent apparently in each other and the moment of musical performance. Yet Sappho is set amid her girls, and the names of her female lovers are all around her, like plaques on the seats, an erotic history, purloined from her own poetic fragments. And she is being touched by a beautiful young woman, garlanded with flowers.

It might well be thought that if there is a sexual tension here it is a tension between the tradition which makes Sappho a lover of women and the tradition which has her dally with men—and indeed kill herself for love of a man. Is Sappho to cross the line between her band of girls and Alcaeus? The empty center of the picture is a question. The picture asks the viewer to read desire in the painting. Who wants whom and in what terms?

Reading the mute expression of desire is always fraught with danger, however, and we need a more developed frame for this question. The first element of this frame is made up by the Victorian concern about the expression of sexualized beauty in art, and the feelings aroused in the viewers of such art. The depiction of the nude, of flesh, and of the moral horrors of adultery, lust, and failing self-control, was explicitly debated in contemporary society, and this multiform debate, as I outlined in chapter 1, has been very well discussed by recent critics to show how the public performance of prudishness contrasts with a flourishing market for such art and with a more ironic self-awareness about the pleasures and hypcocrisy of unveiling the naked human form.[11]

Alma-Tadema himself became a focus of such worries four years before *Sappho and Alcaeus* with his painting of *A Sculptor's Model*, a life-size naked woman with no pretensions to mythic veils (plate 4), although it is based on the Venus Esquilina, excavated only in 1874 (Alma-Tadema visited Rome in 1875–76)—with a touch of the (male) *diadoumenos* of Polycleitus. Lord Haddo, whom we met in chapter 1, had proposed to Parliament in 1860 that all funding should be removed from art schools that used life classes, because of the immorality necessarily involved—that against the background of the Contagious Diseases Act, also of 1860.[12] Haddo was resoundingly defeated, but the concern over the relation between artist and model rumbled on through the last quarter of the century. Interestingly, this painting was produced because Robert Collier, Lord Monkswell, had asked Alma-Tadema to take on his son as a pupil. Alma-Tadema refused, but agreed to let the student attend his studio while he painted this painting, provided that Monkswell bought it afterward.[13] It is a painting where an artist stares at the nude from behind in his studio, while the viewer stares at her from the front, painted to teach a watching student. Lord Haddo would have had apoplexy.[14]

The Bishop of Carlisle was vexed by the Alma-Tadema picture. He wrote to a friend: "For a living artist to exhibit a life-sized almost photographic representation of a beautiful naked woman strikes my inartistic mind as somewhat if not very mischievous."[15] It would be much easier if the artist were dead, it seems, or the woman less obviously sexy and, well, big. Richard Jenkyns is right that this is a private letter and written in a tone that is sophisticated and self-ironizing (though the bishop's comment is sometimes quoted as if it gave direct access to a simple outraged Victorian prudishness).[16] But when the picture was exhibited in Liverpool in 1878, a whole series of outraged letters was published in the press, often signed by such sobriquets as "An Offended Father," and expressing strong moral objections to the painting and its display—utilizing a familiar contrast between the Plain Man and the Sophisticated Artist.[17] As usual with such press-fomented scandals, the public responded by going to the gallery

in droves. The exhibition was visited by 89,110 people, a 20 percent in-
crease on any previous year. The painting was a *cause célèbre* and a *succès de
scandale*.

The degree to which art stimulates or expresses desire between artist
and model, or between picture and viewer, is an area needing maximum
care in Victorian culture, and requiring particular attention concerning
what is publicly articulated about such feelings.

The second element of the frame is scholarly. In the academy and be-
yond, there was, as Jean DeJean and Yopie Prins have outlined, a lengthy
and often heated debate taking place, led by German scholarship, on the
nature of Sappho's desire—a debate to be set against the background of
new homosexual legislation, high-profile trials, and the very invention of
the words "homosexual" and "lesbian" in an attempt to pathologize the
desiring subject.[18] Alma-Tadema was obsessive about his scholarly accuracy
(and it was a topic of much press commentary).[19] He was forced to defend
the chair on which Alcaeus sits, and does so stridently by citing archaic pots
whose design he was imitating.[20] He writes the girls' names in Greek let-
ters. He—and a good part of his audience—was likely to know well the
potential for highly transgressive sexuality with Sappho.

What's more, there is a long tradition of paintings of Sappho *as* expres-
sions of female desire. These are usually associated, however, with her love
of Phaon, a man, and her suicidal leap from the rocks into the sea. Let me
contrast two of these, which will be particularly useful for us in thinking
about the centers and margins of cultural normativity. Plate 12 is Auguste
Mengin's painting of Sappho. Mengin has never been a well-known or cel-
ebrated artist, and this painting of 1877 was donated to the Manchester
City Art Gallery in 1884, where it has been exhibited without much notice
since. I have not been able to trace any contemporary reviews of the paint-
ing, and there has been no study of Mengin the artist. This is a picture
from the margins of mainstream culture.[21] Sappho is dark, as Ovid de-
scribes her, though not exactly short and ugly, as Ovid also adds.[22] Rather,
she appears as a passionately moody romantic artist—she is carrying her
lyre—contemplating death and love. She stares with an inward gaze, her
face shadowed by her hair and robe which run into each other, as she melds
into the dark rocks. This is not the Greece of light and purity, sunshine
and rationality, but the physical embodiment of a dangerous passion,
"where burning Sappho loved and sang." But Mengin in an extraordinary
gesture has bared Sappho's breasts and shoulders. The light burns as
brightly here as the rest of her is shaded. It is not at all easy to see how any
light source could produce this effect. It is as if her breasts illumine what
we can see of her face. Archaeological accuracy is not what is at stake here.
Rather, *this* dream of Greece lets the viewer stare full on at the young girl's
exposed and fleshly body (such images still help sell paintings as well as cars

Fig. 2.1. *Sappho* (1841) by Queen Victoria, ink on paper. Reproduced from *The Critic*, June 1900

and newspapers). It might be possible to intellectualize the image and say the burning love in her breast is a passion that lights her face, the mirror of the soul—a metaphor for the passion of artistic creativity. But with whatever rationalizations, the viewer is obviously offered an erotic stare at the girl's body—and takes pleasure in looking. This is a very *sexy* painting about a poet of love.

This second Sappho (figure 2.1) is also preparing for a leap into suicide. Her hair is in a neat bun—a few strands have escaped in the most refined distress. Her hands are joined not in simple prayer, but probably to indicate her inner turmoil. Her dress is standard Greek issue—uncovered arms and shoulders, with the barest hint of bodily form beneath. The "fallen woman" is one obvious image recalled here.[23] What makes this sketch interesting is not just the telling contrast with Mengin's image. It is also the artist. Because this is drawn by Queen Victoria. She drew it as a young woman in 1841. It began as a private sketch, but was actually published in

1900.[24] Here is one critical response from the press. "It will be hard to re-
fine upon the poetic beauty and romantic intensity of Sappho as etched by
her Majesty the Queen. . . . It is simple and impassioned."[25] This may be a
courtier's flattery, but the reviewer is insistent on seeing this sketch as an
intense and impassioned embodiment of female desire. If this sketch started
as a private and marginal self-expression of female desire and loss, when
published as the work of a now aged Queen, it must be seen as an image
from the very center of British culture, but it also becomes a deeply layered
and complex opportunity of recognizing desire. The dignity of the queen,
the aged queen's recollection of youth, the queen allowing the publication
of a formerly private image, now after all these years, all provide filters that
manipulate the viewer's recognition. The courtier's reaction is only an ex-
treme version of the dynamics of power and publicity that make the va-
lence of this picture so hard to judge.

## Touching

An image of Sappho, then, invokes a tradition of desire, of female desire.
But in that tradition, it is extremely rare indeed to have Sappho *touch* any-
one. A touch is always a charged moment in Victorian art, a moment of
embodied emotion, a significant gesture. I have found, however, only two
paintings where Sappho is touched by a human.[26] The first is David's *Sap-
pho and Phaon* (plate 13). There are two points I need to make about this
complex canvas. The first is that this picture barely enters the tradition of
Western cultural knowledge. It was painted for Prince Youssoupoff who
took it to Russia where it remained in private hands. David himself had to
ask Youssoupoff for a sketch of the canvas to remind himself of it.[27] It is not
even clear whether the one contemporary critical comment on it that has
survived, was based on a description of the painting or seeing the painting
itself. This painting, despite being by the celebrated David, is marginal in
that no one saw it to be influenced by it.

The second point, however, is that the touch does something extraordi-
nary to the painting. David himself briefly describes the work, and says that
Phaon has come in to surprise her and as he touches her cheek from behind,
she drops her lyre, which Eros picks up to play the Hymn to Aphrodite.[28]
The word "Phaon" can be seen written on the scroll on Sappho's lap. But
modern viewers have had more trouble with the picture than this narrative
gloss may suggest. The strange way in which Sappho and Phaon gaze out
of the frame at us the viewers (and not at each other), coupled with Sap-
pho's odd look—a "sensuous, self-satisfied and somewhat fatuous smile," as
one critic puts it[29]—is less easy to fit into the apparent allegory of the pro-

duction of erotic lyric. What's more, this is an erotic narrative that we know is leading to Sappho's death. The picture has consequently provoked some intensely uncomfortable readings.[30] When Sappho is touched and passion erupts, the regulation of the imagery of desire fractures. The story becomes much harder to control.

The second painting of Sappho being touched is a lush Pre-Raphaelite watercolor now in the Tate in London (plate 14), painted by Simeon Solomon in 1864, and called *Sappho and Erinna in a Garden at Mytilene*. Two "wasted and weary" Pre-Raphaelite beauties, complete with fawn and flowers, nearly brush lips, in what looks like a sexualized clinch. The dark Sappho on the right is hugging and leaning over a rather resistant Erinna. Erinna was also a poet, who was said by a very late Greek encylcopedia in the usual way of such things, to be a student of Sappho (though this is impossible in terms of date).[31] If there is a hint of an image of poetic inspiration here, it is outweighed by the less salubrious teacher/pupil relation on display.

Again, I have two brief points on an image that could bear more extensive discussion. First, Solomon is as marginalized and self-marginalizing as you can get in Victorian high culture. He was a Jew. He was flamboyantly open about his sexuality; he was reputed to have cavorted naked with Swinburne, and he illustrated Swinburne's unpublished poem on flogging. He was explicitly shunned by all good society after he was arrested for soliciting in a public urinal. He died a destitute alcoholic.[32] Because of this, quite a lot of shocking people in the know talked about him quite a lot—Symonds, Wilde, Pater, Rossetti, and so forth.[33] As the poet John Gray wrote in 1891, "People no longer speak of him, except in whispers."[34] There was a flurry of retrospective exhibitions of his work between his death and the First World War, but many of his pictures circulated not merely in private circles but between self-selected aesthetes. That he was *both* so marginal *and* so connected shows how intricate and intimate the dynamic of celebrity and influence can be. The second point is that *this* picture comes out of—or rather stays in—a specifically homosexual environment, which privileged Greekness as a coded expression of desire.

There is a more precise evocation here, however, than the generalities of "Greek love" and "Sapphism." For this painting functions as a visual instantiation—an illustration almost—of Swinburne's notorious poem "Anactoria." Swinburne as a young writer was the great white hope of English poetry, closely linked to the Oxford Aesthetic Movement and a man about town. After a debilitating episode of alcoholic dysentery, he spent his last years in the suburb of Putney, although his poetry remained popular and in print.[35] The turning point in his career was the publication in 1866 of the volume that included "Anactoria"—published against the advice of his

closest friends. The following lines convey the poem's thrill—as it describes Sappho's desperate desire to put her lips to Anactoria's body:

> Ah that my lips were tuneless lips, but pressed
> To the bruised blossom of thy scourged white breast!
> Ah that my mouth for Muses' milk were fed
> On the sweet blood thy sweet small wounds had bled!
> That with my tongue I felt them, and could taste
> The faint flakes from thy bosom to thy waist!

The vividly portrayed longing for flagellation and blood, licked from the "sweet small wounds," "from bosom to waist," is only part of what makes these verses (still) outrageous. When Sappho touches and is touched—especially by a woman—the eruption of fleshly desire is, within Victorian cultural norms, deeply disturbing. Swinburne is knowingly scandalous because of what he publicly expressed and how he expressed it. Sapphic desire needs careful control.

Alma-Tadema referred to archaic vases in the defense of his archaeological realism, and there is a celebrated image from one classical pot in particular which the composition of his picture may recall, from the workshop of Polygnotus from around 430 BCE, which I mentioned earlier.[36] This shows Sappho surrounded by three of her companions. She is seated and reading with an open scroll from which she is performing or preparing to perform for her girls. One companion holds out her lyre. Another stretches her hand over Sappho's head, and above her hand is a wreath. Alma-Tadema's Sappho no longer performs, though she leans forward with great intensity. The wreath of victory is no longer hers. But, most strikingly, now one of her companions touches her. . . .

Even in the context of classical mythologizing, the touch—like the naked body—is a charged area, where female desire becomes visible and hence frightening. Figure 2.2 is Leighton's *Siren and Fisherman*, where the intensely liquid form of the Siren is pressed against a Fisherman, looking like a crucified Christ by Michelangelo, a martyr to desire. Her desire kills him, and he appears as a troubling victim, unable to resist her embrace and her feelings. The physical interface—the touch—between man and woman is here a source of fascinated horror.[37] But consider this sequence of pictures of Oedipus and the Sphinx. The famous Ingres painting of Oedipus (figure 2.3) from the early nineteenth century (1808), offers an Oedipus who is posed in the act of thinking, faced by the protuberant breasts and enigmatic smile of the statuesque Sphinx. She merely reaches out a shadowy paw toward him. Figure 2.4, however, is the painting that made the name of Gustave Moreau in 1864. The Sphinx has leapt violently on Oedipus. But he resists, like a Desert Father, and dominates with a stern gaze. The Sphinx symbolizes the lascivious and tempting woman, wrote one contem-

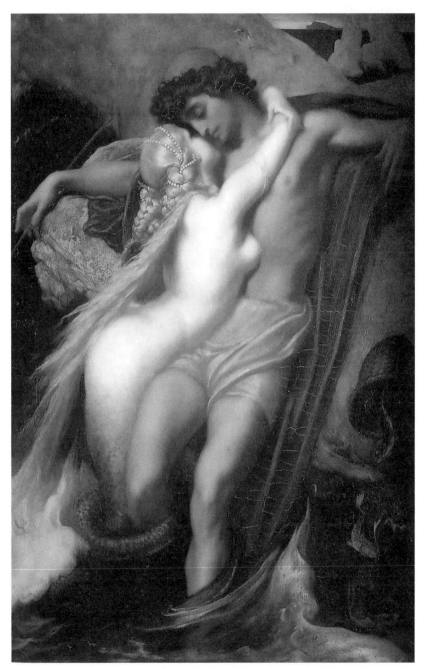

Fig. 2.2. *The Fisherman and the Syren* by Frederic Leighton, First Baron Leighton (1856–1858). Private collection

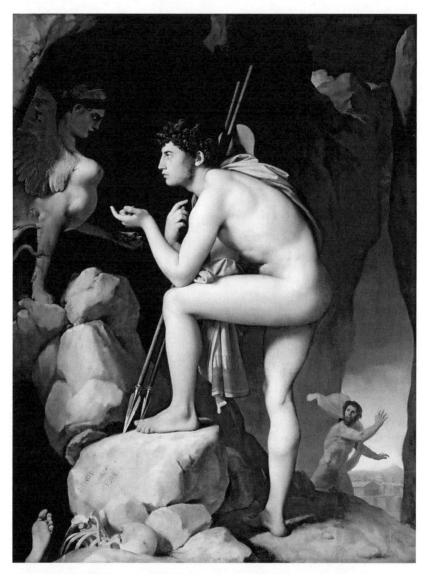

Fig. 2.3. *Oedipus and the Sphinx* (1808) by Jean Auguste Dominique Ingres (1780–1867), oil on canvas, 189 × 144 cm. Musée du Louvre, Paris, France. Photo: The Bridgeman Art Library. Image reference: XIR267669

porary critic, a "bestial humanity" that the man conquers. "Faithful and calm in his moral strength he looks at her without trembling," as Moreau himself put it. She is the image of "modern female beauty," wrote another overheated critic (whose experience of modern females must have been very upsetting).[38] Stuck's *The Kiss of the Sphinx* from 1890—just nine years

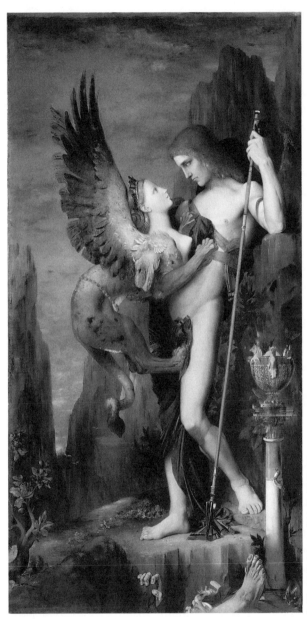

Fig. 2.4. *Oedipus and the Sphinx* (1864) by Gustave Moreau (1826–1898), oil on canvas, 206.4 × 104.8 cm. Bequest of William H. Herriman, 1920 (21.134.1), The Metropolitan Museum of Art, New York. Photo © The Metropolitan Museum of Art / Art Resource, NY

after Alma-Tadema's *Sappho*—takes the involvement of man and monstrous female a step further (plate 15). The Sphinx and Oedipus are locked in a carnal embrace. The scarlet palette embodies the unclassical and degenerate. The artist's own features make up the face of Oedipus. There is no question of faithful and calm resistance here. The artist portrays himself

lost in the swirls of a mythological and rapacious desire.[39] There can be little doubt about which poem was in Stuck's mind, however: Heine's *Sphinx*.

> Before the gate there lay a Sphinx –
> Terror and lust cross bred!
> In body and claws a lion's form
> A woman in breast and head.
>
> A lovely woman! Her white eyes
> Spoke of desire grown wild;
> Her lips gave silent promises,
> Her mute lips arched and smiled.
>
> The nightingale! she sang so sweet –
> I yielded, passion tossed –
> and as I kissed that lovely face,
> I knew that I was lost.
>
> The marble image came alive,
> Began to moan and plead –
> She drank my burning kisses up
> With ravenous thirst and greed.
>
> She drank the breath from out my breast,
> She fed lust without pause;
> She pressed me tight, and tore and rent
> My body with her claws.

Heine, the sardonic Jewish poet despised by the growing racism of German nationalism, was an icon for the artists of high Expressionism, and typically here the Oedipus myth becomes a Pygmalion-like tale of artistic self-destruction, in which female desire, as so often in this period of "decadence," is violent, destructive, frightening, something to lose yourself in— vampiric and monstrous.[40] The trajectory of Greek mythological imagery of sexual desire is another frame in which to view the touch of Sappho.

Unlike the case of Waterhouse, with Alma-Tadema we have a good deal of biographical information about the artist. We know he holidayed with a fast set on Capri, that Oscar Wilde popped into his parties, that his studio and house were decorated in exotic style, that he studied the scholarly sources in some detail for his classical paintings. Alma-Tadema was a sophisticated, well-placed, and connected personality in the art world, a significant public figure. Both the fact that Alma-Tadema was at the height of his status and the fact that he was deeply engaged not just with the classical past but with an artistic milieu in which its encoding was an integral part of sexual expression, invite us to view *Sappho and Alcaeus* with some care.

All this should indeed make Alma-Tadema's painting a remarkable image. It seems to be one of the very few public privileged works of art to suggest, however carefully, a tension between a woman's sexual love for a woman and a woman's sexual love for a man. This should be a very transgressive picture indeed, bringing a dangerous and marginal desire into the very center of the image world of Victorian high culture.

## Sappho on the Strand

So it is fascinating to see what viewers and critics made of it. *Punch* imagines an "academic dialogue," which might seem to recognize this tension.[41] A "Critical Lady" asks a "Wise Young Judge," which figure is Sappho. He points to one. "Which? The man?" asks the woman. "Oh is that a man? I didn't see exactly—" "But," asks the critical lady, "was Sappho a man or a woman?" The Wise Young Judge can't answer ("Ah—was Sappho a he or a she?"), but eventually decides she was one of the Muses. This might seem to play with the sexual ambivalence of Sappho or the soft beauty of Alcaeus. But it seems to me that the joke is actually on the pretentious buffoon who doesn't know what we know—and goes no further than that. It is yet another *Punch* joke about the insufficiently educated and pretentious. . . . The same week a cartoon from *Punch* depicted the painting as Alcaeus taking a photograph of Sappho and the other girls on the *exedra* (entitled "Sap-pho-tography").[42] It is equally unrevealing, except of the current fame of the picture and artist.

*The Times*, however, published a review after *Punch* had appeared (it refers explicitly to the *Punch* parodies of the show) and it is the one dissenting voice in the chorus of lavish praise that greeted Alma-Tadema's picture in reviews of the exhibition. It too focuses surprisingly on the problem of identity: "we hardly know which is Sappho, and, what is worse, we do not care. . . . [F]or Sappho and what she is reading or singing we do not care a straw, nor did the artist, if appearances may be trusted."[43] That the reviewer seems to think that it is Sappho who is singing or reading in this picture seems uncannily to embody the *Punch* joke! This confusion over the subject of the canvas (which may have motivated its change of title) can be seen in the range of identifications. Edmund Gosse in the up-market *Fortnightly Review* had no difficulty in identifying Alcaeus, nor did the reviewer of *The Athenaeum*. Other reviewers offer no name, or in the case of a somewhat overheated article in *The Daily Telegraph* identify him as Phaon.[44] A viewer's response depended on what narrative the picture was meant to capture—different narratives reveal different interests and silences.

Particularly telling is a lengthy article published in *The Nation* in New York five years after the exhibition, which finds the painting outrageous

and viciously attacks it—for its archaeological inaccuracies.[45] The author was particularly upset that the little statue of Victory could not have been produced until at least two hundred years after Sappho, and, worst of all, that the graffiti is not written in the letters of sixth-century Lesbian but fifth-century Attic! It is a long and strident article. Equally odd to my mind is the response recorded in the *American Journal of Philology*.[46] One critic, we are told, says that the object of the poet, Alcaeus, is to "enlist Sappho's support in a political scheme of which he is the leader, if not chief prophet, and he has come to Sappho's school in Lesbos with the hope of securing another voice and other songs to advocate the views of his party."[47] This is a direct though unattributed quotation from the review in *The Athenaeum*.[48] We are meant to see in the painting, in other words, a piece of lobbying for a political campaign—the poets as the spin-doctors of ancient Lesbos. But the editor of the *American Journal of Philology* knows better. What is at stake here is not politics but metrics. Alcaeus is singing "new songs with new rhythms"—as Sappho "hears it, she feels that there is a strain of balanced strength in it that she has not yet reached." The editor does think that the clausula at the end of a Sapphic stanza is "the incomplete echo of the cry of yearning love, a passionate invocation." But the tension in Alma-Tadema's painting stems from the discovery of a new metrical scheme. The *American Journal of Philology* reached a different audience from *The Nation*, but the two reviews are equally strident in their criticism of the painting—in finding archaeology, orthography, or metrics the question passionately posed by this painting.

In 1885, four years after the painting, Wharton published what was to prove the most influential translation of Sappho for the next fifty years and more.[49] It was the first English translation to be explicit about the female gender of the object of Sappho's desire. And Wharton took the head of Sappho from the Alma-Tadema painting for his frontispiece. But twenty-five years later in 1910, Mary Mills Patrick still had no doubts about Sappho. She was a woman with high moral ideals. And she had proof. Sappho was headmistress of a school and "There never has been an age of the world when society was so corrupt that young women would be sent from a distance to study under a teacher who had a sullied reputation."[50] (It is no surprise that Mary Mills Patrick was a headmistress, of the far off Constantinople College, the leading American school in Turkey, which might seem worryingly close to the East and the isles of Greece, where Sappho burned.) Sappho's words "do not describe love at all," she writes, "but the unhappiness occasioned by the loss of the affection of her friend."[51]

Contemporary reviewers were not swift to see desire in Alma-Tadema's painting. *The Athenaeum* might be thought to show us the effort of repression. It noted that the image "depicted a political as well as a poetical flirta-

tion between two of the greatest lyric poets of antiquity," where the word "flirtation" may suggest a *frisson* between the protagonists. Like Gosse, he calls Sappho "a *précieuse*," which at least notes a certain self-consciousness in the image of Sappho (or in the reviewer).[52] But he adds "He has avoided giving to her physique any impression of that voluptuous temperament that the scandals of a later age attributed to her"—a statement that tellingly reminds us of what *not* to see in this image. He adds immediately a novel identification: "The figure of Sappho's daughter, who sits at her side, is charming."[53] The juxtaposition of these two sentences (and Freud would note the misrecognition of the girl as sitting when she is standing) may indicate by their emphatic sense of propriety some of the potential anxiety for viewers of this painting.

Only *The Daily Telegraph* saw a "burning Sappho"—"the quick-witted full-blooded, passionate daughter of Scamandronymus."[54] Indeed, for him "Sappho reminds us much more of Sappho the amorous matron . . . than of Sappho, the sentimental and love-lorn maiden." She stares with "the eyes of a love-sick jaguar from Java." He identifies Alcaeus as Phaon and suggests that Sappho's companions were rather sniffy about their leader's infatuation. But, he adds, with knowing tone, "Sappho was a very literary lady indeed. A terribly literary lady." And with this hint, the review drifts into direct comedy with a fantasy that Phaon was connected to the Press and Sappho threw herself over the cliff because of bad reviews. This article has a quite different tone from the other notices of the exhibition, and it alone seems to flirt with recognizing in Sappho a figure of potentially improper desire: a "terribly literary lady"—though even here the joke is primarily on the "modern woman" in publishing, a stereotypical concern of the 1880s. She may appear as infatuated with a man, Phaon, but he turns out to be, like the reviewer himself, "associated with the Press," as the story reverts to a tale of literary ambition.

If this painting of Alma-Tadema, like so many of his works, seems to express a sense of sexual desire in classical dress, it is hard to find significant comment on it in contemporary Victorian society. Where *A Sculptor's Model* unleashed a barrage of shocked private and public response, *Sappho and Alcaeus* seems to have evoked no sexualized narrative at all, except for the jokey and knowing *Daily Telegraph*, which emphasizes all too clearly what is missing in the other notices. For almost all of the Victorian viewers it is declared to be a picture about politics, meter, education, architectural features, coloring[55]—anything but erotics.

This raises some fascinating questions, not just about the recognition of desire, but also about how we conceive of centrality and how transgression is negotiated. Swinburne and Solomon, when they represented the touch of Sappho, were deeply scandalous, and their scandalous flouting of acceptable

social normativity focuses attention on the norms against which they were judged. In this way, they become icons of transgression for others, and have an effect on the center, and at the center, by making the transition across boundaries visible. Queen Victoria, however, located at the apex if not the center of the social system, when she represents Sappho, may open a narrative of remembrance of things lost, but her very position, and the consequent response to her, also produces its own blindnesses and silences. The very center here is also wholly exceptional. Even marginalized.

Yet when Alma-Tadema, protected by his social position, his artistic reputation, the classical subject and the restraint of his portrayal, opens a space where desire may be viewed, the response is either silence, or a careful turning of the head, or a retreat into humor. It cannot be seen, or rather, it cannot be directly said to have been seen.

The question therefore could be asked like this: When it comes to recognizing an eroticized relationship between Sappho and Alcaeus, and Sappho and her girl friends, named on the walls of the *exedra*, does the silence of Victorian viewers exist because there is nothing there to be seen, because there is no eroticized look except in the eyes of a modern observer? So Peggy Reynolds, a modern critic usually swift to find the *jouissance* in an image of Sappho, may be being just Victorian when she writes dismissively that Alma-Tadema placed Sappho "in her schoolroom . . . surrounded by some of her girls on a marble rank of benches engraved with the names of her pupils and listening to a performance of Alcaeus."[56] Or is the silence of Victorian viewers of this painting maintained because silence is the proper reaction—proper because it does not publicly recognize any sexy feelings either in the viewer or between the characters in the painting? An anthropologist aims to reveal the tacit knowledge of a community, to reveal the structures of belief that a society cannot say of itself. Since Thucydides, historians have been committed to the polarity *logo men, ergo de*: "what was said . . . but what really was the case." The threat of any historical or anthropological analysis, however, is the imposition of modern assumptions where different assumptions exist in the people or culture being studied. When you have a hammer, everything looks like a nail. . . . Nowhere is this tension more insistent than with recognizing desire. Being too quick to see the signs of desire is the sneer at the psychoanalyst and the fool in love. Being unable to see how desire is not expressed directly but always veiled is the sneer at the naïve literalist—and the fool in love.

At the time of its first exhibition, this picture was viewed by many different people. It was exhibited in a central gallery in London, and entered the public domain more broadly through reviews, commentary, reproductions, and satirical magazines.[57] It was viewed through a set of overlapping frames—philhellenism, the expectations of the genre and iconography of Alma-Tadema's classicizing art, the changing sense of how sexuality and desire

were part of the artistic world, the history of images of Sappho, the knowledge of Sappho and Alcaeus as ancient figures and as redrawn by subsequent generations, the protocols of touch and the representation of the fleshly body, the recognized use of Greekness to talk about same sex desire. It was also viewed by different individuals and groups of individuals: the characters imagined by *Punch* are at one end of a spectrum; the circle of Wilde, Swinburne, and Solomon at another. The event of this painting's reception takes place within these different and overlapping variables with their different patterns of marginality and centrality, of being in the know and out of the picture.

Yet what the central empty space of the picture, the silence or veils of its language of desire, provokes is a heightened sense of the grounding problem of all such historical analysis. Not only must a modern viewer explore the complex dynamics of the historical moment of the picture's reception, but also we must negotiate our own processes of appropriation—the inevitability of seeing ourselves in the mirror of painting. How much does *our* desire to construct a particular image of the Victorians affect the narrative we tell of the Victorian reception of classical antiquity as a scene of desire?

Reception is a process of more complex dynamics and more intricate and constant negotiation than the standard model of influence and impact allows—or the static image of a map would suggest. I am drawn back again and again to the space between Sappho and Alcaeus—and the viewer faced by that space. What does this picture know? What does it expect the viewer(s) to know? How *knowing* is this learned painter's image of classical antiquity? It is here the social expression of this picture becomes evident—and where the reception of the classical takes place.[58]

PART 2

✿ ✿ ✿ ✿ ✿ ✿ ✿ ✿ ✿ ✿ ✿ ✿ ✿ ✿ ✿ ✿

Music and Cultural Politics

*Chapter 3*

❀ ❀ ❀ ❀ ❀ ❀ ❀ ❀ ❀ ❀ ❀ ❀ ❀ ❀ ❀ ❀ ❀

# WHO KILLED CHEVALIER GLUCK?

CHRISTOPH WILLIBALD GLUCK is an unlikely revolutionary hero.

He had been music tutor to Marie Antoinette in Vienna and, after her marriage to Louis XVI, followed her to Paris, where he was a regular at Versailles. He was celebrated and supported in the very highest echelons of royal Europe. Indeed, he was knighted by the Pope, and always signed himself "Chevalier" or "Ritter Gluck." He was an irascible and fierce conductor of his own music, but a bonhomous host, who died two years before the Revolution broke out, after sneaking a good slug of liqueur, forbidden to him by his doctor, when his watchful wife left the room.[1] Gluck was already sixty years old when his music became such a *cause célèbre* in Paris in the 1770s, and he barely entered the strident polemics that swirled around the performances of his operas.[2] In the face of the aggressive nationalism that opposed French and Italian (and British and German) culture in this period, he did announce that he strove to write "a music fit for all nations," and he bluntly dismissed "the ridiculous differentiation between national styles."[3] But he avoided replying to the string of heated pamphlets about his art. Yet despite these far from revolutionary credentials, Jean-Baptiste Leclerc, a politician, music theorist, and ardent revolutionary, writing in 1796 in the full flood of revolutionary fervor, could declare:

> Driven by national vanity, Antoinette brought the celebrated German [Gluck] to France, and recreated dramatic music for us. In this she was unwise. For it is not at all inaccurate to say that the revolution accomplished in music shook the government: the chords awoke French generosity, and the energy that enlarged our souls at last burst out. The throne was shattered. And now the friends of liberty have used music in their turn, employing these same vibrant sounds this German composer produced.[4]

A much shorter version of this chapter appeared as chapter 12, "Who Killed Gluck," in Peter Brown and Suzana Ograjenšek eds., *Ancient Drama in Music for the Modern Stage* (2010), Oxford University Press.

All translations from French, Italian, and German are my own unless otherwise noted. All references to Lesure (1984) are to Volume 1 unless otherwise noted. Sources are cited from modern editions where possible, and all quotations have been translated.

For Leclerc, Gluck's music led to the shattering of the throne of France. This may look like crazily bad history: Gluck, or any other music, rarely features as a major cause of the French revolution. But when a serious revolutionary makes such a claim, we should try and find out what he could have meant by it. Leclerc, like many revolutionaries after him, took a very strong line on the relation between arts and politics. In hyper-Platonic guise, he wanted to ban all purely orchestral music from the new Republic of France on the grounds that music without words was too open to interpretation.[5] Here with Gluck, however, he has to tread a careful line. Leclerc sees in Gluck a liberating musical force that led to the collapse of the monarchy. Yet Gluck is *German* (he was actually from Bohemia in what is now the Czech Republic, but as we will see, he becomes a figure for "German Music" in particular); what is more, Gluck was closely associated with the court and Marie Antoinette in particular. Leclerc cannot simply celebrate a German court composer as a major factor in the French Revolution. Hence it must turn out to be a nationalist mistake of the necessarily mistaken Austrian queen that brought the German to France, which allowed his music to awaken good French spirit, which in turn led to the collapse of the throne. Yet for all Leclerc's careful self-placement—speaking out in revolutionary times is always dangerous—he is still making the strong claim that Gluck's music was a powerful revolutionary spur. This is strikingly at odds with the most common modern perceptions of Gluck. It may therefore seem surprising that at least some modern scholars have found that Leclerc's claim actually points toward an important historical insight: "With the changes in perception sowed by Gluck and reaped by the revolutionaries, music lost its political innocence."[6] Chevalier Gluck's operas, it seems, *should* be seen as turning points in a revolutionary narrative.

This chapter will begin by looking at how Gluck's opera reforms responded to classical culture to become the revolutionary icons his contemporaries believed them to be. To appreciate what made the performances of *Iphigénie en Aulide*, *Orphée*, and *Iphigénie en Tauride* such events in Paris at the end of the Ancien Régime, we will need to look not just at formal elements of composition, important those these are, but also at a range of frames of comprehension: the role of classicism in the critical understanding of theatre; the role of musical and literary tradition, not just reaching back to Euripides or other ancient sources but also to Racine, Rameau, and, more broadly, Diderot, Voltaire, Rousseau, and the Encyclopedists; the move of the theatre away from elite circles into a more popular and public neoclassical architectural space and a wider audience; the role of dance in opera, and its debated classical roots; the role of the chorus as a specifically classical element in modern opera. It will also involve exploring the differences between Vienna and Paris and London as sites for Gluck's operatic success and failure—within the incipient but self-conscious na-

tionalism of the era. This will be a story deeply involved with the history of naturalism in the theatre, the history of tears, the history of listening, and the history of Romantic Hellenism. It is particularly striking to see Gluck's work being praised during the 1760s in exactly the terms that Winckelmann will make *de rigeur* for the Romantic appreciation of classical art—"*eine edle Einfalt*," "a noble simplicity"[7]—and to recall that Gluck and Winckelmann may have met in Rome.[8] Gluck stands as one of the most significant figures at a most significant juncture in the history of classicism.

Any model of reception that focuses on a single author reading a single ancient text, is merely a distraction in the case of Gluck. The composition of each of these operas is a collaborative effort between librettist, dance master, composer, and performers; they are responding to several different horizons of expectation and several different bodies of polemical material, as well as to ancient texts. The audience engages with the performance from a range of perspectives, too—where the circulation of critical pamphlets is tellingly formative of public opinion and of the terms in which opera can be viewed. (There are around 1,000 pages of pamphlet material from Paris in the late 1770s alone discussing Gluck's operas, arguments which were immediately recognized to be important enough to have been collected and republished as a volume, as early as 1781—a move that changed the ephemeral war of pamphlets into a long-term debate.[9]) What Gluck's classicism means also depends on the responses of his audiences: Gluck changed the text and the music of the operas repeatedly in response to his audiences and his own changing ideas. Other producers of his work cut and pasted at will to produce *pasticcio* versions. Gluck pillaged his own earlier work to make his later operas.[10] It was not the same work performed in Vienna, Paris, and London—nor, indeed, even during the same run in Paris.[11] The reception of Gluck and Gluck's reception of the ancient world is very much a process, not a point or a moment.

The chapter will—consequently—continue with the engrossing scene of Wagner's rewriting of Gluck in the 1840s, to produce a score that then enters the German repertoire as Gluck, even though Wagner's Hellenism (and orchestration) is now stamped all over it. Wagner's version is still played, though far less commonly now that the authenticity movement has gained such momentum. It will also look at Berlioz's reinvention of Gluck. Berlioz, like Wagner, was obsessed with Gluck, and worked tirelessly to promote Gluck in his own image (as did Wagner) culminating in a hugely successful revival of *Orphée* in Paris in 1859, a production set against the contemporary taste for Grand Opera, which had largely silenced Gluck in Paris (unlike in the German-speaking world where Wagner, for example, had repeatedly conducted the operas). Between Berlioz and Wagner, we will see one particular nineteenth-century model of Gluck developing—

where Gluck's classicism and revolutionary spirit plays a crucial role in the (classical and revolutionary) aims of Berlioz, composer of *Les Troyens*, and of Wagner about to write *The Ring*, and to found the Bayreuth Festival for it. We will end, however, with an English performance of *Orphée* in London in 1910, the first fully professional production in England since 1860. This production opened the night before Strauss's *Elektra* (and Strauss also rescored Gluck). The contrast between Gluck and Strauss was played out in the British press as a contrast in classicisms, in visions of the ancient world, as much as in musical styles. But after Strauss, for fifty years and more, Gluck was seen in Britain at least as epitomizing an outmoded, and rather boring, idealized view of the ancient world: white sheets and columns rather than blood and incest. The authenticity movement has more recently reclaimed Gluck (as it has Handel and other baroque music, thus in the imagination of audiences often tying Gluck back to early opera rather than seeing him as a revolutionary figure looking forward to classical and romantic opera)—but Gluck remains an operatic composer well outside the huge popularity of a Puccini, Rossini, Mozart, or Verdi, a second-rank status he has held for most of the nineteenth and twentieth centuries. When a starkly modernist *Iphigénie en Tauride* was staged in London in 2007, it was the first performance of Gluck's masterpiece in the capital for thirty years. For modern audiences, Gluck's classicism seems to occupy a similar position to "period instruments"—part of the specialist recovery of a lost world of operatic style, rather than a revolutionary artistic and political aesthetic.

When I ask "Who killed Gluck?" I am intending to explore the cultural history that turned a revolutionary icon at the center of a polemical storm into a dull or, at best, curious embodiment of a recognized but uninspiring classicism of a bygone age. Listening to Gluck in the eighteenth century in Paris produced a storm of tears, recriminations, anguished passions, and a turmoil of social and intellectual disagreements: I want to explore why that seems so bafflingly strange to modern audiences.

## Revolutionary Opera

Gluck arrived in Paris as a celebrity, as Leclerc notes. He had moved from his humble beginnings as a promising forester's son in Bohemia through university schooling in Prague and a training in Italy to the position of Kapellmeister in Vienna. What might have continued as a sleepily middle-aged successful career at the heart of the Austrio-Hungarian Empire changed in the 1760s with a series of influential artistic collaborations, under the patronage of Count Giacomo Durazzo, the head of the court theatre, who actively encouraged new artistic directions especially for opera,

partly motivated by his own passion for French theatre.[12] Three productions in the 1760s changed the status of Gluck and the direction of opera as an art form.

First, in 1761 he collaborated with the choreographer Gasparo Angiolini to produce a ballet, *Don Juan*. Ballet played a regular part in opera and other shows, usually as interludes dividing up the action of the dramatic narrative. Ballets were formal dances often in elaborate costumes, which related most closely to the court dances of the elite who made up the audience for the operas.[13] Angiolini, following his own teacher Hilverding, introduced a more naturalistic style of dancing. Greek and Roman texts talked of pantomime dancing as being more expressive, clearer, and more moving than mere words, and in pursuit of this ideal, a more expressive form of physical representation by gesture in dance was explored as a specific classicizing aesthetic. *Don Juan* staged this new expressiveness—but it also turned dance away from being an embellishment or interlude within a dramatic action to being the whole story itself. *Don Juan* was a narrative ballet. Angiolini, as we will see, was obscured, much to his own bitterness, by the rise of Noverre, known now as the father of modern dance, with whom Gluck collaborated in Paris. But *Don Juan* with Angiolini created for Gluck a foundational recognition of the potential for the integration of dance into a narrative form, an aesthetic strategy central to the shock and success of his later operas. "*Don Juan* was just as bold [as the operas] in breaking with current conventions and in laying claim on antiquity."[14]

Second, in 1762 Gluck collaborated with Ranieri de' Calzabigi to produce *Orfeo ed Euridice*. Calzabigi was an intellectual (and social) adventurer, with a passion for classics (as well as money-making schemes, women, and literature; Casanova recognized in him a fellow spirit).[15] Calzabigi wrote the libretto for *Orfeo ed Euridice*, and he followed it up with a series of polemical pieces of prose articulating and defending the artistic principles on which the production was grounded. The classical principles here are explicit, and the reform of opera that these principles enacted has been extensively discussed in the musicological literature.[16] Unlike the complex plots of Italian opera, always with at least a first man, second man, first woman, second woman, and a string of complex, often erotic subplots, *Orfeo ed Eurdicie* has only three characters and a chorus. Orfeo himself dominates the action (Euridice has only one aria in the Vienna libretto). The model of three actors and chorus looks back to classical tragedy. The plot of *Orfeo ed Euridice* is simple and direct: Orfeo laments Euridice, Amore (Love) appears and encourages him to go to the Underworld to recover his beloved, with the stipulation he must not turn around to look at her. Orfeo goes to the Underworld, where he recovers Euridice; she berates him for ignoring her till he finally looks around, and she fades away. Orfeo once again laments (with the famous aria "Che farò senza Euridice?"), but Love appears

to tell him that his undying love will be rewarded and he is reunited with
Euridice. There are no subplots, no minor characters, no imbroglios or
intrigues. The music follows this with simple dramatic lines, without the
repeats and musical introductions and verbal pyrotechnics of Italian opera.
The chorus—first of fellow mourners and then of Furies in the Under-
world—was fully integrated into the action, and their ballets formed part
of the action—the mourning rituals around the tomb of Euridice and the
threats of the Furies. *Orfeo ed Euridice* is coherent, dramatic, focused on the
emotional reactions of the characters, with an intensity and directness un-
paralleled in Italian opera, and it had a profoundly moving effect on its first
audiences. Orpheus, the singer whose song is so powerfully moving that he
can charm the world, has always attracted artists as a self-reflexive and self-
authorizing ideal of the power of literature.[17] *Orfeo ed Euridice* not only had
an overwhelming Orphic effect on the emotions of its audience, but also
became a self-reflexive and self-authorizing image for the recovery of a
dead classical tradition through the power of art.

Crucial to the success of *Orfeo*, as the creative team recognized, was the
performance of Guadagni in the title role.[18] Guadagni was a castrato who
had trained with Garrick in London. Garrick had pioneered a new style of
acting that had become famous throughout Europe for the expressiveness
of his bodily and facial gestures. It was said by Noverre that a foreigner
who understood no English could follow a scene acted by Garrick on the
strength of his physicality alone.[19] (As we will see, Garrick was also very
closely connected with Noverre, who designed the dances for Gluck's Paris
successes.) Guadagni's acting brought what was recognized as an unparal-
leled emotional intensity through the focused expressiveness of his move-
ment and gestures—which was necessary for a plot that involved so much
mourning and slow journeying instead of the stage machines, spectacle,
and excited activity of Italian opera, and which also contrasted vividly with
the static formal singing style of traditional opera. Part of the stunning ef-
fect of Gluck's work came from the collaboration of the direct emotion of
the music and the direct emotional expression of Guadagni in the perfor-
mance of the music—and from the recognition that this was at the epicen-
ter of a European-wide shift in aesthetic norms.

Third, in 1767 Gluck again collaborated with Calzabigi on *Alceste*. *Al-
ceste* also turns on the recovery of a female from death, and on the redemp-
tive possibility of love. Unlike *Orfeo*, *Alceste* is based on a specific ancient
Greek play. Calzabigi wrote a preface to the libretto (which Gluck signed
as his own), outlining the importance of the classical in the conception of
the drama. Where *Orfeo* allowed a general sense of the classical and the
pastoral to be evoked, *Alceste* rewrote a Euripidean masterpiece for modern
tastes—thus encouraging a closer sense of intertextuality. But it also looked
back to the arguments of the seventeenth century, where Quinault's opera

*Alceste* had been the cause of a small but important pamphlet war, in which Racine's preface to his drama *Iphigénie* played a significant polemical role.[20] (Racine also left an *Alceste* unfinished at his death.) What makes Gluck's operas self-consciously revolutionary is in part the implicit and explicit critical engagement with the great tradition of French classical theatre, its arguments about the ancient and the moderns: this is not exactly a redis-covery of the classics, but, as with Strauss in the twentieth century, a rejec-tion of the previous generation's conception of the classical.

When Gluck was commissioned by the Paris Opera under the patronage of Marie Antoinette to produce six operas for them, his reputation as a producer of a new and dangerously modern art had already spread from Vienna. The contrast between the 1760s and 1770s is striking. Gluck first visited Paris is 1764, when *Orfeo ed Euridice* was engraved there and pub-lished (thanks to Count Durazzo). Those involved with the publication were greatly excited by the piece, and keenly awaited Gluck's arrival. In the event, the book sold only nine copies, and there was a studious indifference from the Parisian public. In 1774, when *Iphigénie en Aulide* opened (closely followed by *Orphée*), the interest was intense from before the first night and immediately prompted a storm of increasingly heated pamphlets. It was in Paris that Gluck's music reached a wide audience and entered the public imagination, and thus in Paris that the revolutionary force of Gluck's operas was realized.

There can be no doubt that Gluck's classicism became a specific focus of debate (although we will see how this also became an alibi for other con-cerns). Calzabigi made a sharp distinction between his libretto and the overstuffed ornate style of Metastasio, the paradigm of Italian opera: "There are no maxims, no philosophy, no politics, no similes, no descrip-tion, and no bombast . . . [no] senile obedience to the crazy rule about the 'second man' and 'second woman.'"[21] (It is indeed striking that there is barely a single simile in the whole stripped-down libretto of *Orfeo*.) This cleansing of the script was specifically put under the aegis of a return to Greek values: "Reduced to the form of Greek tragedy, the drama has the power to arouse pity and terror, and to act upon the soul to the same de-gree as spoken tragedy does."[22] Calzabigi quotes Aristotle's aim of arousing pity and fear because he knew well that their works were criticized for not following the so-called Aristotelian rules of the unities, so important to the previous generation. Rediscovering Greek drama also meant rereading Ar-istotle.[23] The new classicism was not only a question of the script, of course. As *Le Mercure de France* declared: Gluck "makes real the prodigious effects that antiquity attributes to music"[24]—the power to move profoundly, or, as Calzabigi wrote with political caution in the introduction to the score of *Iphigénie en Tauride*, "the power to soften men without corrupting them, and to make them governable without degrading them."[25] Gluck himself

"took no credit for the success of his work . . . he gave the Greeks all the honour."[26] Gluck's music—its simple lines, emotional directness, and austerity—not only contrasted with the trills and twists of Italian opera, but also had, as one might expect from reading Plato's account of ancient modes, an ethical drive: "The examples of classical virtue on which [Gluck's operas] are based, are not only expressed, but literally illustrated by the chastity of the music itself."[27] "This music," eulogized one pamphlet, "renewed from the Greek, is the only expressive, the only *dramatic* music."[28] Another declared, "The curtain rose. Here I truly believed myself to have returned to the time of ancient Greek tragedy."[29] Another found himself "transported to the heart of a Greek Temple" by *Alceste*.[30] Yet another: "Every time I listen, I feel myself cast back to the days of ancient Athens, and I believe that I am sitting at productions of the tragedies of Sophocles and Euripides."[31]

What did the audience see and hear that produced these reactions? Classical subjects had been a staple of opera from Monteverdi onward. But these operas, with their stripped down plots and casts, seemed to demand a new aesthetic gaze, a re-figuration of what constituted the dramatic. The opening of *Orfeo* is paradigmatic. The scene is set around the tomb of Euridice, and a chorus of country-folk sing and dance mournfully around the grave, while Orfeo himself raises his voice high above the slow choral rhythms. There is no "scene setting," no minor characters in recitative— no development of action. But the scene was viewed as capturing the "funeral rites of the ancients" with an unparalleled archaeological accuracy, like a frieze come to life—music and architectural form are sister arts: "the dance airs in *Orphée* are like classic bas-reliefs, the frieze on a Greek temple."[32] The incipient Romantic fascination with the *Realien* of ancient art, fueled by the discovery of Pompeii, as well as by the dissemination of Winckelmann's art criticism, gave a conceptual depth to the aestheticizing gaze here. *Envisioning* the classical past here, as with the first two chapters of this book, is central to the theatrical experience. This shift in style in staging, costume, and narrative was integral to the impact of the operas on the Parisian audience. But perhaps the most immediately striking theatrical effect was the chorus itself. In traditional French opera, the chorus had stood to the side of the stage, arranged in a social hierarchy according to the class of the characters, in full and heavy costume.[33] Grimm, in an article on "Poésie" in the *Encylopédie*, mocked "the songs of the French Opera, without action, arms crossed, with the lung-power to stun the most hardened ear."[34] But Gluck's chorus members, as one pamphleteer marveled, "were no longer immobile figures, strangers to the action: it is completely an animated group" [un Peuple animé].[35] This too was immediately seen as classical. As the *Wienensches Diarium* commented on the first performances of *Orfeo*, "The chorus, in whose reintroduction we rejoice, and the activity

given them by Herr Calzabigi, show sufficiently how well he knows the traditions and the customs of the classics."[36]

The animated chorus emerged from a range of influences. I have already mentioned Angiolini and the narrative ballet of *Don Juan*. Angiolini too was committed to an ideal of classical tragedy (he defines the tragic in a way that outlines Gluck's classicism perfectly: "By tragic, I mean a simple action which gradually leads from the pathetic to the terrible, which wakens horror in me without presenting me with it, which ends with vice punished and virtue in triumph"),[37] and he found his intellectual sources for his dance in Horace's *Ars Poetica*, and (probably second-hand) accounts of the success of Pantomime in Greco-Roman culture from the days of Augustus onward. He was a committed Aristotelian. But he was eclipsed by the great dancer and choreographer Jean Georges Noverre, who was signally important in the opera revolution.[38] Noverre and Angiolini swapped insulting pamphlets, as Noverre rose to fame—and Noverre staged ballets parodying Angiolini's work. When Angiolini accused Noverre of breaking the Aristotelian rules with his new narrative forms of dance, Noverre was brutal in his reply to "Sieur Angiolini and his petty oracles": "The rules of Aristotle were not made for the dance," he declared peremptorily, "Rules are excellent up to a certain point . . . [but] Woe betide those cold composers who cling tremblingly to these petty rules of their Art . . . imbecility gives them inverted wings which far from raising them to perfection drag them in the mire."[39] Noverre's publications and success had a dire effect on Angiolini's career. Although Noverre himself eventually left Paris crushed by the in-house fighting of the Parisian Opera, his contribution to the success of Gluck's works was major.

Noverre, like Guadagni, was a close collaborator with Garrick, and played more than one season in London. His first performances at Garrick's Drury Lane theatre resulted in a scandalous riot. When it was rumored that a French dancer was to appear at Garrick's Drury Lane theatre, "the scribblers, the small wits and the whole tribe of disappointed authors declared war. . . . The spirit of the inferior classes was roused and spread like wildfire through London and Westminster."[40] The upper classes, who had close associations with France, arrived wearing swords to protect their entertainment; the "inferior classes," paid to boo, according to Noverre, came with staves and cudgels. Despite Garrick himself coming on stage in order to try to quell the violence, the show was ditched at the end of five days of mayhem.[41] Interestingly, Guadagni had fared no better when he sang Gluck in London: the audience was annoyed that he would not step out of character and acknowledge the applause they offered to each aria.[42] Where he was fully engaged with the new aesthetic of the integral work of art and with his new expressiveness of acting, the London audience was still responding in a traditional manner, as if the piece were made up of set

piece arias for famous singers and interludes for the rest. Gluck's works were all too often extracted and reordered after this in London. In contrast to Vienna and Paris, Gluck seems to have had little revolutionary effect in England (and has largely remained out of favor with London audiences ever since), despite the influence of Garrick, through Guadagni and Noverre, on Gluck's success in Europe. The new aesthetic drew from London, but could not reexport successfully to it.

Noverre himself describes the genesis of the animated chorus, the "action dance," with his usual vivid prose. He came into a rehearsal of *Alceste*—this is still in Vienna—to find Gluck in despair over the singers:

> These choruses required action, movement, expression, gestures. It was asking the impossible for how can you move statues? Gluck, alive, impatient, is beyond himself, throws his wig on the ground, sings, gesticulates but all in vain, statues have ears and hear not, eyes and see not. I arrive on the scene and find this man of genius in the throes of that disorder born of despair and anger; he looks at me speechless then, breaking the silence, he says to me with certain energetic expressions I do not repeat: Deliver me my friend from the sorry state I am in. . . .[43]

Noverre finally suggests putting the immobile and ungesturing chorus in the wings, from where they could still sing, and getting his own dancing troupe to perform on stage: "Its realisation created the most perfect illusion."[44] The "frieze come to life" needed its statues to dance.

Noverre's writings on dance were as broadly influential as the dances themselves. He became one of the most successful theorists of dance not least because his *Letters on Dancing and Ballets* were published at exactly the right moment. It was a combination of two main vectors. First a sudden surge of interest in the form itself: "Dancing and Ballets have become the vogue of the day," he himself noted, "they are received with a kind of passion, and never was an art more encouraged by applause than our own."[45] Second, his articulate and engaging prose had been well prepared for in theme and scope by the leading intellectual figures of the era. Diderot is exemplary of the French intellectual scene in calling for more expressiveness and a return to nature in the arts; Rousseau followed a similar line (and, as we will see, was overwhelmed by Gluck's first performances in Paris and corresponded with him eagerly). By way of contrast, in his *La Danse ancienne et moderne ou traité historique de la dance* (1754), Luis de Cahusac, who collaborated with Diderot, also explored the ancient sources on dance; also, from this reading of the ancients, called for a return to narrative action, expressiveness, and simplicity in modern dance; and also demanded strong feeling and truth to nature in a theatre that should be a "*tableau vivant* of the passions"—but de Cahusac "seems to have been passed relatively unnoticed by his contemporaries." [46] Unlike de Cahusac, Noverre rode the crest. Quickly translated into English, Italian, and Ger-

man, he had a huge influence across Europe. ("I am the first to have attempted to write on the subject," wrote Noverre in an apparently successful if patently false self-advertisement.) He saw his *Letters* as "the first stone of the monument which I desired to erect to that form of expressive dancing which the Greeks called Pantomime."[47] The art of dancing "had been entombed in the ruins of antiquity,"[48] but "if you consult Lucian, you will learn from him, sir, all the qualities which distinguish and characterize the true *maître de ballet*."[49] Emotion will be one of these qualities: "If strong passions be proper to tragedy, they are no less compulsory to the art of pantomime."[50] From Noverre's choreography and writing, in an intellectual context that saw the return to the classical past as a return to the values of simplicity, expressiveness, emotion, and truth to nature, the Parisian audience learned to see in the ballets in Gluck's operas another telling sign of the return of classical aesthetic forms.

I have dwelled on Noverre and his contribution to the impact of Gluck's operas and the perception of their revolutionary classicism partly in order to underline the collaborative nature of the production of Gluck's operas, recognized as such from the beginning, and the consequences of this for what might be understood by classical reception in opera. But my aim is also partly to trace the extended process of reception—across time, as Noverre's writings, say, affect the perception of his dances (and vice versa); across disciplines, as dance, music, and literary polemics interact; across countries, as Parisian audiences are excited to receive the trendy new dance from Austria, along with their Austrian queen, while the English burghers are prepared to riot over the appearance of a French dancer for his mere Frenchness; even in bodily form, as the dancers' bodies are viewed now as classical in their expressiveness. When Noverre boasts "I have achieved a revolution in dancing as striking and lasting as that achieved by Gluck in the realm of music,"[51] he is also reminding us of the multiple levels at which classicism was a force in the event of operatic performance.

## The Art of Crying and the Happy Ending

There was a further revolutionary aspect of Gluck's operas, which also entered the debate on classicism—the powerful emotions his operas released in the audience. Paris in the 1770s was a very tearful place.[52] As Grimm observes, "Men are all friends when they leave a show. They have hated vice, loved virtue, cried together"[53]—a theatre is not like reading alone, you have an audience "to witness one's honesty, one's taste, one's sensibility, one's tears."[54] Crying in public, for men as much as for women, was not merely countenanced, it was expected and honoured: "Tears of sensibility were at the summit of the hierarchy of the signs of pleasure given off by the

body."[55] (The gradual change away from such displays in the nineteenth century marks the shift from sensibility to sentiment.[56]) In the Ancien Regime, the Opéra in Paris was traditionally a place to see and be seen: Upper-class audiences arrived late, left early, talked through the music, and, "virtuosi of the lorgnettes," watched each other as much as the stage.[57] The Opéra was a site for the exercise of the fierce and humiliating rules of etiquette and status. "Musical experience in the Old Regime was strangely mundane, neither intimate enough to transport the soul, nor majestic enough to excite its fragmented public."[58] It didn't do to pay attention to the opera in mid-eighteenth-century Paris. As one nobleman wrote: "There is nothing more damnable as listening to a work like a street-merchant or some provincial just off the boat."[59] This changed markedly in the 1770s. As one contemporary wrote of Gluck: "One sees for the first time a musical tragedy heard with sustained attention from start to finish."[60] It became possible to observe that "the music absorbs all the attention of the spectators."[61] And, as James Johnson concludes, "there was a more dramatic sign that audiences were paying close attention to the musical drama: they wept, loudly and openly."[62] The new aesthetic of Gluck was part and parcel of a revolutionary shift in the experience of opera: "The revolution of Gluck forged a new way of listening among French audiences and in so doing facilitated aesthetic responses of a depth and intensity inconceivable to earlier generations of listeners."[63] Nor is revolution merely a modern term for what was happening. One pamphlet, from a writer who admits to going to opera before Gluck for "pleasantly flattering the ears and bringing joy and pleasure to the spirit," now finds his "soul was touched," and as he cried and wept and "successively felt the sweetest and most violent emotions," he concludes "It was for me a veritable revolution."[64] For Leclerc, with whom I started, it is precisely this type of psychological upheaval, brought on by music's power, which led to the social and political upheavals of the years to come.

Needless to say, this all also prompted a more leery and satirical glance, in this case from Boyé in 1779:

> Oh, oh here is Madame Gertrude, who is arriving all in tears: what is the matter, Madame, has your dressmaker broken her promise? —Ah! Monsieur, I have just heard the opera . . . I am still overcome by it; feel how my heart beats; I am afraid I will be ill over it; how this Gluck can depict the passions; how he can make himself the master of all the parts of the soul; what truth is in his expressions! Do you still maintain your system? Whence come the tears that I have shed if not from the manner in which the music expresses the words? —What a tender heart you have, Madame; your extreme sensibility makes me fear for your health: there, I shall not even ask you why you go to cry at the opera while you play the Devil at home?[65]

The man with "the system" goes on to explain that her feelings come from the poetry and the actor's skill, but not from the music. This passage mocks the overwrought sensibility of the woman; but the man is not merely a cynical bystander. He offers a loaded and engaged account that refers pointedly to contemporary arguments about the relationship between music and poetry, and, above all, the place of an emotional response to opera. As so often happens, humor reveals to us a serious matter of social concern. The self-conscious intellectualizing of an emotional response to opera is a determinative frame for the recognition of Gluck's classicism.

The emotions of opera have coursed through the polemics on staging and dancing that I have been considering so far. The emphasis on "arousing pity and fear" rather than on the unities in taking Aristotle as a guide; the recognition that "In the passions, there is a degree of expression which words cannot attain. That is where the action-dance triumphs"[66]; both allude to this new emotional release through operatic performance. The image of the composer is itself influenced by this sea change: "He lives and dies with his heroes, rages with Achilles, weeps with Iphigeneia, and in Alcestis's dying aria . . . he sinks right down and becomes almost a corpse."[67] Gluck in the act of composing is described in terms that reflect the emotional empathy now expected of the audience. Here, too, however, we find a direct appeal to classicism. These emotions were seen as the recovery of the powerful feelings described by Horace, Plato, and the classical sources— a rediscovery of the experience of ancient drama. This is the point of a celebrated exchange between Arnaud and the Marquis de Caraccioli (the Ambassador from Naples, who was, predictably, a supporter of Italian opera over and against Gluck). Arnaud declared, "He has discovered the dolor of the ancients." The Ambassador replied, "I should prefer the pleasure of the modern."[68] Or as one disgruntled old-style spectator wrote: "I go to the opera for amusement, not to be constantly saddened."[69]

The supporters of Italian opera found their hero and icon in Piccinni. The quarrels between the Gluckists and the Piccinnists, which were still being recalled forty years later, reverted to bickering over classicism repeatedly. "Was tragedy ever *sung*? —It was by the Greeks. —Bah! The Greeks were the Greeks —Yes, sir, and everyone who isn't them is a barbarian."[70] "My uncle accused me of being Greek. . . . Certainly, that is a major fault."[71] The resistance to the "modish Graecization"[72] could take bizarre forms. Suard, a supporter of Gluck, attacked M. de la Harpe for not understanding what the Greeks meant by *mélopée* (chant or recitative), and sniffily suggested that all he needed to have done was read Aristides Quintilianus (the ancient music theorist, who is never an easy read, and has always been obscure).[73] De la Harpe sniffed back: "You attack me on Greek. You pretend to know what the word means from its Greek etymology. . . ."[74] And with deliberately dismissive insouciance he adds, "I have never read Aristides

Quintilianus which you cite. . . . I have other things to do. But I have, like you, read the article in the *Dictionary of Music* where Aristides Quintilianus is quoted. . . ." The sly accusation of second-hand knowledge clearly struck home. Suard replied, "I cited Aristides Quintilianus which I have read, but which I do not boast of having read, because it is nothing to boast of. . . ."[75] This shared display of pompous politesse and high-brow posturing prompted one woman to write in to poke fun at those who "quote Greek and snub each other with Aristides Quintilianus"[76]—but even this trivial swap of barbs shows to what degree responses to opera, the very perceptions of the music, were being filtered through an intellectualized classicism.

Gluck, Calzabigi, and Noverre paraded their return to classical norms as a revolutionary aesthetic for the opera. But for all the quotations of Lucian, Horace, and Aristides Quintilianus, this search for the ancient world was also always mediated through the previous century of French intellectual and theatrical activity. Gluck was delighted when the elderly Rousseau wrote to him. Rousseau had stated that "The French do not and cannot have their own music and if they ever do it will be all the worse for them."[77] Gluck had proved him wrong, causing Rousseau to now admit, "When one can have so much pleasure during two hours, I recognize life could be good for something."[78] Rousseau wondered whether the austere representation of Helen in *Elene et Paride* was not an anachronistic image based on later views of Sparta; Gluck replied that he took his model from Homer, where she was already a mournful and contrite figure.[79] Voltaire announced that "It seems to me that Louis XVI and M. Gluck are going to create a new epoch."[80] Gluck's works were seen to fulfill Diderot's hope of escaping from "pallid and debased copies of classical tragedy."[81] Diderot indeed had specifically recommended Iphigeneia as a good subject for an opera—Racine's *Iphigénie*. Gluck's operas with their appeal to nature, expressiveness, and sincere emotion, seemed to follow the agenda of the Encyclopedists,[82] and his music comes out of and speaks to a specific intellectual environment. In 1774, two performances of numbers from *Orphée* were given at the house of Abbé Morellet, with Gluck himself on the harpsichord and his niece singing. Those present included D'Alembert, La Harpe, Suard, Philidor, Arnaud. Gluck's operas emerged at the center of the intellectual crisis of France of the Ancien Regime.

But this trendiness also brought Gluck into awkward tension with the masters of French Classical Theatre. Du Roullet, the librettist for the French version of *Alceste*—a very different and more "reformist" piece than the Vienna version—first wrote of the *Iphigénie en Aulide*, "The author seems to me to have followed Racine with the most scrupulous attention: it is his Iphigeneia itself set to opera" and "The author gleaned the idea for this as much from Greek tragedy as from Racine's own preface to his *Iphi-*

*génie.*"[83] Greek tragedy and Racine's drama go hand in hand in the horizon
of expectation of Gluck's readers. But the librettos did not have all the lines
of Racine's wordy play, nor could they be sung with ease. So how could the
lines of the greatest French poetic dramatist be altered—desecrated? Du
Roullet himself later worried that "in adopting one of Racine's immor-
tal masterpieces for our lyric theatre, many of its beauties have not been
retained, and particularly that in preserving several of the great poet's
thoughts and images, these have been expressed in other words than his."[84]
Nor was it only Racine and French classical theatre that mediated between
Gluck and Greek tragedy. Virgil was an integral part of the furniture of the
mind for his audience. Zinzendorf appreciated the sets of *Orfeo* in Vienna
through Virgil's pastoral poetry: He compared the scenery to lines of Latin
pastoral poetry.[85] A typical list of authorities who "followed the example of
the Greeks" in their beautiful representation of grief reads "Virgil, Racine,
Voltaire."[86] The complexities of the relationships between Gluck's operatic
productions, and the enlightenment intellectuals he read and met, and the
dramatic masterpieces of earlier French classical theatre with which both
Diderot and his associates, and Gluck and his associates, were engaging,
are too extensive to be discussed here. But enough has been said already to
demonstrate that Gluck's reception of the Greeks is passed through a series
of mediating prisms. He does not simply "respond to the Greek" or "re-
read Greek tragedy." His neoclassicism is constructed out of a contested
and multiform relationship with an extended classical tradition that in-
cludes Virgilian epic and Racinian theatre.

To a modern classicist, one of the most surprising features of *Orfeo* is the
ending. In classical sources, when Orpheus fatefully turns his gaze back to
Eurydice, she fades away into a second death, and he, inconsolate, wanders
the world mournfully singing his loss, until he is finally pulled to pieces by
Thracian maenads (violence often explained as expressing the anger of
Aphrodite at Orpheus). In *Orfeo*, Amore returns Euridice to her husband
and a happy ending follows. Indeed, *Iphigénie en Aulide*, *Alceste*, and *Iphigé-
nie en Tauride* each in its own way ends happily, with the salvation of the
heroine and the triumph of love. (Iphigénie in *Iphigénie en Tauride* sings so
passionately of her love for her brother Oreste, that it is easy to see how
both Wagner, with his fascination with brother-sister incest, and Strauss,
with Elektra's love song for her dead father, could find an ancestor in
Gluck.) The question of tragedy's ending had already been raised by Ra-
cine (whose discussion, of course, like all such discussions, looks back to
Aristotle's *Poetics*). Racine *opposed* his tragic drama to lyric opera (a conflict
that continued throughout the eighteenth century; La Harpe again:
"Where did you get the idea that opera is or could be tragedy for us?"[87]),
but despite the claims of literature to eschew the corrupting influence of
opera, it is also clear, as we have seen, that opera was approached through

the lens of neoclassical poetics. Racine had declared of his *Iphigénie*, "How would it appear if I concluded my tragedy through the intervention of a goddess and a machine, and through a metamorphosis, which might have found some credibility in the time of Euripides, but which would be too absurd and too unbelievable for us?"[88] It was for him distasteful to kill the young Iphigeneia, and lacking in verisimilitude to revert to Euripides's conceit. Hence, as Racine explains in his preface, he found a new version thanks to Pausanias, to avoid both of these unattractive endings. His Calchas changes his mind (aided by a convenient break in the wind direction). The combination of human opportunism and a change in the weather speaks to Racine's Jansenism, and has often been seen a grimly sour ending to the piece. Gluck's first version in 1774 followed Racine, but this was changed for the Paris production of 1775. Now the goddess Diana appears, resolves the plot and guarantees a happy future for the lovers, Achilles and Iphigeneia.[89] Du Roullet was clear that this was the only satisfactory conclusion to the tragedy. "It is essential in tragic-opera that the *dénouement* is happy," he wrote. Since Diana was the figure who had demanded the sacrifice, she must be the one to release Iphigeneia. Far from lacking in verisimilitude, the divine machinery was integral to the narrative: "This supernatural *dénouement* is part of the subject, and all necessary verisimilitude is maintained." There is also a principle of the emotions involved in this. Since "the soul is affected in the extreme and disturbed" by opera's potent combination of words and music, it is crucial to end with "an agreeable celebration, which distracts and consoles it."[90] The emotions that the operas raised so strikingly needed a catharsis in a return to satisfactory joy. The vocabulary of calm, contemplation, and noble simplicity that Winkelmann made the center of his classicizing aesthetic—emotional values that constantly look toward an ethical as well as a psychological stance—find an important parallel in the turn away from the brutal, cynical, or despairing conclusions of ancient Greek tragedy. Gluck's rediscovery of Greek tragedy produced enough "dolor of the ancients" without having an unhappy ending, too. . . .

Even the physical design of the theatres themselves could be seen to contribute to the sense of Gluck's operas as a classical and revolutionary event. "The neo-classicism of late eighteenth-century architecture . . . announces a desire to refashion social space."[91] This was no longer the theatre of the court—a closely bounded and controlled, private, elite arena. Rather, as Downing Thomas has discussed at length, new theatre designs, coinciding with new ideas and ideals for spectatorship, produced a new construction of the audience within public space. Paris's neo-classical architecture is part and parcel of the "signifying possibilities of theatre as cultural monument rather than private possession"[92]: broad approaches, elegant plazas in front of the theatre, classical columns at the entrance, the classical friezes inside

the theatre (so that the chorus seemed to bring the friezes to life, just as the women in the audience can seem "to replace the bas-reliefs of [the] architecture"[93]), and an audience space that allows both a heightened focus on the stage and an increased awareness of the audience as a collective, all helped to "re-invent the spectator as the figure of a Roman citizen."[94] When Marx wrote that the French Revolution was enacted in Roman dress, he was referring primarily to the Republican spirit and Roman rhetoric of liberty that ran throughout the language of the era—classical texts were a way of understanding and promoting political action.[95] But the public neoclassical architectural space of theatre, also constructed a space for the performance of citizenship. The theatre of the ancient world was held up as an ideal of seriousness in contrast with modern theatre, which Grimm called "a diversion" for an "idle population," whose "most moving tragedies" and "masterpieces" would be judged by the ancient Athenians as no more than the "amusement of children."[96] It was Gluck who brought the modern audience closer to the ideal promoted by this image of the ancient world. The Opéra house itself, rebuilt after fire in 1763, did not have as grand an entrance as the Odéon, say, but Gluck's operas with their rediscovery of classical tragedy and their new emotional seriousness found in the neoclassical architecture of the new theatres a significant frame for the promotion of the classicizing aesthetic ideal of a serious, emotionally and ethically engaged audience.

Opera could become a site for the most direct political activity. The line in *Iphigénie en Aulide* "Chantons, celebrons notre reine" ("let us sing, let us celebrate our queen") was received with an ovation when Marie Antoinette was in the audience[97]; in 1790, the duchesse de Biron provoked an ugly scene when she stood and cheered at the same line: Half the audience whistled and hooted, the other half called for an encore, fruit was thrown, and when the singers repeated the chorus, the duchess threw a laurel wreath onto the stage.[98] (The danger of any form of outspokenness in such interesting times is wonderfully demonstrated by the extraordinary story of the actor Arouch, who was put to death in 1794 for having said in character on stage in Caldéron's *Life is a Dream* the line "Long live our noble king." He went to the scaffold desperately repeating, "But it was in my part."[99]) But despite such anecdotes and despite the noble ethical values that the eighteenth-century critics saw in the libretti, what made Gluck's operas a revolutionary event in 1770s Paris was not such direct political reading. It was rather a far deeper sense of a new classical aesthetic: the focused plot with reduced cast, the integrated chorus, the role of dance and expressive acting, and, above all, the powerful emotions released in the audience by the performance, were all related to classical models by audiences, composer, librettist, dancing master, and commentators alike—and were all developed in a shared search to rediscover the values of ancient tragedy.

What was new in Gluck—from the music to the costumes to the relation between music and text—was understood and debated through a turn to the classical past, as mediated through the intellectual milieu of the Encyclopedists and the tradition of French classical theatre, especially Racine. An ideal image of the past in the ancient world was the route to understanding the present—and to changing it. Thus, Gluck's music could become an icon of a broader revolutionary vector in Paris.

## Disinterring a Classic

Gluck's moment did not last. The theatre of Napoleon's Paris was a very different political and aesthetic regime. A revival of *Iphigénie en Aulide* in 1811 was received with public indifference, which prompted one journalist to comment brutally, "Gluck is dead and his music is sick."[100] In 1809, another spectator had written, "The music of *Alceste* puts the pretty women and the clever men straight to sleep."[101] By 1859, "In the general Parisian consciousness, Gluck no longer meant anything."[102] Indeed, "it would be difficult to argue that [Gluck] was ever canonic during the nineteenth century."[103] As the *Révue et Gazette Musicale* noted in 1859: "How many men are there alive today who have seen an opera of Gluck performed?"[104] But one man in Paris conducted a passionate personal crusade against this tide of indifference: Hector Berlioz.

Berlioz declared he had found some selections of *Orphée* with guitar accompaniment in his father's library as a child and become obsessed by them. At fifteen, he read Michaud's biography of Gluck in the *Biographie Universelle* again and again.[105] When he came to Paris in order to become a composer, he sat in the library and copied out the scores of Gluck and studied them with deep intensity. Attending a rare performance of the *Iphigénie en Tauride* confirmed in him his desire to spend his life in music, he recalled. At one concert, he leapt to his feet in the audience and loudly denounced the performance for introducing a cymbal where there was none in Gluck's score.[106] Le Gouvé was at the concert: "In the midst of the resulting hubbub, I looked round and saw a young man literally shaking with rage, his fists clenched, his eyes blazing, and a head of hair—how can I describe it? An immense canopy, overhanging the beak of a bird of prey!"[107] (Berlioz was always a difficult character. Mendelssohn wrote, "I cannot tell you how the sight of him depresses me," and Wagner was no less dismissive: "The sight of him, pondering the destiny of that nameless absurdity [*The Trojans*], as if the salvation of the world and of his own soul depended on it, was more than I could stomach."[108] Their shared visceral distaste was quite differently motivated, of course, and in Wagner's case was fueled by a complex envy as much as an aesthetic disagreement.) Later,

le Gouvé heard Berlioz talk brilliantly about Gluck often: "When he spoke, the whole of him was in it. The eloquence of his words was enhanced by his expression, his gestures, tone of voice, exclamations of enthusiasm, and those sudden flashes of inspired imagery which are sparked by the stimulus of a listener hanging on every word."[109] (The last clause slyly notes Berlioz's self-dramatizing need for an audience and his audience's slightly uncomfortable consciousness of it.) Berlioz wrote often and passionately about Gluck in newspaper and journal articles[110] and in his letters (Berlioz, unlike Wagner, is a marvelous writer, and his autobiography's sharp wit and staggering self-confidence makes for a great read, but also demonstrates how he could make himself so unpopular). He also used Gluck as his major source for examples in his study of orchestration. His writing often exhibits the fanatical enthusiasm that le Gouvé describes: "As no one could challenge [Gluck] in power, veracity, grandeur, energy, in the development of tragic passion, in the expression of grief or in scenes of terror, he was pronounced lacking in grace, freshness, melody. . . . One wonders where the pallid specimens that were preferred to him are now."[111] Berlioz's love of Gluck is combative, and deeply tied up with his own battles to have his own music recognized. Berlioz is pursuing Gluck's revolutionary success, a success now touched with all the luster that the Romantic movement could give to the revolutionary artist's solitary fight. Berlioz is struggling not just to rehabilitate Gluck, dismissed in the mid-century as dull and old-fashioned, but also to reconstruct a genealogy of modern music, revolutionary hero to revolutionary hero. (It is a familiar narrative strategy in the history of Great Men.) Berlioz's own father, a doctor, was never supportive of his son's choice of career, and Berlioz found in Gluck an aesthetic father. As he wrote in a letter in 1858 after a performance of his own music, with his characteristic mixture of bragadaccio and sudden, winning self-awareness: "I feel that if Gluck returned to earth, he would say of me when he heard it, 'Truly this is my son.' That's not exactly modest of me, is it?"[112] This was how Berlioz was set up to conceive his destiny: as le Sueur wrote to Berlioz's father, justifying the boy's choice of career after Berlioz finally won the Prix de Rome in 1830, "Nothing can prevent his being . . . a musician-philosopher such as Gluck."[113]

Berlioz's love of Gluck was also tied up with his love of the ancient world. He read Virgil with his father at home as a boy and reports how he was so moved by the passages on Dido that his father had to stop the lesson to allow the boy a solitary hour of grief (the making of a Romantic artist is a narrative that structures the autobiography in patent ways). But Virgil also appears in Berlioz's later life in article after article, quoted in Latin as a familiar reference point for aesthetic response. He read his classical texts so repeatedly that they had to be rebound ("My friends are back: Aeschylus, Sophocles, Euripides, Aristophanes, Shakespeare, nicely bound, are here."[114]).

His massive opera, *Les Troyens*, is closely bound up with his reading of Virgil—and his aesthetic response to Gluck's *Orphée* is inevitably mediated through such a classical prism: "There is elegy; there is antique idyll: it is Theocritus—it is Virgil."[115] Virgil emerges as the climax of praise and celebration. As Berlioz struggled with the classical past in his operatic composition, so he turned to Gluck. Gluck, for Berlioz, captured the classical past as no other composer: "we seem to be transported to the ancient gynecium; and to imagine we see the beauties of Ionia, with forms worthy of the chisel of Phidias"—once again, classical sculpture and the visual imagination transport us back to antiquity; "Gluck [in *Alceste*] gives us local color, if anyone ever did, for it is literally ancient Greece that he reveals to us, in all its majestic and beautiful simplicity."[116]

Berlioz masterminded the only fully successful revival of Gluck in nineteenth-century Paris—the celebrated production of *Orphée* in 1859, a production that finally came very close to meeting his own exacting ideals.[117] This production was a fully commercial event, with the familiar power structures of commercial theatre (against which the struggling Berlioz often foundered), and with different structures of patronage, different audience make-up, and different aesthetic preoccupations from Gluck's day. But, like Gluck's productions, this show was also a collaborative process. Delacroix designed Orpheus's costume (which was a classical dress that perfectly suited the *en travesti* role); the set reminded one critic forcibly of Poussin's *Et in Arcadia ego*, an icon of classicizing art;[118] the dances were directed by Lucien Petipa, the celebrated dancer who had danced the first Albrecht in *Giselle* (and whose brother, Marius Petipa, went on to be instrumental in the foundation of the ballet school at St. Petersburg); two leading mimes were hired to dance the leading roles of the chorus; the youthful Massenet played timpani in the orchestra; but it was Berlioz's collaboration with the contralto Viardot that was crucial to the success of the performance, much as Guadagni had been crucial to the first performance in Vienna.

Berlioz rescored the piece for Viardot's voice, working closely with her, and she seems to have played the role of muse and confidante to him throughout the creative process[119] (somewhat to the discomfort of her friend and admirer, Turgenev; Berlioz, as she herself noted with a mixture of prurient surprise and real distress, "after a long and cordial friendship has had the misfortune to fall in love . . . all of a sudden" with her[120]). Berlioz was thrilled with how little "she resemble[d] a woman in male costume": she was rather "a young poet of the ancient world" with "accents, pose, facial expressions, to make the heart turn over."[121] Figure 3.1 and figure 3.2 show a drawing and a photo of Viardot in the part—and the gap between the two marks not just a different genre of reproduction but also the space of the vision of desire, the will to see antiquity on the modern

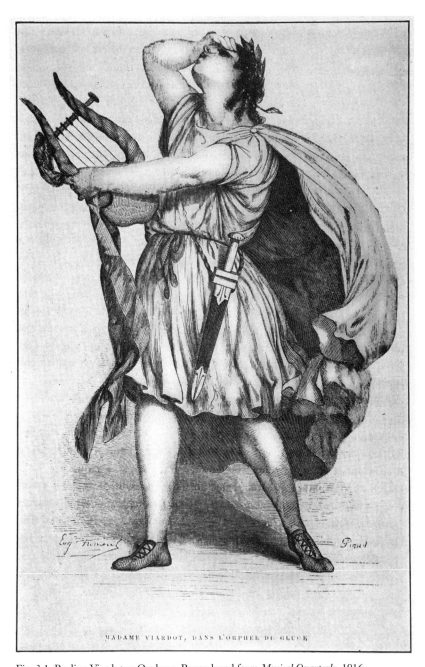

MADAME VIARDOT, DANS L'ORPHÉE DE GLUCK

Fig. 3.1. Pauline Viardot as Orpheus. Reproduced from *Musical Quarterly*, 1916

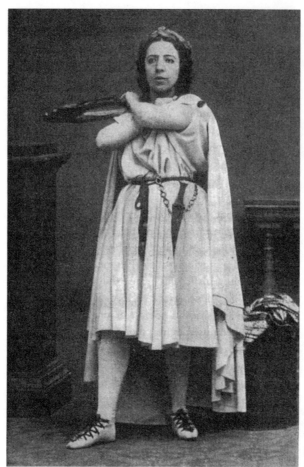

Fig. 3.2. Pauline
Viardot as Orpheus
(Hector Berlioz Photo
Album)

stage. George Sand agreed with Berlioz's enthusiasm in a letter to her
daughter: "This is no doubt the purest and most perfect artistic expression
that we have seen for half a century, this Orpheus of hers—*understood,
clothed, played, mimed, sung, spoken and wept through* in the way that she in-
terprets it."[122] The reviewer in *Ménestrel*, D'Ortigue, was similarly gran-
diloquent in praise: "Melancholic, heroic, elegiac, impassioned, majestic in
love, majestic in grief, she brings to life [*réalise*] the Orpheus of ancient
times."[123] Frederick Leighton, the English artist, was equally impressed: "It
is wonderfully fine and pathetic, the first chorus particularly is quite har-
rowing for the accent of grief about it. Madame Viardot's *acting*, too, is
superb—so perfectly simple and grand; it really is antique"—though this
great painter of the antique did not view Viardot with the rose-tinted spec-
tacles of her lover Berlioz and great friend, George Sand: "And when you

Fig. 3.3. Pauline Viardot, portrait. Reproduced from *Musical Quarterly*, 1916

consider all she has to overcome—a bad, harsh voice, an ugly face, an un-gainly person; and yet she continues to look almost handsome"[124] (figure 3.3). The English critic Chorley also noted her "want of regularity of fea-ture and of prettiness," but was overwhelmed: "the wondrous thrill of ec-stasy which spoke in every fibre of the frame, in the lip quivering with a smile of rapture too great to bear, in the eye humid with delight, as it had been wet with grief, at the moment of recognition and of granted prayer; these things have been dreamed of; but assuredly never expressed be-

fore."[125] Flaubert went to see the opera on several occasions, and Dickens ("a most extraordinary performance—pathetic in the highest degree—full of sublime acting") was led backstage after the show, his face "still disfigured with crying." Viardot herself described the first night with satisfaction: "People embraced each other in the passage-ways during the intermission, they wept, they laughed for delight, they trampled the floor; in a word, turmoil and jubilation such as I have never seen in Paris."[126] It was a huge critical and popular success.[127]

At least in Paris Lord Leighton may have loved the performance (as did Dickens and Chorley), but he also wrote to his sister that "I am afraid there is no chance of her singing it in England this year, if at all. I don't think the Covent Garden audience would sit through it."[128] He was right. Mrs. Russell Barrington, some forty years later, recalled sadly that the show, with Viardot in the lead, came over for two performances, where it was preceded by another short and already popular piece. The house was almost empty by act III of *Orphée*, though, she notes also, Lord Dudley, a "true lover of music" stayed through to the end. Barrington may not have known that when Viardot visited England in 1859 she gave a private performance of *Orphée* with the full cast and a small orchestra at Dudley's house,[129] so he was already a great fan. (Viardot also met Chorley more than once in England, and liked him, though without the depth of his feelings for her, it seems: "Chorley is a fine fellow in the fullest sense of the word . . . he likes me exceedingly, and I return the liking." She also writes, "He is physically unsound, nervous, irritable to a degree. He can make himself most thoroughly disagreeable to persons who do not suit him entirely."[130]) Once again, the continental emotionality of Gluck in performance received a quite different response in England, where, despite a Dudley, a Chorley, or a Dickens, the Victorian audience remained stolidly unmoved by the opera's classicism or by Viardot's emotional heights. In London through the 1850s and 1860s (and beyond), Mendelssohn's *Antigone* was a secure banker. When Spicer put on his *Alcestis* in 1855, it was a play with choruses added from Gluck (and advertised as such).[131] Burlesque versions of Greek tragedy were popular; melodrama was a dominant aesthetic.[132] In this artistic milieu, Gluck's classicism, revived with all of Berlioz's commitment to eighteenth-century musical values, failed to make any significant impact. In contrast to Paris, where Racine had remained central to the repertoire, London found Gluck's version of antiquity something to walk out of.

Berlioz was driven in part by the popularity of Offenbach's *Orpheus in the Underworld*, which had opened in Paris the previous year, 1858. Gluck's *Orphée* had remained in the repertoire mainly through concert performances of the famous scenes of Orpheus in the underworld, and Offenbach's operetta parodied Gluck mercilessly—and, to Berlioz's chagrin, it was an instant hit (as the famous can-can has remained).[133] "A dirty par-

ody," he railed, and suggested that the "Polonius class," as he termed those who failed to appreciate the true aesthetic value of Gluck or Berlioz, "ought to be constrained to hide themselves when they go to their favorite parodies in a theatre which it is forbidden to name."[134] Berlioz was not prepared to see Offenbach's joke, and his stirring revival was a bold restatement of what he saw as the lasting value of Gluck, a rejoinder to the scoffers. He was particularly keen to recover the authentic Gluck from the mess not just of parody but also of pasticcio and new, modernizing orchestrations. He privately claimed to stage "the true movements whose tradition I know" (from what sources it is hard to imagine).[135] The obsessiveness about the original score, which he had shown as a young man in the audience of concert performances of Gluck, now found a more productive outlet.[136] He had the nerve to review the 1859 production himself for the *Journal des Débats*, where despite lavishing praise on Viardot's performance, he took her to task for her adornments, which went beyond Gluck's score.[137] Berlioz (as Wagner and Mendelssohn knew) could never leave be.

This aesthetic combativeness of Berlioz may help us see some of what made Gluck in the Paris of 1859 different from Gluck sixty years earlier. For Offenbach, Orpheus's power to bring the dead to life through music takes the form of revivifying old Gluck through parodic appropriation; for Berlioz, it is recovering Gluck himself from the dismissiveness of an uncomprehending modernity. Gluck's work now has become fully a classic, something to be appreciated through a constant historical self-consciousness, part of an established tradition, a revolution recollected in tranquillity. So in January and February of 1859, P. Hédouin could retell the forgotten story of Gluck and his row with Piccinni in *Ménestrel*—as history, not as polemic.[138] Although Berlioz can write that "it is literally ancient Greece he reveals to us in all its majestic and beautiful simplicity," not only are the terms "majestic and beautiful simplicity" clichés now of a familiar Romantic Hellenism—this is very much a Greece we know rather than the challenge that Gluck's Greece proved to the eighteenth-century audience—but also it is a Greece mediated through an eighteenth-century aesthetic, with music that inevitably sounded like the music of a previous generation, however excitingly revivified in performance. The Russian composer César Cui, who heard Berlioz conduct Gluck on a tour of Russia, captures the double vision well: "Gluck he has made new to us, alive, unrecognisable—outmoded by now, maybe, but undeniably a brilliant innovator, a genius."[139] Cui praises Gluck in exactly the terms Berlioz would want: new, alive, unrecognizable, brilliant innovator, genius. But he cannot help but add "outmoded by now"—and the "maybe" indicates his sense of the tension in what he is expressing, the wistfulness of his recognition of the once revolutionary. Gluck's image of Greece now comes layered with its own performance history. The reception of Gluck from the first performances on

through the nineteenth century plays out changing recognitions, changing manipulations of his image of the classical past.

One writer captured this strange death and reinvention of Gluck in a prescient and uncanny short story. E.T.A. Hoffmann was the source for the libretto of the most famous work of Berlioz's nemesis, Offenbach, in his *Tales of Hoffmann*. Hoffmann published "Ritter Gluck" in 1809 in the *Allgemeine musikalische Zeitung*, a music journal, which may indicate something of the first audience in the musical world, where, as we have noted, Gluck was dying a death. In it, Hoffmann's narrator comes across a strange man, a composer, at various musical occasions, who shares his distaste for the performances they hear, but who behaves so oddly and describes the act of composition in such wonderful mystical terms, that the narrator becomes obsessively interested in his new acquaintance. Eventually, he goes to the man's house, where the composer offers to play him *Armide* on the piano. The narrator, who turns the music for him, is shocked that the pages of the score, taken from an impressive collected works of Gluck, are quite blank. But the familiar music is made even more brilliant and exciting by the pianist's "new and inspired twists." The "melodic *melismas* . . . seemed to be recurring in ever rejuvenated form."[140] After the astonishing performance, the pianist menacingly approaches the narrator, only to "seize him gently by the hand" and "smiling strangely, [say] '*I am Ritter Gluck*.'"[141] The Romantic obsession with the revenant, the inspired sublime, the uncanny, the boundaries of madness, are by now familiar tropes. But Hoffmann's short story is also an essay on music, which offers a remarkably telling image of Gluck, however the levels of sanity and normality are parsed in the narrative. Gluck is back from the dead like Orpheus, rejuvenating his music, rejuvenated in and by his music, a figure of discomforting creativity. Hoffmann's story, written the same year as the sniffy Parisian reviews of Gluck's oh-so-boring operas, depicts Gluck's music mysteriously and wonderfully rising to the heights of sublimity again.

## The German Way

Richard Wagner's Gluck shows this process of the reinvention of Gluck with striking clarity. Wagner was also a great fan of Gluck. But where Berlioz demanded that every note was exactly what Gluck wrote (which, granted the state of Gluck's scores, involves no little interpretative activity in itself), Wagner was more than happy to rewrite Gluck to his own agenda. He produced and conducted *Iphigénie en Aulide* in Dresden in 1847, some twelve years before Berlioz's triumphant *Orphée*. In 1847, Wagner was deeply engaged in the political thinking and activity that would lead to his messy and dangerous involvement with the bloody political European

upheavals of 1848; this was a formative period in his thinking on revolution, Germanness, and musical history. If Gluck was an unwilling or even unconscious political revolutionary, Wagner passionately asserted the connection between politics and music—and his role in the history of opera as a political art form. Not long after his production of Gluck, Wagner found himself in exile, reflecting, in print, on art and revolution. Unlike Berlioz, Wagner's revolutionary aesthetics cannot be separated from his revolutionary politics.

To reproduce Gluck, Wagner set about a whole scale revision of the score (which he wrote about both in an article for the press and in his autobiography). He was horrified (his word) at the translation, and began a revision first of the vocal stresses, but then worked "to eliminate everything redolent of French taste."[142] His sneer at French taste is an early sign of the virulent nationalism of his later years.[143] Not only were many words and phrases changed, but the third act of the opera was wholly rewritten. Wagner particularly disliked that the relationship of Achilles and Iphigenia was turned "into a sentimental love affair," and so he "completely changed the ending, with its inevitable marriage, to make it more consonant with Euripides's play of the same name."[144] As would be the case with *The Ring*, Wagner rejected the superficial satisfaction of a clichéd happy ending.[145] To this purpose, he claims to be the first to have introduced Artemis into the action.[146] Wagner apparently did not appear to know that Gluck had already introduced the goddess into the action for the Paris production, though for Gluck this is precisely to enable the happy marriage to proceed. Artemis in Wagner appears aloft in a blaze of brass, and, contrary to the plot logic of the love story, declares that Iphigenia will be taken away to be a priestess in her cult: "nicht dürste ich nach Iphigenia's Blut," she sings, "es ist ihr hoher Geist, den ich erkor," "I do not thirst for Iphigenia's blood; it is her more elevated spirit I choose." Iphigenia finds transcendence in purity and chastity (somewhat to the disappointment of Achilles): "Achilles! zu seligem Los," "Achilles, [I go] to a blessed fate," she consoles; "Seh' ich sie zu der Göttin hohem Sitz sich erheben," "I see you transcend to the gods' high abode," sings one character. It is not by chance that Wagner was writing *Lohengrin* at the same time as he was systematically redrafting Gluck's *Iphigenie*: The happiness of achieved marriage is given over to a vision of purity and (self-)sacrifice. It might be significant that where in Gluck Achilles tells Iphigenia not to doubt his love (*Liebe*), Wagner's Achilles promises his much less sexy "fidelity" (*Treue*). There is no change in rhythm or phrasing, but the choice of noun is a pointed anticipation of the new libretto's move toward Wagnerian knightly honor.

Tellingly, Wagner also changes the name of the goddess. Now she is called Artemis, her Greek name, rather than Diana, her Roman one. The very first word of the opera, spread over five notes and two bars, is "Diana":

in Wagner's hands it becomes "Artemis." It announces Wagner's agenda. Where most eighteenth-century intellectuals would be happy enough to approach Greek tragedy through Latin, by the middle of the nineteenth century there is a different emphasis on the purity of the Greek tradition, especially in a German context where notions of race and a privileged German genealogy back to Greece are actively being fostered. Wilhelm Riehl, who contributed to Germanic self-awareness through his folklore, and sociological and musical studies, captures in a nutshell the German passion for Greece, when he describes his schooldays in Gymnasium in the 1850s, looking back with a golden glow toward the end of his life in the 1890s:

> We even thought ancient Greece belonged to Germany, because, of all peoples, the Germans had developed the deepest understanding of the Hellenic spirit, of Hellenic art, and of the harmonious Hellenic way of life. We thought this in the exuberance of national pride, in virtue of which we proclaimed the German people the leading culture of the modern world and the Germans the modern Hellenes. We announced that Hellenic art and nature had been reborn more completely in German poetry and music than in the poetry and music of any other people. . . .[147]

In such a context, the name "Diana" jars in a nineteenth-century Hellenizing text in a way it would not in an earlier classical tradition. Jupiter and the other named gods are also given in Greek forms. This renaming is one sign of the impact of the new politicized German Hellenism, with its deep investment in the construction and promotion of a national identity (in a way Gluck would have found alien and alienating). It is also worth noting that the plot is changed with reference to Euripides: a return to the authentic Greek (in contrast with Racine's recognition, followed by Du Roullet, that what was acceptable to Euripides was no longer suitable to modern manners). Greece is a privileged country of the imagination for mid-nineteenth-century Germans. And Gluck's Greece is no longer Greek enough.

Greece was indeed already Wagner's obsession. After describing the success of his Gluck in his autobiography, the next paragraph continues:

> People were amazed at that time to hear me talk with particular vivacity about Greek literature and history, but never about music. In the course of my reading, which I zealously pursued and which drew me from my professional activities into increasing solitude, I was soon impelled to turn my attention to a new and systematic study of this all-important source of culture, in the hope of filling the perceptible gap between my boyhood knowledge of these eternal elements of humanist education and my current desolation on the terrain . . . I was soon filled with such overwhelming enthusiasm for [Greek antiquity] that whenever I could be brought to talk, I would only show signs of animation if I could force the conversation around to that sphere.[148]

This is all too typical of Wagner's bombastic self-dramatization, especially where his classical education is concerned, but the recognition that his treatment of Gluck is deeply interwoven with his passion for ancient Greece is telling—and looks forward to *The Ring* in ways that have perhaps not been adequately appreciated. In his musical changes to *Iphigénie*, Wagner composed "transitions, postludes and preludes"[149] in order to link the arias and choruses more integrally; he added newly composed arioso recitatives for Iphigeneia and Artemis; he also systematically changed the instrumentation to match his own sound world, with particularly noticeable added brass; the ballets are cut (and with them, Noverre's legacy). In his discussion of the overture, Wagner pointed out how Gluck introduced musical ideas for particular emotive states that ran through the piece—like leit motifs.[150] By this rewriting and commentary, Gluck is appropriated musically to Wagnerian modernism—and Wagner's rewriting is usually called a grotesque travesty these days by modern critics, especially from within the authenticity debate—but it remains significant that it is through an operatic version of an ancient Greek tragedy that this experiment is conducted. As I (and many others) have written about elsewhere, *The Ring* itself is Wagner's most systematic attempt to re-create the power and effect of ancient tragedy in modern art.[151] Wagner's rewriting of Gluck is aimed at forcing Gluck's revolutionary Hellenism into Wagner's own very different agenda for renewing ancient theatrical forms. Gluck is molded by Wagner into the ancestor he wishes for his own project.

Wagner was surprisingly successful at promoting this new genealogy. When Gluck had become the unwilling shuttlecock in the battle between French and Italian music styles in the eighteenth century, the idea of German music barely entered the debate, and the argument certainly had no sense of the German *Sonderweg*, in Wagnerian terms. As the idea of a musical canon began to develop, and nationalism became a force in musical history, the placement of Gluck also changed. A paradigm of this shift is Emil Naumann, a student of Mendelssohn, who taught at Dresden, and who published one of the most influential histories of music from the last decades of the century (translated into English in the 1880s, and going through at least three editions in the next decade). He also published on Wagner's *Zukunftsmusik*. Naumann celebrated Gluck's classicism in what are now familiar terms: "The master sought the historic land of the Hellenes with his whole heart and found it."[152] But he also saw Gluck in the new, nationalist terms as one of the "heroes of the genius-epoch of German music."[153] Music itself can, for Naumann, only be understood and appreciated as a nationalist German narrative: "the era of musical renaissance in its true and highest significance begins only with the genius epoch of German music," which is itself an expression of German culture. He cites Klopstock, Wieland, Lessing, Winckelmann, Luther, Herder, and honorary German Rousseau as the framework of his discussion.[154] And,

"after Gluck, the only other instance" of such an avatar of Germanness is (inevitably) "Richard Wagner."[155] Naumann's genealogy of geniuses starts with Bach and ends with Wagner, but a true German hero is needed for the generation before Mozart and Beethoven. Gluck takes up that role. The Bohemian writing in French in Paris needs to be carefully redescribed to play this part: "It is to the German public . . . that the honour is due of first having supported the new style. . . . The assertion that these immortal works were written for a French audience and not for his compatriots, unequal to their appreciation, is either a wilful misstatement or ignorance."[156] It would be hard to imagine a clearer example of the ideological retro-construction of Gluck—as an icon of German music in the battles over art as an expression of a national culture. As the nineteenth century goes on, and Gluck's Hellenism needs to become "more Greek," so the composer himself has to become more purely and more exclusively "German."

Berlioz, with a neat reappropriation of Wagner's much-heralded *Zukunfts-musik* (Music of the Future), praises Gluck's forward-looking novelty: "Gluck himself belonged to the 'school of the future'; for he says in his famous preface to *Alceste*, that there is no rule that he has not felt justified in sacrificing readily in favour of effect."[157] Wagner's idea of *Zukunftsmusik* was always part of a social and political project as much as a teleological history of opera. But for Berlioz, a return to Gluck's neoclassical Hellenism is firmly part of an *aesthetic* agenda. On the one hand, it is Berlioz searching to ground and inspire his modern music in a classical idealism, both of the ancient world and of Gluck's version of the ancient world. On the other hand, in attempting to produce an authentic Gluck free of the accretions of later rewriting, Berlioz's production of *Orphée* allowed the revolutionary Gluck to emerge *as* a classic, with all the historicizing filters the category of "the classic" demands: Gluck's classicism embalmed as a (rediscovered) classic. Wagner, in attempting to bring out Gluck's revolutionary novelty in the name of a return to Euripides and a real Greekness, redrafts Gluck in his own (revolutionary) image. For Wagner, Gluck's Hellenism is fully part of Wagner's pursuit of a political as well as an aesthetic Germanness through an ancestry in ancient Greece. Now between France and Germany, Gluck's Hellenism is pulled this way and that in the currents of the mid-nineteenth-century's struggle over what ancient Greece means for modern art and modern self-consciousness.

## London Fashion

In 1890, Sir Charles Villiers Stanford, Professor of Music at the University of Cambridge, conducted an amateur performance of *Orphée* at Cambridge, with one Mrs. Bovill in the lead role (figure 3.4), and sung in En-

glish translation. This was the first fully staged production of *Orphée* in England since 1830, as several national newspapers noted with surprise. The national newspapers covered the amateur performance in part because of the novelty of hearing Gluck, and in part because the opera had been organized by a committee of national distinction. Stanford was already a well-respected composer and conductor; Sir Richard Jebb, professor of Greek and a member of parliament chaired the committee; A. W. Verrall, a leading literary critic, expert in Greek tragedy and destined to become the first Professor of English was on it, too; and there was a Ladies' Committee, including Mrs. Jebb and Mrs. Verrall, who sang in the chorus. The same team had been instrumental in inaugurating the Cambridge Greek Play, an amateur performance of a Greek tragedy in ancient Greek, which also attracted extensive national coverage. For both the first Greek play and for *Orphée*, special trains were put on from London for the large fashionable audiences which made the productions a success. There were some robust criticisms of Mrs. Bovill's singing (though not her beautiful stage-presence and attitudes), which prompted in reply some defensive remarks in the press. Only the *Scots Observer* saw fit to compare Gluck favorably to Wagner's modernism, with the proud if misplaced certainty that there was "nothing old-fashioned" about what Cambridge had staged.

*The Daily News* indicates something of what attracted the audiences: "That the dresses were as far as possible archaeologically correct may be judged from the fact that they were passed by a committee at the head of which was Professor Jebb."[158] *The Guardian* commented that "the frequent performances of Greek plays which have taken place in Cambridge of late years have familiarised the Cambridge public with classical drama, and on this occasion great care was taken to ensure accuracy in the matter of dress and movement."[159] At one level, this represents a continuity of response to Gluck: so Ernest Newman in the first significant English book about Gluck in 1895 can quote Grimm from a century earlier with approval and agreement: "When I hear *Iphigénie*, I forget I am at the opera; I seem to be listening to Greek tragedy."[160] But now the criteria for the vision of Greece have shifted: Where the eighteenth century focused most intently on the emotional intensity of the Greek experience and the power of ancient music to move the soul (for which the integrated and active chorus was an instrument), now in late nineteenth-century classicism, it is the appeal to the scientific and the scholarly, the accuracy of the recovery of the past that fascinates. The authority of Professor Jebb allows the audience to be certain that what they are seeing is a real replica of ancient Greece, and it is this, the frieze come to life, which stimulates wonder. There are no reports of tears at Stanford's performance. Indeed, a slip had to be placed in the program for the later performances asking patrons to refrain from conversation during the overture and the ballets: The eighteenth-century

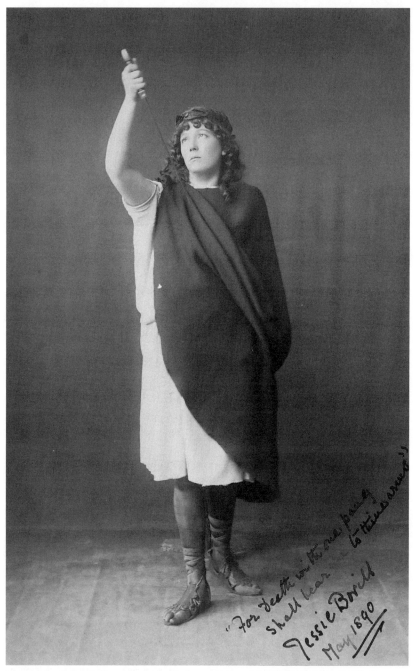

Fig. 3.4. Jessie Bovill. Reproduced by kind permission of the Syndics of Cambridge University Library

silent and weepy awe at Gluck seems to have passed back into a fashionable night out.

Stanford went on to conduct a production of *Iphigénie en Tauride*, which opened on February 18, 1910 in His Majesty's theatre, London. It starred Viola Tree, daughter of Sir Herbert Beerbohm Tree, the larger-than-life Victorian actor and grandee. The performance was a great success, and the run was extended by popular demand. But its success was not just because of the virtues of the music or the careful publicity for its publicity-hungry young star. Strauss's *Elektra* opened in London the night after, February 19. This was the event of the year in London artistic life: It had been much heralded, caused a storm of controversy, and was fiercely debated by the leading intellectual figures of the era.[161] Stanford, Tree, and Gluck became caught up in *Elektra*'s shocking new music and violent, bloody, tortured image of Greek tragedy. Gluck became the icon of the solidly respectable against which Strauss was set. The reviewer of *The Times*, who already knew he was going to hate *Elektra* the next night (and duly did), wrote "It is good to consider how perfect is the adaptation of the simple means available to the composer's purposes and how he attains a truly Greek horror while hardly ever transgressing the operatic conventions of his day."[162] For this critic, Gluck must appear as the superior opposite of Strauss. So where Strauss had a famously large orchestra with novel sounds and instruments, Gluck seems perfect in his "simple means" (the challenge for his contemporaries of Gluck's new music is quite forgotten here, of course). Where Strauss was violent and emotional, with a psychologically and physically horrific ending, where Elektra dances herself to death in ecstasy as her brother murders their mother, Gluck's avoidance of violence and chaste if powerful brother–sister emotions, represents "truly Greek horror": as with Berlioz and Wagner, what is at stake here is the *real*, the *truly* Greek experience. Where Strauss shattered orchestral and operatic conventions with a vivid wilfulness, Gluck now must seem hardly ever to go beyond the conventions of his day. One can't help feeling that it must be harder to combine "true horror" and "conventionality" than *The Times* suggests—and that this difficulty indicates something of the stress in the critic's position. There is no sense here of the revolutionary transgressiveness that Gluck's contemporaries felt. For *The Times*, Gluck has become the face of conventional, and therefore proper, classicism.

This contrast was played out in the press at various levels. Here, for example, (figure 3.5) is the notice of *Iphigénie* from *The Illustrated London News*. Viola Tree, elegantly draped in white classical robes, takes up a carefully chaste, poised pose. Her statuesque image is framed not just by the review, but by columns of portraits of the great and good of the British artistic world—like a classical gallery of busts. Here, however, (figure 3.6) is Strauss's *Elektra* in the same journal: black rather than white; rags rather

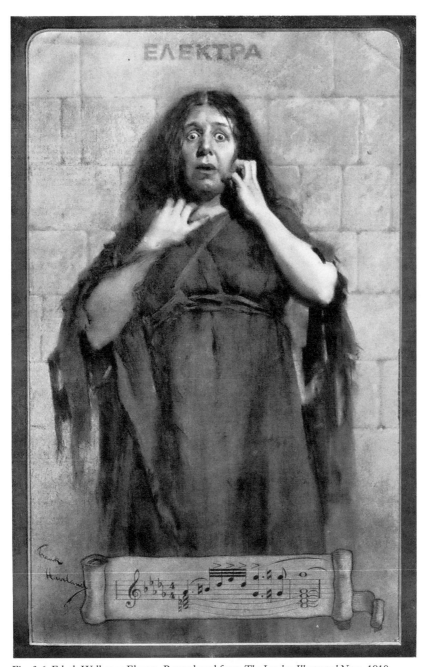

Fig. 3.6. Edyth Walker as Electra. Reproduced from *The London Illustrated News*, 1910

than robes; mad staring eyes, rather than the head turned down and away from our gaze; hands scratching at face rather than delicately lifting a veil; a block wall behind her, rather than misty depths; no worthies to support her, but her name (misspelled) in Greek letters above, and a snatch of the famous "Agamemnon" theme below. Edyth Walker is represented by a drawing, Viola Tree by a photograph—the contest over the real enacted in the very form of the reproduction. The contrast could scarcely be more emphatic.

The productions of the Strauss/Hofmannsthal, the cultural history of which I have analyzed at length in my book, *Who Needs Greek?*, produced a deeply threatening and exhilarating challenge to Victorian classicism, and also to the Wagnerian reformulation of the classical.[163] In England, its first performance also got caught up in a debate about national identity and revolutionary politics.[164] Gluck—the former revolutionary—by virtue of Stanford's production opening the night before *Elektra*, became taken up as the icon of the most traditional view of Hellenism, the repository of the purity, chastity, and the safety of the white, Hellenic ideal. What had been disturbing, weeping, wrenching emotions for the eighteenth-century audience, now could be lauded as restraint, propriety, and dignity to be set against the wildness, extremism, and sheer explosiveness of Strauss's hysterical heroine. Gluck was for Berlioz and Wagner both a classic and a means of reaching toward a new sense of the classical to invigorate their own operatic compositions. Now in London in 1910, Gluck was a bastion set up to defend a (doomed) classical idealism against the modernist image of the past.

So one answer to my opening question might be that modernism in the form of Strauss's *Elektra* killed Gluck. It turned Gluck into an image of traditional, conservative classicism—the anathema of contemporary thinking on art, which privileges the revolutionary, the transgressive, the provocative; it is a slur from which Gluck has struggled to emerge.[165] It was fascinating, to take but one example, to read the reviews of the 2007 production of *Iphigénie en Tauride* at Covent Garden. Several newspapers—and many audience members—complained that the production was so overtly modernist: The characters were all dressed in black, emerged out of deep shadows, wrote in chalk on the walls and wiped the writing off in water, and the chorus danced in a thoroughly modern style. Gluck, for these critics, should have offered a more traditional form of classicism, as the Edwardian critical tradition had constructed him. Yet it was a production precisely set in the tradition of modernist treatment of Greek tragedy—back to Reinhardt's *Oedipus* and Strauss's *Elektra*, with lessons learned from the post–Second World War French tradition of adaptations of Greek tragedy in Sartre and others. As such, it paid due attention both to the long contemporary tradition of resisting the idealism of Hellenic purity and ra-

tionality, and to Gluck's own credentials within operatic tradition as a trendy, challenging, innovator.

But to say that Strauss killed Gluck would be far too glib, even as short-hand for the complex clash of images of antiquity that was being played out between the performances of Gluck and Strauss in 1910. For what we have seen is a series of appropriations of Gluck's music to a set of different agendas. Each revival of Gluck recognizes his death, and brings him back to life, in a chain of Orphic moments. As d'Ortigue wrote tellingly in 1859, "*Orphée*, I have said the word, is a *resurrection*."[166] Where Beethoven, say, has never left the canon or the repertoire, Gluck has gone through long periods when it has been very hard to hear his operas, and where he has had almost no public face. This radically discontinuous tradition provides a fascinating model for thinking about reception. His vision of antiquity was central to the intellectual, social, political, and musical upheavals of Paris in the late eighteenth century, and, as the extensive contemporary literature reveals, became a focus for a range of anxieties in this era of significant and violent change. Gluck lets us see what is at stake in the neoclassical, and helps us understand why Marx, for example, saw the classical as such an important element in the revolutionary. But for Berlioz and Wagner in the mid-nineteenth century, rediscovering Gluck as a classic was for them a way of exploring the place of antiquity for their own modernist aesthetics, creating and promoting a new genealogy and a new image of the past. Gluck's Greeks needed to be made authentic again (on the road to *Les Troyens* and *The Ring*) by rewriting, by reformulating Gluck's image of antiquity according to the model of Wagner's or Berlioz's image of antiquity. Stanford's productions at the end of the nineteenth century are received first as an archaeological gaze at the Greek past, with barely a reference to eighteenth-century France, and second as a bastion of a traditional idealistic view of Greece to set against the threat of contemporary art uncovering the dark secrets beneath the white robes of idealism. One could say that Gluck's Greeks are appropriated to shifting models of Hellenism. Or one could say that Gluck is killed and revived at different significant junctures of opera's love affair with the ancient world. As Gluck's *Orphée* is a self-reflexive artistic expression for the revival of the classical past, so reviving Gluck is a repeated, self-conscious, discrete gesture in opera's rediscovery of antiquity. Where Gluck changed the view of antiquity for eighteenth-century France, resurrecting Gluck has since become a different and key way of rewriting opera's engagement with the past—both the past of antiquity and the past of the operatic tradition.

Gluck, then, provides a wonderful example of how the experience of the artwork becomes layered with its own performance history, as it is reproduced for—reexperienced by—different audiences over time. The "true," the "real," the "authentic" Greece is the stake—not just the true,

real, authentic representation of antiquity, but also the true, real, authentic experience of the classical. From the crying audience in pre-revolutionary Paris, conscious of the novelty of their reaction and their understanding of it through Greek models; to the tearful rediscovery of the classical in Paris again with Berlioz—the new, real again Gluck; to the construction of a new but truly Greek genealogy for Germany with Wagner's rewritten Gluck; through to the "truly Greek horror" of Edwardian London's conventional Gluck; each (re-)performance contests anew what Greece is to be, and re-determines the ideal of Hellenism in and through Gluck's operas. As César Cui underlined, hearing Gluck was to recognize how the old, and possibly outmoded, becomes "new for us"—a rediscovery for *us*, a modern community, of a new and telling version of antiquity, which, in the search for its own authenticity, cannot ever fully repress the memory of less authentic, earlier images of Greece and of Gluck.

We have moved in this chapter from the art gallery to the opera house, from single artists to more collaborative projects, from physical objects to which viewers respond in multiform ways over time and space, to artworks that are rewritten and reconceptualized in different performances, where the notes, the instruments, the words themselves can change significantly from production to production. For all that both painting and opera visual-ize, embody, and enact antiquity for the nineteenth-century cultural imag-ination, there is inevitably a considerable shift in emphasis with this move between genres and institutions. Yet both painting and opera enter the public domain not only through their institutions of display or perfor-mance, but also through extensive contemporary discussion, in published and private forms. It is hard to overestimate how the new technical poten-tial of cheap printing, the circulation of the popular press, and the gossip of the mail as much as the salon, made the paintings in the gallery and the operas on the stage such hot topics. The audience for both genres in this sense is huge: Wagner entered the imagination of many who never heard *The Ring* in the concert hall.

The strange performance history of Gluck, then, with its particular pat-tern of dramatic reinvention, lets us see not just how Gluck's Greece is a shifting terrain, but also how hard it is to delimit the scene of reception as an event within cultural history. It is this broad sense of reception that we will continue to explore in *Victorian Culture and Classical Antiquity*.

## Chapter 4

❀ ❀ ❀ ❀ ❀ ❀ ❀ ❀ ❀ ❀ ❀ ❀ ❀ ❀ ❀ ❀ ❀ ❀

# WAGNER'S GREEKS:
# THE POLITICS OF HELLENISM

AFTER THE TEARFUL PLEASURES of Gluck, this chapter will enter some painful territory: painful for classicists, painful for me as a Jew, and painful for anyone who cares about the development of the twentieth century and the place of Hellenism in it. There is no comfortable place from which to look at how Wagner's engagement with classical antiquity relates to his politics and to the performances of his operas. In the previous chapter, we looked calmly at how Wagner's rewriting of Gluck was part of his revolutionary pursuit of Germanness. Taking on Wagner's Greeks more fully will require us to broach some of the nastiest aspects of modern politics—the violence of racism, the aggression of nationalism, the bleakest sides of German history in the twentieth century. But such a project also has to face up to the complicity of a love of ancient Greece with this story—a complicity about which no classicist, with philhellenism in their blood, should feel wholly sanguine.

This study of Wagner's Hellenism is, first of all, an exercise in performance history. It is a more limited exercise than the previous chapter's discussion of Gluck: I will be essaying a brief analysis of two contrasting Bayreuth productions of *The Ring*, two self-consciously epoch-making performances in the same theatre, the first directed by Richard Wagner in 1876, the second by his grandson, Wieland Wagner in 1951. (My title perhaps should have been "The Wagners' Greeks.") There have been a huge number of performances of Wagner's operas, of course, in Bayreuth and elsewhere.[1] My choice of these two productions is partly because the second was put together explicitly and pointedly in contrast to the first and the tradition it had founded, and partly because the rhetoric of the juxtaposition will

A version of this chapter appeared as chapter 20, "Wagner's Greeks: The Politics of Hellenism," in Martin Revermann and Peter Wilson eds., *Performance, Iconography, Reception: Studies in Honour of Oliver Taplin* (2008), Oxford University Press. I have taken out the references to Oliver in this new version of the chapter, but the dedication and thanks remain.

be so starkly telling about a particular type of cultural forgetting, that is central, I will argue, to the idea of Hellenism. "Performance" has in recent years come to be a buzz word in contemporary classical studies, linking the orator's strutting, the emperor's dining, the philosopher's posing, to the language and institutions of theatre;[2] and "performance studies" has a long history (which would inevitably involve J. L. Austin's theories of performative language, Irving Goffman's sociology of behavior as scripts and performances, Turner's analysis of ritual, as well as Schechner's use of such theorizing in the theatre).[3] This chapter aims to offer a performance analysis, which puts a performance into a developed historical and cultural context in order to ask the question: What makes a performance significant as a cultural event?

Second, however, this essay is a reflection on how Hellenism—a passionate love of the Greek past—has become part of the politics, as well as the aesthetics, not just of opera but also of twentieth-century culture. This chapter deals with the power of Hellenism in the transition between German idealism and the Third Reich (and beyond): the lastingness of ideologically laden images of the past from the Victorian period. But again there is a general point which I am hoping to underline. I have emphasized with quite enough force that I am somewhat leery of the seductive concept, from which Reception Studies takes its start, of focusing tightly on a single author's response to the ancient world: Wagner's reading of the Greeks as it were (a topic that has certainly been approached in exactly this manner by several writers).[4] In this chapter, however, I want to add a new note. As with my discussion of Gluck, my analysis will proceed first by developing the multiple frames of response to these performances—the audience as well as the artist, the audience's expectation of the artist and the artist's of the audience, the critic as guide to the audience, and the critic as enemy of the audience, and, of course, the multiform nature of an audience in all such engagements, especially in the case of Wagner who was supported and loathed with equal intensity by the audiences of Victorian Europe, and recognized as "a unique figure distorted out of all recognition by the factions of hatred and partiality"[5] during his own lifetime and beyond. But my point is not just that reception—as a cultural moment—becomes thus a more diffuse and contestatory space than many literary critics have allowed (as we discussed in the previous chapter), but also—and this is my new note—that, with the case of Wagner, we can see how the critical strategy of focusing primarily on the artist's reading of classical texts turns out to be part of the politics of reception itself. How we conceptualize Wagner's engagement with antiquity is—for him and for us—always going to be a political gesture. And here is where the forgetting bites.

## "To be half a day a Greek!"

Now there can be no doubt that Wagner was deeply engaged to the point of obsession with Hellenism, as we have already begun to observe in the previous chapter. The first sentence of his first theoretical work is a direct statement of a Hellenizing ideal: "In any serious investigation of the essence of our art today we cannot take a step forward without being brought face to face with its intimate connection with the art of ancient Greece."[6] From that opening credo, Wagner constantly explored this intimate connection both in his continual commentary on his own music and in his relentless self-promoting mythologizing of his own life. Wagner's passionate and public engagement with an ideal of Greece makes him an extreme example of Greece's tyranny over the German soul—and the German culture hero's formation through Greekness.

Wagner's life is the most written of all composers, and it all started with his own self-portrayal as revolutionary hero and artist of the German Geist.[7] "No boy could have had a greater enthusiasm for classical culture than myself,"[8] he declares, although he actually never got to read Greek tragedy in Greek comfortably, despite trying several times to learn the language. Nonetheless, through translations he idealized at full throttle: "the only way I seemed able to gain a breath of freedom was to plunge into this ancient world."[9] In one famous passage, he describes the power of Aeschylus on his artistic inner life. It is worth quoting in full as it sums up so vividly Wagner's self-dramatizing love of Greek:

> For the first time I now mastered Aeschylus with real feeling and understanding. Droysen's eloquent commentary in particular helped to bring before my imagination the intoxicating effect of the production of an Athenian tragedy, so that I could see the *Oresteia* with my mind's eye, as though it were already being performed, and its effect on me was indescribable. Nothing, however, could equal the sublime emotion with which the *Agamemnon* trilogy inspired me, and to the last word of the *Eumenides* I lived in an atmosphere so far removed from the present day that I have never since been really able to reconcile myself with modern literature. My ideas about the whole significance of the drama and the theatre were, without a doubt, marked by these impressions.[10]

It is through a German translation, Droysen, that Wagner has these overwhelming feelings.[11] It is not the power of the Greek language itself, which so moved Hölderlin, Goethe, and other great German Romantics. His Greeks are already German, or rather the link between the German language and Greek, which many asserted in the pursuit of a genealogical link between antiquity and contemporary society, here enables Wagner to avoid

any worries about authenticity in his response.[12] It is a response full of archetypal Romantic expression. He reaches for the sublime, that peak of Romantic aesthetic experience. It is his imagination that is overwhelmed with "real feeling" and "intoxicating effect," emotions that are, however, so deep as to be "indescribable" (of course). The sublime takes him to his true home: He is removed from the sordid and mundane world of the present day. As he writes elsewhere, "I felt myself more truly at home in ancient Athens than in any condition which the modern world has to offer."[13] This desire to be "at home," "truly at home," in antiquity is another commonplace of German philhellenic longing, full of the German ideology of *Heim* and *Heimat* (not to mention *Heimweh*). So Hegel, one of Wagner's philosophical Urtexts, and Nietzsche, one of Wagner's erstwhile friends, and many others, all proclaimed Greece to be what Riehl called "a second Homeland"—or as Nietzsche put it, "*man ist nirgends mehr heimisch . . .*" (one is no longer at home anywhere . . .); all the broken roads of modernity "*führen überall hin, in alle Heimaten und Vaterländer die es für Griechen-Seelen gegben hat!*" (lead everywhere into all the homes and fatherlands that existed for Greek souls).[14] It is typical of the Romantic artist to express his alienation from contemporary society in a longing for the ancient past conjoined with a fervor for a revolutionary future—a *Weltanschauung* epitomized by his friend and admirer, Nietzsche.[15] For Wagner, looking back to Greece and forward to a future in art, it is this revelatory encounter with Aeschylus that determines his sense of the significance of theatre.

It was a revelation Wagner liked to share, too. In her diary, his wife Cosima Wagner describes how in 1880 in the Villa Angri near Naples, Wagner read aloud to the assembled guests the whole of the *Oresteia* on three successive evenings—playing all the parts himself. Cosima recorded "I have never before seen him like this, transfigured, inspired, completely at one with what he is reading."[16] Paul Joukovsky, a Russian poet and artist in the admiring audience, wrote some 50 years later, that the cry "Apollo, Apollo" still echoed in his ears from those magical nights. (Joukovsky designed the first production of *Parsifal* in 1882, although he had no previous experience of set design.)[17] Wagner's flair for self-dramatization is taken up and spun into the myth of the Master by those around him.

Aeschylus does indeed have a profound influence on *The Ring*, as has been noted by scholars since the turn of the nineteenth century.[18] *The Ring* is, like the *Oresteia* and like the *Prometheia* (as Wagner knew it from contemporary reconstructions), built out of three serious works, and a lighter shorter piece, *The Rheingold*, which comes before rather than after the trilogy as the ancient satyr play would have.[19] There is no other opera in the repertoire with such a trilogic structure. The *Oresteia* is concerned with a vast intergenerational narrative where conflict between the genders and between the generations is central to its narrative, as is *The Ring*. The *Pro-*

*metheia*, even more than the *Oresteia*, is a *divina comedia*, a drama where divine forces on the largest possible scale are struggling over the structure of the universe. Here, too, Wagner's work goes well beyond the norms of the operatic genre in the nineteenth century (and it was recognized as such from the first performance). In these grandest lines of mythological narrative, the parallels between the Aeschylean trilogy that Wagner advertises, are evidently integral to the structuring of *The Ring*.

Scholars have gone further in drawing out more detailed parallels between Aeschylus's writing and Wagner's libretto (though it is sometimes hard to know how far to press apparent similarities, such as the superficial similarity of the chorus of *Prometheus Bound* and the Rhinemaidens, watery nymphs, both).[20] The "wide spread cult of Prometheus in Romantic literature"[21] as a figure of artistic creativity and a struggle for freedom against tyranny is certainly important to Wagner's revolutionary aspirations, but the intertextuality between the *Oresteia* and *The Ring* seems more directly insistent. Take, for example, the end of *Götterdämmerung*, where Brünhilde processes to her death and to the destruction of Valhalla accompanied by a torch. Although the destructive final image may recall the earthquake at the end of *Prometheus Bound*, the torchlit procession most strikingly recalls the end of the *Oresteia*, though there it is a procession of women to the center of the city, the Acropolis, Athene's house, celebrating the potential of the city as a source of order and control, whereas Brünhilde is a lone figure, marching into a self-immolation and the destruction of the house of the gods. Wagner draws out the meaning of this ending in telling terms when he describes it as "the surrender of the gods' direct influence, faced with the freedom of human consciousness."[22] At one level, this may look toward the discourse of power and control in Aeschylus's *Prometheus*—and certainly the triumphant freedom of human consciousness is a typical Romantic understanding of the importance of Prometheus. But more importantly, in stagecraft as in concept, it destroys the sense of hierarchical order that the end of the *Oresteia* proclaims. This theodicy is profoundly in opposition to any Greek sense of divine system, and reveals how much Wagner was committed to his modernism, even and especially in moments that seem to draw on the theatre of the Greeks.

There can be little doubt, then, that Wagner's self-dramatization as an artist is deeply involved with a German idealization of the Hellenic past; nor can there be any doubt that Wagner's masterpiece, *The Ring*, owes much in its structuring and in its more detailed focus to an engagement not just with the *Oresteia*, but also with what he thought he knew of the *Prometheia*. I have traveled very quickly though this material, which is one base of what follows, partly because it is has been extensively discussed in the scholarly literature, and partly because I have already offered a brief treatment in my book *Who Needs Greek?*[23] But with this base, I wish here to take

the argument in a different direction, and for this we will need to enter into the depressing world of Wagner's prose writing rather than his operas. There is a vast number of his prose works to wade through, on everything from revolution to the climate, and each treatise presents its case at numbing length and in a numbingly turgid style (I take the word "numbing" from John Deathridge, a scholar who has spent more time with them than most).[24]

I will start with three early works, *Art and Revolution* (1849), *The Art Work of the Future* (1849), and *Opera and Drama* (1850), a period when Wagner was committed to a quasi-Hegelian spirit of revolution. Greek drama is the foundation of Western art as an ideal. The ideal is of a society where art is fully integrated into a fully political sense of citizenship, where art and life are not disassociated. He goes so far as to suggest that the Spartan state was "a purely human communal artwork" (an expression that weirdly anticipates some of Baudrillard's wilder claims).[25] Tragedy holds a special place: "This flower was the highest work of Art, its scent the spirit of Greece; and still it intoxicates our senses and forces from us the avowal that it were better to be half a day a Greek in the presence of this tragic Art-work, than to all eternity an—unGreek *God!*"[26] As Achilles in the Homeric underworld would rather be the humblest workman and alive than king over all the dead, Wagner (in his typically overheated expressiveness) would rather be a Greek at a tragedy for half a day than an unGreek god for eternity. But—and this is where the Hegelian side comes to the fore— while Greek is an ideal and its spirit must be preserved, at the same time it must be annulled in order for progress to happen. There is a dialectical process of *Aufhebung*, whereby Greek will be absorbed, transcended, and finally reappear as the *Zukunftskunstwerk*, the Artwork of the Future. "We do not try to revert to Greekness," he writes in *Art and Revolution*, "only *revolution* not slavish restoration can give us back the highest art work."[27] And in *Opera and Drama*, which gives the full teleological history of the development of opera toward Richard Wagner, he takes Antigone as his model of this process: "Holy Antigone! On thee, I call! Unfold thy banner to the winds that we may march beneath it—to destroy but still redeem."[28] It is important to note the phrase, "to destroy but still redeem" [*vernichten und erlösen*]: It sets an agenda that will be followed through in more disturbing terms elsewhere in Wagner's project, as we shall shortly see (the translator's "but still" for Wagner's "und" reflects a desire to turn Wagner's extreme expression into a more manageable paradox). For Wagner, as for Hegel, then, Antigone becomes a prime model, specifically as a figure who stands against the repression of the state.[29] It is only in such a revolutionary narrative that the full significance of Antigone can be appreciated: so "Never since the rise of the political State, has any step forward in history occurred without tending in some way to the State's downfall [*Untergang*]. . . . The

State, considered in the abstract, has always been in the act of falling."[30] Here, too, we see how important it is for Wagner that his aesthetics always has a strong political importance. Art and revolutionary politics go together. "Public art" was for the Greeks "the expression of the deepest and noblest principles of the people's consciousness"; this has been lost in contemporary bourgeois society. "Greek tragedy" was "the entry of the artwork of the People upon the public arena of political life," and it "flourished for just so long as it was inspired by the spirit of the People."[31] Again, we should note the phrasing: the *Volksgeist*, the spirit of *das Volk*, is integral to tragedy's political and aesthetic power.

How will the current state of things be changed? By a revolutionary commitment to the Artwork of the Future, the *Zukunftskunstwerk* (a phrase that anti-Wagnerians repeatedly used to mock the Master's music). This new form of art will be, in a striking phrase, "conservative afresh"—that is, a new form that looks back to the great days of Greece. It will come hand in hand with a new society, where "each man will . . . become in truth an artist."[32] It will put back together the disassociation of modern society. It is against this political ideal that Wagner's famous ideal of the *Gesamtkunstwerk*, the total work of art, resonates. The festival theatre of Bayreuth was designed to re-create the institutional frame of the Great Dionysia in Athens—that is, a shared place where *The Ring* could be produced over several days, for a collective audience of the people, where art and politics were linked in the total experience of the opera. It is a minor irony that Wagner's socialist ideals of *Volkskunst*, art imbued with the Spirit of the People—for an audience of the People—should have ended up with the most exclusive and expensive seats in the operatic calendar.

It was in 1850, the same year as *Opera and Drama*, that Wagner also published an essay called "Judaism in Music." He published it under a pseudonym ("Mr. Freethinker"), and it caused a small rumpus. He republished it as a pamphlet in 1869, under his own name, when he had become extremely famous, with a self-serving introduction, justifying and intensifying his commitment to the ideas of the piece. It is an attack on what Wagner sees as the undue influence of Jews in the musical world. It begins from what he calls "The involuntary/instinctive revulsion we possess for the nature and the personality of the Jews."[33] This is physical, both the "outward appearance" and "in particular the purely physical aspect of the Jewish mode of speech repel us."[34] But it is also moral and spiritual. The Jews, the wandering Jews, can never be connected with the Volk, the soil of the nation, and thus can never produce true art, which, as we already have seen, must be inspired by the *Volksgeist*. This leads to a general statement about Jews in relation to the human: "For the Jew to become human together with us is tantamount to his ceasing to be a Jew"[35] [*Gemeinschaftlich mit uns Mensch werden, heißt für den Juden aber zu allernächts*

*so viel als: aufhören, Jude zu sein*]. Jews are, for Wagner, dehumanized—that is, they can only join in the human race in so far as they stop being Jews. Hence, he continues with an apostrophe to the Jews: "Join unreservedly in this self-destructive and bloody battle [*an diesem selbstvernichtenden, blutigen Kampfe*], and we shall all be united and indivisible."[36] In 1869, he significantly changed the sentence to read " Join unreservedly in this work of redemption that you may be reborn through the process of self-annihilation" [*Nehmt rücksichtslos an diesem, durch Selbstvernichtung wiedergebärenden Erlösungswerke theil, so sind wir einig und ununterschieden*]—adding that expression which we saw with his discussion of Antigone, redemption through destruction [*vernichten und erlösen / Selbstvernichtung . . . Erlösungswerke*]. But with either reading it is clear that destruction is the note with which he wishes to end—for the last sentence of the work is "But remember that one thing alone can redeem you from the curse that weighs upon you: the redemption of Ahasuerus—*destruction!*"[37] That last word, *der Untergang*, rings as a grim prophecy of Wagner's power in Hitler's Germany.

In which light, it is fascinating to see what the *Wagner Handbook*, a seminal critical volume, makes of this passage. The distinguished Wagner scholar Dieter Borchmeyer writes that "To quote this sentence out of context and to read into it an idea of genocide . . . is completely misleading." "It has nothing in common" with such ideas. The issue here, argues Borchmeyer, is just a "quasi-mystic transubstantiation of the Jew, enacted in a realm remote from socio-historical experience . . . [which is] the effect which will be produced by the . . . artwork of the future."[38] Thus, "destruction" is for Borchmeyer a symbol or a metaphor (though it is not quite clear what it is a metaphor for . . .). This moved the editor of the English version of the *Handbook* to add a section to his essay on Wagner scholarship disassociating himself from such a stance: He points out that you cannot place Wagner's aesthetics in a worldview conditioned by anti-Semitism and exonerate those aesthetics from such a charge in the same breath.[39] Wagner's ideological purpose includes the so-called redemption of the Jews through their destruction as Jews. Wagner saw his politics as one with his artistic output, and it seems an all too obviously motivated move to attempt to separate his operas from his aesthetics.

Early commentators did not make such a strategic move: indeed, they insisted on the unity of Wagner's thought and music, in support of the Master. David Irvine, one of Wagner's most committed supporters in England, wrote in 1897: "Those who go to *The Ring of the Niebelung* thinking they can detach its music from its sources of inspiration, to cheer or applaud it without committing themselves to an opinion . . . had better either keep quiet or join the ranks of ragged anti-Wagnerism."[40] Bernard Shaw reveled in Wagner's linking of politics and art, as one might expect.[41] There was an equal and opposite reaction from those who despised his politics. It

is only since the Second World War that the move to separate Wagner from the implications of his political stances has become a standard and perhaps necessary gesture. So, where many contemporary critics are prepared to assert that "Wagner's music has nothing to do with blond Aryans,"[42] Hanisch bluntly reminds us that Wagner's political effect was so powerful in part precisely because "The image of Siegfried, the young golden-blond hero, caused the breasts of German youth to swell with the elation of male glory"—as it was intended to.[43] It is simply not true to Wagner's own agenda to retreat to a musical pleasure separate from what we should recognize as the darker forces in his aesthetic program.

What is most surprising to me, however, is how little critics have linked Wagner's evident anti-Semitism with his Hellenism. It is surprising because it became a central plank of his writing in what we might call the second phase of his response to the Greeks through the 1860s, with a long series of essays collected together under the title *German Art and German Politics*. As the title of this work suggests, Wagner becomes more stridently nationalistic through these years, and more blatantly anti-Semitic and anti-French. The bare lines of Wagner's argument are clear enough and run as follows. The Greeks were the origin of what can truly be called Art. What modernity needs (and history has been leading toward) is a rebirth of this true spirit of art. But—and here comes the nationalistic twist he learned in part from Fichte—it is only the German race that can achieve this rebirth, and only by returning to its primordial language, cleansed of all Jewish and French influences, that this true German art will arise from the German nation. This is the *Sonderweg*, the unique fate of the German people.

The Artwork of the Future is thus integrally linked to German music. There are, as John Deathridge has neatly captured, three strident claims Wagner is making. First, the individual citizen will be "ennobled through a dramatic art based in part on the Greek ideal and borne on the wings of German music." Second, "it will stipulate the creation of a purified and hence unified culture of the kind once supposedly possessed by the Greeks." Third, it will "underwrite the integration of the German race, not with debilitating criticism or scientific reasoning, but with a mystical belief in the supremacy of the racially pure but yet-to-be-created German nation-state."[44] What distinguishes this second phase of Wagner's aesthetics from the first stage of the 1850s is the addition of this utopian image of German nationalism, the belief that only a purified Germany can provide the conditions for true art and true political fulfilment. It is against this background that Wagner inscribed his dedication on the score of *The Ring*. The frontispiece of the first printed score records that Wagner's masterpiece is "dedicated in trust to the German spirit."

The inherent link between German nationalism and Hellenism in Wagner's thinking is pervasive. A single example from *Was ist Deutsch* will have

to suffice here: "Through its inmost understanding of the Antique the Ger-
man spirit has arrived at the capability of restoring the Purely-human itself
to its pristine freedom, not employing the antique forms to display a cer-
tain given 'stuff', but moulding the necessary new form itself through an
employment of the antique concept of the world."[45] It is by understanding
antiquity—and here, as always, Wagner primarily means Greek antiquity—
that German art progresses. The *German* spirit is specified and what it
strives for is the "purely human" [*reinmenschliche*]: It will be remembered
both how the Jews were barred from the human by virtue of their Jewish-
ness, and also how important the values of purity [*Reinheit*] are for this
discourse. So when King Ludwig II commended Wagner for allowing a
Jewish conductor for the first performance of *Parsifal*, the Master instantly
responded with a letter that "comes as a shock even to hardened Wagner
scholars"[46] in which he declares that he regards "the Jewish race as the born
enemy of pure humanity [*reine Menschheit*] and everything noble about it.
They will be the ruination of us Germans."[47]

It is not imitation of the past Wagner seeks, however, but a fully classical
world view, from which the revolutionary artwork will emerge. So Wagner
in another of his apostrophes writes: "Hail Winckelmann and Lessing, ye
who beyond the centuries of native German majesty, found the Germans'
real ancestors [*Urverwandten*] in the divine Hellenes!"[48] The Greeks are
genealogically linked with the Germans, as those archetypal German Hel-
lenists Winckelmann and Lessing discovered. Jonathan Hall has sharply
analyzed the ideological force of German claims to be the "New Dorians."[49]
Here is Wagner's aesthetic and racial equivalent.

Wagner's ideology of German nationalism is based, then, on two mutu-
ally implicative claims: on the one hand, the foundation of a "homogenized,
idealised, unified, purified, communalized, culturally deified"[50] Greece; and
on the other, the exclusion of the Jewish and the French, which are defined
as The Other in this pursuit of national culture. The destiny of the Ger-
man spirit depends on the destruction of the Jewishness and Frenchness
that threaten its purity. Wagner's Hellenism and his anti-Semitism are in-
tegrally connected.

## Staging the *Sonderweg*

We are now in a position to look at what happens to this ideology in per-
formance, and how the history of performance reflects on this ideology. I
will focus first on the first performance of *The Ring*, which took place in
Bayreuth in 1876.[51] The performance attracted a huge international audi-
ence, larded with eighteen critics from London, eighteen from Paris, four-
teen from New York, twenty from Berlin, fifteen from Vienna, as well as a

Fig. 4.1. A contemporary sketch of
Wagner conducting a rehearsal of
*The Ring*

sprinkling from Italy and Holland.[52] Wagner was involved in the produc-
tion from beginning to end, "his hand was everywhere."[53] He directed the
action from a desk on stage, with his score propped up against a crate, on
which an oil lamp stood (figure 4.1). (The desk had to be screwed to the
floor because of Wagner's excited gestures during rehearsals to prevent the
danger of fire.)[54] Heinrich Porges gave a typically hagiographic picture of
rehearsals in the house journal *Bayreuther Blätter*: "He stood before us as if
he were the one *total actor* [*Gesammtschauspieler*] of the whole drama. . . .
[He] literally embodied it [truth to nature] in every movement, facial ex-
pression, sound or word."[55] The genial Richard Fricke, the choreographer
of the production, who spent every evening in the tavern, Angermann's,
drinking and carousing with his friends (as he itemizes in his diary), was
more directly engaged and considerably more acerbic: "It really was very
amusing and funny watching Wagner trying to emphasize and stress every
single word by means of his animated movements and constant waving of

his hands. . . . It is difficult working with Wagner because he soon loses interest in what he is doing. . . . He will insist on being his own producer [*er will sein eigner Regisseur sein*] but he is, as it were, totally lacking in the qualities needed for such detailed work."[56]

Alone with Fricke after the exhausting first production Wagner confessed "Next year we will do it all differently"; after the first night "he sat in his room, beside himself with fury, hurling abuse at the performers."[57] There were technical disasters—a stagehand raised the backdrop at the wrong moment revealing people standing around in shirtsleeves and the back wall of the theatre; the dragon had not completely arrived from Britain where it was being made, because—a wonderful example, this, of how contingency invades history—a clerk had sent it by mistake not to Bayreuth, but to Beirut, where no doubt it was received with bafflement; and the final scene was "beneath contempt."[58] Nonetheless, Cosima Wagner—constructing and preserving the myth as always—later wrote dismissively to Chamberlain who was trying to renegotiate some new performance angles: "*The Ring* was produced here in 1876, and therefore there is nothing more to be discovered in the field of scenery or production."[59] (The *Parsifal* scenery completed in 1882 was still in use in 1912: thanks to the Bayreuth team, the radical Wagner became his own monument to conservatism.)[60] And although some critics disliked the "shoddy pantomime magic,"[61] others reveled in the spectacle: "From beginning to end the stage effects were splendid. . . . Nothing more terribly real was ever put down upon the stage . . . a series of representations unequalled for scenic truth and grandeur."[62]

The sets (for which a landscape painter, Hoffmann, was hired, though they were built by the Brückner brothers) and costumes (by Doepler) embodied Wagner's ideals of Germanness.[63] Figure 4.2 is a wonderful photograph of Frantz Betz as Wotan. He is dressed as a Nordic icon. From his winged helmet, to his cuirass, from his torques on his belt, armlets and studded leg bindings, he steps straight out of the casting manual for Norse kingly warriors, and he captures one stereotype of Wagnerian production values all too precisely. Equally telling are the sets. Figure 4.3 is a design for *Götterdämmerung*, the Hall of the Gibbichungen on the Rhine from Act I. It shows a medieval German house, idealized, and made especially grand in scale. The wooden frame is designed to leave a hole in the roof for the smoke of the fire to escape. The carvings on the walls reflect medieval German craft traditions. The shields leaning against the wall remind us of the manly militarism embodied in the hero center stage in his armor, and the dark youth leaning on his spear. The lauding of early German history, for which Tacitus's *Germania* plays a special role, is crucial for this imaging, and it would be interesting to set this interest against the Pre-Raphaelite Brotherhood's similar penchant, or the European delight in Scott's medievalism. Although Norse myth may not have been especially popular nor

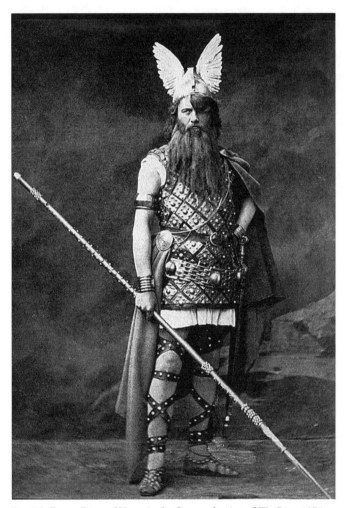

Fig. 4.2. Frantz Betz as Wotan in the first production of *The Ring*, 1876

Fig. 4.3. Hoffmann's design for Act 1 of *Götterdämmerung*, 1876

even well-known in German culture before Wagner's championing of them, his ability to latch on to and mold public taste is particularly canny.[64]

The set design is a picture, and was not built exactly as depicted here. The closest we have to a photograph of the set is from a production by Angelo Neumann in Leipzig in 1878, which was based on Hoffmann's designs for the first performance (figure 4.4)—and which gives some sense of the practical negotiations with the ideal in making a piece of theatre. Here, however, (figure 4.5) is Hoffmann's representation of a woodland scene by Rhine. As one would expect, the hero is clothed and armed, the females with whom he is faced—here the Rhinemaidens—are naked, at least on their upper bodies. They certainly were not naked in production, though there was a fine swimming machine for their river scenes (figure 4.6).[65] But it is the Romantic love of the woods—*die Wälde*—that is most strongly evoked by this set—and the German obsession with the woods as part of the symbolic topography of Germany is well known.[66] Those who made drawings of the production (figure 4.7) may not have represented the stage set with photographic accuracy, but certainly seem attuned to this high Romantic imagery. Even after the set-builders' negotiations with the real, the spectators can view with idealizing eyes.

This setting, however, is all very unclassical: Ancient Greeks don't do the woods, and certainly not like this.[67] But why should we expect to see Greek

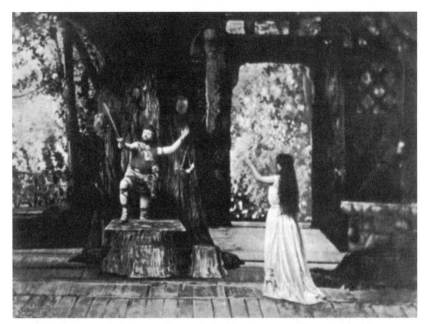

Fig. 4.4. Neumann's set for Act 1 of *Götterdämmerung*, Leipzig, 1878

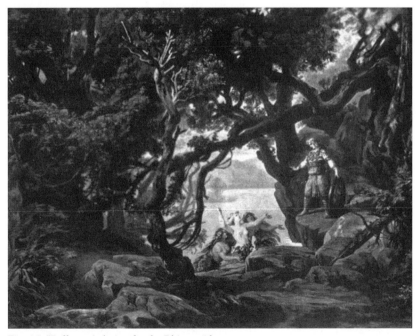

Fig. 4.5. Hoffmann's design for the Rhinemaidens

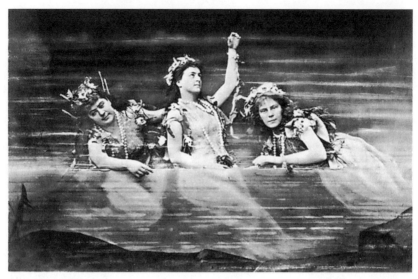

Fig. 4.6. The Rhinemaidens in the first performance at Bayreuth, 1876

imagery here? Wagner may have celebrated Bayreuth as a Greek festival for his revolutionary art of the future, but, as we have seen, Germany's Geist inherently, naturally recalls its genealogy in Greece. This pure German art is the endpoint of a *Sonderweg* that started in ancient Athens. If we are attuned to Wagner's aesthetics, we will be able to see the values of Hellenism in the resolutely non-Greek-looking stage sets and costumes. So in-house critics encouraged the viewer to see "the idealism of classical tragedy" (fused with the realism of Shakespeare).[68] *The Ring*'s spectacular paean to Germanness relied on the cultural appeal to Hellenism—its history and destiny.

## Endeavoring to Forget

In the decades after this performance, Wagner's circle at Bayreuth was increasingly taken up with the development and promotion of Wagnerism. They published journals, most notoriously the *Bayreuther Blätter*, dedicated to spreading the most aggressive and nasty anti-Semitism, conjoined with anti-French feeling and Willhelminian Imperialism. Apart from Cosima, who always tended the shrine of the Master (even when he was alive), the two leading players here were Ludwig Schemann who was the translator and biographer of Gobineau, the founder of racial theory in France, and Houston Stewart Chamberlain, Wagner's son-in-law, from England. I have written elsewhere about Chamberlain whose great work,

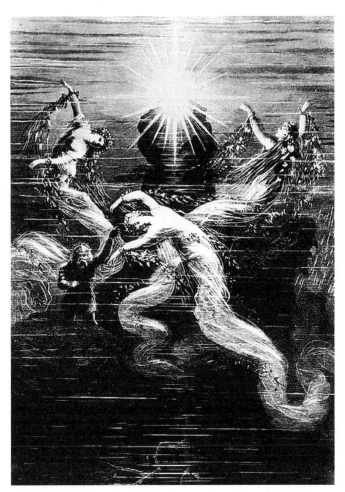

Fig. 4.7. A contemporary drawing of the Rhinemaidens from the first performance at Bayreuth,1876

*Die Grundlagen des Neunzehnhunderts*, was a founding work of racism.[69] He put racial theory at the center of German cultural life, and Bayreuth at the center of racial theory.

Chamberlain is one direct link between Wagner and Hitler. When Chamberlain died in the 1930s, Hitler came and publicly kissed his hands in obeisance. Hitler says he discovered Wagner in 1901, when he attended his first performance of *Lohengrin* at age twelve. "I was captivated at once," he writes, "My youthful enthusiasm for the Master of Bayreuth knew no bounds. Again and again I was drawn to his works. . . ."[70] There are as many self-serving, exaggerated, and fictional stories circulating of Hitler's engagement with Wagner as there are of Wagner's own life.[71] But Hitler did as a young artist sketch stage sets for imagined performances of *Tristan* and *Lohengrin*. As he rose in power, he became close friends with the Wagner family, with an especially close bond with Winifred, wife of Wagner's son Siegfried (who, in only one of the startling misprisions of her life, "could not understand why, in the final years of the war, Hitler only wanted to hear *Götterdämmerung*").[72] As Chancellor, Hitler designed performances that were staged. He loved to go to Bayreuth, where he was particularly at home with the Wagner family and felt especially at ease and happy. It became known in Berlin that one way to get an appointment with Hitler, that might otherwise take months, was to let it be known you had photos of a new staging of a Wagnerian opera. Wagner was a defining hero for Hitler (along with Luther and Frederick II). "After coming to power," he wrote, "my first thought was to erect a grandiose monument to the memory of Richard Wagner."[73]

Hitler attended each Bayreuth Festival from 1933 to 1940. It made a major impression on the public association of Hitler and Wagner. The town was filled with swastika banners, and the whole entourage of Hitler's government followed the Führer, filling the town. Brecht called Hitler "Führer of the Bayreuth Republic." Hitler even developed a plan, which was stopped only by the outbreak of war in 1939, to encase Wagner's concert hall in a neoclassical shell. Figure 4.8 shows Hitler greeting and being adored by the Bayreuth audience in 1934. Bayreuth became deeply associated with Hitler, and, consequently, Wagner with the agenda of National Socialism –even though the other cultural grandees of the Reich, let alone the soldiers, had less time for Wagner's music or Wagner's revolutionary politics. The program for the 1938 *Ring* chillingly makes the connection between Wagner's music and racism. A conductor, it declares, must be aware that Wagner's music "brings to our consciousness with unexampled clarity in the *Ring* the terrible seriousness of the racial problem."

So the question was, "What to do with Bayreuth after the war?" Financially crippled, with damaged buildings, and a morally bankrupt legacy, it was not clear which route the Bayreuth team could go. The operation was

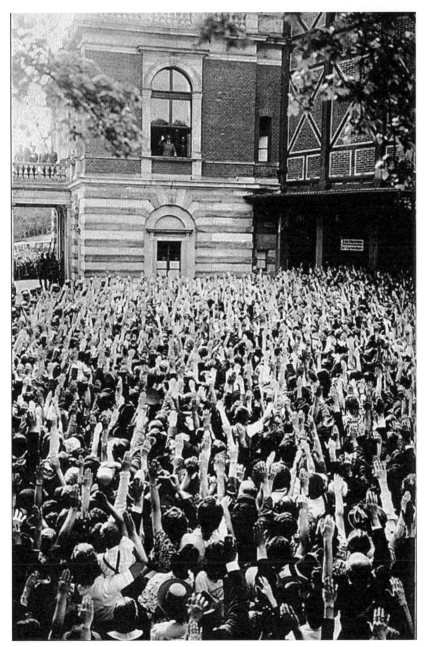

Fig. 4.8. Hitler celebrated at Bayreuth, 1934

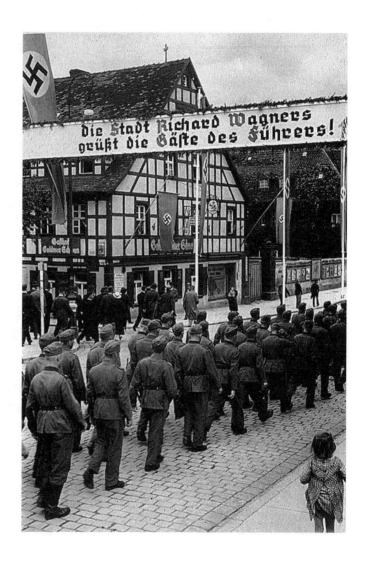

led by Wieland and Wolfgang Wagner, the two sons of Siegfried (as Winifred was moved aside as part of her denazification process). But Wieland himself had been given a Mercedes when he graduated from high school by Hitler himself, and been personally exempted from military service by him, and continued to design sets for performances during the Third Reich (as Thomas Mann sardonically pointed out). It has recently been proven that Wieland actively participated in the concentration camp system.[74] In terms of the German denazification program, Bayreuth was a special case. And it took a fascinating route.

It raised money by setting up the International Friends of Bayreuth Organization, and by 1951 was ready to open with its new set of shows. It decided to take the high ground of an opposition to politics in art. Figure 4.9 shows one of the quite extraordinary posters that festooned the opera house. "In the interest of a smooth progression of the festival production we ask that there is kindly an avoidance of discussion and debate of a political type at the festival theatre site. The aim here is Art." The catch phrase, "*Hier gilt's der Kunst,*" was taken from another poster that Siegfried Wagner had used back in the 1920s to assert Bayreuth's separation from political influence. But the poster is still absolutely bizarre for 1951 (or any other year). It looks like an administrator's version of John Cleese's famous cry "Don't mention the war." Nike Wagner—the next generation—in her rather charmingly bitter memoirs, reveals her carefully nuanced sense of the audience's response to the poster: "In the strongly depoliticised context of post-war Germany, art that was non-political—even anti-political—was in the ascendancy. . . . Wagner would never again seem so free from ideology."[75] This poster captures the truly amazing attempt of Bayreuth to depoliticize itself—and the audience's evident complicity with such a process. This was a wholly conscious decision. "No more German gods," was Wieland's motto, or, as he told the conductor Cluytens in 1956 how to play, "anything but German, you know."[76] The New Bayreuth, as it became known, "endeavoured to let this subject [Wagner's racism and the war] . . . be forgotten."[77]

The productions themselves tried to follow this through in a remarkable way. They cut out all the clutter of medieval German or Norse mythology: no woods, no huts. By 1953, as the action became "ever more Attic,"[78] the set was dominated by a large bare disk on the floor, which was explicitly said to be a version of the Greek *orchestra*. The costumes reverted from the winged helmets and leather studs to simple Greek dress. Figure 4.10 is Wotan, played by Hans Hotter, with Brünhilde (Martha Mödl). Their costumes are explicitly designed as Greek. Where the costumes in the thirties were specifically modeled on the sculptures of Strasburg Cathedral, these are fashioned from generic Greek sculptures ("*wie griechischer Statuen*").[79] Figure 4.11 is the Awakening scene from *Siegfried*, which was one of the

> Im Interesse einer reibungslosen Durchfüh-
> rung der Festspiele bitten wir von Gesprächen
> und Debatten politischer Art auf dem Fest-
> spielhügel freundlichst absehen zu wollen.
>
> „Hier gilt's der Kunst"
>
> Die Festspielleitung
>
> gez. WIELAND WAGNER        gez. WOLFGANG WAGNER
>
> Bayreuth, im Sommer 1951

Fig. 4.9. A poster from the first performance of the *Ring* at Bayreuth, after the Second World War

production's most famously sublime moments. You can see the circular stage mirrored by the circle of the backdrop. The clutter-free stage is deliberately "timeless." The simple lines and the basic costumes again deliberately evoked a Greek ideal. Figure 4.12 shows how the circle of the Greek *orchestra* also had walkways for the heroes to enter—as in the Greek theatre.

In 1956, Curt von Westernhagen wrote a piece for the Bayreuth program linking the *Maestersinger* to Greek tragedy, and it proved highly significant that in 1962 Wieland Wagner invited Wolfgang Schadewaldt, with whom he had had long discussions in the development of *The Ring*, to deliver at Bayreuth a set of lectures on Wagner and the Greeks. Schadewaldt, a very distinguished classicist, himself had been associated closely with Nazi academic politics.[80] ("The festival accepted the return of former Nazis as a matter of course.")[81] In his lectures, he wholly ignores the connection between Wagner's Hellenism and his German Nationalism and anti-Semitism. It is a series designed to surround the Wagner project with a new, safe Hellenic idealism, a Hellenism untarnished by the foulness of Wagner's politics. And almost all critics since have followed this separation of Wagner's Greeks from Wagner's Jews. Almost no scholar who discusses Wagner's anti-Semitism discusses his Hellenism in that connection, and almost no scholar who works on his Hellenism mentions his anti-Semitism.[82] Schadewaldt's rhetoric seems to have worked.

Fig. 4.10. Wotan (Hans Hotter) and Brünnhilde (Marta Modl) from Wieland Wagner's *Ring*

Fig. 4.11. The awakening scene from *Siegfried* in Wieland Wagner's *Ring*

The audience reacted to the New Bayreuth with a mixture of shock, horror, and (on occasion) delight. One angry spectator upbraided the conductor and claimed he thought he had been at a rehearsal and wondered whether the sets and costumes would arrive later. Most saw the turn away from the past as strongly pointed and divided along predictable but passionate lines around such a marked gesture. The production is often taken now, with some justification, as a foundational moment in post-war German theatre. What is crucial for my purposes in this chapter, however, is the staggering irony that it is to Greece that Bayreuth turned in order to depoliticize its plays, when we have seen the absolutely essential place of Greece in the construction of Wagner's own political and theatrical ideals. Where Greece was integral to Wagner's nationalism, now it is Greece that enables a move away from the baggage of nationalism. As Wieland put it, they endeavored to forget.

This is what makes Wagner's Greeks such a fascinating case for performance history and Reception Studies. For Wagner, Greece was essential to his nationalism, but when he staged his works, Greece remained immanent in a wholly Germanic staging. Physically invisible, but everywhere a grounding. Part of the politics of theatre, but not part of the staging of theatre. For those that had eyes to see, Hellenism was fully part of the

Fig. 4.12. The walkways from Wieland Wagner's set for the *Ring*

Wagnerian nationalist project. When Bayreuth wanted to escape from the burden of the past, however, it did so by making explicit a new Hellenism: now, central to the staging, but with any political import resolutely silenced. Wagner's Greeks take a different shape over time, locked into different narratives and different structures of forgetting, different politics and different senses of their own history. The forgetting seems as important as the sense of history.

In this history of performance and reception, *where* we see the Greeks, and *what* we make of what we see, is a complex question indeed. The complexity stems from three vectors: first, from the diffused, shifting, and historically dynamic sense of Hellenism, as it is promoted, forgotten, and re-promoted as an ideal for productions of *The Ring*; second, from the self-consciousness induced in us by the political positions of the story's major players: Richard and Wieland Wagner (and their teams) manipulate Hellenism in different ways (explicitly and implicitly), demanding different strategies of distance and complicity from us as critics; third, from the contrasting and conflicting responses of critics and audiences to both productions—which makes reception a scene of contest. For a modern Hellenist, it is not a comfortable position to dwell between Richard Wagner's linking of the Greek ideal to racism and nationalism, and Wieland Wagner's injunction to leave politics out by turning to Greek idealism. Nor is it particularly comfortable for a modern cultural historian to see how the lauded theatrical

modernism of Wieland Wagner, which was so influential in European drama, is so heavily intertwined with an attempt to rewrite the past with such bad faith: Modernism is veined with ironically unpleasant reflections of its parentage. It is an uncomfortable place, but one where a sharp light is thrown on why theatre history needs to consider in the broadest terms the social and intellectual significance of its performances.

❀ ❀ ❀ ❀ ❀ ❀ ❀ ❀ ❀ ❀ ❀ ❀ ❀ ❀ ❀ ❀ ❀

# Fiction: Victorian Novels of Ancient Rome

## Chapter 5

❁ ❁ ❁ ❁ ❁ ❁ ❁ ❁ ❁ ❁ ❁ ❁ ❁ ❁ ❁ ❁ ❁

# FOR GOD AND EMPIRE

## Every Book Needs a Hero

One hero of this section of my book will turn out to be Fred Farrar. F. W. Farrar taught Classics at Harrow before becoming a pioneering headmaster of Marlborough School.[1] Later in life, with the easy shift between university, school, and the church characteristic of Victorian society, he rose in the church to the position of Dean at Canterbury Cathedral, a major public role in the Anglican establishment, from where his liberal sermons managed to provoke a storm of protest from more evangelical Christians. As a young man in the 1860s, he had already edited *Essays on a Liberal Education*, a polemical collection of writings from high liberal worthies at the center of the heated political arguments about political and educational reform. He is customarily called a Broad Church man, but this broad title doesn't adequately capture the range of his reputation or his contribution to the culture of England. For some traditionalists, he was, even when elderly, a Young Turk, a dangerously liberal threat from within the church and the corridors of power to the solid institutions of English religious life. For others, his writings provided a deeply personal and comforting guide to their increasing involvement with Christianity—which led radicals to attack him as the bland comfortable face of conformity. Still others remembered him as a firm but fair headmaster who was a moral mentor in the tradition of Thomas Arnold at Rugby, whose iconic status for the new, earnest English education was cemented by his portrayal in *Tom Brown's Schooldays*. For others yet, he was the evocative image-maker of childhood, through his schoolboy fictions. A man of many parts, then, and a glimpse into the fascinating interface between religion, politics, and education in Victorian Britain. But why precisely should Dean Farrar be a hero of this chapter?

Farrar wrote—among his many books, sermons, and essays—his *Life of Christ*, which was a major bestseller: Thirty English editions were published in his own lifetime. This "florid" and "exuberant" (or "gushing") book was hurtfully attacked by more austere critics for being *popular*: "We have had the Lives of Christ presented to us under forms of German philosophy

and French sentiment, and now we have one in that most popular English style, the style of *The Daily Telegraph*. 'The Life of Christ by a Special Correspondent of *The Daily Telegraph*' may sound irreverent, but if so, the fault is not ours."[2] The slur of popularity was not just the customary academic sniffiness about a colleague's success; it also has a particular context in Victorian Christian arguments. At one level, large-scale and aggressively emotional evangelical meetings, religious riots, and suspicious religious demagogues were familiar aspects of the landscape across the century (given particular edge by the popular revolutions of 1848 and the Chartist demonstrations): Being popular could maliciously suggest a nasty or self-interested manipulativeness, though Farrar's character and position certainly stood against such a slur.[3] At another more pointed level, some Tractarians of the Oxford Movement, in their pained journey toward, and sometimes into the church of Rome, had suggested that there were elements of Christian theology that *should* be kept apart from the masses—a doctrine destined to be viewed as insidious by more bluff and muscular Christians.[4] Popularity, from one extreme, could be seen as the rejection or ignorance of serious theology, something lamentable in an age of earnestness, especially for a figure of such public stature. So the *Athenaeum* declared Farrar's work "a hindrance to the cause of . . . earnest criticism": his "book is retrogressive, obscuring these grave questions which earnest men are trying to solve, so that the truth of Christianity may rest on the divine teaching and life of Jesus. Into their province preachers should not incur, except to learn. . . ."[5] The life of Jesus was too serious, too troubling a topic, to be handled in a *popular* way.

Farrar knew well that to write a life of Jesus was to enter particularly difficult terrain. David Strauss's *Life of Jesus*, translated anonymously from the German by novelist George Eliot when she was still Marian Evans, was the scandalous and inspirational epicenter of fierce battles about the status of the texts of the Gospels, the relation between history and religion, the role of tradition and criticism in religious life.[6] It was a dense scholarly book more argued over than read, but its rationalist criticism of the textual tradition of the Gospels and the historicity of miracles, was seen not just as an attack on Christianity itself, but also as a manifesto for radical democracy.[7] (As Feuerbach wrote, "theology is for Germany the only practical and successful vehicle for politics. . . .")[8] Strauss stated categorically in his preface that his book was written only for scholars, not for laymen, and he placed his critique in a long scholarly tradition, but his defensiveness, disingenuous or no, did not stop his name from becoming an icon in England (nor stop him from losing his job in Germany).[9] As Schleiermacher's critics had asserted, the historicization of theology threatened to introduce relativity into absolute Christian values.[10] Renan's *Life of Jesus* (the "French sentiment" to Strauss's "German philosophy" in the *Athenaeum*'s account) was

more widely read—indeed it was another major bestseller, despite virulent critical reaction, especially from orthodox apologists—partly because it brought together a travelogue's sense of the landscape of the Holy Land with a novelist's flair for narrative: a "sense of romance and Oriental realism."[11] But Renan's positivist historical criticism too, even for supportive voices, appeared as "the spring tide of an advancing wave of thought inimical to Christianity."[12] The anonymous *Ecce Home*, written, as later became public, by John Seeley, Professor of Latin at London, and best known as a leading British and European historian, offered an English voice to the debate about the life of Jesus.[13] While there is surprisingly little direct historical criticism in *Ecce Homo*, its meditation on the humanity of Jesus was a knowingly provocative gesture, when the realism, history, and truth of the biblical narrative had been set at stake. It was a book that intrigued, disturbed, and "played havoc with the traditional parties of British thought."[14] As John Henry Newman worried, it was impossible to determine whether the author "was an orthodox believer on his road to liberalism, or a liberal on his way to orthodoxy."[15]

The very title of Farrar's work set him in opposition to these much-discussed predecessors, and when he announced in the preface that he wrote "as a believer," his colors were firmly nailed to the mast. The *Westminster Review* predictably sneered "a 'believer' means one who systematically sets at naught the ordinary laws of historical criticism."[16] But for many more readers, Farrar offered exactly what the *Athenaeum* feared: "Many pious Christians will peruse the glowing descriptions here presented, unconscious of difficulties, unwilling to be disturbed with doubts, or fondly believing that all has been settled on a smooth foundation by the reverent carefulness of such advocates as Dr. Farrar."[17] Farrar's numerous readers loved his *Life of Christ* (significantly not a Life of *Jesus*) precisely because it provided—against the doubts and positivism of trendy critics—a Life that encouraged belief, comfort, and joy in Christian tradition. The accusation of popularity was thus also an attack on Farrar's apparently successful deflection of the force of modern critical thinking for so many still pious readers. It is no surprise that Farrar's own biography, written by his son, mentions the hurtfulness of this charge of popularity, and somewhat bitterly prints a selection of letters from all around the world, from readers gratefully recording the intense emotional effect the book had produced in their personal lives, especially in times of great stress or misery.[18] Reaching out generously to as many people as possible is offered by Farrar's biography as a Christian ideal to set against the ungenerous accusations of the critical.

At the same time, Farrar was especially famous for his schoolboy fiction, and, in particular, his novel *Eric or Little by Little*. This is an extraordinary story to read today, for all that the Victorian invention of the boarding

school novel is the generic foundation of *Harry Potter*, as well as the string of widely read books, set in public schools, produced throughout the twentieth century.[19] The strident moralism of the book, its mawkishness, and its fascination with good-looking young men, whipping, and tearful boys quoting poetry to each other, had become an object of scorn even by the time of Kipling (not exactly a clear-cut enemy of sentimentality, nationalism, or the promotion of heroism for boys). For Kipling's characters in *Stalky and Co*, "ericking" is the dismissive slang term for boys who are excessively pious and totally drippy. It cannot be by chance that the book's doomed hero, Eric Williams, seems to have his name hewn from the author's: Fred*eric William* Farrar. Eric's fate is a threat to each Victorian reader's self. . . . In its moment, however, *Eric* was also a major success, with thirty-six editions in Farrar's own lifetime—and allowed Farrar to express his views about education in a different format from his campaigning essays and speeches, much as his *Life of Christ* allowed him to express a view of Christianity in a narrative form rather than in sermons or tracts.

These widely read and discussed narratives are integral background to understanding a third output of Farrar. The Dean of Canterbury also wrote two influential novels about Christianity during the Roman Empire, one on Nero and the other on John Chrysostom. The first, *Darkness and Dawn* explored the earliest days of Christianity, where the luridly corrupt Nero leads a mad persecution of the new religion; the second, *Gathering Clouds*, showed how the church turned against its own first principles and sank into internecine argument and petty corruption. This section of *Victorian Culture and Classical Antiquity* is going to focus on the remarkable profusion of Victorian novels set in the Greek and Roman world, and especially in the Roman Empire of early Christianity. More than 200 novels on Roman themes were published in English between 1820 and the First World War, some of which never rose above obscurity, but many of which were major commercial and critical successes: authors such as Charles Kingsley, Wilkie Collins, Bulwer Lytton, and Walter Pater have remained in the canon; *Quo Vadis*, *Ben Hur*, *The Sign of the Cross* have remained famous thanks to the films and plays made of them; Cardinal Wiseman and Cardinal Newman are still celebrated divines of the Catholic Church—even though they may not be remembered today so much for their once highly influential novels about the Roman Empire. These novels on the ancient world were published throughout the century, and each decade from the 1830s on had its bestsellers and its scandals. But the genre starts to appear in strikingly increased numbers in the 1870s, and during the 1890s fully forty new volumes were published in England, and from 1900 till the end of the First World War another 60.[20]

I began this section with Farrar not just because he wrote two of the more gripping novels in this genre, but also because he embodies so fully

what is at stake with this range of fiction—not least through the normative thrust of his diverse but interconnected writings. For what makes these novels so interesting is precisely what Farrar's collected works offer in germ: the heady combination of religious controversy, the power of nationalist narrative coupled with self-conscious debate about the reach and aim of Empire, the educational anxiety and idealism attached to classical antiquity, the heightened appreciation of history in the age of progress. Such fiction about the Roman Empire and the origins of Christianity could be sexy and fun—from orgies to chariot races to torture—but they also raised deeply worrying and interconnected questions for their Victorian audiences. What faith should be placed in the religious stories handed down from antiquity? Were religious texts open to the same critical scrutiny as historical writing? How did the traditions of the past relate to the institutions of today? Could historical novels provide a serious perspective on the past or were their fictional narratives inevitably mired in dangerous pleasures and lies? Here is an arena where Victorian engagement with classical antiquity was enacted in the most vivid, complex, and far-reaching manner. Novels such as *Ben Hur*, *Hypatia*, *Marius the Epicurean*, *Robert Elsmere* crossed the boundaries between fiction, social commentary, religious polemic and political propaganda, both in their writers' agendas and in their audiences' reception. As such, these books played a fundamental role in the construction of the cultural imagination of the Victorian reading public, and with their often huge sales, these narrative fictions acted as an instrumental, mediating form between high-level intellectual, theological, university-led argument, and popular culture.

These novels of the Roman Empire need to be viewed, then, within a series of intertwined polemical contexts to which they made an active contribution. Let me briefly, for clarity's sake, disentangle the four most pressing of these linked contexts. First, religion, of course: Charles Kingsley, a radical chartist turned aggressive Christian Socialist, wrote in direct contest with Tractarian turned Catholic, Cardinal Newman (with whom he also had a very public tiff that led, as we will see, to Newman's remarkable *Apologia Pro Vita Sua*), and also with Cardinal Wiseman, Cardinal of Westminster, and the reviled focus of Anglican suspicions about Catholic power—"papal aggression"—in England. Three celebrated religious leaders competing through their fictional narratives of the past (something hard to imagine in today's cultural climate, where even the Archbishop of Canterbury's poetry attracts only passing interest). Novels were part of an intense argument about faith. What view to take of early Christianity was a central question for contemporary theologians and for the public debate about Christianity, which so vexed mid-Victorian society.[21] Novels were part of a religious "battle for hearts and minds."

Second, history: Since Walter Scott's Waverley series, the historical novel was a genre that was exceptionally popular, but also much debated as a genre. Novels about the distant past played a formative role in the construction of a nationalist history, and through it, a national identity. Britishness or Englishness emerges like a flag, and not just when Boudicca revolts. Several novels delight in finding Christian characters in early England, or they may bring northern Goths in contact with southern Romans to debate racial purity, or dramatize the clash of the corrupt Romans with the upright and brave northerners. Constantine, the first Christian emperor, is celebrated as "British born."[22] As late as 1897, an American divine, Dr. A. Gray, D.D. wrote *The Origin and Early History of Christianity in Britain: From Its Dawn to the Death of Augustine*.[23] In the traditional narrative, Augustine brought Christianity to Britain at the end of the sixth century, but for Gray "Augustine found Christianity in Britain when he arrived." Gray revived the wonder-filled medieval story that Joseph of Arimathea came to England and was buried at Glastonbury; St. Paul came too, as did Lazarus (after being raised from the dead, obviously). Pomponia Graecina, who appears in many novels as a Christian, for Gray is the sister of Caractacus, the Welsh king who resisted the Roman invasion.[24] He recognized with a certain understatement—that "some may argue" that such legends "do not rank as authentic history," but they remain crucial to his argument that "The Roman Catholic Church had no existence in England until the twelfth year of Queen Elizabeth, A.D. 1570."[25] Henty in *Beric the Briton* even has a Roman religious historian recognize parallels between native British religion and the new cult of Christianity.[26] The connection between religion and national identity is integral: these are (ancient) novels about *Anglicanism*, the embattled Church of *England*, often in the barest of disguises. Martin Bernal's much derided and influential polemic *Black Athena* has reminded us of how much nineteenth-century historiography on the ancient world was specifically anti-Eastern, anti-Semitic, and racist (perhaps the least surprising claim in his book).[27] The image of the ancient world and the values of its historiography are developed and contested in historical fiction as much as in historiography—and these fictions often reached a broad audience for their committed representations of a foundational historical past.

Third, historical novels are also concerned with education and the place of scholarship in understanding the past, especially the classical past. These are novels with footnotes. Farrar's personal experience as an educator, his role in the debates on educational reform, and his novels, form a continuum of an intellectual and political life dedicated to understanding and promoting a particular relationship between the present and the past. As we will see, this relationship is even articulated as a continuity between the schoolboy heroics of *Eric* and the struggles of early Christians: not so much

muscular Christianity as *plucky* Christianity. Like the saints, the equation goes, these boys must honestly, pluckily stand up for what they know is the truth. But how scholarship and imagination interact to construct a true picture of the past is repeatedly discussed within the novels as well as in the critical commentary about them. So which scholarship should count, especially in the history of the church? How critical, how awe-struck should a modern account of a miracle be? This is especially pertinent with novels on classical antiquity: classical antiquity was basic to the Victorian educational world both as an ideal and idealized past and as a challenged privilege. Producing images of the classical past was a charged gesture in Victorian Britain—as this book has explored at length already—and the novels about the ancient world were typical in this.[28] Novels no less than historiography reveal the *complicity* between scholarship and political agendas.

Fourth, as one might expect from a space articulated by religion, national identity and history, these novels are also inherently political, and are often so in a direct and committed manner. From Scott's retelling of Bonnie Prince Charlie's story in *Waverley*, to Kingsley's drama of the working man's aspiration in *Alton Locke* or the Elizabethan nationalist excitement of his *Westward Ho!*, to the discussion of discipline and order in Henty's *Beric the Briton*, Victorian historical fiction, whether set in both the more recent or the more distant past, loves to explore an ideology of government and social order, of progress and tradition. In part, this is a question of the degree to which the Roman Empire is the model for the British Empire.[29] In part, however, and more insistently, it is a question of finding the roots of a unique British sense of political freedom: as Macaulay paradigmatically puts it, "our liberty is neither Greek nor Roman; but essentially English."[30] Green's *Short History of the English People*, one of the best-selling history books of the 1870s and 1880s, with nearly 250,000 copies sold, made the importance of liberty—and a British institutional commitment to liberty—its guiding principle.[31] So a German visitor to Westminster Abbey, in a best-selling novel, declares "your venerable Abbey is to me the symbol of a nationality to which the modern world owes an obligation it can never repay. You are rooted deep in the past; you have a future of infinite expansiveness before you. Among European nations at the moment you alone have freedom in the true sense, you alone have religion."[32] Before the Abbey—the embodiment of religious and architectural heritage, national roots from deep in the past—Europe paid tribute to the uniqueness of English freedom. The novels of the Roman Empire for the British Empire provoke the pressing question: How much are contemporary political ideals, contemporary institutions, formed and legitimated through history?

These four areas of religion, history, national identity, and politics, are, of course, intricately and intimately enmeshed throughout nineteenth-century

regimes of knowledge and representation, but the novels set in the Roman Empire reveal one grounding paradox that is at the heart of my argument about the Victorian public arena. On the one hand, classics can form the bulwark of British institutional and intellectual conservatism. Classics is supported in the education system because of its perceived function in bolstering the church, the public schools, and, as the rhetoric flourishes, educational values, national character, and a sense of class and place. The comfortable, broad circulation of the images and language of ancient Greece and Rome is the unacknowledged reflex of this system. On the other hand, not only does Classics thus also become the inevitable arena of argument about the formation of a citizenship through such institutional and intellectual structures, but also and more pointedly it becomes the very means and matter of criticizing and even undermining them. The strength of feeling and the sheer number of texts that are dedicated to thinking about the classical past in the nineteenth century, stem from the need to work through this double vector. The more questions critical ancient history posed of the early church, the more heated the arguments became about maintaining the place of Classics.

But—and this seems to me also to need special care—the case of our hero Farrar also lets us see the complex class and cultural dynamics involved in the construction of a dominant image of the past. Farrar writes as a member of the elite, for sure, and is fully engaged with the high-level religious and social politics of the time. He has himself been exceptionally well educated in the classics, English literature, and theology, and is capable of writing for those who share such an education. But he also writes books that reach out across the class and national divides. (His work was translated into Russian, Japanese, and so forth.) His schoolboy fiction was enjoyed by many who did not necessarily progress far in formal education, and his *Life of Christ*, it seems, was read by the (self-)educated working class. The sneer against his popularity with which I began, is also testimony to the range of his potential and real readers (a range that some contemporary critics, in the nature of elites, found disturbing). New media spread new styles of narrative to a hitherto unimagined audience.[33] The more popular historical novels became, the more anxious elite critics became about that popularity—about the sort of narrative, the sort of *history* being offered—culminating in the virulent critical hostility to the success of Marie Corelli, one of the most popular novelists of them all. Many of the novels I will be discussing reached out to a wide audience, and were an active part of what can properly be called popular culture.

Indeed, these texts have also provided the raw material for some of the most lasting popular icons of the classical past—the chariot race of *Ben Hur*, Nero playing while Rome burned, the Christians in the Colosseum, the dangerous and seductive Roman orgy. Each of these images has ancient

sources and a long tradition, for sure: Nero's singing over the flames of the city is a rumor recorded already in Tacitus; the lethal chariot race goes back to Homer and Sophocles. But the Victorian novels have been particularly instrumental in forming the familiar modern picture of a corrupt ancient Rome. We will see reasons for the construction of this portrayal when we discuss the novels in detail—Christian apologetics, an ancient Roman tradition of lamenting the decadence of the present, an anxious comparison between the modern city and the classical world, all play a part—but for the moment I want to stress how the work of the elite, often tied in to very serious arguments about theology, church history, and national identity, also helps form these iconic images of popular culture. These images may be crystallized by a particularly brilliant embodiment, especially in the supremely popular form of film: Charlton Heston's filmic chariot race is known even by those who haven't seen it—and certainly by many who have not read Lew Wallace's novel of *Ben Hur* (or who know that Wallace was a general in the Civil War and then American ambassador to the Ottoman Empire). But the constant repetition of certain standard ideas between novels—call them *topoi* or clichés—also produces a horizon of recognition, a more diffuse sense of antiquity, or a more general sign of the classical (like the Venus de Milo in the background to a perfume advertisement, adding a touch of class as well as the classical). It is not necessary to have seen the effetely sadistic Charles Laughton as Nero, or the macho Kirk Douglas as Spartacus, to appreciate the cruel Roman emperor as a type or the gladiator as a model of heroism against the odds, important though each actor has been in the continuation and construction of the paradigm.[34] The sheer profusion of Victorian novels about the Roman Empire, for all their personal politics and religious controversy, also helped articulate and circulate what would become the modern and often most trivial stereotypes of classical antiquity.

When Reception Studies have been particularly fascinated with individual and strong readings of great works of previous generations, it has tended consequently not to be so interested in the rather hazy circulation of clichés or stereotypes as a recognition or appropriation of the classical past. This chapter's discussion of Victorian novels about the Roman Empire will suggest not only that the cultural imagination works *between* such stereotypes of the past and the potential for more attentive and critical engagements, but also that the reception history of these novels needs to take into account the slippage between heated controversy and tired familiarity, between elite and popular learning, between history as intellectual earnest study and history as an alibi for glamour and sexiness. The novels may have been forged in a particular time of controversy, but their legacy—their reception—is also a set of soft-focus images of antiquity. This, too, is part of the classical tradition.

This section of the book has three chapters. The first will locate these novels on a classical theme within some of the crucial frames of comprehension necessary to appreciate their cultural impact: the Victorian conceptualization of history and of the historical novel as a genre of fiction; the role of Classics as a specific privileged past caught between the idealism of philhellenism, the use of the Roman Empire in thinking about the British Empire, and the rejection of Roman society within the rhetoric of Christian moralism; particular debates about early Christianity and their place in the contemporary crisis of faith and institutionalized religion; and finally, the importance of nationalist narratives of Britishness (race and empire). This chapter provides the necessary frames—the background, if you must—to the discussion of the novels, as these historical novels centered on classical antiquity cannot be understood without a look at the broader genre of historical fiction, and the broader concerns with history, Classics, and the politics of race and religion in the nineteenth century. The focus here and throughout this section of the book is primarily on the British and Anglophone scene. German and French material emerges primarily for its influence in Britain—and one thrust of this chapter is the importance of the Anglican framework, which provides such a different context from European intellectual debates for the growing tradition of the novel. The second and longest chapter, chapter 6, will look in more detail at particular novels and their engagement with antiquity—which often takes the form of a polemical appropriation. How do Jews fit into this normative world? How is sexual identity an issue? Can a negotiation be found between the barbarism of early Britain in Roman eyes and myths of origin? How complex a picture of conversion, of the spread of Christianity, of the attractions of the pagan world can be developed? Here—the central claim of this chapter—we will see in detail how the engagement of these novels with Christian polemics sets the classical past in the paradoxical position of *both* being heralded as a bastion of tradition—that is, of conservative political or religious ideology—*and* being the precise intellectual route through which tradition with its ideologies is challenged in the most far-reaching manner. In the third and shortest section, I will turn to look very briefly at two writers who combine in very different ways many of the concerns of the chapter, Charles Kingsley, and the man with whom I began this chapter, Frederic Farrar, in order to see how the various themes outlined in the first two sections together interlace in the experience of a single life, and how the telling of a life is integral to the processes of reception in the nineteenth century.

While there have been useful if inevitably incomplete bibliographies drawn up of Victorian novels set in the ancient world,[35] and while novels of faith and doubt,[36] and, of course, historical novels as a genre have been discussed by critics,[37] there has been no adequate extended discussion of these books on classical themes as a group, despite their evident, self-conscious

interaction and despite their recognition as a genre from early on;[38] barely any have been treated in detail as individual texts (which is not surprising in terms of changes of fashion as well as the dubious quality of many of them). In particular, there is no adequate treatment of these novels within the historical and cultural background that gives them their contemporary impact. My aim is partly to explore a particularly rich site of Victorian engagement with classical antiquity, rich not only for the imaginative and affecting fiction, but also for the self-reflexive and explicit concern with historical narrative and the relation between past and present in the novels themselves, as well as in the fertile and sometimes febrile commentary on the novel. But I also intend that my discussion will contribute to a central question of current reception theory—namely, how to negotiate between seeing reception as a broad cultural process—the Victorian view of early Christianity, as it were, or the clichés of classicism—and seeing reception as a strong individual's interaction with the works of the past—Cardinal Newman's reading of the church fathers, as it were. These novels shimmy between polemical and engaged agendas and the mundane commercialism of the glimpse of flesh beneath the toga or the prurience of a torture scene—and thus became a particularly productive place to debate *how shared* the past is or should be.

## Whose History?

The writing of history underwent a sea-change in the nineteenth century. By the end of the century, history, along with other subjects of the humanities, had become a recognized discipline, with the growth of university departments and academic positions and courses, along with the attendant journals, jostling for position, and public authority.[39] The corollary status of the professional historian was slower to develop. George Grote was a radical politician and banker before he turned to writing the history of Greece. Thomas Macaulay was a politician, too (MP for Edinburgh), who progressed from writing reviews and essays to his history of England. Neither held a university position. Even John Seeley, for whom the Cambridge University History Library is named, was trained as a classical scholar and became Professor of Latin in London, from which position he wrote about British and European history, before he was appointed to the Cambridge chair of history after Kingsley. When Charles Kingsley became Regius Professor of History at Cambridge (his books were great favorites of the Queen who had the right to make the appointment), he was repeatedly, if usually privately, criticized for not having the right credentials, but this was not a matter of his degrees or inability to work in the archives, nor just the envy at the full lecture rooms his celebrity status

guaranteed. It was rather that he had not published any real or respected book of history, rather than historical fiction, yet. Within a few years, an appointment like Kingsley's would be impossible, rather than one that raised the eyebrows of a few critics. But even when the discipline had taken on its recognizable lineaments by the end of the century, there were still few students at universities who took a history degree, and few if any full-time historians.[40]

Yet the status of history writing had risen remarkably. Not only were Grote's history of Greece and Macaulay's history of England bestsellers— "The country *en masse* read [Macaulay's *History*] as it never read anything before, except, perhaps, the Waverly novels"[41]—but also they provided authoritative versions of the past: explanatory models of how the world was the way it was, as powerful and imaginatively gripping as Darwin's or Marx's. Their authors were distinguished intellectual leaders. Inevitably, as history writing became a source of authority and power, it too became an arena of contestation and debate. What sort of history counted, how history should be written, became a topic of general debate in the reviews. For the first time, history really mattered as a public discourse: a master discipline, with immense reach in society

What led to this rise of history writing? At one level, the development of history as a field is linked with the power of nationalism across the century, as the story of a national past increasingly featured both in the self-assertion of a national identity and in the expression of imperialism.[42] As we will see, in the Victorian period, terms such as Anglo-Saxon, Norman, and Roman, as elements in a British past, took on considerable charge in the exploration and proclamation of a normative Englishness. The rise of the British Empire needed an explanation, and, as Livy, Varro, and Virgil had managed for Augustus and the Roman Empire, so the distant classical past— mapped by historian, scholar, and poet—created a necessary past for Victorian Britain. At another, interlinked level, the rapid social change associated with industrialization, produced a heightened awareness of the period as "an age of transition," or "an age of progress."[43] The modernity of the nineteenth century reconstructed the medieval and more distant past and even the eighteenth century, as a lost world, whose difference defined the present; and at the same time, looked forward to a future (where progress was heading), of technological and social advancement.[44] This notion of time, and sense of placement within time, was quite different from the Christian providential history that had dominated in the eighteenth century and before, and found expression in extended public arguments about conservation and preservation, in epoch-making displays such as the Great Exhibition and Crystal Palace, in social utopian experiments and intense debate about revolution, or, in a weaker form, liberalism versus conservatism. The grand theorists of Victorian thought—Darwin and Chambers,

McLellan and the other revolutionary social theorists, Marx, Darwin, Freud—are linked by their aggressive realignments of the relation of the past to the present as the prime explanatory model of things. Understanding evolution—of the race, of society, of species, of the person—is understanding how the past makes the present inevitable, and thus explains the present afresh. The threat of geology, the archetypal trendy Victorian science, is that it undoes previous knowledge of what the past is.

It would be possible to explore the development of history as an institution, as a form of display in the city, and as a form of writing—and as an expression of Victorian uncertainties and explanatory modeling—at great length (and such a discussion would ground well my argument in this section). Historical consciousness takes a new shape in the nineteenth century. But for the purposes of this chapter, I intend to focus on the more specific connections between church history and classical history, always with an eye on the British imperial context. This too could certainly merit an extended and detailed account. But again I want merely to underline what seems crucial for understanding the novels toward which I am traveling.

The great model that haunts nineteenth-century historiography is Gibbon's *The History of the Decline and Fall of the Roman Empire*, and no chapters of that masterpiece caused more difficulty than chapters 15 and 16.[45] There are no references to Christianity in *The Decline and Fall* until the last sentence of chapter 14. After chapter 16, the first volume ends, and the second picks up (some years later) with a return to the narrative of Roman power. Chapter 15 and 16, which focus on Christianity, emerge thus as a kind of caesura to the narrative of empire, and are strongly marked out as a separate section. Their ironic Enlightenment rationalism, thus highlighted, provoked an instant outcry from his early audiences, and complaints did not cease even after Gibbon was enthroned as a classic. With exemplary discomfort, Bowdler bowdlerized Gibbon in 1826 "for the use of families and young persons" in an edition that simply omitted chapters 15 and 16 (along with references to nakedness and other corruptions—the decline and fall were, with Bowdler, considerably less vivid). Henry Hart Milman, a historian of the early church as well as Dean of St. Paul's in London, published his emended edition of Gibbon in 1838–39 (reprinted in 1854 and 1882). He attempted to defuse Gibbon's sneering with a more devout version of the early days of the church—he emended away the irony, the sharpness, the *difficulty*. He was followed in 1853 by a cheap, sanitized edition for Bohn's British Classics series, edited by Henry Bohn himself, master of vulgarization. Gibbon's description of the early church remained a historical challenge that had to be faced and, for these committed and devout churchmen, bracketed or silenced.

Nor is it hard to see why. Gibbon's account follows the standard church history, but with such a sardonic distance and such biting criticism that it is

possible to believe, as early readers certainly did, that Gibbon was making Christianity responsible for the fall of the empire, that he was snidely dismissing the ancient sources for Christianity with Thucydidean superiority, and was even challenging the possibility of belief itself in the name of Enlightenment rationality. The rather overheated response to Gibbon probably depends on a rather under-nuanced reading. But it is remarkably striking just how many of Gibbon's sarcasms will be fully worked out in the novels of the Victorian period—and it is really surprising how little Gibbon's influence on nineteenth-century fiction has been noted by modern critics. It is as if the fiction of the next century is written through Gibbon, the unacknowledged draughtsman of the map of failing empire.

This elaborate intertextuality is so pervasive that it would be easy to offer a string of examples. His treatment of the relationship between pagans and Christians is exemplary of the bitter irony of his prose—and it is not hard to see why so many readers were made deeply uncomfortable by it: "The condemnation of the wisest and most virtuous of the Pagans," he writes, "on account of their ignorance or disbelief of the divine truth, seems to offend the reason and the humanity of the present age. But the primitive church, whose faith was of a much firmer consistence, delivered over, without hesitation, to eternal torture, the far greater part of the human species."[46] It is hard to be sunny and simply pious about the early church, faced with the swirling counter-voices of this judgment. Is it just a sign of firmness of faith to condemn the greater part of humanity to eternal suffering? Is the primitive church, as it is properly known, *morally* primitive, in contrast with the reason and humanity of today? Is the church *offensive*? The discomfort readers felt with Gibbon's tone here was exacerbated by a nicely scholarly footnote, which added that this condemnation of those living before Christianity is "still the public doctrine of all the Christian churches," whatever individual Christians may choose to think.[47] There seems to be an invitation to modern individuals—his readers—to distance themselves from church thinking: Notice it is the church, and not God, which delivers the pagans over to eternal torture. Farrar, a century later, was embroiled in a fuss precisely about eternal punishment (as we will see), in precisely Gibbonian terms, after his teacher, F. D. Maurice, was sacked from King's College, London, for his gentle and what his enemies regarded as his unacceptably heterodox views on the same topic, but the fate of the honest pagan runs through many a novel as a post-Gibbonian problem. Are the best pagans, those who help and admire Christians, destined only for eternal punishment? Is Hypatia almost a Christian as she dies? Can one be *almost* a Christian? Does Marius the Epicurean convert finally? Did Seneca's philosophy come close to Christian ideals, and if so does this make him better or worse—a question to which Farrar devoted the good part of a book?[48] The novels give an emotionally laden portrayal of Gibbon's intellectual probing. The extremism of the early church is re-

peatedly tempered into a gentle but firmly principled opposition to the excesses of the empire (wise eyes, fearlessness, and long-suffering integrity are the Victorian watchwords, rather than the violent rejection of family ties, the obsessiveness of asceticism, or a Eulalia's willful pursuit of martyrdom, which modern scholars would emphasize), but there remains a tension between the novelistic interest in complex and riven characters, and the absolute moralism of eternal punishment. What can or should happen to a good pagan, short of conversion and martyrdom?

Gibbon is blunt on the relationship between Christianity and the leading intellectuals of the empire, whom he terms "the most worthy of the heavenly present":

> The names of Seneca, of the elder and younger Pliny, of Tacitus, of Plutarch, of Galen, of the slave Epictetus, and of the emperor Marcus Antoninus, adorn the age in which they flourished, and exalt the dignity of human nature. They filled with glory their respective stations, either in active or contemplative life; their excellent understandings were improved by study; Philosophy had purified their minds from the prejudices of popular superstition; and their days were spent in the pursuit of truth and the practice of virtue. Yet all these sages (it is no less an object of surprise than of concern) overlooked or rejected the perfection of the Christian system. Their language or their silence equally discover their contempt for the growing sect. . . .[49]

Gibbon's classicism has no difficulty in seeing the great figures of the empire as glorious in their search for truth and virtue, and, in true Enlightenment colors, as free of prejudice and superstition thanks to the purifying rationalism of philosophy. Yet these great figures, he firmly underlines, had no truck with Christianity. Again, Gibbon's tone is discomforting: Is there irony in his use of "perfection" for the Christian system? Whose "surprise" or "concern" is being recorded? The passage both undercuts the easy triumphalism of the coming of Christianity, and insistently reminds us of the virtues of the men condemned to eternal torture.

But the novels of the nineteenth century, in contrast with the "contempt" Gibbon records, repeatedly portray historical characters coming into contact with Christianity and being impressed by it, or even converting to it. Seneca meets St. Paul, and they find each other soul mates; Domitian's wife—even more ludicrously—is an intimate of St. Luke; even the future Emperor Titus can make the sign of the cross and is secretly becoming Christian; Acte, Nero's mistress, is a regular Christian—though Gibbon was bitterly sarcastic about the figure of the apparently Christian mistress (Marcia) of the Emperor (Commodus): "though it was impossible that she could reconcile the practice of vice with the precepts of the gospel, she might hope to atone for the frailties of her sex and profession by declaring herself the patroness of the Christians"[50]—few such snide niceties flare up in the novels. Most bizarrely of all, Antinous, the lover of Hadrian,

drowns himself for unrequited love of a pure Christian girl.[51] In fiction, Gibbon's hard gaze is softened: now any pagan can come into contact with a pure and noble Christian and be swayed; those who do reject Christianity, do so with violence and malice (and thus deserve eternal punishment because they are the evil pagans—and often almost parodically melodramatic in their evil). Indeed, for the Victorian novelist it seems hard to imagine any distinguished Roman *without* an upright, honest-eyed, and long-suffering Christian slave.

Gibbon's sharpest critique and most biting sarcasm is aimed at the miracles of the early church. "But how shall we excuse the supine inattention of the Pagan and philosophic world, to those evidences which were presented by the hand of Omnipotence, not to their reason but to their senses?" he asks.

> The lame walked, the blind saw, the sick were healed, the dead were raised, daemons were expelled, and the laws of nature were frequently suspended for the benefit of the church. But the sages of Greece and Rome turned aside from the awful spectacle, and pursuing the ordinary occupations of life and study, appeared unconscious of any alterations in the moral and physical government of the world. Under the reign of Tiberius, the whole earth, or at least a celebrated province of the Roman empire, was involved in praeternatural darkness of three hours. Even this miraculous event, which ought to have excited the wonder, the curiosity, and the devotion of mankind, passed without notice in an age of science and history.[52]

For Gibbon, his Enlightenment commitment to science and to the laws of nature, as much as his Protestant distaste for the miraculous, allows him to juxtapose the silence of the authoritative classical sources with the proliferation of miraculous stories in the early church, with brilliant rhetorical effect—whence came his reputation for sneering and mocking at religion. Even more shockingly, he questioned the extent and violence of the persecution of Christians, and suggests that stories of martyrdom might well have been exaggerated. Since the blood of the martyrs is the seed of the church, as Tertullian, a church father dismissively quoted and then silenced by Gibbon, puts it, this attack goes to the heart of the church's understanding of its own heroic narrative of growth.

Gibbon famously concludes his analysis of the self-serving tales of martyrdom with a credo that captures the threat of historical enquiry to faith: "But I cannot determine what I ought to transcribe, till I am satisfied how much I ought to believe."[53] Gradational belief—"how much"—profoundly challenged the authority of the church and its use of its own past, as Gibbon well knew. (You cannot say "*Credo*, to a degree.") For nineteenth-century theologians, miracles, after Gibbon's leery eye, remained a source of deep contention.[54] If the miraculous stories of the late antique were re-

jected on historical grounds, what did this mean for the Gospels? What was the connection between faith, historical realism, and the miraculous? When and how could healing be seen as miraculous?[55] Between Anglicans, Tractarians, and Roman Catholics, the reasonableness or wonder of miracles became a charged battleground, which shifted its lines of attack over the century. Paradigmatically, Robert Elsmere's crisis of faith—which was for so many readers the paradigmatic fiction of the Victorian crisis of faith—is captured in one emphatic line: "*miracles do not happen.*"[56]

For the novelists, who were in the main Protestants, and many of whom were churchmen, the miraculous was drastically played down and largely limited to Christian recollections of Jesus's life—and sometimes the miraculous was radically rejected. Gibbon made it hard even for the Catholic novelists to write of the miraculous in the style of the Acts or even the Greek novels. Strauss and Renan continued the pressure with their anti-supernatural accounts of the life of Jesus: For Renan, the tale of Lazarus is a "pious fraud"; the miracles no more than stories invented to bolster the status of a good but misunderstood human teacher, turning him retrospectively into a divine figure. The apparition of the Virgin Mary at Lourdes in 1857, with accompanying miraculous cures, caused as much theological consternation as triumphalism (although Lourdes became a hugely successful site of pilgrimage).[57] The events were written up by Henri Lasserre, whose previous publications included a vitriolic attack on Renan. His highly romanticized account went through 142 French editions in seven years, and by 1900 it had been translated into eighty languages and over a million copies had been sold. Even Lasserre, in line with the era's sense of historical propriety, offers official documentation and witnesses to the miracles—and his sales testify to the continuing popular piety in Catholic countries.[58] The Pope declared his belief in the apparitions not long before papal infallibility was promulgated as doctrine. For many Protestants, however, distaste for what was thought to be unseemly scenes about a peasant girl's visions combined easily with disdain for the claim of human infallibility to dismiss Catholic religious fervor, once again, as superstition. Although Strauss and Renan were widely lambasted and lampooned,[59] although Lourdes attracted thousands of visitors, the easy representation of a miracle became a nigh impossibility for the (realist) novel, especially in English. But martyrdom remains a central, lurid, and violent drama of many a story. The calm and religiously infused suffering in the arena or in Nero's garden is taken as proof of the power of the new religion. But martyrdom is firmly a human event: the willingness and peace of the Christian is witnessed by a non-Christian who marvels, and is led toward an appreciation of the new religion as an inner strength. Far from the "extravagant legends" that Gibbon found so distasteful, and which Strauss and Renan filleted, even Catholic novelists strove to write under the rubric of realism,

and portrayed martyrdom as a spectacle of human forbearance. The miraculous survival of St. Thecla in a pool of sea lions ran the risk of looking rather silly both to nineteenth-century historians and to nineteenth-century novelists.

Bulwer Lytton, in *The Last Days of Pompeii*, often viewed as the first and one of the most successful novels on a classical theme, engages with Gibbon's worries about "the struggles of the early church," in his voice as instructional narrator: "Whoever regards the early history of Christianity," he writes, "will perceive how necessary to its triumph was that fierce spirit of zeal, which, fearing no danger, accepting no compromise, inspired its champions and sustained its martyrs. In a dominant church the genius of intolerance *betrays* its cause; – in a weak and a persecuted church, the same genius mainly *supports*. It was necessary to scorn, to loathe, to abhor the creeds of other men. . . ."[60] For Bulwer Lytton, the aggression and intolerance that Gibbon snidely regrets—"scorn," "loathe," "abhor" are not usually held up as winning Christian values—are explicable and even supportable according to a religious Realpolitik for a new and threatened church. In the same light, there is in *The Last Days of Pompeii* a brief walk-on part for a now aged "son of the widow of Nain," who testifies to the biblical miracle of his return from death. But the leading Christian in the novel, Olinthus, is a violent and disruptive man, to whom the narrative refuses the crown of martyrdom. Even though he is imprisoned awaiting a fight with the lions in the arena, the final earthquake allows him to escape to die, without symbolic or theological glory, elsewhere in the conflagration of Pompeii, along with many others. For Bulwer Lytton writing in the 1830s as a maverick liberal (who will end up a conservative),[61] and from a non-evangelical, middle-of-the-road Anglicanism, Gibbon's sharpness can be tempered by some robust political sense.

W. II. Withrow, an American Christian academic archaeologist writing fifty years later, in his thoroughly second-rate novel *Valeria*, is exemplary in his direct scholarly engagement with Gibbon, and in his Christian apologetics, when he declares, "The pages of the contemporary historians, Eusebius and Lactantius, give too minute and circumstantial accounts of the persecutions, of which they were eye-witnesses, to allow us to adopt the complacent theory of Gibbon, that the sufferings of the Christians were comparatively few and insignificant."[62] In the middle of his story, Withrow makes explicit the polemical engagement of his narrative with Gibbon that underlies so many depictions of martyrdom in the novels. So Kingsley reread Gibbon before writing *Hypatia* to see where his emphasis should fall in his depiction of "the spiritual pride, the wasteful asceticism, and coarse fanaticism of the church in the desert; – the intrigue and the faction, the ambition and covetousness of the church in the city," while Newman, Kingsley's opponent in so much, in his turn derided Gibbon for his "cold heart, impure mind, and scoffing spirit."[63] In a wonderfully direct demon-

stration of this influence of Gibbon, John Walker Brown, even though his novel *Julia of Baiae* tells a naïve martyr story, when he wants to construct a background picture of ancient Rome in his opening chapters, simply copies out wholesale a string of sentences from *The Decline and Fall*.[64] More shocking than the plagiarism (from a man of the cloth) is the fact that the cribbing is from such a dangerous source.

Gibbon's sharply sardonic rationalism looms over the historiography of the nineteenth century, especially where the image of the early church is debated, and his shadow stretches over the novels about Rome and Christianity, keen as they are to parade their historiographical credentials. Historical novels are drawn toward the modalities of realism both by the claims of the genre of the novel and by the claims of the genre of history. If it seems hard anyway to fit the wondrous stories of early Christianity into such a form, the difficulty was exacerbated by the acerbic scrutiny of Gibbon, and his rationalist heirs. The novels' reticence on divine intervention, the miraculous, the supernatural, in their stories of early Christianity reflects this intellectual tradition. Hume's criticisms of miracles were carefully studied by the most philosophical readers of the nineteenth century, and modern critics, keen to line up with this most rigorous of critical thinking, have emphasized Hume's influence on nineteenth-century writers. But for the far more widely read novels of religion and the Roman Empire, it is Gibbon, followed by Renan, who form a constant presence in the new discourse of realist historical fiction.

For early Roman history, the German historian Niebuhr has a comparably celebrated role. Niebuhr's impact is less easy to explain, especially in England. He was not the first to question the authenticity of ancient historical sources, nor the first to discuss the role of legends and myths in the construction of early history. Nor when his multivolumed history of Rome was first published in 1811–12 did it attract any notice in England. But when the revised edition was translated between 1828 and 1842 by Julius Hare, Connop Thirlwall, and (for the third volume only) William Smith, it became a lodestone for anxieties about what history should be, and what Roman history in particular meant for Victorian readers.

Ancient history always had the dangerous potential "to inculcate democracy and a foolish hankering after undefined liberty,"[65] but Niebuhr, whatever his own rather conservative political tendencies, was taken to embody the threat of a scepticism that went hand in hand with a radical liberalism in religious and political matters. The shock of Niebuhr will be hard to feel today from his own prose. He states—winningly for his British audience— that "In modern history the English alone have had a career like that of the Romans," and consequently, "these two histories must ever remain the most important ones."[66] He sees history as a vocation, almost a faith. He summarizes the qualities of a true historian—soundness of judgement, well-cultivated and practiced taste, and so forth—and ends with the ringing,

almost biblical endorsement: "above all, *conscientiousness and uprightness, free from all feelings of display and vanity—a blameless walk before God.*"[67]

But he also knew that what he offered was something new: "in former times," he declared, the standard response to classical authority was "simple honest belief." Now he was prepared to declare baldly "The history of the wondrous birth of Romulus is an historical impossibility. . . . This is also the case with the rape of the Sabine women. . . . There is a poetical impress of hoar antiquity in the story of the combat between the Horatii and the Curatii."[68] Niebuhr, that is, was turning a critical analytic gaze onto the authority of Livy, one of the masters of Roman history, and dragging his authoritative account of early history into the precarious and murky world of bards, minstrels' lays, and misty legends—a territory romanticized and radicalized by Wolf, Müller, and others. He was questioning the status of one of "the most important" histories for modern Europe. Worse still, his research into the complex beginnings of humankind suggested even that creation could have taken place at different places and times. Polygeneticism was incompatible with Adam and Eve. Religious truth was set at stake by Roman history.

The excitement of Niebuhr's provocation was aided by his translators' reputations. All were liberals, and from the center of the group that most worried the conservatives. Julius Hare, who became one of Queen Victoria's Chaplains, was married to F. D. Maurice's sister. Maurice, whom we will meet again, was the inspirational father figure of Charles Kingsley, amongst others of the Christian Socialists—and Maurice had studied Plato at Cambridge with Hare. Smith, the quietest of the three, who published distinguished works of lexicography, came from a nonconformist background and taught at University College School, a school unique at the time in its openness to pupils with any (or no) religious belief. Thirlwall, who had been at school with Hare and Grote (and is buried in the same grave as Grote in Westminster Abbey), resigned from his fellowship at Trinity College, Cambridge, because of his involvement in controversies over compulsory attendance at Chapel and the failure of proper theological education for students. He rose subsequently to become bishop of St. David's under the patronage of the Whig government, despite having translated Schleiermacher's shocking commentary of St. Luke, a publication that established his radical credentials and dogged his progress in the church hierarchy for several years. As a bishop, he stood out against preventing Archbishop Colenso from preaching during the so-called Colenso scandal. Thirlwall also was the only bishop to vote for the disestablishment of the Irish Church; he supported the admission of Jews to parliament, and he took a radical liberal position on the Gorham case, which few distinguished, and no high or even conservative churchmen could do. Like Hare, he was great friends with the Prussian diplomat, Bunsen, and was actively

supportive in the establishment of the joint Prussian–English bishopric in
Jerusalem, which so annoyed the evangelical Christians. Indeed, Thirlwall
was the liberal churchman *par excellence*.[69]

Niebuhr's history, then, came trailing clouds of liberal progressivism.
Even so, attacks on him from within conservative circles were surprisingly
fierce. He was for one reviewer "a pert, *dull* scoffer" (as Wordsworth had
called Voltaire), whose work was "pregnant with crude and dangerous
speculations" and the cause of turbulence. Under his influence in Heidel-
berg, "ungovernable youths were holding democratic meetings."[70] Hare
replied with a pamphlet of even greater hostility. In response to what was
actually only a footnote in a review of another book, he turned out sixty
hot-headed pages defending Niebuhr's political stance and his religious
attitude.[71] It is striking, however, that both Niebuhr's detractors and his
defenders agreed that it was inevitable and proper to see in the *History of
Rome* the strong expression of a *contemporary* political position on democ-
racy and the church. And Niebuhr (thus) became a banner under which to
march. In France, Michelet saw himself as following Niebuhr, and, in En-
gland, so too did Thomas Arnold, the Headmaster of Rugby, famously de-
picted in *Tom Brown's Schooldays*, written by Thomas Hughes, great friend
of Charles Kingsley and F. D. Maurice—to complete the liberal, broad
church connection. Arnold's *History of Rome* was begun in the 1830s, while
the first Reform Bill was being debated, and his interest in the checks and
balances of government power in the development of the Roman constitu-
tion were in part motivated by the contemporary parallels he saw in British
politics. From Niebuhr and his followers, Roman history emerged as a
potentially provocative subject, linked to liberal reformist politics in church
and state, heightened by the parallels drawn between the Roman and Brit-
ish constitutions. When the novelists turned to Roman history and to the
development of Christianity within the Roman polity, it was with this
charged historiographical background that their fictions engaged.

George Grote did for Greek history what Niebuhr had achieved for
Rome.[72] E. A. Freeman, the distinguished historian who became Regius
Professor at Oxford toward the end of the nineteenth century, wrote that
Grote's work was "one of the glories of our age and country"—"to read the
political part of Mr. Grote's history . . . is an epoch in a man's life."[73] This
is a telling judgment. It sees Grote as a particular product of the age of
progress and of a singular country, England. This is *located* history, within
time and a national context, to which it speaks. It also insists that engaging
with Grote's politics is a life-changing moment (for a man . . .). As Frank
Turner has discussed in superb detail, Grote's history was indeed a political
event.[74] Mitford, the standard history of Greece for the earliest years of the
century, had been dismissed—unfairly but in significant terms—by Macau-
lay: "He is a vehement admirer of tyranny and oligarchy, and considers no

evidence as feeble which can be brought forward in favour of those forms of government. Democracy he hates with a perfect hatred."[75] As with Niebuhr, ancient history is understood through the prism of the modern historian's political persuasion. As Bulwer Lytton put it, "The history of Greece is for ever modern—it must be the manual and textbook of real statesmen to the end of time."[76] The description of Greece is seen as part of a modern argument about democracy—that is, about reform and the constitution of England. Connop Thirlwall's eight-volume *History of Greece* (1835–45) was in a different scholarly league from Mitford, and after it, no further edition of Mitford was published. But Thirlwall, as the liberal churchman *par excellence*, "wrote from the liberal Anglican view of history."[77] Although he implicitly criticized Mitford's conservative line, he did not vindicate democracy; he used myths to portray the early history of Greece (despite his understanding of Niebuhr), and praised Alexander the Great lavishly.

It was Grote who completed the liberal drafting of Greek history. Grote's history began to appear in 1846, the year after Thirlwall's was completed, and, as had Mitford before him, Grote conceived his history as a "vehicle for contemporary political polemics,"[78] and it was received as such. His sterling defense of democracy saw Athens as a positive model for liberal modern Britain. Where Mitford had seen the lawlessness and mob rule of democratic Athens as proof of the threat of liberal reform in England, for Grote "democratic freedom was the best guarantor of both stability and civic virtue."[79] Grote's work changed the Victorian perception of Athens, and contributed significantly to the debate around political change in the nineteenth century. For the purposes of my argument here, Grote vividly demonstrates the deep-seated expectation that ancient history, whatever the claims of Thucydidean objectivity and the growing criteria of scientific scholarship, was also an active engagement with contemporary politics: a discussion of the ancient constitution could not but comment on modern reforms. In the same light, historical fiction displayed, as Kingsley subtitled his novel, *Hypatia*, "new foes with an old face." And indeed for one reviewer of that book, the whole novel was a simple allegory, where the Alexandrian bishop, Cyril, well known from Gibbon's stunningly negative judgment on his Christianity, was really just Bishop Phillpotts, the protagonist of the Gorham controversy, "The bishop of Exeter, into whose body the soul of Cyril has unquestionably migrated. . . ."[80]

If modern politics was contested through ancient history, the self-understanding of the English and their place in history was also fundamentally altered by modern histories of England, and above all by Thomas Babington Macaulay's best-selling *History of England*, which, as John Burrow has shown, was instrumental in formulating England's special status in the world—understood in part as a sense of the privileged possession by En-

glishmen of their own history: "to be English was to belong to a people privileged in history and worthy of its privilege."[81] Macaulay—whose role in the changing Victorian models of historiography as well as in the construction of an idea of Englishness has been much discussed in recent scholarship—also tellingly embodies the two-way dynamics between fiction and history.[82] On the one hand, his narrative flair was recognized early on as owing a great deal to Walter Scott's historical novels: the style of history writing, its sense of what the story of history can be, its requirement of dramatic excitement or psychological depth, all came about in response to the popularity of historical fiction, much as historical fiction borrowed the scholarly apparatus of footnotes, the citations of sources, and awareness of competing arguments about actuality. Macaulay's early essay on "History," which explores at length the ancient historiography of Greece and Rome, and compares it, more briefly, with modern trends, declares "History begins in Novel and ends in Essay," and he praises Scott, who "has constructed out of [historians'] gleanings works, which, even considered as histories, are scarcely less valuable than theirs."[83] But, with a predictive self-assertion, he concludes that "a truly great historian would reclaim those materials which the novelist has appropriated."[84] Only a history written thus with a combination of reason and imagination "would be not merely traced on the mind, but branded into it."[85] History for Macaulay is about the formation of the mind—its deep formation, its *branding*—and for this the devices of the novelist are necessary. National identity is formed out of such fictional techniques, such storytelling.

On the other hand, Macaulay also wrote the remarkably popular *Lays of Ancient Rome*, which remained a must for schoolboy learning for generations.[86] These poems tell stories of early Roman history—or legend—such as the fight of Horatius, the very tale that had for Niebuhr "a poetical impress of hoar antiquity." Macaulay imagines he is writing a ballad "made about a hundred and twenty years after the war it celebrates."[87] He is consciously echoing Niebuhr's argument about the role of minstrel's songs in the preservation of early history. He finds support in Walter Scott (again) "who, united to the fire of a great poet the minute curiosity and patient diligence of a great antiquary, was but just in time to save the precious relics of the Minstrelsy of the Border." There must have been early "ballad-poetry" in Rome. "'Where', Cicero mournfully asks, 'are those old verses now?'"—Macaulay rediscovers them, as it were, in his own imagination. His aim, he states directly, is "to reverse that process, to transform some portions of early Roman history back into the poetry out of which they were made."[88] The historian, that is, re-creates the old fictions that earlier historians had mistaken for history, as modern critical historians had revealed. Not only are historical novels from Scott onward a fundamental part of this interplay between fictional narrative and analytic historiography,

but also, as we will see, self-consciously explore—or flirt with—the status of their own history writing. Late twentieth-century arguments about the precarious boundaries between fiction and history, like so much of modernism's discourse, have deep, but often unrecognized roots in Victorian culture.

So when George Eliot translates Strauss's *Life of Jesus* and studies Wolf's *Prolegomenon* on either side of writing *Middlemarch*, a novel replete with its images of true and false learning about antiquity, as well as its own commitments to contemporary science, she is exemplary of the active and mutually implicative worlds of novelistic fiction, historiography, and scholarship. When Gladstone sold thousands of copies of a pamphlet on the place of ancient Greece in providential history, what attracted readers was his rather bizarre take on the pressing question of how Homeric scholarship and Bible scholarship affected ancient history's importance for modern Christian Britain.[89] If the Hebrew bible was the origin of Christianity and the Greeks the origin of Western culture, how should they be related? Gladstone's defense of a providential account of ancient history is set against the modern trend by which "The opening volumes of George Grote's *History of Greece* (1846) set the Homeric question and its implicit relationship to the Bible before the British reading public and permanently associated the issues with rationalist, radical, and utilitarian thought";[90] or as Pusey put it schematically, "The scepticism as to Homer ushered in the scepticism in the Old Testament."[91] What Niebuhr and Grote achieved for ancient history, Strauss and Renan achieved for the biblical accounts: a critical Thucydidean intellectualism that challenged the status of stories, a belief in which was central to personal religious identity. The Christian novelist and archaeologist Withrow again cannot resist being explicit: as one of his pagan characters sardonically dismisses tales of Christian miracles, the author adds a footnote, "Strauss and Renan and their rationalizing school rival this pagan sophist in eliminating the miraculous from the sacred record."[92] The new rationalism indeed challenged "the sacred record," both in its sacredness and in its status as true record. Elizabeth Barrett Browning in her popular poem "Aurora Leigh" captures the anxiety nicely:

> Wolf's an atheist
> And if the *Iliad* fell out, as he says,
> By mere fortuitous concourse of old songs,
> We'd guess as much, too, for the Universe.

From Homeric scholarship straight to the constitution of the Universe. . . . Ancient history, like geology or evolutionary science, seemed to put the very order of things at stake.

The political thrust and idealism of Romantic philhellenism (it is not by chance that Elizabeth Barrett Browning starts with Wolf) is translated through critical history into the questioning of church history, which in turn challenges the self-placement of the Anglican in the world. It is within and against this history of historiography that the historical novel comes to the fore in the nineteenth century.

## Fictionalizing the Past

The historical romance, or the historical novel as it later was known, always had a problem with its britches. First, it had to get the cut just right. The antiquary's obsession with detail, sometimes masked as a scholarly concern for science, was quick, insistent even, on catching any slip of verisimilitude. "You cannot be too careful about accessories," as A. J. Church confides.[93] As we saw with the critical response to Alma-Tadema's realism in art, or Gluck's stagings, this fascination with academic precision could swamp any broader concerns with philosophical history or with the moral didacticism of fiction. Historical narrative opened itself to the (negative) judgment of historical accuracy. Anachronism—"the very antiquities and local colour of the time itself are a good deal advanced . . ."[94]—was a slur to avoid.

Second, it always ran the risk of seeming too big for its britches. By virtue of claiming to be more than mere romance and partaking of the privileged authority of history writing, the historical romance also opened itself to charges of falsely claiming a status it did not deserve. "The historical novel is aureoled with a pseudo-sanctity, in that it purports to be more instructive than a mere story."[95] So George Lewes in 1846 violently declared against historical romances: "this false emotion, joined to a false imagination, produces an abortion, to which we prefer the flimsiest of novels."[96] For him, it was a reader's laziness that gave these narratives their allure: "Idleness; - a wish to get at knowledge by a royal route; a pleasant self-sophistication that reading such novels is not a 'waste of time'—these are the great encourager of historical novels."[97] He does grumpily confess that he is really attacking only the claim of bad historical novels to be better than bad ordinary novels—George Eliot had not yet written *Romola* (nor had he met her yet)—but the attack on romantic fiction as weak learning, pretending to educate where it merely amused, recurs throughout the high-minded criticism of the genre.

Lewes was arguing against the self-promotion of the historical novelist that the novel "can give the truth of history without its monotony—the interest of romance without its unreality."[98] Or, most grandly, that "No art

was ever attempted by man more elevated and ennobling than the histori-
cal romance."[99] Leslie Stephen, for his part, simply reversed the novelist's
positive judgment: "Sir F. Palgrave says somewhere that 'historical novels
are the mortal enemies to history'; and we should venture to add that they
are mortal enemies to fiction"—worse than proper history and worse than
proper fiction.[100] Most surprisingly, F. H. Stoddard, a professor at the top
of the tree in New York in 1900, found the whole concept of historical fic-
tion a theoretical oxymoron: "Fiction is the underlying basis of the novel;
fact is the underlying basis of history."[101] How could they ever properly
come together? These antagonistic responses certainly testify to the criti-
cal awareness of historical novels as a genre: indeed many a review of a
novel began with a history of the genre (Saintsbury took it back to Xeno-
phon in the fourth century B.C.E.); and regularly articles explained how
Scott had revitalized the despised genre of the novel, and even, as *Black-
wood's Magazine* claimed, how Scott had *invented* the historical novel (some-
thing hard to square with the long history of the genre). The history novel
itself, that is, was declared to be a sign of the times, a mark of history, and
Scott in particular a great figure "of the age." The hundreds and hundreds
of articles about Scott and the historical novel bolster and perform his ce-
lebrity, a celebrity that the quite remarkable sales figures of his novels most
directly indicate.[102]

George Lewes, Leslie Stephen, and George Saintsbury, intellectual
grandees all, writing from the middle of the century onward, each demon-
strate a certain awkwardness about the popularity of the historical novel,
and its status in relation to historical truth. The more popular the novel,
the more dismissive these lofty critics are—Dumas, for example, comes in
for some particularly harsh treatment for his shallowness. Scott, whose ex-
traordinary popularity stretched across all types of audiences in the first
third of the century, by its last years was simply not in fashion any more—
so that with the archetypal reversal of taste, the connoisseur Saintsbury in
1898 can admit that "I think [Scott] much deeper than it is the fashion to
allow," while the young Lewes in the first flush of the backlash was of the
decided opinion in 1846 that Scott was "not gifted with great powers of
mental analysis"—a judgment of Scott's lack of "clear and all-embracing
intelligence" that F. D. Maurice had already made back in 1829.[103] As the
novels of one generation helped produced the clichés of popular culture
(and the casual assumptions of a less intellectually self-conscious social
elite) for later generations, both individual novels and the genre as a whole
moved between the trendy, the safe, the frowned upon. What "Scott" or
"Kingsley" or "Bulwer Lytton" means, within the self-conscious tradition
of the genre and its critics, shifts within the eddies of hyperbolic praise and
blame, the changing patterns of forgetting and memory, and the develop-
ing understanding of the styles of historical writing. For the novelists of

the Roman Empire, engaging with the ancient world is always also engaging with this baggy and fractious genre of historical fiction.

This self-reflexive generic engagement can seem quite straightforward. *Comrades under Canvas* (1907) is a Boy's Own adventure of no great talent (unconsciously—I assume—and hilariously full of what now reads as outrageous gay innuendo). The boys at Boys Brigade camp are lucky enough to meet a national hero, General Whitmarsh, and have a hike together. It is pointed out that they are walking precisely in the setting of a famous scene in Kingsley's novel *Two Years Ago* (itself a book full of references to other fiction). "'I am glad you know *Two Years Ago*', said the General, 'which books do you like the best?'" The boys produce a paradigmatic list: *Tom Brown's Schooldays*, *The Fifth Form at St Dominic's*, *Lorna Doone*, *Treasure Island*, *Westward Ho!*, *Forty-one Years in India*, *David Copperfield*.[104] The adventure they are having is thus inscribed in a list of great adventure books of the last century—though *Comrades under Canvas* never made it onto the honor roll it hoped to join.

Scott from the start shows how sophisticated this engagement with the genre could be, however. The first Waverley novel, *Waverley*, was published anonymously in 1814. Its opening chapter begins not *in medias res* of the plot, but *in medias res* of a reflection on writing: "The title of this work has not been chosen without the grave and solid deliberation which matters of importance demand from the prudent." It continues with an amused run-through of potential genres of fiction, and how the sound of a title might cue the wrong expectations of a "romance of chivalry," say, or "a tale of modern manners." It also reflects on the structuring of historical and geographical distance: "some favourable opportunities of contrast have been afforded me, by the state of the society in the northern part of the island at the period of my history. . . ." Temporal and spatial distance inevitably provoke social distance ("the state of society"), which will serve "to illustrate the moral lesson" of the novel.

This amusingly self-conscious self-placement is picked up in the novel both by characters reflecting on the effect of tales of the past, and by the narrative voice ("Now I protest to thee, gentle reader . . ."), but reaches a climax in the final chapter, "A Postscript which should have been a Preface"—which ends where it might have been expected to start, with a dedication of the volume to Henry Mackenzie a Scottish novelist, "by an unknown admirer." Scott places his preface here, he states, because "most novel-readers . . . are apt to be guilty of the sin of omission respecting the matter of prefaces"—and also tend to "begin with the last chapter of a work." So putting the preface last is increasing its chances of being read. This playful recognition of the writer's anticipation of his readers' back-to-front habits leads into a backward-looking description of how much Scotland has changed over the last sixty years (the book is subtitled *'Tis Sixty*

*Years Since*), and his own experience of this change ("It was my accidental lot. . . . I have witnessed. . . . I have embodied. . . . I then received. . . ."). The author, that is, represents himself as part of an age of progress, acutely conscious of change, and as a historian reflecting on his narrative and his sources, while teasingly maintaining his anonymity ("an unknown admirer"). The tease worked: for the next ten years, speculation was rampant about who the "author of Waverley"—who continued to publish best-selling novels—might be (until it became an open secret and was finally confessed). But both the game with the persona of the author, the self-consciousness about historical writing, and the willful and playful manipulation of the frame of fiction continued in the Waverley novels.

Take the Dedicatory Epistle of *Ivanhoe*, which does appear at the beginning of the volume. It claims to be a letter from Laurence Templeton (dated November 17, 1817, and written from Toppingwold near Egremont), which is addressed to the Rev. Dr. Dryasdust of York. Both these characters are actually figures from *The Antiquary*, an earlier novel in the Waverley series. The Epistle justifies the choice of subject (the move to an English rather than a Scottish tale) and style of treatment—in a somewhat pompous and affected manner. The novel itself continues the antiquarian posture: "we have only to extract from the industrious Henry one of the numerous passages which he has collected from contemporary historians, to prove that fiction itself can hardly reach the dark reality of the horrors of the period." The supposed extract is properly footnoted "Henry's Hist., edit, vol vii. p. 346." The fictional author nicely articulates how fiction can barely reach the horror of history itself. (Henry's *History* was a well-known book of the previous century: its author, a Member of the Society of Antiquarians of Scotland, died before it was finished, and Book vii, from which Scott cites, was actually written entirely by one Malcolm Lang—which adds another joke, perhaps, to the game of authorship here.) Scott goes on also to cite as a prominent source for his story "the more apocryphal authority of the Wardour MS." But Wardour too is a leading antiquarian character from *The Antiquary*. (And Wardour Street in London, home of an unreliable second-hand furniture market, was a byword for the pseudo-archaic, the sham antique.) The manuscript is apocryphal not in the antiquarian sense of a work of challenged authority, but rather as a work that simply does not exist, that is wholly fictional. Scott, as public debate about the identity of "the author of Waverly" and about critical status of his texts swirled, knowingly enjoys flirting with the concealment of his identity as author, with the historicity of his historical tale, and with the Waverley series as a generic sequence.

*The Antiquary* itself, which some critics (including me) have regarded as Scott's finest novel (and Scott called his own favorite), revels in multiple levels of historicity.[105] The Antiquary himself is a figure of fun for his naïve

views of the past, his constant quotation of Latin, and his fascination with
etymology, as is his bumbling friend, Wardour (of the apocryphal Wardour
manuscript) for his obsession with genealogy and digging for the lost gold
of former days.[106] The Antiquary's discussion of Ossian reminds an audi-
ence of how many (of us) have been excitedly committed to an unreliable
view of the olden days. So the Antiquary hopes that Lovel, the hero of the
story and, as his name suggests, the lover, will write an epic on early Scot-
tish battles, a fictional masterpiece still being hopelessly proposed at the
end of the novel. This historical fiction revels in failed or misleading sto-
ries of the past, or, better still, in the *pleasure* of historical imagination, the
joy in the stories and objects of the past, even when they are destined for
mockery or failure. The narrative of the book itself ambles along from
site to site (the Roman fort that turns out to be modern, the spooky mines,
the stately homes, the sublime view), happy in its own digressive touring.
The scepticism that makes Niebuhr, Grote, Strauss so threatening, in Scott
appears as a source of self-conscious pleasure and amusement within the
historical fiction.

But the novel, *The Antiquary*, itself is a view of history, past wars, past
intrigues. It has a glossary at the end for its strange dialect terms, a linguis-
tic passion parallel to the pursuits of the Antiquary and his friends (remem-
ber Macaulay's praise of Scott the antiquary precisely for saving from
oblivion the poems and language of the distant Scottish past). The book is
fascinated also by the manners, dress, and attitudes of the former era: the
past embodied in the outmoded wearing of a wig. Scott's Notes to *The
Antiquary* follow the final sentence of the story, which tells us that the An-
tiquary "has completed his notes, which, we believe, will be at the service
of anyone who chooses to make them public." Scott draws himself as au-
thor close to the Antiquary—a "self-posturing" that may be "tongue in
cheek,"[107] but which also artfully and humorously mixes the roles of fiction
writer, historian, and mocked antiquary. The description of the Antiquary's
house is uncannily—or precisely—echoed in published descriptions of
Scott's own house with its collection of historical memorabilia. The irony
of the self-posturing also creates a nagging question about the intellectual
authority of the various forms of history writing in its mutually implicative
and competitive guises. When Macaulay, moving toward the claim that the
historian must reappropriate the novelist's power, worries that Herodotus
"perpetually leaves the most sagacious reader in doubt what to reject and
what to receive," he is also trying to reorganize the generic confusion, the
confusion in authority, that Scott has allowed.[108]

I have focused on Scott to this extent because his work highlights three
essential and interrelated issues for historical fiction about the Roman Em-
pire, and because, as by far the most popular and celebrated historical nov-
elist of the early years of the century, his influence in this is inevitably

pervasive across the field. First, Scott underlines how the boundary be-
tween history and fiction, their different claims on the real or the historic-
ity of historical narrative, is a constant source of concern. So W. H. With-
row D.D. in his novel *Valeria, the Martyr of the Catacombs: A Tale of Early
Christian Life in Rome* signs himself as "Author of *The Catacombs of Rome and
their Testimony Relative to Primitive Christianity*," and in the preface states
paradigmatically:

> The writer having made the early Christian Catacombs a special study for sev-
> eral years, and his larger volume on that subject having been received with great
> favour . . . has endeavoured in this story to give as popular an account as he could
> of early Christian life and character . . . he has been especially careful to maintain
> historical accuracy in all his statements of fact, and in filling up of details he has
> endeavoured to keep the historical "keeping" of the picture.

And the reader is directed to the note at the end of the volume which
advertises the big academic book, price and all. Popular writing—in this
field—needs to ground itself in the scholarly. In the same vein, Wilkie Col-
lins in *Antonina* explains that he rejected writing a book starring historical
characters because he would be obliged "to fill in with the colouring of
romantic fancy the bare outline of historical fact," and did not think he
could do a really coherent plot "without some falsification or confusion of
historical dates"—but nonetheless he proudly affirms that "exact truth in
respect of time, place, and circumstance is observed in every historical
event in the plot." Or, as Victor Hugo, put it, equally self-servingly and
equally tellingly: "Fiction sometimes, falsification never."[109] As he gets to
the city of Rome, Collins aims to depict "the living, breathing, actions and
passions of the people of the doomed Empire"—and consequently "Anti-
quarian topography and classical architecture we leave to abler pens, and
resign to other readers."[110] Even—especially—for a gothic fantasist such as
Collins, it was difficult to write historical fiction about the classical past
without such authorizing gestures: fiction needs to parade truth, and the
truth of history was located in academic testability.

Second, this desire to locate fiction within academic history affects the
form of the novels. Both the novels that focus on early Christianity and
those that focus more closely on pagan life, parade their footnotes, declare
their moments of anachronism, and support their fiction with a display of
scholarship. So in Farrar's *Darkness and Dawn*, his narrative slides in the
same paragraph between reflective commentary on the times—"The let-
ters, and all the latest writings, of Seneca vibrate with terror"—and appar-
ently direct story-telling—"'And death', he [Seneca] said to himself, 'means
only not to be'"—and scholarly support. He adds to Seneca's words a foot-
note: "Sen. *Ep.* liv: 'Mors est non esse.' *Troades*, v. 393: 'Post mortem nihil
est, ipsaque mors nihil.'"[111] Farrar weaves together in his narrative a histo-

rian's distance, a narrator's storytelling, and a scholar's apparatus. More often, as in Edwin Abbott's *Onesimus*, endnotes give sources for the novel's speeches or arguments. So Bulwer Lytton's *The Last Days of Pompeii*, the first great historical novel set in the empire, has a preface, footnotes, and endnotes, and throughout the text makes regular comments on the relation between the past and the present, including a passionate plea on the contemporary politics of Italian unity. It should also be clear that in both the conceptualization of the boundary between history and fiction, and in the formal devices of scholarship within the narrative, Scott's playfulness and sophistication find few parallels in the novels about Christianity and the Roman Empire. Sales figures from the nineteenth century and the modern predilection for literary cleverness suggest that both Victorian and modern readers value Scott's writing more highly than most of the footnoted novels on classical themes. This difference between Scott on the one hand, and Farrar and the rest on the other, may not rest just on aesthetic evaluation, however. Classics and the history of the early church have an institutional structure and inherited earnestness behind them that eighteenth-century Scotland cannot match, even when its characters fight in the cause of religion. Even Farrar's footnotes lack the self-conscious wit of Scott's scholarly apparatus, and this helps locate these novels of the ancient world more firmly, more consistently *seriously*, within a didactic and morally driven historical framework. As Carlyle famously (and self-servingly) wrote in 1838, Scott is "not profitable for doctrine, for reproof, for edification . . . the sick heart will find no healing here, the darkly struggling heart no guidance; the Heroic that is in all men no divine awakening voice."[112] All too many of the novels on early Christianity seem to set out to fulfill Carlyle's hopes for history writing, and the seriousness of their scholarship reflects this hunt for the menacing trinity of doctrine, reproof, and edification.

Archaeology in particular mattered. The challenge to the authenticity and reliability of the biblical narrative was countered by archaeological expeditions to ground the scriptures in the irrefutable physical remains of the Holy Land. (Or, as in the case of the search for evidence of the Exodus from Egypt, to fail hopelessly.)[113] The lure of Pompeii for novelists from Bulwer Lytton onward was the apparently direct contact with the materiality of the past as a grounding for the narrative, and Bulwer Lytton goes so far as to identify each of his characters with a skeleton uncovered from the ruins, as if his story was an act of revivification, a resurrection, rather than a fictional construction. Schliemann's discovery of Troy had so powerful an effect on the Victorian imagination and was embraced so enthusiastically by Gladstone precisely because it appeared to vindicate the narrative of Homer after the attack on the reliability of Homer from Wolf onward, a critique which had been an instrumental element in the modern sceptical attitude to the past even, and especially of, the Bible.[114] Novels that tell

the story of early Christianity in the Roman Empire footnote their ar-
chaeological authenticity—and describe houses at length and clothing and
other accessories, in order to locate their stories within the authentication
of the real. The account of Christianity authorizes itself by its manifest—
demonstrated—material reality.

Third—and this is inherent in the first two points—there is a telling lack
in Victorian historical fiction of any consistent attempt to maintain the
frame of fiction. Rather, constant attention is drawn to the present time
(and place) of the reader and writer, and thus to the negotiated and con-
structed distance between present and past. Of course, there are novels
where the boundaries of the fictional world are maintained, but these are
few and far between (Gissing's *Veranilda* is unfinished, and late, but will do
as an example, though even here there is one small footnote identifying the
modern name of an ancient town). But the combination of the intru-
sive narrator's voice, familiar from the eighteenth century, together with
the scholarly apparatus, and the insistent pointing out of the relation of the
past to the present, make the figure of the author as scholarly *cicerone* an
essential part of the horizon of expectation in Victorian historical fiction.
This is in striking contrast, I think, with modern historical fiction. Mary
Renault, Robert Harris, Stephen Saylor (and so forth) construct a fictional
world from which modernity, in the form of a recognition of the reader or
the writer as a modern figure looking back, is excluded, although Rome as
an allegory or model for today is a constant potential, fully exploited by,
say, Robert Harris's *Imperium*. The boundary of the fictional ancient world
is maintained, even in the case of the knowing humor of a Lindsay Davies.
Even when, as with Harris or Saylor, there is an endnote that lists modern
and ancient sources, this is more a question of copyright or research cre-
dentials than the authorization of a historical vision. And the endnote is
clearly separate from the fictional world of the narrative in place, print,
and voice, unlike, say, Withrow's discussion of Gibbon in the middle of his
story. The closest we get in modern fiction to the pervasive Victorian
frame-breaking is in a passage of prophecy like this from Robert Harris's
*Pompeii*:

> "She [the Sybil] saw a town—our town—many years from now. A thousand years
> distant, maybe more." He let his voice fall to a whisper. "She saw a city famed
> throughout the world. Our temples, our amphitheatre, our streets—thronging
> with people of every tongue. That was what she saw in the guts of the snakes.
> Long after the Caesars are dust and the Empire has passed away, what we have
> built here will endure."[115]

The image of Pompeii as future tourist site is fully within the frame of
the novel as a prophecy of the Sybil, recalled with awe by a character; it is
further buttressed by its echoing not only of Macaulay's famous image of

the New Zealander looking out across a ruined London, but also of classical reflections on the passing of empires and the destruction of once great cities, which Macaulay also evokes. The passage is knowing, for sure, but part of its knowingness is in its refusal to recognize explicitly the modern reader. Modernity is heard only "in a whisper." And even such moments as this are few and far between. Of course, there are exceptions here, too, though perhaps not among mainstream novels about the ancient world: two of the best-known examples are Fowle's *The French Lieutenant's Woman* and Byatt's *Possession*, both of which have an academic narrator prodding and directing the story with an apparatus of scholarship. Significantly, both are self-consciously *Victorian* pastiche. And ironically, and tellingly, with little understanding of how thoroughgoing the pastiche is, critics repeatedly single out this scholarly frame-breaking as a specific sign of these novels' modernism![116]

The tension between these two models of historical fiction—breaking the frame, maintaining the frame—may be marked and facilitated by a series of novels and short stories, mainly from around the turn of the century, often set in Pompeii, which depict modern travelers who dream, fantasize, or hallucinate themselves into the past—that is, who maintain the frame of fiction, but still manage to express a strongly articulated distance between the contemporary world and antiquity. Jensen's *Gradiva* is particularly well known, thanks to Freud's analysis. Norbert Hanold, a young archaeologist, becomes obsessed with a figure on a Roman frieze. He dreams about Pompeii and decides that Pompeii is where the girl ("Gradiva") must have come from, and visits Pompeii. As he walks in the ruins, he sees a girl whom he thinks *is* Gradiva ("It was a noonday dream picture that passed before him and yet also a reality."). He begins to lose control over actuality, as, in a marvelously evocative phrase, there "stirred a feeling that death was beginning to talk." The city itself seems to come alive in its ancient colors and glory: "He felt from the secret inner vibrations that Pompeii had begun to live around him"; "The dead awoke; Pompeii began to live." By the end of the narrative, the girl turns out actually to have been his neighbor in Germany, and he returns, "cured," as Freud puts it, for modern life (and marriage). The experience of living Pompeii is determined as a temporary aberration. But, as Freud noted—and Freud himself, with his collection of antiquities in his study, and his fascination with uncovering the past, was very much like the archaeologist hero of the story, though surprisingly he did not himself care to analyze this parallel[117]—the tale depends on "the wish, comprehensible to every archaeologist, to have been an eye-witness of that great catastrophe of 79."[118] For Freud, the desire that motivates historical research, is the desire of being there, in the past, as it happened. In *Gradiva*, such desire emerges in dreams, imaginative projections, obsessive and delusional behavior. Thus the hallucinatory imaginings of Hanold

become a disturbing model for the very motivations of historical narrative: wandering in the ruins, till the dead speak. . . .

Perhaps the earliest of these tales is Théophile Gautier's feverish short story of 1858, *Arria Marcella*, where a young man, suitably named Octavian, has a dreamy sexual encounter with a woman of ancient Rome: "All normal conceptions of time were now hopelessly confused in Octavian's head. He came to believe that the Pompeii in which he was walking was not the dead, frozen corpse of a city half dragged from its shroud of ashes; but a living Pompeii, a youthful and unblemished city, over which the torrents of burning lava from Vesuvius had never flowed."[119] In the swirling of his confused consciousness, the modern hero slips back into a different, vivid, and insistent historical world. In the same vein, Hugo von Hofmannsthal, the exemplary modernist, visits the Parthenon, and, while he is obsessing about his inability to experience the past fully ("This was Athens. Athens? So this was Greece, this antiquity. A sense of disappointment overwhelmed me. . . . Does nothing penetrate me?"), a phantom of Plato walks past him, mocking his inability to participate in the lost glories of former years.[120] The past as a living ghost . . . Hofmannsthal's "ever searching" encounter with the phantom of Plato, like Octavian's sexual embrace with a woman of ancient Rome, images the desire of the writer for antiquity—and the desire is strong enough, it seems, to bring the lost past into the present or to transport the self into that lost world. These stories seem strikingly remote from the didacticism of Farrar or Bulwer Lytton—and each, tellingly, is European, not British—and it is not by chance that each has been taken as a harbinger of modernism.

It is hard to be certain what this fascinating difference between Victorian frame-breaking and twentieth-century frame-maintenance betokens, but it is worth hazarding a tentative general answer, not least because it may seem at first blush surprising that it is in the realist tradition of the nineteenth century and not in the modernist tradition of the twentieth where we see the predominance of such self-conscious display and manipulation of the author's authority.

One broad context through which to understand this difference must be the changing status of classical education in the general reading public for whom the novels are written. A Victorian reader might be expected to approach a novel with a style and content of learning that would encourage a close reading of historical detail—in a way that few modern readers may now bring to the table. Of course, every modern novelist reports stories of weird and overexcited readers writing in to point out historical errors: Lindsay Davies has declared that she inserts two deliberate mistakes into each novel to deflect—excite?—such interest. But the need to bolster a text with the apparatus of scholarship changes as the status of such scholarship changes in society. As *The Times* can no longer use Greek and Latin with-

out translation,[121] so the readers of the novel are less likely to have been brought up on Republican history and a detailed reading of Cicero. And, as we have seen, the importance of archaeology in arguments over the status of Holy Scripture as well as classical texts informs the scholarly apparatus of the Victorian novel in a way that lacks purchase in the changing religious and scientific concerns of the later twentieth century. So, too, the association of a free indirect discourse with the privileged status of the novel as a literary form within culture, and the parallel association of trickiness about levels of the real in narrative with literary modernism (a twentieth-century phenomenon), determines these modern novels about the past as *traditional*—a positive value (in this context) tied up with the status of the classical itself as well as with the projected market of readers. These novels are designed and sold to a large audience as "a good read," for which sophisticated game-playing with authorial status is thought anathema.

But beyond these very general cultural shifts, I think there is also a further question about history at issue here. At one level, the difference between modern and Victorian historical fiction seems to suggest a different positioning for the reader: the Victorian reader, constituted as a historical subject, located in the here and now, turns back to see the difference of the past, perhaps for doctrine, reproof, or edification, and is constantly asked both to recognize the gap between present and past, and to consider with what authority it is constructed by an author; but the modern reader is asked to engage with (to accede to) a fully formed fictional world—to lose oneself in a good story, as the advertising would put it. This is a prime example of the Victorian historical (self-)consciousness at work.

At another level, this difference between frame-breaking and frame maintenance seems to suggest a different sense of history itself. The stories of power with which modern fiction is obsessed (Alexander, Augustus, Caesar . . .), or the detective stories set in the ancient world, certainly allow the ancient world to be a model for today, or even an allegory of it. (Rome as America? So goes Robert Harris's *Imperium*; even *Pompeii* has been described by its author as if it were a *roman a clef*—"Pliny the Elder in *Pompeii* is Roy Jenkins.") But what is at stake in Rome for the modern reader and writer is by and large conceived in a different way from that in Victorian culture. For the Victorian historical perspective, Rome matters because it is where we—as moderns—have come from. The past held the germ of the present and the future. The classical world is firmly a privileged and inevitable origin of Western culture, to set besides the moral source that is Israel, and, as we have mentioned and will see in detail later, historical fiction is interwoven with accounts of national identity and nationalist history. For the modern reader and writer, Rome does not matter in this way. So ancient Rome must be populated (also) by earnest Christians in Victorian fiction, where there is no such compunction in modern fiction. The

historical past in modern fiction does not matter because it inevitably leads
to and thus explains the present, but because it offers a mirror to it. Ancient
history plays a different role in the story of national, religious, and cultural
identity. It's not just that Rome no longer self-evidently constitutes one of
the two most important of histories; it is also no longer self-evidently *our*
history.

The self-implicating complicity of "our history" also produces what will
emerge as a foundational tension within the corpus of Victorian novels
about the ancient world and Christianity. There are three, much discussed
elements that go toward the construction of this tension. First, there is the
dominant role of classical education in the Victorian period, which I have
just underlined as a crucial factor in the writer's anticipation of his or her
readers' expectations. ("His or her" is no mere lip-service to correctness:
classical education and novel writing are both deeply gendered fields in
Victorian culture, and the gender of the writer and of the audience makes
a significant difference.)[122] Classical novels played a part in education.
They were discussed explicitly as teaching tools: children's books make up
a particular subgenre. There is even educational discussion on how to write
historical novels. A. J. Church, writing in a magazine for girls interested in
fiction, tries to warn them off ancient subjects: "I could not recommend
any one not well provided with classical scholarship to choose such a
theme." Since it was so hard for any girl to be "well provided with classical
scholarship," the assumption of male superiority smiles dismissively
through this advice.[123] "Nothing can give a writer a more stiff and uneasy
gait than the sudden and hasty adoption of the toga," adds Bulwer Lytton,
flush with his own success as a novelist.[124] But the privileged status of
the classical world, enshrined in the privileged status of a classical edu-
cation, is integral to the reception of these novels: *our* history, as *our* educa-
tion insists.

Our history, our education—but not uncontested. Bulwer Lytton him-
self, looking back no doubt toward Scott, contends that "to paint the man-
ners, and exhibit the life, of the Middle Ages required the hand of a master
genius," but this was perhaps an easier task than to turn to Rome, because
"With the men of the feudal time we have a natural sympathy and bond of
alliance; those men were our ancestors—from those customs we received
our own. . . . We trace in their struggles for liberty and for justice our pres-
ent institutions; and in the elements of their social state we behold the ori-
gins of our own."[125] Bulwer Lytton's still liberal views inform his particular
account of the olden times as a precursor of the contemporary fight for
reform, a true, radical Englishness. But he sees no such sympathy with the
Roman past: "But with the classical age we have no household or familiar
associations." Indeed, "they are rendered yet more trite to us by the schol-
arly pedantries which first acquainted us with their natures, and are linked

with the recollection of studies which were imposed as a labour, and not cultivated as a delight."[126] At first blush, this seems an extraordinary claim. Not only is an active engagement with the classical past an expectation in all levels of educated Victorian society—familiarity with the classics is the very mark of being a gentleman—but also as one otherwise slashingly rude reviewer of Bulwer Lytton's works conceded "His works bustle with Latin and Greek, and he always expresses himself with the easy confidence of a man to whom the life and languages of antiquity are perfectly familiar."[127] It is better, thus, to see Bulwer Lytton not so much as denying the importance of Classics as distancing his prose from the tedium of schoolroom classics as a preemptive disclaimer: this will be classical but not the dull rote of remembered schooldays. This gesture is indeed frequently repeated as novelist after novelist promises the classical past but untinged by the boredom and rigor of the classroom—classics, as Byron always hoped, with the sex and glamour put back in.

Second, there is the earnest debate about religion that runs throughout the nineteenth century, which made the novels a battleground of belief, a fight over the image of early Christianity. Missionaries, the warriors of evangelical Christianity, were likened to early Christians traveling in places that did not yet know the Gospels. (It is here where the religious narratives abut most directly on the expansionism of empire, though the relation between missionaries themselves and the officials of the British Empire were complex and variegated.[128]) It is hard not to read the repeated scenes of evangelical persuasion and conversion in the novels against such a background, much as the novels' depictions of the delights or horrors of sexual abstinence consciously echo heated arguments about the asceticism of the Oxford Movement's Anglo-Catholicism. Early Christianity is portrayed as a challenge to and rejection of the values of ancient Greco-Roman society. Our history, because early Christianity will explain what Christianity should mean for us, a history that puts our immortal souls in the balance.

So Bulwer Lytton, having declared with whatever disingenuousness that the classical age has no "familiar associations" continues—and the tension between these views seems hard to reconcile—"It was the first century of our religion . . . the conduct of the story lies amidst places whose relics we trace; the catastrophe is among the most awful which the tragedies of Ancient History present to our survey." This is a past "we trace" (in archaeology as well as in narrative). It promises the most awful tragedy to "our survey" (our interest and emotions will be excited), but above all it is the beginnings of "our religion." Hence, our commitment to the narratives of ancient history. The most successful novel of religious faith in crisis was probably Mrs. Humphry Ward's *Robert Elsmere*, which sold over 200,000 copies in America and was a *cause célèbre* for a decade after its appearance in 1888. Like her hero, Mrs. Ward's own crisis of faith was prompted precisely

by the study of ancient history. As she wrote to a friend, "What convinced *me* finally and irrevocably was two years of close and constant occupation with materials of history in those centuries which lie near the birth of Christianity."[129] By complementary contrast, Cardinal Newman also found ancient texts crucial to his spiritual conversion: "My stronghold was antiquity . . . I saw my face in that mirror, and I was a monophysite."[130] Newman sees the modern world reflected in antiquity, and for him the study of antiquity leads not just to a rejection of Protestantism, even the "middle way," but to his conversion to Roman Catholicism—rather than the rejection of faith that Mrs. Ward and Robert Elsmere experienced. For Victorians, struggling with the evidence for Christianity, it was not "science," as the contemporary academy tends to think, so much as *"the education of the historic sense* which is disintegrating faith."[131] Ancient history as a subject proved a profound threat to the self, the religious self. Here we see most clearly how the study of Classics was defended earnestly and actively by members of the church at precisely the same time that the critical study of ancient Greek and Latin sources was undermining the authority of the traditions of the church.[132]

Third, Englishness and the reach of empire are constantly invoked. In part, the easy Orientalism and racial physiognomics of the novels regulates a normative Englishness. ("This deformed Hercules was no solitary error of Nature—no extraordinary exception to his fellow-beings; but the actual type of a whole race, stunted and repulsive as himself. He was a Hun.")[133] Physiognomics is a growing scientific racialized discipline in the nineteenth century[134] and the novels focus obsessively on the Greek profile of its heroes, or the brutish barbarian grimaces, or the clear Nordic faces. Closely linked to the art that illustrates these books, there is a strongly physical language of race and nation running through each story (which performs the spread of physiognomics in social discourse). In part, historical novels also love to focus on crossing points, key junctures of national history: the coming of the Romans, the invasion of the Normans, the clash of humanism and scholasticism, the Jacobite rebellion. A perfect example is the wonderful book, *The Wonderful Adventures of Phra the Phoenician* by Edwin Lester Arnold (1890). (The book has a laudatory preface by his father, Edwin Arnold, who was head of the Sanskrit College at Poona, before becoming editor of *The Daily Telegraph*. He was a major figure in mediating Eastern culture and especially Buddhist religious ideas to England.[135] The preface was written from Japan, where he lived with his third wife, a Japanese woman. As editor, he sent Stanley to the Congo. Edwin Lester Arnold, in short, comes from a particularly interesting empire background in terms of engagement with the Other.) Phra is a sort of time-traveler. He is a Phoenician who, when threatened with death, falls asleep only to wake

from the grave centuries later. Thus he participates in the major crises of
national history, from the Druids' resistance to Rome up to the Elizabe-
than Renaissance, and experiences the changes of the country over the cen-
turies. A constant outsider, who can turn an anthropological gaze at En-
glish culture, but who becomes an insider in each era.[136] For Phra, this life
upon life becomes a question of identity, which is an emblem of the over-
layered identity of the English, the palimpsests of the modern nation: "Was
*I* a Roman, I wondered. . . . What was I? Who was I?"—and, centuries
later, "In truth I was more English than I had thought."[137] Our history,
because the past leads to, and explains, who we are.

But—and here is the grounding tension—can the privilege of the ideal-
ized classical world live alongside the rejection of the values of the classical
world by Christianity? Which past determines the Englishness of the mod-
ern world? How easy is it to reconcile a training in pagan authors with the
rhetoric of Christian living? Walter Pater's strange novel *Marius the Epicu-
rean*, a novel almost entirely without dialogue (and pictures, as Alice would
have noticed), is in many ways not typical of the toga dramas that dominate
the corpus. But it is absolutely exemplary in that its hero on the one hand
epitomizes the learning, elegance, and sophisticated thinking of Greco-
Roman culture, the classical ideal embodied; and, on the other, comes into
contact with—falls in love with—the embodiment of the gentle virtues of
a new Christianity. Can the two ideals be brought together? The novel's
narrative leaves this question in suspense, and ends in an aporia of doubt,
stopped only by the death of the hero. For Pater in Oxford, accused as he
had been of fostering religious doubt by the final chapter of his *The Renais-
sance*, precisely because of his relishing of sensual artistic pleasures, *Marius
the Epicurean* was a heartfelt exploration of the profound ambiguities in
his own cultural experience. In less complex but no less anguished terms,
Mrs. Humphry Ward worries that a modern reader will flee from the bi-
zarre miracle-laden and socially rebarbative tales of early Christianity back
to the Classical world of Greece and declare "*You*. . . . *You* are really my
kindred."[138] Which genealogy from the past will define the present? Whose
history? The novels about Christianity and the Roman Empire may often
seem to contribute with a gung-ho spirit to the ideology of nationalism and
empire, but they also can provide a more explorative contribution to the
concerns about national, religious, and cultural identity that are central to
Victorian historical consciousness. History is our past, but *how shared* is
that past?

Classics is ever an alibi for sex and violence. The novels know this, and
their glamour moves easily into the cinematic world of Hollywood. But
Classics is also a space for the most awkward and searching self-reflection

about identity and the past. Novels about early Christianity and the empire follow both of these conflicting vectors, and this is what gives them their particular cultural power.

With this much general framing, we are now ready to look in detail at how the novels function within it, to see how their representation of the ancient world forges the cultural imagination, and, as Macaulay puts it, brands the mind with a narrative of the past.

## Chapter 6

❀ ❀ ❀ ❀ ❀ ❀ ❀ ❀ ❀ ❀ ❀ ❀ ❀ ❀ ❀ ❀ ❀

# VIRGINS, LIONS, AND HONEST PLUCK

## The Knebworth Apollo

Edward Bulwer Lytton was "not an easy man to like."[1] His lifelong friend Disraeli may have called Charles Greville the vainest man who had ever lived, but he added "and I don't forget Cicero and Lytton."[2] To match Cicero as a byword for vanity—and Disraeli was well placed to draw up an all-time list of the vainest of the vain—takes some doing, especially in the eyes of a friend.[3] Thackeray, no friend, more bluntly disdained him as the "Knebworth Apollo"[4]—"bloated with vanity, meanness and ostentatious exaltation of self";[5] Lockhart wrote to Scott when *Pelham*, Lytton's silver-fork novel of 1828, was published, that the writer was "a Norfolk squire and horrid puppy. I have not read the book from disliking the author."[6] Kingsley dismissed him as "a self-sustained, self-glorifying hot house flunkey."[7] Rosina, his wife, separated from him, scandalously, partly because his womanizing, combined with his jealousy, had become intolerable; and she wrote a series of bitter novels with scarcely disguised portraits of Lytton and his family, which were scabrous enough for Lytton to attempt to get an injunction against her publishing (and his son to get an injunction against her biographer quoting from his father's letters).[8] He even tried to have her committed to a lunatic asylum, a ploy that failed in the face of rather too strong a public outcry. He was a publicly dislikeable celebrity.

The reviews of his writing, especially in the more high-minded journals, were often equally scathing, extreme even for the intense rhetoric of Victorian reviewing, especially as the century progressed. "It would be difficult to extract a dozen pages which show any real command over the English language," opined the *Westminster Review* of his collected oeuvre in 1865, adding on his *History of Athens*, it is "a very bad history no doubt—flashy, superficial, pretentious."[9] "Tinselled truisms feature as new discoveries and obscurity of meaning passes for elevation of thought," summarized *The Athenaeum*,[10] and, as late as 1932, Queenie Leavis expressed her deep distaste for his "pseudo-philosophic nonsense and preposterous rhetoric."[11] Charles Kingsley, in politest mode, chipped in with criticism of Lytton's "washy and somewhat insincere *blague*."[12]

Yet not only was he hugely popular with readers—readers he snobbishly disdained as "the common herd," by whom he felt "little understood, and superficially judged,"[13] at least when his books were less successful than he hoped—he also received critical praise of the very highest order. Margaret Oliphant regarded him as "the first novelist of his time"[14]—surpassing Dickens and Thackeray—and in 1859 the *Encyclopaedia Britannica* declared him "now unquestionably the greatest living novelist." He was lauded for precisely what the critics most hated in him, his philosophizing: "The volumes of Mr Bulwer are imbued with a deeper tone of philosophy . . . than those of his great contemporaries."[15] Ruskin captures the contrasts neatly. In 1836, when seventeen, he wrote in the full flush of youthful enthusiasm that an encounter with Bulwer Lytton's writing "must always refine the mind to a great degree, and improve us in the science of metaphysics."[16] In 1840, with slightly more maturity, he confessed to his diary that "Everybody has a spite at Bulwer because the public thinks him clever and they don't."[17] With its opposition between "everybody"—the self-elected elite, and "the public" (the non-us)—Ruskin's judgment captures how Bulwer Lytton's writing typifies in extreme form the problem of historical romance in general: its popularity can never disentangle itself from critical distrust; its pleasures are guilty ones.

*The Last Days of Pompeii* was written and published in 1834, after Bulwer Lytton and Rosina had visited Italy on a disastrous trip of some months that precipitated their separation. ("Poets ought to be strangled for all the lies they have told of this Country . . . take away the Fine Arts from Italy— and it becomes a dirty Barbarous *Ugly* Country," wrote Rosina home, disconsolate and unromantic, in every sense of the word. They had traveled to reconcile after months of unpleasantness in England, but on the boat out, Rosina discovered that Bulwer's mistress and her compliant husband were on the same ship. In a fit of pique in Italy, she took a lover for herself, a Russian grandee, Prince Lieven. This all precipitated years of violent hostility between the Lyttons, in what was one of the most unpleasant of all Victorian marriages.) Bulwer Lytton, however, was thrilled to visit Pompeii with Sir William Gell as his guide—though Lytton had not yet read Gell's great archaeological study of Pompeii—and found there the inspiration for his novel, of which he wrote a good deal even before he returned to England. It was an immediate commercial success, and had a remarkable effect on the history of the novel. It proved foundational for the whole genre of toga fiction. It was certainly not the first of such novels, and Bulwer was impressed by art he had encountered as well as history books he had read and plays he had seen.[18] Nonetheless, *The Last Days of Pompeii* set in place many of the narrative and ideological structures that were to become the commonplaces of the fiction of the Roman Empire.

The Roman Empire, in part by virtue of its imperialism and in part by virtue of the commercial and political lure of Rome itself, was a multicultural society where zones of contact were frequently tense and regularly discussed as such by classical authors: the Rome of Juvenal's leery gaze, say, offered an image of a crowded, expanding, noisy metropolis where aristocratic Romans despised not just Jews and Syrians, but also the pushy and sinuous Greeks, whose literature and arts they had adopted; a city where modernity and traditional values, luxury and poverty, clashed in scorn and spite, and where the threat of violence, class difference, and the misuse of power repeatedly surfaced. It made Rome an inevitable model for London. Bulwer Lytton's novel offers a particular and strikingly organized matrix of national identity in the face of this multicultural milieu, a concern reflected also in his other published writing, not just in works such as *England and the English*, with its account of the specificities of his own nation, but also in talks he gave around the country such as "Outlines of the early history of the East," given at the Royston Mechanics Institute, halfway between his constituency at St. Ives and London.

There are four different groups in the Pompeii of the novel, defined by nationality, race, or religion: Greeks, Romans, Egyptians, and Christians. The novel first works to separate these interrelated groups, socially, morally, and physiognomically, and then, in the broadest narrative line of the novel, allows the Greeks to transcend all the other groups by becoming a new sort of Christian. Glaucus and his love, Ione, both integrally and passionately Greek, survive the eruption of Vesuvius, escape to Athens—the novel preserves only them, a true heritage—and there, in a narrative twist that seems somewhat forced, they adopt a mild and moderate Christianity, bringing a Greek cultural idealism precariously and relievedly in line with the modern religious requirement, according to Lytton's middle-of-the-road Anglicanism.

Glaucus, the hero, is regularly termed simply "the Greek," and described as if he were a Greek work of art: he "was of that slender and beautiful symmetry from which the sculptors of Athens drew their models; his Grecian origin betrayed itself in his light but clustering locks, and the perfect harmony of his features."[19] He has the profile to match his "exquisite taste," amusingly and typically brought up to date by Lytton, with the author's snobbery, as ever, to the fore: his house "would be a model at this day for the house of 'a single man in Mayfair'—the envy and despair of the coelibian purchasers of buhl and marquetry."[20] A Romantic philhellenic idealism combines comfortably with the expectations of romantic fiction hero: "Heaven had given to Glaucus every blessing but one; it had given him beauty, health, fortune, genius, illustrious descent, a heart of fire, a mind of poetry, but it had denied him the heritage of freedom. He was born in

Athens the subject of Rome."[21] An echo of the modern fight for Greek freedom, the political rallying cry of the liberal heroes of Lytton's adolescence, becomes by the end of the book a triumph of Greek values over Roman. "Oh what can Rome give me equal to what I possess in Athens?" writes Glaucus, rejecting the excitement of a trip to Rome, in the final pages of the novel.[22] Unlike Tertullian's celebrated cry, "What has Athens to do with Jerusalem?" Glaucus, the new Christian, revels in the Greek city precisely for its Greek heritage: "In the streets, I behold the hand of Phidias and the soul of Pericles. Harmodius, Aristogiton—*they* are everywhere—but in our hearts!—in *mine*, at least, they shall not perish!"[23] Glaucus's exclamatory prose does not find freedom in and through his Christianity, as one might expect. His love and his religion can only "support [him] partly against the fever of the desire for freedom."[24] National self-determination is still his abiding commitment, even though he knows that "there is no perfect freedom till the chains of clay fall from the soul"[25]—that is, in death. Indeed, his Greek nature means that he stands out against the zealots among the Christians who cry for eternal punishment (and here the Gibbonian polemic is loud and clear): "some mixture of the soft Greek blood still mingles with my faith. I can share not the zeal of those who see crime and eternal wrath in men who cannot believe as they."[26] Greekness and Christianity come together in the search for freedom—but always conducted with elegant taste and refined sensibility: a "heart of fire, a mind of poetry."

The opposition of Greek to Roman which becomes vivid by the end of the novel has been prepared for throughout. Ione's "Greek soul despises the barbarian Romans, and would scorn itself if it admitted a thought of love for one of that upstart race."[27] (This may be Arbaces, the Egyptian, speaking, but this view at least receives confirmation throughout the narrative.) Magic, we are told, "was alien to the early philosophy of the Greeks," but "under the Roman Emperors it had become, however, naturalised in Rome (a meet subject for Juvenal's fiery wit)."[28] Somehow, magic, although usually thought of as primitive, and tamed by rationality, was not part of early, and thus true, Greece; it was always an outside force for the Greeks—but was "naturalised" in Rome (as Juvenal, a Roman, but a good classical source reveals). The accusations here may not be wholly consistent, and, as such, testify to the work of the discourse's attempt to keep Greece as pure as possible, by denigrating Rome, even when a Roman writer is the inevitable and proper authority for the denigration. The Roman characters in the novel, Clodius and Diomedes, one "a young man of small stature who wore his tunic in those loose and effeminate folds which proved him to be a gentleman and a coxcomb," the other "a man of portly frame and middle age,"[29] are committed gamblers, gluttons and cheats, and turn out to typify Roman corruption, which, as ever, finds ex-

pression in a full-scale description of the bloodlust of the arena, a fascina-
tion of so many later novels. The crowd bay for blood, and in the catastrophe
that destroys Pompeii, the Romans reveal depths of avarice, selfishness,
and cruelty that guarantee their deaths within the moral economy of the
book. Classics and Christianity are brought together by polarizing Greece
and Rome: Greece emerges as the origin and preserver of the values that
inform a noble and moderate Christianity, while Romans become the epit-
ome of a corruption, not merely transcended by the new moral order of
Christianity, but also destroyed deservedly because of its evils.

What place, then, for the Egyptian? Arbaces is certainly the dominating
figure of evil in the novel, who combines the three great Victorian sins of
religious hypocrisy, sexual degeneracy, and foreignness, in a fine portrait of
seductive and manipulative nastiness. As such, he fits easily into the stan-
dard novelistic stereotypes of ancient Egypt for the early decades of the
nineteenth century: tyrannical, dangerous, and corrupt. But Arbaces is also
clearly not aligned with the (corrupt) Romans, whom he himself hates and
despises—he is far more dangerous, and thus more interesting, in terms of
the discourse of race and morality. His body announces this conceptual
danger immediately: "His skin, dark and bronzed, betrayed his Eastern
origin; and his features had something Greek in their outline (especially in
the chin, the lip and the brow), save that the nose was raised and aquiline;
and the bones, hard and visible, forbade that fleshy and waving contour
which on the Grecian physiognomy preserved even in manhood the round
and beautiful curves of youth."[30] This physiognomy needs careful reading
to make it "betray" its otherwise potentially concealed origin; he could be
taken for Greek by a casual glance, though the nose and bone structure are
not fully Hellenic. What's more, "a deep, thoughtful and half-melancholic
calm seemed unalterably fixed in [his dark eyes'] majestic and commanding
gaze. His step and mien were peculiarly sedate and lofty." He has the pres-
ence and the seriousness of a born ruler. Even his status as an outsider is
not clearly denigrating: "something foreign in the fashion and sober hues
of his sweeping garments added to the impressive effect of his quiet coun-
tenance and stately form."[31] Foreignness in Arbaces adds to his impressive-
ness, his stateliness. Arbaces's physicality is dangerous because, unlike the
Romans, its otherness is close to a Greek appearance; it impresses and
commands attention. Arbaces is seductive, and his threat is not merely that
he leads men and women astray, but also that he looks like a real leader. In
the novel, Arbaces manipulates others through spectacle, deception, and
false promises; his body emblematizes his power. Even his name Arbaces is
falsely adopted.[32] Fascinatingly, Arbaces makes claims for the primacy of
Egypt, which rehearse the very arguments used repeatedly in the later de-
cades of the century (as well as in Martin Bernal's *Black Athena*) to establish
Egypt as the true origin of Western culture, with the consequence that

"the glory of Greece was but the After-glow / Of her [Egypt's] forgotten greatness."[33] So for Arbaces, "Egypt . . . is the mother of Athens. Her tutelary Minerva is our deity; and her founder, Cecrops, was the fugitive of Egyptian Sais."[34] Claiming Egypt as the mother of Greece—his blood as the origin from where the Greekness of Glaucus comes—confuses the genetics of nationality. When Lytton has a pillar fall and cut Arbaces in half, and takes the young lovers back to Athens and children of their own, he is reordering the discursive threat of Arbaces in the most direct narratological way.

Lytton himself, however, also seems to find Arbaces his most interestingly complex character, "one of those intricate and varied webs in which even the mind that sat within it was sometimes confused and perplexed."[35] He constructs a seven-page analysis of the Egyptian's inherited racial characteristics and personal deformations as a "sensualist," a picture where desire for Ione is intertwined with ambition, passion for power, rage, political humiliation, self-regard.[36] The image of desire that emerges here, in contrast to the pure and rather familiar lineaments of the love of Glaucus and Ione, is surprising both in its depth, and in some of its formulations: "The Egyptians, from the earliest days, were devoted to the joys of sense; Arbaces inherited both their appetite for sensuality and the glow of imagination which struck light from its rottenness."[37] Does this really mean, as it appears to imply, that the imagination, that prime Romantic faculty, can find light even in the corruption of sensuality, that especially anti-Christian physicality? With the right imagination, can sensual experience lead to true insight? If so, it is easy to see why Lytton's critical readers found his philosophical pronouncements so provocative—for their profundity or their banality or their obscurity. The figure of Arbaces, and through him the idea of an Egyptian inheritance within national characteristics, are certainly denigrated in the novel, but his closeness to the ideals of manhood, and his self-aware manipulation of the anxieties and self-deceptions of society, also make him awkward to fit simply into the moral and national dynamics of judgment. Egypt, as we will see with other novels, too, remains a topos that needs special mapping in both the classical and the Christian imaginary.

The Christians in *The Last Days of Pompeii* are represented in the most unexpected way. Olinthus is, as I mentioned in the previous chapter, "sanguine and impetuous," "fierce and intolerant" in his denunciations of Pompeian society.[38] But his theology is mocked by Arbaces as being but a dim recollection of earlier and greater Egyptian mythology, where the Trinity echoes the tale of Osiris: "the believers of Galilee are but the unconscious repeaters of one of the superstitions of the Nile."[39] What will become a commonplace of comparative mythology later in the century is sufficiently

worrying even to its author that Lytton adds a defensive footnote: "The believer will draw from this vague co-incidence a very different corollary from that of the Egyptian." It seems as if Lytton is concerned that he may have made Arbaces too convincing, or as if he is worried that Arbaces's voice might be mistaken for the author's—and the Trinity is an especially vexed topic in contemporary theological dispute. Perhaps he was right to be worried. Robert Taylor in the 1830s was imprisoned on a charge of blasphemy, and his subsequent book *Diegesis* traced scriptural ideas to Egyptian sources; he defiantly scrawled "Everything of Christianity is of Egyptian origin" on the walls of Oakham Gaol.[40] Lytton also depicts Olinthus as he walks the streets open to all sorts of insults of which "'Atheist' was the most favoured and frequent."[41] But from this scene he draws a surprising moral: it "may serve, perhaps, to warn us, believers of that same creed now triumphant, how we indulge in persecution of opinion Olinthus then underwent, and how we apply to those whose notions differ from our own the terms at that day lavished on the fathers of our faith."[42] The author, like his hero Glaucus, is insistent on tolerance and generosity as necessary Christian values, even if they are not on display from the Christian characters in the novel. Olinthus is condemned to martyrdom in the arena, but is prevented from this glorious end by the earthquake and the eruption of Vesuvius. The final sight of him in the novel is profoundly and troublingly ironic. Silhouetted with his supporters against the skyline, in the crisis of destruction, he is standing uselessly proclaiming again and again "Yea; the hour is come." For the Christians, this is the Last Day, the foretold end of the world, heralding the Second Coming. Glaucus may have discovered Christianity through his encounter with Olinthus in prison, prepared for it as he was by his father having heard St. Paul in Athens, but nonetheless Olinthus dies, unmartyred, in a false belief that a volcanic eruption is the end of time. It is hard to evaluate the moral tone of this narrative undermining, and the destruction of its leading Christian and his community.[43]

Apaecides, Ione's brother, who starts the book as a disaffected priest of Isis and ends as a committed if callow and overzealous Christian, is also removed from the narrative by a convenient death—murdered by Arbaces. (In order to leave Glaucus and Ione together and alone at the end of the story, even the blind girl, Nydia, who saves their lives, has to commit suicide.) Apaecides is described as "heated and excited";[44] along "with his holier feelings were added those of a vindictive loathing at the imposition he had himself suffered and a desire to avenge it." Apaecides epitomizes the zeal of the convert—the zealotry Lytton complains of repeatedly—and thus he too becomes a victim of his own extremism. It is easy to see Lytton's distaste as aimed at contemporary pre-millennial evangelical zealots. We

will see many conversion scenes in the novels that follow Lytton, but none allows this sense of dangerous emotional instability in religious feeling. And none violently removes the Christian figures with such narrative exigency.

Apaecides does have the most uncanny religious encounter in the novel, however. As he walks alone in the woods, contemplating, he meets an elderly Christian pilgrim, who turns out to be the son of the widow of Nain (Luke 7.1–17), whom Jesus miraculously brought back to life. This is the boldest experiment with Christian narrative—to imagine a resurrection from the point of view of the dead and resurrected corpse. "The youth felt his blood creep and his hair stir. He was in the presence of one who had known the Mystery of Death!"[45] The Gothic elements of this scene are evident—meeting the revenant in the woods and relishing the horror of the tale—but it also allows Lytton a moment of Christian idealism, too: "The whole heart of that divine old man was bathed in love; the smile of the Deity had burned away from it the leaven of earthlier and coarser passions, and left to the energy of the hero all the meekness of the child."[46] Even Glaucus can only dream of the chains of clay falling from his soul; the old man seems to have reached a freedom beyond the passions that motivate every other character in the book. But this scene is also unique in its willingness to represent the miraculous (in the world of post-Gibbonian historiography). It resists the historiographical traps of relying on martyr texts, or of directly representing a supernatural scene. Rather, the first-person recollection authorizes the miracle, as the scene imagines the transmission and effect of such a tale. There is a standard device in the novels where a Greco-Roman character meets a saint or similar figure from the scriptures, who tells his—almost always *his*—story, which profoundly affects the soul of the listener. So Seneca meets St. Paul, or an empress meets St. Luke in a Roman tenement as she makes a charitable visit (Roman slumming). But no other author, at least until the shock of Marie Corelli in 1893, went as far as Lytton in attempting to capture a resurrection—in a novel which is, after all, itself a resurrection of the city of the dead.

So the saint wanders off into silence and obscurity; the other, fierce Christians die in a self-deceptive passion in Pompeii; the corrupt Romans perish in the conflagration, foolishly and ruinously clutching the objects of their greed; the Egyptian, finally, is sliced in two by a pillar; the blind girl, still hopelessly in love with Glaucus, kills herself silently. Lytton's narrative has a brusque formal simplicity aimed at bringing his two lovers home to Athens, alone, to embody a Hellenic idealism coupled with a tolerant and cultivated Christianity that sounds uncannily familiar to a low Anglican in the 1830s.

Lytton's sense of history in *The Last Days of Pompeii* shows the marked influence of Scott, and sets the agenda for many of the classicizing novels to come over the next seventy years. First, the strongest connection we

make with the past is through the emotions: we all share a universal human nature. Lytton expresses this "doctrine of the unchanging heart"[47] in characteristically overheated—emotional—prose:

> In the tale of human passion, in past ages, there is something of interest even in the remoteness of the time. We love to feel within us the bond which unites the most distant eras—men, nations, customs perish; THE AFFECTIONS ARE IMMORTAL!—they are the sympathies which unite the ceaseless generations. The past lives again, when we look upon its emotions—it lives in our own! That which was, ever is! The magician's gift that revives the dead—that animates the dust of forgotten graves, is not in the author's skill—it is in the heart of the reader![48]

Emotions are the bedrock of historical continuity and of comprehension of the past: transcultural, transtemporal norms. History's power is thus "in the heart of the reader." The powerful rhetoric of complicity here encourages us to find the past coming alive inside us, revivifying magicians all.

Second, the continuity of time from Roman days to now is constantly asserted: the Roman society of Pompeii stands as a model and foundation for today, an explanatory past. So, in one of the most surprising authorial interventions, as Glaucus reflects on his lack of political freedom as a Greek in the Roman Empire, the narrative slips from generalizations within the indirect discourse of Glaucus—"Ambition in the regions of a despotic and luxurious court was but the contest of flattery and craft"[49]—to a contemporary political harangue by the narrator: "Italy, Italy, while I write, your skies are over me—your seas flow beneath my feet. Listen not to the blind policy which would unite all your crested cities, mourning for their republics, into one empire; false, pernicious delusion!"[50] Lytton's anti-Risorgimento sentiments emerge from within Glaucus's political reflections on power and freedom in empires and small cities. The past is present at the moment of writing, and becomes the frame of continuity within which the scene of writing is formulated.

The archaeological gaze embodies this sense of history most vividly. Lytton never lets the reader forget that the book is based on archaeological observation, culminating in the extraordinary identification of each of his characters' skeletons in the contemporary excavation, specifying in the guise of modern phrenological or physiognomic science the remarkable skull shape of his proposed Arbaces, "so striking a conformation, so boldly marked in its intellectual, as well as its worse physical developments that it excited the constant speculation of every itinerant believer in the theories of Spurzheim."[51] Indeed, so strong is this overlap of authentication via archaeology and fiction's world-making, that in Knebworth, Lytton's country house, there are still two skulls from Pompeii on display, labeled bizarrely but wonderfully with the names of Arbaces and Calenus, presented to the

author by the antiquarian and mountaineer John Auldjo, and displayed as archaeological discoveries (still complete with the handwritten inscriptions of identification in a special case).[52] Arbaces and Calenus are the two figures in the novel to receive full physiognomical descriptions. I have already cited the description of Arbaces, which sets his Egyptian skull in contrast to the "Grecian physiognomy." Calenus is a more straightforward villain: "His shaven skull was so low and narrow in front as nearly to approach to the conformation of that of an African savage, save only toward the temples, where, in that organ styled acquisitiveness by the pupils of a science modern in name, but best practically known (as their sculpture teaches us) amongst the ancients, two huge and almost preternatural protuberances yet more distorted the unshapely head." The racial or national commitments of the science of the body are vividly on display. The slippage here between fiction and (archaeological) science encourages us to see in the display of these dug up skulls the physical embodied truth of the ideology of race, religion, and nation that underlies *Last Days*. Typically, as the narrator as cicerone describes the forum of Pompeii, he spots "a schoolmaster . . . expounding to his puzzled pupils the elements of the Latin grammar," to which he adds a footnote, explaining that this detail is based on a picture in the Museum at Naples—and offering his younger readers a "learned consolation" that their grim schoolroom experiences are "of high antiquity."[53] The focalization slips back and forth between English present and Roman past, intertwining them together through the preserved picture in the museum, to create the writer's archaeology of his own description. The footnote at the bottom of the page becomes like another layer in the stratigraphy of Lytton's historical narrative, the page itself a visual collage of the forms of history writing and fiction.

## The Fiction of the Church

Lytton's commitment to the universality of human emotions and his performance of what we can call the archaeological stance become central strategies of the classical novels over the next seventy years. By mid-century, Lytton's blithe low Anglicanism already seemed very out of date, as the zealotry he disparaged became a dominant cultural force in British society. As John Walker Brown, an undistinguished evangelical Episcopalian American novelist, put it in his 1843 novel *Julia of Baiae*: Lytton "failed in representing truly the religious spirit of the Roman world amid its decaying superstitions, and an awakening philosophical spirit."[54] In the rows over Tractarianism from 1833 onward and its associated mid-century anti-Catholicism, in the continuing rise of a more aggressive Protestant evangelicalism with increasingly fervid missionary activity at home and abroad, and in the challenges of (post-)

Straussian historical criticism and its counter-challenges from conservative theologians, the nineteenth century "witnessed the most intense religious controversies that Britain had seen since the seventeenth century."[55] It became a difficult environment in which to be blithe, religiously. John Henry Newman was central to this history, not only because of the celebrity of his move from Tractarian Anglican to Catholic cardinal, but also, for the purposes of this chapter, because he made the classical past integral to his religious journey. Indeed, his books *The Arians of the Fourth Century* (1833) and *The Church of the Fathers* (1840) were aimed "originally against Protestant ideas," and helped make the early church a fiercely contested arena for Christians.[56] The moves in Church of England Christianity toward investing greater authority in individual bishops and priests, toward increased asceticism, in both fasting and celibacy, and toward monastic withdrawal; all discovered their foundations in the early church. The explanatory and authorizing link between classical past and present became a site of strident contemporary religious disagreement. How could Protestants counter the claim of Catholics of an unbroken tradition of the church back to St. Peter? Could the early church be set against the institutions of Catholicism in the name of Protestantism? It is against such fundamental questions of authoritative history that we should view both Gray's desperate discovery of the longevity of the Anglican Church in England, and the novels from the mid-century onward, which depict early Christianity, often with an equally polemical bias.

Charles Kingsley entered the lists with his novel of 1853, *Hypatia*, which was re-printed many times, particularly from the late 1870s onward, as the genre of early Christian novels became more and more popular. Gibbon had told of the murder of the Hellenizing philosopher, Hypatia, by a fanatical mob of Christian monks. His brief if lurid paragraph uses the language of the martyr texts—"her flesh was scraped from her bones with sharp oyster shells, and her quivering limbs were delivered to the flames"— but this prurient precision of violence against a woman ("*quivering*") serves to criticize, as ever for Gibbon, the zealotry and aggression of the early Christian authorities: "the murder of Hypatia has imprinted an indelible stain on the character and religion of Cyril of Alexandria."[57] Kingsley takes this story (and its tone) and expands it into a full-scale novel, whose anti-Catholicism is strident, even for mid-Victorian hostility toward "papal aggression."

His central hero is an Egyptian monk, Philammon, who travels from his monastic, desert community to Alexandria. There he discovers the chaos of a multicultural city, the grim politics of ecclesiastical power, and the confusions of sexuality. He is deeply attracted to Hypatia, a seductively austere Neo-Platonic lecturer; he discovers his long-lost sister, Pelagia, who has worked as a singer and erotic dancer—her foot has trampled, literally,

in the blood of a martyred Christian child—and is now the mistress of a Goth, a northern warrior. He wishes to convert both women to Christianity, and in his attempts discovers his own weaknesses and strengths. He struggles with his own desires, with his difficult relation to religious authority, invested in all too flawed ecclesiastical individuals, and with the natural muscular expression of his personality (he is a good man to have on your side in a fight, like other Kingsley heroes, though with more monkish regrets). This story is played out against the grand political narrative of the conflict between the bishop, Cyril, and the Prefect of the City of Alexandria, in the context of the imperial upheavals of the fifth century. A subplot leads Raphael Aben-Ezra, a wealthy and sophisticated Jewish associate of Hypatia, to fall in love with a noble and idealized Christian girl, called Victoria (of course), and to convert for her love. It is Raphael who meets Augustine and Synesius (the two most distinguished African Church fathers of the period), in line with the genre's dictum that a great Christian figure of the relevant period and place must cross the canvas of the story and influence one of the characters of the novel.

There can be no doubt that Kingsley's novel is aimed directly at contemporary polemics. "And now, readers, Farewell," his final paragraph states, "I have shown you New Foes under an old face—your own likenesses in toga and tunic, instead of coat and bonnet." And in case the narrative has not been clear enough, the preacher Kingsley cannot resist drawing the moral: "One word before we part. The same devil who tempted these old Egyptians tempts you." He ends with a hope that God may "save you," and with a moment of piety ("Let him that is without sin among you cast the first stone, whether at Hypatia or Pelagia, Miriam or Raphael, Cyril or Philammon"), but he leaves little room for hesitation about who the enemy is, who you must be saved from: the ideology and the practices of the Eastern church, which stands for its modern, Roman institution. For Kingsley, the church of the fifth century created a disaster, a disaster brought to pass by the progress of history, a progress understood as a racial, as much as religious, providence.[58]

The East had severe disadvantages, disadvantages that are stained with a nineteenth-century racial ideology: "Climate, bad example, and the luxury of power degraded them in one century into a race of helpless and debauched slaveholders". . . . "The races of Egypt and Syria were effeminate, over-civilized, exhausted by centuries during which no infusion of fresh blood had come to renew the stock. Morbid, self-conscious, physically indolent, incapable, then as now, of personal or political freedom, they afforded material out of which fanatics might easily be made, but not citizens of the kingdom of God."[59] The link between climate, effeminacy, corruption, and the lack of political freedom is a stereotype of the East that goes back to Herodotus and the Hippocratic treatise *Airs, Waters, Places*, but

Kingsley adds a further nineteenth-century theme, to join his Gibbonian and anti-Anglo-Catholic distaste for fanaticism, a theme that runs throughout Kingsley's writing. For what was needed, he states, was "new blood," new blood to be found in the "great tide of those Gothic nations, of which the Norwegian and the German are the purest remaining type."[60] The East seemed "barred, by some stern doom, from the only influence that could have regenerated it,"[61] and even the West only survived because of the "infusion of new and healthier blood into the veins of a world drained and tainted by the influence of Rome."[62] The northern races, the Teutons, come as saviors for Christianity, infusing into Christian life Kingsley's necessary Protestant values of hardiness, rigor, muscularity, to counter the taint of Catholicism: This power from the North is *"our race."*[63]

Wilkie Collins in 1850, reveling in the potential for grotesque horror in the late antique—Gothic in all senses—already had set up a clash between "The Roman and the Goth: the opposite in sex, nation and fate," and between Christianity and the last lingering touches of Paganism, with its "wretched impostures, the loathsome orgies, the hideous incantations, the bloody human sacrifices perpetrated in secret" (and rather too lovingly described in the novel).[64] Here, too, the northern races come to save Western civilization. Rather dispiritingly, such thrills and violence are in service of a historical vision of "the destiny that future ages had in store," where "the 'middle classes', despised in [that] day, was to rise in privilege and power; to hold in its just hands the balance of prosperity of nations."[65] From the horror of paganism to the householder of Surbiton. . . .

This overarching racial theory of history, with its language of purity, stock, and breeding, is combined by Kingsley with a divinely ordained narrative: "Some great Providence forbade to our race, triumphant in every other quarter, a footing beyond the Mediterranean or even in Constantinople."[66] Providence resulted in a weak East, which could not finally resist the faith of the invading Mohammedans. The contemporary world order where the Western empires lined up against the Ottoman East, and where the Protestants eyed Papal aggression with such suspicion, and where a British belief in political freedom demanded a tie between constitutional history and national character, had, in Kingsley's vision, deep religious and historical roots—Providence.[67]

Kingsley's story is poised at the juncture when the church could have taken a different route—"a critical and cardinal" era.[68] Monastic life produced the opportunity for the necessary work of theology "with a lifelong earnestness impossible to the more social and practical Northern mind."[69] But monastic life also drew men away from a Christian decency and "that living God whom [they], while they hated and persecuted each other for arguments about Him, were denying and blaspheming in every action of their lives"[70]—with the result that "The Egyptian Church grew, year by

year, more lawless and inhuman". . . . "till it ended as a mere chaos of idolatrous sects, persecuting each other for metaphysical propositions, which, true or false, were equally heretical in their mouths because they used them only as watchwords for division. Orthodox or unorthodox, they knew not God, for they knew neither righteousness, nor love, nor peace. . . ."[71] Those that live by the sword. . . . Their destruction by the forces of Islam is seen finally as a Providential punishment.

Christian practice was severely flawed, then. Kingsley sums up the failure of the ideology of the Eastern church more succinctly: It was severed from "the very ideas of family and national life—those two divine roots of the Church."[72] Monastic life constituted an isolation from the duties of patriotic political engagement (as in *Westward Ho!* or *Hereward*), and from the duties of fatherhood, motherhood, and sexual life (so transgressed in *The Saint's Tragedy*). The desire for renunciation of the flesh also had a racial explanation: "the passionate Eastern character, like all weak ones, found total abstinence easier than temperance."[73] Modern critics have been quick to see Kingsley's own sexual life behind his fixation on the dangers of monastic abstinence.[74] His wife had nearly joined a Puseyite nunnery before their marriage: "This anxiety over a happy marriage almost lost permeated his attack on ancient and modern celibacy and monasticism."[75] Kingsley's own highly eroticized practice of sexual abstinence—when separated from his love, they agreed to lie each in their own beds, naked, at an agreed time and think about each other, lying naked in their beds—may also encourage a personal reading of the sexual discourse of *Hypatia*, which is altogether knowing about the powers of sexual fantasy and repressed desire. But the political force of Kingsley's representation of the corruption of the East—celibacy rather than the degeneracy that lured Lytton's imagination—is aimed firmly at contemporary Anglo-Catholic asceticism, and was seen as such by his Victorian readers. Kingsley depicts extreme asceticism, and celibacy in particular, as the resort of weak character that leads to violent social division and the dangers of zealotry. The consequences of this are racially, religiously, and nationally disastrous, as the East will go on to fall to Muslim forces. Rome—the Catholic Church—offers the same taint, and modern moves toward asceticism and celibacy under a guise of Anglo-Catholicism are thus indeed Old Foes in a New Face. Kingsley's agenda could not be clearer.

The meeting of Raphael Aben-Ezra with Synesius and Augustine is particularly interesting within Kingsley's polemic. Raphael is a sophisticated and wealthy Jew who is well trained in Greek learning and is an intimate of Hypatia. The narrative will win over this prize for Christianity. By 1853, the long-expressed desire for the conversion of the Jews had taken on a particular instantiation with the combination of a very active mission to the Jews and the political project of Restorationism, the return of the Jews

to Palestine, which many Christians, especially evangelicals, actively supported and which had been much discussed in the national press from the 1840s.[76] But more importantly within Kingsley's narrative, Raphael not only is won over by the two bishops but also tells Hypatia in such emotive terms that she too is shaken to her core. When she dies it is, as we have seen in chapter 1, almost as a Christian, just as her brutal murderers are Christian only in name. Synesius, a hunting squire of a bishop, who also was an intimate of Hypatia, is well-known for his Platonic philosophizing and resistance to celibacy—the least ascetic, most Hellenizing, of church fathers. Raphael has very mixed feelings toward a man he calls "that most incoherent and most benevolent of busybodies."[77] But Augustine wins him over by a eulogy of marriage (after praising virginity). Kingsley actually added sixteen new paragraphs on the delights of wedded bliss between the serial publication and the story's appearance as a novel.[78] Hypatia is shocked by this desertion of the ideals of Platonic asceticism: "Wedded Love? . . . Wedded love? Is that, then, the paltry bait by which Raphael Aben-Ezra has been tempted to desert philosophy?"[79] Yet it is precisely as a supporter of "pure and wedded love" that Raphael dies fighting for his land, observing "the very ideas of family and national life." Against the Egyptian Church embodied by the evil Cyril, the Church Fathers Synesius and, above all, Augustine speak up for married life and national duty. Through the conversion of Raphael, the early church articulates Kingsley's Protestant ideal, finding a positive historical foundation for his own beliefs.

Cardinal Wiseman and John Henry Newman were swift to reply to Kingsley's polemic with *Fabiola* in 1854 and *Callista* in 1855. Wiseman's *Fabiola* is altogether more pious and less exciting than *Hypatia*. It explains disarmingly in its preface that it might seem a little disjointed—it does seem so—because it was put together over a period, in scraps of time between more pressing duties. It also points out with as explicit an ideology as Kingsley's that the material of the book is taken from the Roman Breviary and from the offices of the saints whose narratives it portrays. The Church of the Catacombs is here the origin of the Church of Rome in unbroken and idealized historical descent. *Fabiola* introduces two of the great themes of conversion and faith for the novels, the promise of eternal life and the bravery of martyrdom. The heroine Fabiola struggles with the death of her father and is desperate to understand mortality: "Poetry had pretended to enlighten it," comments the narrator, "Science had stepped in, and come out scared, with tarnished wings, and lamp extinguished in the foetid air; for it had only discovered a charnel-house."[80] Philosophy, too, had proved useless: it "had barely ventured to wander round and round, and peep in with dread." Christian faith alone will provide the light into the grave that Fabiola seeks—and Wiseman offers a page of ecstatic prose imagining a slave's transcendent vision of light through the promise

of Jesus. (Later novels are far charier with such ecstasy, but repeatedly imagine, with a missionary zeal, that the promise of an afterlife is instantly persuasive.) The martyrdom of the young hero, Pancratius, is equally full-bloodied in its Catholic imagination. The wild animals at first, miraculously, will not touch the boy. He begs the emperor to send in a panther, the animal that killed his own father: "It was a panther which gave him his crown; perhaps it will bestow the same on me."[81] The crowd is stilled with awe. Then the panther leaps. "The arteries of his neck had been severed, and the slumber of martyrdom at once settled on his eyelids. His blood softened, brightened, enriched, and blended inseparably with his father's, which Lucina had hung around his neck" (in an amulet).[82] Wiseman, unlike so many a Protestant author, first allows a miracle, then displays the boy's preternatural calm and joy in his incipient death as a martyr, and then imagines, like Tertullian, how the blood of the martyrs nourishes the future church, with the extraordinary three verbs, "softened, brightened, enriched." Wiseman's novel enshrines the saints as intercessionary figures, sanctified by their suffering. He explicitly encourages the reader to study *The Acts of the Martyrs*, "if the modern Christian wishes really to know what his forefathers underwent for the faith," which are "more natural, graceful and interesting . . . than the boldest fictions of romance."[83] There is no trace here of the historiographical criticism of a Niebuhr, Strauss, or Gibbon. Indeed, in a chapter called "A Talk with the Reader," Wiseman gives a history of persecution of the early church that rebuts Gibbon's critical reading of the sources. *Fabiola* sets out to rewrite sixty years' of critique in a revisionist Catholic narrative.

Newman was commissioned to write *Callista* as a prequel to *Fabiola*, and it appeared in 1855.[84] It tells the story of St. Callista, a pagan girl, who converts to Christianity only after she has been arrested for it, and is martyred brutally. She was in love with Agellius previously and rejects marriage along with her former life. Agellius, however, collects sand soaked in her blood as a relic, and witnesses the first miracle, a cure of a possessed madman, at—by—her holy body in its grave. The description of the torture of the girl, and the miracles associated with her relics, were provocative statements of Newman's commitment to the veracity of ecclesiastical miracle stories, and associated him firmly in the minds of Protestant readers with suspicious, foreign, Catholic practices. In the body of the text, with typical Victorian interest in historiography as well as in the evidences of Christianity, Newman cites two documents. The first is a relief representing a tribunal and a girl being dragged off for punishment, found in Sicca, the site of Callista's tale: a material sign, as it were, of the Christian past in conflict with the Roman establishment.[85] The second is a fragment of the *Acta Proconsularia* of her passion—her cross-examination by the Procurator. Newman worries that her answers to the Procurator were taken down

by a heathen notary, and so may not be accurate, but "As it is, we believe it to be as true as any part of our narrative, and not truer."[86] Newman is well aware of the arguments over the authenticity of such documents, and with self-conscious slipperiness accords the report as much truth as the rest of his narrative—that is, he turns back on the reader the act of faith, the act of discovering the real higher truth in such evidence. As an intellectual position, this is far harder to pin down than Wiseman's hagiography. In view of Kingsley's later accusation that "truth for its own sake" was not a Catholic commitment, Newman's elegant shimmy here is like a red rag to a muscular Anglican bull.

Newman wickedly satirized Protestant attempts to write novels with titles such as "The Lays of the Apostles," "The English Church Older than the Roman," and "The Anglicanism of the Early Martyrs." He had good cause. Several history textbooks, especially for younger readers, and at least two novels make not just England but precisely *Gloucester* the true origin of Christianity. The local historian, Samuel Lysons, whose uncle was a distinguished local antiquarian,[87] noted that Pomponia, the wife of the general Aulus Plautius, had been accused in Rome of "pagan superstition" (she was acquitted), and had accompanied her husband to England and the army camp at Gloucester. This must mean that Pomponia was a Christian—many a novel makes the same assumption—and thus there were Christians in Gloucester only eleven years after the Crucifixion. Indeed, Christianity was exported back to Rome from England. Lysons declares—and Newman's satire is hardly necessary here—"Rome derives its Christianity from Britain."[88] Lysons, who got a third in Classics at Oxford and took up a family living inherited from his father, fleshed out this history in a novel in 1861, called *Claudia and Pudens; or, The early Christians in Gloucester*, where two figures from the Latin poet Martial stride across history as the first British Christians. As late as 1886, Mrs. Jerome Mercier made the same claims for Gloucester in her novel of early Christianity in Britain (reprinted in 1898 and 1901).[89] Grover, who declared in the *Journal of the British Archaeological Association* that "Results . . . won by the spade are undeviatingly true, and carry universal conviction," basing his conclusions on the older Lysons, trumpeted that Frampton pavement is "the most ancient record of Christianity, not in Britain alone, but in the whole of Europe, – outside of the Catacombs."[90] The Church Father Tertullian, with his characteristic overblown rhetoric, claimed that Christianity had spread from Britain to the far East—that is, the limits of the known world—and this is taken literally by Anglican historical writers to prove that Gloucester must have had a flourishing church by the second century at the latest.[91]

Pomponia Graecina is a perfect example of how a character who appears with the barest of stories in an ancient source, takes on a new life in the nineteenth-century's historical and religious imagination. Pomponia appears

as the ideal early Christian woman in many a novel (usually when she is in Rome)—calm, dignified, committed, spiritual.[92] But the claim that she was a Christian was earnestly argued in a host of history textbooks, too, as fiction and normative history share an imagined narrative, based on the brief notice in Tacitus of her trial, acquittal, and subsequent life in mourning. Although this identification of Pomponia as a Christian did appear in at least one widely read account in the eighteenth century,[93] it becomes emblematic of Victorian history of the national church in particular. Henderson tellingly cites Renan (again) as his authority: Renan called Pomponia "The first female saint of the Great World."[94] Poste adds that she was in lifelong mourning probably because she must have done a pagan sacrifice to avoid punishment, and lamented such weakness the rest of her days.[95] Prichard, even more bizarrely, includes her in his heroines of *Welsh* history, as more cautiously does Williams.[96] Ruskin, predictably, celebrates her pure Christian beauty—any heroine, especially for Ruskin, must be beautiful.[97] A string of minor historians accept her cautiously as Christian—with due and repetitive attention to the single and bare classical source as evidence: Timpson, Edmondson, Williams, Hassell, Howorth, Bigg.[98] The theologians Conybeare and Howson in the standard commentary on Paul's *Epistles* make the association, as does the much-printed work of Lewin.[99] More surprisingly, the great scholar Harnack decides "We may therefore consider the Christian standing of Pomponia Graecina as established."[100] As late as 2004, we can find Peter Lampe in a standard work on Christians in Rome cautiously supporting the identification.[101] Conybeare catches the ideology of the argument perfectly: "it would be hard to imagine a series of evidences more *morally* convincing"—it is right, that is, because it *ought* to be right.[102]

One scholar alone, John Allen Giles, stands out for his hard-nosed critical dismissal of the theory due to its extraordinarily weak historical case.[103] Giles had never wished to be in the church, but was directed by his parents into the clergy; he was compelled by Wilberforce, the Bishop of Oxford, to suppress his late dating of the final redaction of the Gospels (though Giles published the correspondence about it anyway), and he was finally prosecuted and sentenced to a year in prison for falsifying parish records while conducting a marriage out of hours (one of the girls to whom he taught typography wished to be married in secret and he helped her out, but his congregation was keen to be rid of him; and his outlandish attempts to influence witnesses and obscure the facts of his case did not help his cause). Giles was a maverick—and his comments on Pomponia were ignored. William Lindsay Alexander reveals his evangelical background more than his reputation for scholarly exegesis when he denies Pomponia could be Christian on the grounds that her husband accepted her defense. For that to happen, she would have had to deny her Christianity, but as a para-

gon of early Christianity, she could not have denied her Christianity, so she couldn't have been Christian. . . .[104] The strain in his idealism is all too evident. Tacitus's brief comments need expansion to make a telling narrative—and the historians as much as the novelists—hand in hand—strive to create a backstory to discover an early Christian, first in the Roman nobility, and then in Gloucester.

It was easy for Newman to mock such grandiloquent parochialism. But he met Kingsley "head on" in "responding to Kingsley's position on marriage and celibacy," with exposition of scripture.[105] In 1864, Kingsley took the opportunity of reviewing Froude's *History of England* (Froude was his brother-in-law. . .) to respond to Newman with a scornful aside on celibacy, which focused on Newman's slipperiness with regard to truth:

> Truth for its own sake has never been a virtue of the Roman clergy. Father Newman informs us that it need not, and on the whole ought not, to be; that cunning is the weapon that Heaven has given the Saints wherewith to withstand the brutal male force of the wicked world which marries and is given in marriage.[106]

It was a commonplace privately or generally expressed that Catholics and the Oxford Movement could not be trusted. Hare, for example, wrote to Whewell: "It is dismal to see how this faculty of lying is cultivated by this new Oxford religionism. They really seem to have an incapacity of speaking the truth."[107] But Kingsley's personal attack was clearly something more bitterly felt. Newman in turn replied, detailing his unsatisfactory correspondence with Kingsley and his publisher; Kingsley published a pamphlet attacking Newman further; and Newman replied with a book-length masterpiece, *Apologia Pro Vita Sua*, which systematically refuted Kingsley, and became a major text for enshrining the official history of the Oxford Movement. For most readers, Kingsley was crushed. As E. A. Freeman, the professional historian and a constantly dismissive enemy of Kingsley put it, "We laughed our laugh at seeing the unfortunate champion of Protestant truth spin round and round like a cockchafer in the strong grasp of the Roman giant."[108] While the details and effect of this argument would take us far from the subject of this chapter, it is worth stressing how fiction is only one aspect of a long-running battle that includes private letters, sermons, newspaper controversy, pamphlets, autobiography—the full gamut of the Victorian culture of writing. There was a war of representation about early Christianity, with high stakes for institutional and personal expressions of religious life. The question of (historical) fiction rapidly slips into a question of (religious) truth. After Kingsley, Wiseman, and Newman, any novel set in the ancient world and featuring a Christian had the potential to be drawn—by readers or writer—into the sphere of such polemics.

This is true even of apparently simple stories without the explicit polemics or historiographical infighting that distinguish Kingsley and Newman.

Elizabeth Rundle Charles was best known for her *Chronicles of the Schönberg-Cotta Family*, a novel of Luther and the German Reformation (published in 1862, much reprinted and translated into many languages, including Arabic). Henry James, very much *d'haut en bas*, dismissed her output as "Sunday reading" . . . "ingenious nothings" that "affect the great figures of history as much and as little as the travelling cloud shadows affect the insensitive mountains."[109] Charles also published *The Cripple of Antioch* (1865), a set of stories on early Christianity in the East, which are the epitome of what James meant by Sunday reading. The title story is extremely mawkish and naïve. A crippled, lonely, and downcast girl (called Victoria) swiftly discovers the true light of Christianity and lives happily ever after. George Eliot in 1856 was already mercilessly poking fun at the instant conversions in silly "modern-antique novels" by lady novelists— "they [the hero and heroine] and their friends are converted to Christianity after the shortest and easiest method approved by the 'Society for Promoting the Conversion of the Jews.'"[110] So, in *Pomponia*, one of the most painfully clichéd of silly novels, the heroine, a young English, Druid-educated girl called Claudia meets a stranger in the woods and asks almost immediately "I want to worship the greatest and best of gods. . . . Can you tell me of a god who is pure and good and benevolent, and who will help me to become so?"[111] Fortunately, he is a passing Christian missionary. . . . It is difficult to exaggerate the triteness of such stories. But for missionaries, brought up on such stories and on the hugely optimistic misrepresentations of the missionary society reports, reality in the field must have been a psychological shock of considerable proportions. Bringing Christianity to the empire was imaged—with naïveté, hopefulness, and often crassness— through the picture of the early Christians in the Roman Empire.

But even with Elizabeth Rundle Charles, as one might expect of a friend of Kingsley and Tait, in the middle of her narrative she emphasizes her Anglican commitments: "Victoria had heard no discussions about the nature of Godhead, the relations between justification and sanctification. . . . Pure and full from the lips of an apostle they had heard the gospel concerning Jesus." And modern life in England is not any further away from this religion based on facts: "We have the living words of the living God, through apostles and prophets; the perpetual miracle of conversion, and the contrasts of a thousand forms of error to illustrate the true light."[112] No church metaphysicians, no intercessionary figures, no saints, relics, no authority of bishops or the church. . . . The only miracle to contemplate is the miracle of conversion, with its supportive institutions of missionary activity. It is a picture of early Christianity that embodies Henry James's assertion "We are all of us Protestants. . . ."[113]

Charlotte Yonge, by contrast, was deeply connected to the Tractarian movement, through her close affiliation with John Keble, who had left

Oxford to be the incumbent of the church in Otterburne where she lived. (She is buried at the foot of Keble's grave there.) Her friend and hagiographic biographer, Christabel Coleridge, called her work, "the spirit of the Oxford Movement in its purest and sweetest form."[114] *The Slaves of Sabinus* takes a story from Plutarch, of a noble wife who fled and lived in a cave with her fugitive husband, and intertwines it with the story of Flavius Clemens, who appears as an early martyr in Christian tradition, to produce a children's tale of no great distinction, and with no great religious polemic. But it does reveal one particularly interesting strategy of complicity. Each chapter is headed by an epigraph. Together these epigraphs provide a horizon of expectation, a framework within which to read the story. The largest number comes from Keble, both from *The Christian Year*, his most popular work,[115] and from *Lyra Innocentium*, his thoughts in verse on Christian children. Children and parents (readers together) are encouraged to view the tale of Jewish, Roman, and Christian children within a particular normative structure of Christian family life. Keble is supported by Shakespeare, Milton, Scott, Elizabeth Barrett Browning (her "The Dead Pan," a poem on the precarious passing of paganism), and Francis Palgrave's *Visions of England*, "Lyrics on Leading Men and Events in English History." That is, the image of Christian family life is buttressed by a history of English literature, exploring history, religion, and Englishness—linking the normative religious frame to a normative account of national identity through literature. (There is one citation of Sophocles, but specifically in the version of Anstice, a professor of Classical Literature in London, who, as the *Gentleman's Magazine* pointed out,[116] rendered Sophocles in the style of Walter Scott: this is a Sophocles assimilated to an English world.[117]) The epigraphs create an image of "our world," where Keble takes his place among the greats of national culture. *The Slaves of Sabinus* was first published in 1861, only a few years after the great rows over Catholicism and the Tractarians; it is a novel written for children and already lacks the sharp antagonisms of the 1850s. But nonetheless it constructs a highly normative image of the Christian past linked through English culture to the Christian present.

Sabine Baring-Gould had far less direct contact than Yonge with the grandees of the Oxford Movement, but he was also a Tractarian by intellectual and emotional leaning.[118] He had grown up traveling around Europe with his mother and somewhat feckless cavalry officer father, and spent most of his long working life as a country parson and landed squire in Devon (he held the living on his own estate). At 35, the emotionally constipated Baring-Gould surprisingly fell in love with a sixteen-year-old working girl, whom he promptly sent away for two years to get "civilized"; they then married and had fourteen children in steady succession. But, despite rarely leaving the provinces, he became very well known through

his writing, and, as John Betjeman puffed for a biography as late as 1957, "there can be few English people who do not owe something to Baring-Gould"—for all that I suspect few today would even recognize his name. He wrote the hymn "Onward Christian Soldiers," and as a collector of folk songs at the height of the folk music revival, he was the man who popularized the song with the refrain "Old Uncle Tom Cobley and All." Beyond hymn writing and folk song collecting, Baring-Gould was also obsessed with local history and the role of archaeology in uncovering it.[119] He discovered and excavated his first Roman mosaic in France when he was only 16, and he continued to ramble through the Devon countryside looking for signs of antiquity, and published voluminous works of local history. Like Montague Rhodes James, he loved ghost stories, with which he entranced his pupils. He also wrote widely on religious matters. He produced a history of the Eucharist, deriving all liturgies "from one parent liturgy . . . fixed almost certainly by the Apostles before their dispersal."[120] This typical Anglo-Catholic turn to antiquity did not lead toward Rome. Like the early Tractarian William Sewell, who we met in chapter 1, he described papal rule dismissively: "It exhibited systematic and purposeful degradation of the people, intellectually, socially, politically, and morally. To stultify his subjects appears to have been the aim of the successor of St. Peter."[121] He also wrote a multivolume *Lives of Saints*, influenced by similar Tractarian historical and theological principles—which was placed on the Index of banned books by the Vatican, but which is shoddy in its scholarship, tedious, and barely reached an audience anyway. ("The temptation to conclude that he wasted his time on a grand scale is a strong one.")[122] This combination of interests—local antiquarianism, religious history, archaeology, and the arts—is a classic picture of a national, historical self-consciousness; and his work duly made Baring-Gould a national figure.

Baring-Gould's *Perpetua* emerges from precisely his Anglo-Catholic commitments—it reads like a novelistic version of one of his saints' lives. Like Yonge's novel, it carries its ideological underpinnings lightly. But its readiness to promote a young female martyr, who resists the lure of married life and dies for the sake of The Lord, leaving a memorial of her suffering from antiquity to today, sets it clearly apart from mainstream Anglican novels—and most obviously and worryingly recalls Newman's and Wiseman's polemical fiction of the 1850s. But in the context of the 1890s, Baring-Gould's work was thoroughly unpolemical. Even Baring-Gould himself barely mentions his fiction in his two volumes of reminiscences (though he barely mentions his wife, either). Yonge's *Slaves of Sabinus* and Newman's *Callista* were both republished in America in 1890; *Hypatia* as late as 1902. In the wake of American anti-Catholic stories of nuns escaping from evil convents, and in emulation of *Ben Hur*'s success, and in re-

sponse to the specific religious conflicts of late nineteenth-century America, novels about early Christianity were a publishing vogue around the turn of the century in the States, and the hits of an earlier time in Britain were republished in a trans-Atlantic trade. But they no longer could cause an outcry. As we will see, a religious novel set in the ancient world could cause scandal, shock, critical outrage, and huge sales in the 1890s—Corelli's *Barabbas*—but not because of its representation of a gentle saint's suffering chastity. Both fashion and theological consternation had moved on.

## The Best-Selling Novel in America

This shift was brought about to a good degree because of one book, which was one of the boldest experiments in linking Christian and Classical narrative. It was also one of the most commercially successful—and finance, of course, has its own power in the market. Lew Wallace was a leading general in the American Civil War and went on to be ambassador to the Sublime Porte, a quite different background from the authors so far discussed, none of whom had seen action or visited the East, except in their imaginations; and Wallace claimed, with whatever disingenuousness, to have written *Ben Hur* in order to sort out his own religious beliefs (that is, without a doctrinaire agenda; he was not a member of any church).[123] It was published in 1880, and became the biggest selling American novel ever (a position it held until the film-led sales of *Gone with the Wind*). In 1912, Sears Roebuck produced a print run of 1,000,000 copies to be sold at 39 cents each.[124] Even before its most famous incarnation on screen, *Ben Hur* was already a classic of popular culture. The play of the book, which opened on Broadway in 1899, was seen by a staggering number of people over the following twenty-one years in shows across the U.S.A. (including one performance in Boston, where, it is claimed, the baddy by mistake won the chariot race).[125] "The American public," declared Frohman, a producer, who was trying to buy a piece of the action, "will never stand for Christ and a horse race in the same show." He may have been being mischievous or calculating, but he revealed even less foresight than he pretended to.

It may be a surprise to many modern readers, however, that *Ben Hur* is subtitled *A Tale of the Christ*, and even more of a surprise that the first section of the book is a slow and rather mysterious telling of the story of the Magi, beginning with a strange meeting of three men on camels in the desert. Unlike all the novels we have considered so far, *Ben Hur* is set at the time of Jesus, and interweaves its heroic plot of national self-determination—the opposition of the Jerusamelite Judah of the family of Hur to Roman rule, and in particular his vengeful hatred of his schoolboy friend Messala—with the narrative of Jesus's ministry and crucifixion. Ben Hur moves from supporting

Jesus as a potential leader of a revolt to recognizing and worshipping God the Father and Christ the Son (these are the last words of the final section of the narrative, before its coda). The coda of the novel fullfils Ben Hur's earlier dreams, too. He returns to Rome to join the Christians in the Catacombs, and "Out of that vast tomb, Christianity issued to supersede the Caesars."[126] Ben Hur is at the foundation of a successful revolution against Roman rule.

Wallace particularly loved *The Last Days of Pompeii* and *Hypatia*, and read Gibbon as well as Josephus in his research for the novel. Some forty years after Bulwer Lytton, the representation of Ben Hur reveals a growing complexity in the matrix of national identity. Ben Hur is a well-to-do Jew from Jerusalem, who becomes a slave of the empire, is adopted by a Roman patrician and becomes a prosperous Roman citizen, who travels back toward Palestine, through the pleasures of Eastern Greek life, intent on personal revenge, only to discover there a desire for national rebellion, which in turn leads him toward the religious revolution of Jesus, and thus back to Rome to end his days there as a proto-Christian, a self-marginalizing exile within, destined to seed a future triumph. Ben Hur is not a wandering Jew, so much as a Jew who shifts between identities in a way profoundly alien to Croly's or Lytton's sense of placement. This may have helped the book's extraordinary popularity in America. (Unlike *Uncle Tom's Cabin*, it was never such a wild hit in England.) Between 1880 and 1910, the population of America doubled, largely due to immigration. This was a story of an individual hero who struggled to make his way against the forces of nature and the societies of the Old World toward a new, hopeful future. Ben Hur's tale of personal revolution spoke with particular force to an American audience, a self-consciously new society in search of a genealogical myth.

Nonetheless, against this complexity, *Ben Hur* also captures many of the clichés of the genre of Christian/classical fiction from Lytton onward, and helps establish them within popular culture. Physiognomics and racial distinctions are also seen as determinative: "An observer skilled in the distinctions of race, and studying his features more than his costume, would have soon discovered him to be of Jewish descent". . . . "The comeliness of the Roman was severe and chaste, that of the Jew rich and voluptuous."[127] Corruption comes from the East: "The flow of the demoralising river was from the East westwardly, and . . . this very city of Antioch . . . was a principal source of the deadly stream."[128] Religion in Rome (and Palestine) was a sham: "The old religion had nearly ceased to be a faith; at most it was a mere habit of thought and expression, cherished principally by the priests who found service at the Temple profitable."[129] Modern and ancient world are mutually explicable: "the Sadducees, who may in a general way, be termed the Liberals of their time . . ." "studying the situation after two thousand years, we can see and say. . . ."[130] The archaeological stance is

linked with a low-level ethnography: "The reader is presumed to know something of the uses of a house-top in the East. . . . The roof became a resort—became playground, sleeping-chamber, boudoir, rendezvous for the family, place of music, dance, conversation, reverie and prayer."[131] The Games are a defining arena of Roman pleasure—one Wallace wants his readers to experience (these are chariot races rather than gladiatorial combat): "let the reader . . . share the satisfaction and deeper pleasure of those to whom it was a thrilling fact. . . . Every age has its plenty of sorrows; heaven help where there are no pleasures!"[132] So too there is the alluring scene of sexual degeneracy (the Grove of Daphne—combined with a beautiful Egyptian seductress), the gothic horror of the imprisonment and final release of Ben Hur's mother and sister; the praise of Roman military organization and system. Galleys and shipwrecks with pirates, the gladiatorial training ground, revolutionary war against the legions of Rome give as much derring-do as could be wished for. The novel is a handbook for the popular image of the classical world and its clash with Christianity.

But what makes *Ben Hur* still quite astounding—and unparalleled—is its use of the Gospels themselves. As he is dragged off to the galleys, Ben Hur meets the young Jesus, who gives him a drink and makes a deep impression on the suffering youth.[133] This may seem little more than an upgrade of the cliché of a novelistic hero meeting a saint in passing and realizing a spiritual encounter. But it is the beginning of an appropriation into the novelistic form of the life of Jesus. Ben Hur is not merely a witness to the Passion—he sees Judas's kiss, the arrest, the crucifixion—but also he actually becomes a figure from the Gospels. There is a famous crux in the Gospel of Mark in its narrative of the crucifixion. When Jesus is betrayed and arrested, "they all forsook him and fled" (14.50). There follows this baffling verse (14.51): "And a young man followed him, with nothing but a linen cloth (*sindōn*) about his naked body; and they seized him, but he left the linen cloth and ran away naked."[134] This event is not found in the other Gospels, and its apparent lack of motivation or consequence has prompted critics to excise it, to read it mystically, to see it as a sign of conflicting historical developments of the text and so forth. In *Ben Hur*, the mysterious young man is Ben Hur himself. He feels the need to ask Jesus a final question "Goest thou with these of thine own accord?" to see if rescue is wanted. The guards and crowd see Ben Hur: "He is one of them. Bring him along; club him—kill him!" But with a burst of passion, he frees himself from their hands and, leaving his *sindōn*, runs naked into the night.[135] In the Gospels, just before Jesus dies, a person soaks a sponge in vinegar and gives it to him to drink.[136] Again, in *Ben Hur* this anonymous figure is Ben Hur, repaying Jesus for the drink he received at the beginning of the novel.[137] Farrar's *Life of Christ* sees in the gift of vinegar a moment of awestruck humanity where someone—"we know not whether he was friend or enemy,

or merely one who was there out of idle curiosity"—acts out of "simple pity."[138] Wallace has made the moment part of his hero's life story.

There are no footnotes or apparatus of scholarship in *Ben Hur*. Wallace seems to bypass the historiographical anxiety that pervades the novels we have considered so far, by fully interweaving his adventure story with the Gospels. He claimed to have been stimulated to write the book after a chance meeting with a sceptic who challenged scriptural evidence, in a less than full-formed Gibbonian or Straussian manner.[139] But rather than respond with a case for the veracity of religious sources, Wallace utilizes the reality effects of the genre of the novel to create a world where fiction and religious truth are so overlapped that the hero of the chariot race is also a figure in the Gospels, authorized as—by—the word of God. Fictional characters acting in the Truth. This is a limit case for the interaction of the genres of religious history and novelistic fiction. Macaulay wanted to regain the power of the novel's narrative for history; Ranke's claim for empirical history's task was to write *wie es eigentlich gewesen*, "how it actually happened." Wallace offers the central story of Christian faith both as uncontestable truth and, at the same time, as fiction.

Wallace's success in the marketplace no doubt helped stimulate the explosion of classical novels over the next twenty-five years: 118 of the 195 novels I have surveyed were published in the decades after *Ben Hur* till the end of the First World War (and eleven earlier novels were reprinted and repackaged, especially for the newly flourishing American market; William Ware's rather turgid *Letters from Palmyra* (1837) was advertised in 1886 as *The Last Days of Palmyra* in an obvious attempt to sex up the old-fashioned epistolary novel with a nod to Bulwer Lytton).[140] Many were "Sunday reading," where the promise of the afterlife leads women to burst into tears and convert, and Christians suffer violence with such bravery that onlookers are awed into receiving the Christian message; some wrote stories of plucky adventure for schoolboys, and gentle piety for schoolgirls. Others found Christians lurking in the court of Nero, even as the mistress of the emperor—thus describing the corruptions of Rome with equal lasciviousness and piety. But perhaps the oddest production in the immediate aftermath of *Ben Hur*, however, is Walter Pater's *Marius the Epicurean*, a novel as different as is possible from *Ben Hur*.

It is odd not just because it is a novel almost entirely without dialogue, except for Marius's conversations with himself, and almost without incident (no games, no human sacrifices, no sex scenes), but also because it constructs a representation of a pagan faced by his own doubts and his incipient contacts with Christianity, a representation that is resolutely intellectual, carefully hesitant, and unfulfilled. This is certainly not Sunday reading. Pater heard Renan (again) lecture on Marcus Aurelius, and this experience has been seen as an inspiration for the novel.[141] The book has

the form of a *Bildungsroman*, a spiritual biography (though it is as far from Carlyle's *Sartor Resartus* as from *Ben Hur*), in which Marius reflectively moves through classical philosophy toward Christianity, but dies before any conversion takes place, leaving the narrative, like the Roman world, poised on a cusp. (It was perceived as "autobiographical"—in some sense— by readers from the start.[142]) He is buried by Christians who held "his death, according to their generous view of the matter, to have been of the nature of a martyrdom."[143] Pater's withdrawal from direct judgment is elegant, and marked: the Christians were "generous" in their view, and their view was that his death was not exactly a martyrdom, but "of the nature" of a martyrdom. The reader, like Marius, is left to reflect.[144]

Marius's final position may be held in suspension, but Pater does articulate a rather particular view of the history of the church, which turns out to be surprisingly embracing and even conservative (although he was from an early age "drawn to Renan").[145] In chapter 22, "The Minor Peace of the Church," Pater finds in the church of this Antonine period under Marcus Aurelius an especially significant moment, as Christianity emerged from its "subterranean worship" and as it escaped from earlier millenarianism and asceticism toward an ideal of spiritual development. Tellingly, the aesthete Pater likens this experience to that "which, centuries later, Giotto and his successors, down to the best and purest days of the young Raphael, working under conditions very friendly to the imagination, were to conceive as an artistic ideal."[146] There could be no higher praise from Pater. This ideal for the church is to be found in the honoring of chastity within the family, respect for women, good deeds, hard work, and naturalness—embodied in the image of the mother suckling her own child, which, claims Pater, returned as a practice of the period and is captured in "the image of the Divine Mother and the Child, just then rising upon the world like the dawn!"[147] These ideals are also connected to his aesthetic commitment to beauty, which finds a social corollary in the precarious peace in which the church delighted at that moment:

> This severe yet genial assertion of the ideal of woman, of the family, of industry, of man's work in life, so close to the truth of nature, was also, in that charmed hour of the minor "Peace of the church," realised as an influence tending to beauty, to the adornment of life and the world.[148]

This "profound serenity" and "reasonable gaiety" was epitomized by the early Christian text, the *Shepherd of Hermas*, and descended—with a uniquely Paterian genealogy—through Gregorian music, to Francis of Assisi, and to "the voice of Dante, the hand of Giotto."[149] This ideal was the original spirit that enabled Christianity centuries later to produce "an art, a poetry, of graver and higher beauty, we may think, than that of Greek art and poetry at their best."[150] It is as if the proof of the truth of this historical

moment in religious development is the beauty of the art that can be traced to it. To this mix was added ritual: "The Mass, indeed, would appear to have been said continuously from the Apostolic age"[151]—and ritual in this form is privileged because of its age, its organic growth, and *its* beauty. Pater describes a church hallowed by its ancient origins in the Roman Empire, without the excesses of asceticism, ritualism, and the distorting power and violence that alienated Kingsley, and without the Reformation's evangelical moralism. For all Marius's internal anguishing, the answer, it seems, can be found in a High Church Anglicanism, with a proper aesthetic sense of beauty—an answer, that is, located suspiciously close to Pater's beloved Oxford.

Pater's aestheticism sets him apart from many of the novelists I have been discussing and was intended to do so. But, for all his mannered love of the "sacred perfume" of the past, his novel also fits squarely into much of what I have been discussing. In *The Renaissance*, Pater argues against the "trenchant and absolute" division between the Pagan and the Christian,[152] and *Marius the Epicurean*'s representation of Marius's spiritual transformation toward, but not into, Christianity is a response not only to Gibbon's wedge between the classical and the Christian, but also to the post-Gibbonian novelistic tradition with its variations on the dynamics of transformation between Christian belief and classical culture. Marius is closer to Kingsley's Hypatia than either author, I suspect, would care to think—and nowhere more so than at the moments of extreme helplessness of their ends where each author brings his subject to the very brink of belief but leaves them tottering.

Furthermore, *Marius the Epicurean* acts as an "aesthetic meditation upon history," even "a theory of historical fiction."[153] Marius is "swept up in the most important historical change taking place at the time"; he is no great man, at least in the traditional sense; but for Pater, as for Hegel, "the real forces of historical change are . . . an invisible, spiritual force" of which the great kings and warriors are "merely concrete representatives."[154] On the one hand, this reminds us of the heroes of Scott's historical fiction, wavering and prey to the force of circumstances (with all the subsequent implication for Macaulay's recapturing of historical agency for his type of historical narrative), but on the other, and more importantly, it emphasizes that however particular and eccentric it may seem in its overlayered and multiform vector, Pater's genealogy is, like the other novelists of the antique past, creating a genealogy for now: our history.

The melange of past and present in Pater's prose is the performance—the act of persuasion—of how the world should be experienced by a historical subject, where "personal identity and historical culture [are] correlative and interlocking developments";[155] the role of typology in Pater's prose, which Williams has splendidly uncovered, speaks powerfully to the

typological strategies of nineteenth-century auto/biography (well analyzed by Peterson). There is a fine-grained and subtle manipulation of genealogical form in Pater, finding the past in the present and the present in the past.[156] In an extraordinary gesture, toward the beginning of the novel he translates the story of Cupid and Psyche from the Latin of Apuleius. It is a text roughly contemporary with Marius; a pagan text, from an outrageous, sexual, and picaresque ancient novel, a tale told by an old woman, an "old wives' tale." It has also been taken as a Platonic allegory of the soul and desire, redefined as a Christian allegory—and a text much rewritten in Victorian verse and painted by Victorian artists, a site for the exploration of classical desire in Victorian eyes. Pater's reframing of the story offers it first as a piece of charged material for Marius's reading (the scroll itself, a "golden book," wrapped in yellow picked out with purple letters, is "perfumed with oil of sandalwood, and decorated with carved and gilt ivory bosses at either ends of the roller," an object for an Epicurean's pleasure).[157] But it is also described, with a typical, apparently hesitant invitation, as "full also of a gentle idealism, so that you might take it, if you chose, for an allegory." An allegory, now, "if you chose," not just of Platonic or Christian desire, but of Marius's own journey between paganism and Christianity. "Cupid and Psyche" "composed itself in the memory of Marius"[158]—the passive form is how Marius engages or rather is engaged by the external world—and impresses upon him "the *hiddenness* of perfect things: a shrinking mysticism, a sentiment of diffidence," and a sense of the "the fatality which seems to haunt any signal beauty, whether moral or physical."[159] The allegory here appears to stretch beyond Marius to Pater himself and the reader, who, like Marius, have just read and translated the story in full. "Cupid and Psyche" becomes an icon and performance of the typological process (an allegory of allegory, if you chose)—the past neither as mirror nor as linear genealogy for the here and now, but as indwelling, through the process of translating (for) the present.

The hyper-self-consciousness of Pater's sense of subjectivity, the consequent aestheticized construct of historical significance, are certainly not the style of the bluff Bulwer or the tearful impulsive Kingsley. But Pater's narrative, like theirs, still inevitably turns to the antiquity of early Christianity to explain the present, and—since *Marius the Epicurean* is profoundly autobiographical in genesis and force—to find the self, its narrative. Pater's sense of genealogy is not simply linear, and has been celebrated as a harbinger of modernism by a host of excellent recent criticism. Viewed from the perspective of Kingsley's *Hypatia*, however, Pater appears more closely embedded within a tradition than the teleological narrative of modernism has allowed.

Petronius, the most fascinating character in Sienkiewicz's *Quo Vadis*, is best seen as a dark and twisted version of the qualities of Marius and Raphael

Aben-Ezra—and as such, stands as a final point in the development of the image of the pagan who encounters Christianity. *Quo Vadis*, "a narrative of the time of Nero," is another story better known in its filmic version than as a novel, despite Sienkiewicz winning the Nobel Prize for Literature in 1905. (*Quo Vadis* was most famously filmed in 1951, with Robert Taylor, Deborah Kerr, and Peter Ustinov as Nero; Fellini filmed a version of Petronius's *Satyricon* in 1969.)[160] *Quo Vadis* intertwines the disastrous reign of Nero with the perils of the early church in Rome. The beautiful Christian, Lygia (who is in love with Vicinius, a Roman general), and Nero's mistress, Acte, are ranged (in goodness, faithfulness, and piety) against Poppaea, Nero's wife, who is aligned with Jews against the new religion of Christianity, the parasite Tigellinus, and the corruption of the city of Rome (embodied in the increasingly unhinged Nero). St. Peter and St. Paul meet the central characters, and are, as ever, instantly impressive, noble, and inspirational presences. There are fine set scenes of the fire of Rome, orgiastic dinner parties, the staged trial of Pomponia Graecina, the inevitably noble Christian woman, and stirring gladiatorial deeds of Christian triumph. But throughout the narrative there is Petronius, the "connoisseur of elegance," *elegantiae arbiter*, whose *Satyricon* is one of the best-known raunchy, satirical accounts of ancient Roman corruption. At first, Petronius, who is barely sketched in Tacitus, appears as a stock character of the court: "After that feast, at which he was bored at the jesting of Vatinius with Nero, Lucan and Seneca, he took part in a diatribe as to whether a woman has a soul. Rising late, he used, as was his custom, the baths. . . ."[161] His judgments seem a blend of dismissive stereotypes and a rather camp aestheticism: "Bodies really athletic are becoming rarer in Italy and in Greece; of the Orient no mention need to be made; the Germans, though large, have muscles covered with fat, and are greater in bulk than in strength."[162] But as the novel progresses, he both encounters Christian thinkers and noble Christian practice and finds himself more and more alienated from Nero and the life of the court. He becomes a figure through whom the narrative is focalized, as he transcends the violence and triviality of imperial power. His death is the final chapter of the book, followed only by the brief epilogue of Nero's demise. He commits a politically required suicide with his faithful mistress while at a dinner party he has himself organized as a final grand gesture. He smashes to the ground a priceless vase from which he has poured a libation to Aphrodite, so no one else could ever touch the special vessel of his love. He reads aloud a shocking letter, wittily humiliating of Nero. The guests are terrified: even to hear it is an act of unpardonable treason. He and his mistress open their veins and die together before them, erotically disposed on a rose-strewn couch, to the sounds of beautiful Greek lyrics. "Friends," he says as he dies, "confess

with us perishes . . ."—and the narrator completes his dying words with "poetry and beauty," as a valedictory epitaph.[163]

Petronius has the sophistication of Raphael Aben-Ezra and Marius. Like Raphael, he is at the center of power within the novel, rich enough and well-connected enough to make a difference; like Marius and Raphael, he is educated in Greek philosophy, and, like Marius, a lover of Greek art and culture. Like Raphael, he comes into contact with a beautiful and noble Christian woman, hears the teaching of Christianity from the mouths of saints, and reaches toward a better morality than his own community offers. But unlike both earlier heroes, he remains resolutely unconverted, an aesthetic Roman, whose death is not a martyrdom but a marvelously staged performance of suicide, a self-wrought spectacle. It is not what Farrar calls "the callous levity of the infidel voluptuary."[164] But it is here that Sienkiewicz's narrative closes, leaving the emperor's death to an epilogue, and without the standard reminder of the triumph of Christianity to come (much heralded though it is within the novel's Christian discourse). There is a good deal of fierce religious triumphalism in *Quo Vadis*. But at its center runs a story of growing moral strength, political resistance, and spiritual searching which meets but stands apart from Christian values. Petronius, in Sienkiewicz's narrative, appears as ironic, self-aware, and, despite all opportunities, resistant to any self-expression through Christian moralism. Petronius has to die, of course, but the "poetry and beauty" of his unchristian death weaves into the narrative a classical aestheticism, described with a disturbingly loving attention. The cultural climate of the late 1890s found a place for the languishing, sardonic, and self-dramatizing Petronius, which would have been hard to imagine in the clashes between Newman and Kingsley in the 1860s. A hankering for the high culture of the Greco-Roman world was never fully repressed even in the more pious of novels about the Roman Empire, but Sienkiewicz sets Petronius at the center of pagan degeneracy, brings him morally away from it, and yet has him die with some dramatic bravery and without any explicit Christian condemnation. Petronius remains a provocation to the moral expectations of the Christian reader.

## The Harry Potter Effect

The representation of Christians and Christianity in the novels of empire changes markedly over the seventy years after Lytton's aggressive Olinthus died, unmartyred, at Pompeii, a post-Gibbonian narrative victim. The fierce altercations over the status of Catholics in Britain and the response to the Tractarians of the Oxford Movement structure the historical novels of

Kingsley, Newman, and Wiseman in the 1860s. Early Christianity was a narrative and theological battlefield for authorizing and stigmatizing the present. But by the 1890s, there is much more fluidity, where affiliation to sectarian religion is less stridently asserted, and where the most commercially successful novel, which represents Jesus directly and writes its hero into the Gospels, can be authored by someone without allegiance to any established church; and where—in a Nobel Prize–winning author—a pagan can die as a hero of aestheticism, amid the persecution of the Christians by Nero, seduced to evil by Poppaea and the Jews.

Yet throughout this same period there remains something of a continuity in the representation of Rome and the Romans. Rome has to appear as the corrupt center of power and degeneracy, against which Christianity rises—and in this is often set in explicit or implicit contrast with an idealized Greece, home of Western civilization. From Lytton to Sienkiewicz (and beyond), Rome is a good place to set an orgy, and again and again the novels stress the "foulness" and "corruption" of paganism in opposition to the "sweetness" and "purity" of Christianity. Sacrifices, bloody games, gambling, and sex . . . both the high moral writers and the knowingly lascivious have a stake in shaking their heads at the excesses of the Roman Empire, and, particularly with scenes of torturing the flesh, especially female flesh, it is not always easy to see a strong divide between Christian glorification and pornographic prurience. Gambling, for the more evangelically inflected novels, was a particular horror. Here is how Cardinal Wiseman describes a potential convert rolling the dice: "Conscience had retreated; faith was wavering; grace had already departed. For the demon of covetousness, of rapine, of dishonesty, of recklessness, had come back, and brought with him seven spirits worse than himself, to that cleansed but ill-guarded soul; and as they entered in, all that was holy, all that was good departed."[165] The full weight of shocked Christian moralizing, with all too clunking significance for the contemporary reader, is brought to bear on the tempted and falling Roman gamester.

This image is in contrast with—but not a contradiction of—the admiration for Roman military order and discipline, the foundations of empire. Idealized Hellenism (with its opposition to Hebraism, for Arnold, or its links through Homer to the Hebrew Bible for Gladstone) needed the order of Rome to be transmitted into the Western tradition. The celebrated skeleton of the soldier who stayed and died at his post in Pompeii, as the story has it,[166] finds many an echo—Titus, the honest and faithful guard of Nero in Hugh Westbury's *Acte*, there till the end, is paradigmatic—and the place of Rome in thinking through British ideas of empire, familiar from the political theorizing of the later years of the century in particular, informs the more military minded novels. Ben Hur, who has lived among the Romans, tries to instill some Roman military discipline into the Jewish rebels; Beric

the Briton in Henty's Boys'-Own novel, is responsible for the victories of the Iceni because he has studied Roman military values and practice. Indeed, he fights against Rome, he claims to his Roman captors, "because I studied Roman books, and learned how you value freedom and independence."[167] For political theorists, Rome mattered as a model of empire, and could be lauded as a bringer of civilization to Britain (and artists showed Britons lamenting when the legions left). Stobart in the best-selling *The Grandeur that was Rome* is exemplary: "The Roman Empire bears such an obvious and unique resemblance to the British that the fate of the former must be of enormous interest to the latter."[168] This notion had already become commonplace in school textbooks: in the Roman invasion, "we find the first steps on a ladder that has conducted Englishmen to such power and greatness. . . . Let us heartily thank God for it."[169] For Henty, following in the footsteps of Kingsley, it is a question of racial strength: Roman legionaries married British wives, and although this had the effect of "diminishing the physical proportions of the British," it also "introduced many characteristics hitherto wanting in the race," and thus "aided in their conversion from tribes of fierce warriors into a settled and semi-civilized people."[170] At the novel's ending, Beric, "already strongly inclined to the Christian religion, openly accepted that faith"—for Henty, "True heroism is inseparable from true Christianity"[171]; and Beric and his descendents go on to rule in eastern Britain, "a contented and prosperous province of the Roman Empire," awaiting only the new constitution of the English nation and the Anglican church to be fully civilized. In this regard, the opposition of Rome and Greece takes on a different light, where the Greeks can appear as effete philosophers in contrast to the practical Romans, a dynamic that speaks to the British self-representation as direct, competent, and empirical.

There are many disparate elements that go into the construction of this double picture of Rome's civilization of military discipline and seductive degeneracy. But here I want to look at four exemplary areas that will indicate with special vividness how the genre of the novel produces its *topoi*—in this case, of narrative, gender, violence, and what might be called the Harry Potter Effect—all of which have had a very long shelf-life. It is in these areas where we can see with greatest clarity the formation of the popular image of Rome. These strategies of representation, the *topoi* of cultural and narrative expectation, their variations and repetitions, are central enactments of the reception of classical antiquity within the genre of fiction. Their impact on the cultural imagination is demonstrated by their longevity within it, and it is more important to see how these clichés function than to dismiss their artistic merit.

The first area concerns Vestal Virgins and the narrative of suspense. Vestal Virgins, a Roman institution with no parallel in Greek culture, were

peculiarly fascinating to the nineteenth-century imagination. A group of six women, chosen as children, dedicated to chastity and religious life, central to the state's well-being, and indeed imbued with a certain civic authority, touched many chords with the writers exploring the relation between the Christian city with its values, and the Roman past. And, as ever, the secluded female enclosure attracts the male gaze (and fantasy). In Plutarch's *Life of Numa*, we are told of the Vestal Virgin's great privileges, including (10.3) "if they accidentally meet someone being led to his death, he is spared; the Virgin must swear that the encounter was unintended, by chance and not by design."[172] There is no recorded example in the ancient sources of this form of pardon actually happening. Its very proposition, however, indicates something symbolically significant about the salvatory power of the Vestal's body. But for the novelist, this remark in Plutarch proved an irresistible variant on the last-minute reprieve.

In Farrar's *Darkness and Dawn*, Onesimus, the Christian slave and hero, is on his way to execution, when Titus sneakily leads the Vestal Laelia to meet the procession and encourages her to save him. Farrar adds "The right of the vestals was well known in Rome, though it was rarely used. . . . But it was understood that, in order to be valid, the meeting of the vestal and criminal must be accidental."[173] The unacknowledged citation of Plutarch defends the suspenseful plot device, beloved of James Bond, whereby the hero is led to the moment of his death and yet preserved with a brazen narrative twist. The very same scene appears in Westbury's *Acte* (1896) and also in William Stearns Davis's *A Friend of Caesar* (1900). Davis's book was published when he was just graduating from Harvard, but he was sufficiently aware of the genre to apologize for what looks like a shameless crib from Farrar, the "incident was too characteristically Roman not to risk repetition."[174] What was noted as "rare" by Farrar has become "characteristically Roman" for Davis—as the conventions of the novelistic genre rather than Roman history itself start to define what is typical of the ancient city.

The second area concerns Nero and his mistress Acte. Nero, of course, is a modern fixation, especially of the novelists and, afterward, the filmmakers, gripped by the lurid tales of Tacitus and later Roman historians.[175] The fire of Rome, Nero's persecution of the Christians, his love of performance, and his degenerate and violent home life, are all standard images of the novels, and they enter the artistic repertoire too. Similarly Poppaea, Nero's scheming lover and empress, familiar from the history of opera, also enters the novel not only as an evil woman, but also, and more surprisingly, as a Jew or a Jewish sympathizer. It was probably Renan who popularized this idea that Poppaea was bound up in Judaism, though Gibbon had already called her "a very powerful advocate . . . of the obnoxious people," but it has continued into the history books of the twentieth century, as well as

through a string of nineteenth-century fictions.[176] It helps provide a matrix of religious politics in the bedroom of Nero, to set against the persecution of the Christians in the public domain. But Acte, the young Nero's freed-woman lover, who has a very brief role in Tacitus's and Suetonius's account of Nero's early emotional life, also becomes a major figure, in a way that says more about Victorian stereotypes of gender than about Roman history. In Westbury's extraordinarily misogynistic novel *Acte*, she is a selfish, manipulative, sexually charged young woman, a fair rival for Poppaea. At the other extreme, Ernst Eckstein, a popular German author of the 1880s and 1890s, whose Roman novels were quickly translated into English, in his *Nero* imagines a pious Christian girl, whose master, the fierce Christian, Nicodemus, tries to persuade her to give in to the emperor, Esther-like, to save her people. She flees, but is recovered eventually to the love of Nero, a man "naturally so gentle, uncorrupted, magnanimous and noble" (the book is to explain how he became an "inhuman monster").[177] Acte loves Nero truly, and at the end runs onto the emperor's dagger, before he kills himself. Eckstein plays out the *Liebestod* to the full: "'There is no pain', she whispered with a happy smile, 'What would this world be without you? I have lived alone—alone and desolate—far too long. Now I shall be . . . with you . . . forever . . . forever.'"[178] Nero, as he dies, despairing of his one true love, strains to catch her final "whisper of infinite love and, almost too faint to hear, the fervent pleading 'May God be merciful to us!'" Nero passes away to a Christian blessing, touched but unsaved by the love of a good and suffering woman. The death of Nero, described by Roman historians as humiliating, vulgar, and disgraceful, here becomes an erotic genre picture. In *Quo Vadis*, Acte is studying Christianity, but does not yet think herself worthy of conversion: she arrives after Nero's death to take care of his corpse. For Farrar in *Darkness and Dawn*, passionately engaged with a Christian discourse of recovery in city life, Acte is the first-cousin of the hero, Onesimus (according to the genre's wish to connect all Christians), and is a penitent woman, living quietly, blushingly, in the palace still, re-gretting the folly of her too youthful love, and turning to Christianity in her sorrow, for comfort—a saved woman. Bulwer Lytton had declared the "emotions are immortal"; the different representations of Acte demon-strate that in practice this means translating a story of Roman sexual incon-tinence, infused with snobbery and violence, into a set of alternative Victo-rian stereotypes of the malicious vamp, of unrequited and noble love, of the fallen but repentant convert. As ever, it is hard to project the inevitable historical consistency of emotions without also making ideologically laden assumptions about how human relationships must follow fixed narratives. It is striking that while in the twentieth century the classical world has be-come a place where novels have wished to explore sexual norms, as in Mary Renault's books on Alexander, for example,[179] and while the classical world

provided the space for thinking about male homoerotics, say, in other areas of Victorian culture, the classical novels of the Victorian period, with very few exceptions (even or especially when indulging in titillation or execration), offer little but the familiar ideologies of sex and gender.

The third area concerns the gladiatorial games and the representation of violence. The ancient world already had Seneca to scorn the games, and Augustine to tell of their temptations, through the story of his friend Alyppius, as obsessed by blood as Augustine was by sex.[180] But the nineteenth century, with its own concerns over crowds, spectacles, violence and the dangers of public pleasures, heightened in post-revolutionary Europe by the rapid and uncontrolled growth of urban living, expressed its fascinated disquiet by a repeated lurid depiction of gladiatorial shows, usually surrounded with scenes of fervid gambling on the outcome of fights, to make the moral disapprobation doubly clear.[181] Byron's famous tag from *Childe Harold* recalling the gladiator "butcher'd to make a Roman holiday" was quoted repeatedly, until it took on the shape of a proverb, and made an instantly recognizable chapter or picture title.[182] Indeed, much as the illustrations within the novels construct directive visual cues for reading, classicizing art often depends on the novelists' narratives for their emotional effect. Briton Rivière's *A Roman Holiday* is paradigmatic (plate 16). It depicts a dying gladiator, lying by a dead tiger, shaping a cross in the sand with his sword. The implied narrative—the brave gladiator, brave enough to kill a tiger, even as he is killed, who testifies to his new tested faith in God as he dies, and who, no doubt, has died to save some offstage young woman—draws on the clichés of the novel's depiction of the arena. (Byron's call for revenge "Shall he expire and unavenged? Arise! ye Goths, and glut your ire," and his archaeological gaze at the now ruined Colosseum, as inspiration for his reflections, also prefigure the discourse of the genre of the novel.[183]) The crowd's dubious and excessive pleasures, a typical slur of Christian invective, were colored by nineteenth-century worries about class, gender, and social change. Yet again and again the novels depicted acts of extraordinary violence, designed precisely to capture and enthrall the reader's imagination. Fights have the drama of a boxing match or football game, and, in the case of *Ben Hur*, a murderous race can be reveled in precisely for its visual and narrative pleasures. Novelistic plots even involve someone leaping into the arena unannounced to fight a wild animal, usually triumphantly. So in *Quo Vadis*, which drags out the fate of Lygia over several chapters of false hopes for escape, delays from sickness, and depictions of extreme violence, her huge and faithful slave, Ursus ("bear," played, almost eponymously, by the boxer, Buddy Baer, in the 1951 film), enters the ring and wrestles a wild bull to the death to save her (497–501)—a fulfillment of her Roman lover's hope for a miracle and his repeated incantation, "I believe. I believe."[184] Another hero, although armed only with a tiny

dagger, kills a lion to the admiration of the crowd. In other novels, where the pull of romance is stronger than the Christian promise of the crown of martyrdom, a mysterious flash of lightening (A. J. Church's *To the Lions*) or a supportive clique in the imperial box (Whyte Melville's *The Gladiators*)[185] preserves either the hero or heroine for Christian marriage at the very point of slaughter.

At the same time, the influence of the martyr acts leads to a representation of violence in these novels at a level far bloodier, more macabre, and unpleasant than in even the Gothic tradition. Christians are burned alive, cut to pieces, eaten by animals, all to the sounds of a baying crowd (and pagan crowds always "bay" in this genre, rarely cheer, and never sing). Christian heroism in the face of such violence—a Stoic, passive, unpained, and unfearing suffering—impresses the Roman audience, as a sign of the strength of the new religion. The reader is placed in an awkward position, as if in the crowd to these scenes, observing the superhuman strength either of the active hero who fights back, or of the passive hero who suffers so grandly. The encouragement to awe is in tension with the narrative pleasure in the drama—the story's desire to save its hero or heroine for the last page in tension with a religious evaluation of the hero's or heroine's death. Particularly as the genre moves away from the committed religious agendas of the 1860s, the gladiatorial games function as a site for competing narrative and social vectors. Like Augustine's Alyppius, the reader is encouraged to take his hands off his eyes and see the spectacle of the games, while maintaining a Christian perspective—something Alyppius found emotionally quite impossible.

The fourth and final area brings together the place of Classics in the school system, together with the Sunday schools and other popular educational movements, and the didactic thrust of so much evangelical Christianity. For the growing market of children's reading, novels of the ancient world and Christianity were attractive, as variations on other tales of imperial adventure, or at least as school prizes. Henty's adventure books sold probably 25,000,000 copies (though his classical tales were among the least successful), and their influence on the cultural imagination of generations of British schoolboys is rather frightening to estimate.[186] These novels perceive the world through the lens of a public school of the British Empire (hence The Harry Potter Effect). The archetypal hero "had a reputation for being a leader in every mischievous prank; but he was honourable and manly, would scorn to shelter himself under the semblance of a lie."[187] He faced up to evil foreigners and other enemies with the archetypal schoolboy quality of *pluck*. (One of Henty's first stories was called *By Sheer Pluck*, and George Newnes, who edited *Tit Bits* for adults, tried a publication for boys called *Pluck*.) Between honest pluck and mischievous pranks, Rome is mapped as a post-Arnoldian Rugby.

For Farrar, master of the schoolboy novel, it was perhaps inescapable in *The Gathering Clouds* that the relationship between John Chrysostom and his young pupil should come out like that between one of the pioneering headmasters (like Arnold or Farrar himself) and an aspiring schoolboy. But my favorite example of the Harry Potter Effect is the wonderfully titled *The Unwilling Vestal* by Edward Lucas White, an American schoolteacher, which was published at the end of the First World War, but which seems untouched by the horrors of that conflict. It has been reprinted several times since then. The story is of Brinnaria, a precocious young girl, forced to become a Vestal. (The difficulty of getting Vestals is attested for the Augustan period.) The Vestal's college is treated as a girls' school with the emperor as wise and understanding headmaster, and the Pontifex of Vesta as a foolish and mean vice-master who is into corporal punishment. Brinarria, a lively gal, gets into pranks: "At last, after many days, she perpetrated her first and most undignified prank. It was a terrific occurrence, judged by the standards of the Atrium". . . . "Within a month she did far worse. . . ."[188] This far worse "prank" involves the Vestal Virgin throwing off her clothes, down to her shift, and leaping into the gladiatorial arena to save a young man she rather likes the look of. This is ludicrous by any expectation of Roman society, but just about fits into the models of the genre: interrupting the games is usually a male prerogative, but tomboys in schoolgirl books get such privileges; Vestal Virgins do save lives (though not usually on purpose); and wild girls do behave in a way that opens them to unwarranted scandal, though always motivated by honest feelings. She gets sent to the emperor (headmaster's study), who understands her behavior just as high jinks, and gives her a talking to about her future. Later, after another misdemeanor (she protects a friend who let the fire of Vesta go out), she is faced with a beating. In Plutarch, we are told that beating is indeed the punishment for a Vestal for even minor offenses, and—in terms guaranteed to fire the prurient imagination—the "Pontifex Maximus on occasion scourged a miscreant's naked flesh in a dark place with a curtain interposed."[189] In *The Unwilling Vestal*, the fat and pompous Bambilio, the Pontifex of Vesta, in the absence of the Pontifex Maximus, the emperor, takes it on himself to punish Brinarria in this way. She takes her punishment pluckily, but then in a fit of anger grabs the scourge and beats the Pontifex. Again she escapes serious repercussions, thanks to the understanding of the emperor, who understands her reasons for "wallop[ing] the priest," and secretly admires her forthrightness.[190]

*The Unwilling Vestal* toys chastely with the potential of the Victorian Roman novel. Brinarria grows up to be rich and beautiful (the description strains to be jolly, I think), rather than sensuous or lascivious: "Very handsome she was, full-fleshed without a trace of plumpness, fun breasted without a hint of overabundance."[191] ("Fun breasted" is quite an extraordinary

expression, but the philologist in me regretfully knows that it must be a misprint for "full," rather than a school master's jolliness: "What fun breasts are!" The same type of misprint, "Bokrie drew up to his fun height," occurs in the reprint of Compton-Rickett's *Quickening of Caliban* also.[192]) In line with romantic expectations, she ends up marrying her heroic boyfriend whose love she has nurtured since childhood throughout her time as a Vestal. She has to struggle, of course, but succeeds in repressing her desire, while a Vestal Virgin, in the name of social propriety. Her pluck is not explicitly related to any contemporary interests in women's freedom (despite the date of the novel), and wealthy marriage is the inevitable conclusion of this as for so many stories. There is no hint of Christianity, despite the fact that this is already the time of Marcus Aurelius, the same setting as *Marius the Epicurean*—although Brinarria does practice what is explicitly called "slumming," like a good Victorian woman.[193] The novel, written for older children, recognizes the violence, religious conflict, and sexual tension of the genre, but the frame of schoolgirl fiction blanches the story into a restaged public school playground drama. At one level, this is a limit case of Rome as contemporary figures in togas. At another, more important level, such fiction is formative of the cultural imagination. It helps circulate the clichés of the representation of Rome in popular culture, but also structures the Roman past as part of the self-fashioning models of heroism, authority, and personal discovery.

Rome in the novels becomes a backdrop of clichés, buttressed by the supports of scholarship. The dictates of narrative and genre take over from the search for history, so scenes are self-consciously repeated with variation from book to book; narratives express contemporary social expectations of gender roles; the thrill of narration itself brings its own discursive demands of suspense and survival; other literary forms, such as the school novel, provide a narrative framework. The past may be another country, mapped by scholarship, but its representation enters the cultural imagination in a symbiotic relationship with the most familiar structures of popular culture.

## Jews, Egyptians, and Other Clichés of the Popular Sublime

Egypt was integral to Bulwer Lytton's matrix of national identity; his vision of the dangerously corrupt and attractive mysteries of the East continued throughout the nineteenth century (and beyond), locating in Egypt a potent combination of a profoundly long history and a central role in the Bible, as a lure to be rejected in the formation of the people of Israel, on their way to revelation at Sinai. No surprise that the Jewish Ben Hur's seductress is Egyptian. But the deciphering of hieroglyphics, a set of extraordinary archaeological discoveries, made popular also by new photographic

circulation, and the growth of Egyptology as a discipline and a popular concern, changed the status of the novel of ancient Egypt, especially in the last quarter of the century. Egypt (and after Egypt, the lost world of deepest Africa) became *the* setting for sexy adventure stories—always with a tang of religious or spiritual mystery. So too British involvement in the politics of the region, both through the funding of the Suez Canal and through military and economic intervention leading to Egypt coming under British control in 1882, increased the public awareness of Egypt and, with the invention of the steamship, also increased the direct contact of British travelers with the country itself. There was, too, a handful of explorers, eccentric Englishmen who mapped uncharted deserts for the military, and encountered unknown tribes, and wrote about it, such as T. E. Lawrence or Mark Sykes. They took the travelogue in the East, a massively overproduced genre, to a new level of excitement, and brought fiction and autobiography close together in narratives of heroism and derring-do. In the empire, stories like Henty's and that of Lawrence of Arabia mutually reinforced each other. (The history of the Middle East is still deeply scarred from this imperial "making of reality.") This shift in the comprehension of Egypt fundamentally affected the place of Egypt as a frame for the Victorian historical novel.

Georg Ebers was a distinguished German Egyptologist who discovered one of the world's oldest and largest medical papyri in Egyptian Thebes, known now as the Ebers Papyrus, and who published major academic works on ancient Egypt and a guidebook to modern Egypt.[194] We met him in chapter 2 as the biographer of Alma-Tadema, whose orientalizing images are as distinctive as his classicizing imagery. He also wrote a string of novels, translated rapidly into English, which popularized the discoveries of the Egyptologists, and which were instrumental in the changing perception of Egypt. As with the stories of the Roman Empire, scholarship is integral to the novelistic discourse (*The Egyptian Princess* has a full battery of notes), and, as with the other novels of the last two decades of the nineteenth century, there is an increasingly sensitive appreciation of the complexity of the encounter between traditional paganism and the new Christianity—in *Serapis*, the heroine is an Egyptian girl who is tormented by her slowly growing interest in Christianity. For Ebers, Egypt was not the lascivious, corrupt, and dangerous East but a complex sophisticated civilization, with a rich material and intellectual culture. This Egypt provides the frame for one of Ebers's most interesting novels, *The Emperor*, which deals with the emperor Hadrian in Egypt. *The Emperor* was translated into English in 1881, and appeared thus shortly after *Ben Hur*, but the specifically German obsession with the East also frames Ebers's rise to celebrity—an obsession that we have seen in its least salubrious form with Wagner's distaste for the Eastern, Semitic other, but which also finds a

ground both in the long history of Aryan linguistic and cultural history, and in the German political involvement with the Ottoman Empire, which grows through the last decades of the century to culminate before the First World War in a battle of propaganda, expansion, and financial investment with Britain above all.[195]

In *The Emperor*, Ebers is faced with the problem of how to represent the relationship of Hadrian and Antinous, the celebrated beautiful boy, with whom Hadrian, a Hellenophile, had a passionate erotic relationship, and whom Hadrian commemorated after his death in Egypt by having the boy's portrait set up in temples around the empire for worship (much to the scorn and disgust of Christian moralists). Ebers has Hadrian once stroke the boy's hair, and his single kiss chastely grazes the boy's forehead "with fatherly affection."[196] At the height of his mourning, the emperor laments "Oh faithful, lovable, beautiful boy!" and it is his "goodness and faithfulness" as much as his beauty that prompts the emperor's acts of commemoration (so much less passionate than Tennyson's poetic memorial for Hallam).[197] Antinous himself, in a truly surprising demonstration of the power of romantic narrative cliché, drowns himself in the Nile out of unrequited love for a martyred Christian maiden, Selene, but with praise for the emperor on his lips.[198] As much as Egypt is cleansed of its most negative Orientalist stereotypes, so the very barest hints of a physical relationship between Hadrian and Antinous do no more than underline the normative heterosexual narrative at work here.

Ebers's novel is in stark contrast with Adolf Hausrath's *Antinous: a Historical Romance of the Roman Empire* which appeared in English the previous year (1880). Hausrath, whose work was published in England under the pseudonym George Taylor, was a staunch Protestant professor of theology at Heidelberg, who wrote admiring academic studies of Strauss and St. Paul, as well as historical novels. *Antinous*, uniquely among mainstream novels of this period, engages explicitly with ancient homoerotic desire.[199] The preface daringly states "That Antinous was oppressed by his relations with Adrian is certain, but religious as well as sensuous motives mingled up with this relationship." This tale, that is, will face the oppression of male sensuousness full on, but the story of Antinous and Adrian is also to be interwoven with a Christian tale—which, shockingly, but with wholehearted Protestant discipline, sees corruption even in the charitable giving away of property, because it is a sign of a dangerous and self-regarding asceticism. Antinous meets Christian boys who taunt him: "It does not become one who can throw the discus as you do to perform woman's service for the Caesar."[200] When Adrian offers him a garland afterward, Antinous explodes: "'I do not wish to be adorned like a mistress', cried out Antinous angrily. . . . 'I hate this love which degrades me to myself.'"[201] Antinous, "with an oppressed voice," begs for release, "Let me be your friend, not

your beloved! Set me free! As a man, I will serve you with double fidelity."[202] Finally, Antinous, who finds himself thinking of girls,[203] and who has learned something of the better world of Christian living, sacrifices himself for the empire, in the hope that by his death Adrian would survive to rule well and outlive the threat of his menacing successor. Hausrath imagines Antinous as a complex victim, striving for something better than a "destiny to be beautiful," but he sees Christianity also as already prey to manipulation and false piety. Morality is located firmly as an individual's choice of behavior and belief. From this Protestant standpoint, racial identity does not determine character. Hausrath's combination of stern religiosity and unexpected sexual directness bypasses the nationalist claims of blood.

The Egypt of the novel by the end of the century combines a dominant image of an ancient civilization, the privileged origin of culture, with counter, long-lived stereotypes of the degenerate and untrustworthy East. The Jews, as has been extensively discussed, despite the growth of the Restorationist movement among evangelical Protestants, are less sympathetically represented in the novels, and in general with surprisingly less engagement than shown by the contemporary travelogues to the Holy Land.[204] Anti-Semitic stereotypes of money-grabbing avarice, squalor, and untrustworthiness abound: "the pushing, aggressive, hook-nosed Jew, who in every age and every land seems to have a genius for finance, banking and the handling of money";[205] "the wild Oriental with his mingled aspect of guile and fanaticism, his harsh Semitic features and his unsavoury griminess."[206] Jews are the sworn enemies of the new Christianity: "It is notorious that the Jews were far more malignant persecutors of the Christians than even the Pagans themselves—as is apparent from the Acts of the Apostles and other records of the early Church."[207] (Note the display of scholarship— "facts"/"science"—to support racism, as ever and especially in the nineteenth century.) As early as *Ivanhoe*, a beautiful and pure Jewess is imagined as a potential love object, but she is with typical narrative exigency confined safely to a religious retreat by the end of the story. So, even in novels where the defense of the Temple in Jerusalem is a central moment of military heroism, the only truly good Jew is one who converts, like Raphael Aben-Ezra, or who sees at least the need for a better, Christian spiritual existence: "Mariamne was no bigoted daughter of Judah . . . with all the pride of race and national predilections, she had imbibed those principles of charity and toleration which formed the ground-work of the new religion."[208] As in the burgeoning missionary movement, the terms "obstinate," "bigoted," or "perverse," stigmatize the Jews who as a race reject Christianity; individuals in the novels are more harshly and dismissively depicted. There is no equivalent of the figure of Daniel Deronda in the historical novels of the Roman Empire.

The most influential depiction of the Jews, however, came in a very early and quite astounding book now almost entirely forgotten—but which Lew Wallace at the end of the century, when it was reprinted, named as one of the six greatest English novels ever written—*Salathiel, A Story of Past, Present and Future* by George Croly. (The other five on Wallace's list? *Ivanhoe*, Bulwer Lytton's *The Last of the Barons*, *A Tale of Two Cities*, *Jane Eyre*, Kingsley's *Hypatia*—the crucible of historical fiction, religious polemic, and sentimentalism from which *Ben Hur* emerged. . . .) *Salathiel* was written in the late 1820s (three editions), reissued in 1851 and 1858, and then republished under the new title *Tarry Till I Come* in 1901, which was successfully rediscovered in the great flourishing of classicism at the turn of the century. George Croly was an irascible, dislikeable, evangelical Christian who did not get a living until he was fifty-five years old. He made his way from Ireland to London as a writer and polemicist, but even his hagiographic biographer confessed he was a "disappointed man" and "his feelings in this respect were frequently manifested in his writings."[209] He was a fierce preacher, "harsh in manner and even careless as to formal religion" who "scrupled not to express his disgust and contempt,"[210] though it was he whom Charlotte Brontë expressed a wish to hear on her first sightseeing trip to London.[211] He was parodied by Byron in *Don Juan* as "the very Reverend Rowley Powley . . . a Modern Ancient Pistol."[212] His reactionary politics were virulent: "Democracy, with its slow, personal malice, and searching, insatiable cupidity, and bloody fears, turns [a nation] into a dungeon and a grave."[213] If he is remembered today, it is foremost perhaps as the man who wrote the historical descriptions attached to David Roberts's celebrated three-volume set of pictures of the Holy Land, a book dedicated to the Queen who headed the illustrious list of subscribers. "The History of the Jews," wrote Croly there, "is the most characteristic, the most important and the most sublime in the world," and like many evangelicals, he shared a vision of Restoration: "the dawn of [the] unending day will be the restoration of the exiles of Judah. . . . The Jew will be restored." But, also in common with many evangelicals, he was bitterly opposed to the admission of Jews (and Catholics) to Parliament. "*The Jews are a people under Divine condemnation*," he expostulated, "*We must reject the Jew*."[214] After the vote was lost, he continued to write history to keep the fight alive. From the time of the admission of Catholics and Jews, he proved to his own satisfaction, "England has lost its pre-eminence abroad and its stability at home."[215]

*Salathiel*, published first in 1828, five years before *The Last Days of Pompeii*, is an early revelation of Croly's angry and certain religious opinions, explaining why the Jews are a people under Divine condemnation. It is a multilayered historical irony that when it was republished in America in

1901 with a preface by Lew Wallace (and further scholarly historical foot-
notes), the editor added "Anti-Semitism in America, even the feeblest
whisper of it, is an anachronism and an anachronism of the grossest sort."
For, he asserts confidently, "Yes, we are living in a better land and a better
time."[216] In 1901, when the admission of the Jews, which so vexed Croly,
was no longer an issue, the republication of *Salathiel* is seen by its editor to
be divorced from any direct political impact. This would have looked very
strange in Europe where the political realities of anti-Semitic policy and
behavior in 1901 were pressing. If there is the barest nod toward the harsh
violence of an older Europe (and no hint of the harsher violence to come),
it is smoothly and smugly covered over in the assurance ("yes") of a better
here and now. *Salathiel* comes layered with the politics of its own (re)pub-
lication history.

Salathiel is the foundational tale of the Wandering Jew. The Jew is cursed
to wander forever—or until the Second Coming of Christ—because he
cried out for the crucifixion of Jesus. Salathiel, the hero of the novel, is the
man who led the mob's screaming for blood—but who immediately regrets
it. He knows he is cursed, and although he fights nobly for the preservation
of Jerusalem, and struggles with his recognition of guilt, his family is de-
stroyed, the Temple falls, and, in a catalogue of Gothic scenes, he suffers
terribly—and, as the novel grimly and satisfiedly asserts, Salathiel has con-
tinued to suffer throughout history and will continue to do so. Salathiel
was with Alaric as he marched into Rome, with the Muslim as Islam was
founded, there at the discovery of America. Hence the novel's subtitle, *A
Story of the Past, the Present, and the Future.* "The name of the Jew," there-
fore, "is now but another title for humiliation."[217]

But Salathiel is also the hero of the novel, and the logic of Restoration
provides a frame for his deeds of derring-do. It may be that "the fall of our
illustrious and unhappy city [Jerusalem] was supernatural . . . the decree
was gone forth from a mightier throne" than Caesar's—but nonetheless,
"Restoration, boundless Empire, imperishable glory, were written upon its
bulwarks."[218] Thus, "let no man blame the stubbornness of the Jew till he
has weighed the influence of feelings born with a people, strengthened by
their history, reinforced by miracle, and authenticated by the words of in-
spiration."[219] Croly's religious and political views vividly reveal in this nar-
rative a tension that runs throughout the voluminous historical fiction
about the fall of Jerusalem. On the one hand, the Jews must suffer and must
be seen to suffer condign punishment. On the other hand, by virtue of the
novel's focalization, the victim also becomes the narrative's hero with
whom the reader engages. So Croly's Salathiel is repeatedly punished by
suffering, but, as the Wandering Jew, cannot be killed off—and so like the
hero of many a historical fiction, keeps on escaping death in increasingly
perilous adventures. When after 1,000 pages and three volumes of desper-

ately seeking his wife and child, he finally loses them to death, the narrative cannot escape its roots in sentimental melodrama.

*Salathiel* was followed by a string of undistinguished novels on the fall of Jerusalem, which revel in all the clichés set in place by *Salathiel*—the war story with its self-defining Christian view of doomed Judaism, and usually a love story, typically across the Christian/Jewish/Roman cultural divide.[220] But one novel stands out from the descendents of *Salathiel* not only because it was a huge commercial success which for contemporary and modern critics emblematizes the changing face of popular fiction in the late Victorian era, but also because it took the image of the Jew calling for the blood of Jesus to a new level—to what the stolid Andrew Lang reviled as "a gory nightmare."[221]

Marie Corelli published *Barabbas* in 1893. Its characteristically overstated subtitle is *A Dream of the World's Tragedy*. In one year it went through fourteen editions. There were fifty-four editions in Corelli's lifetime, and it sold more than 150,000 copies. It was a sensation. It was translated into every European language, as well as Hindustani and Gujurati. By 1900, Corelli was "regarded as the highest-paid living writer and the most notorious figure in literature: discussed, condemned, praised and pilloried by everyone."[222] There were many self-fashioning public figures in Victorian Britain—from the music critic Ernest Newman who chose that telling name for himself as part of a thorough-going concealment of his past, to Eliza Lynn Linton whose public and published self-image of conservative female propriety was in stark contrast to her actual private life—but none was more obsessive, indeed hysterical, about the maintenance of a fictional persona than Corelli. She concealed her real name—Mini McKay—her parentage, her age, her education. She used every means including the law to control pictures of herself appearing in the press—and those she allowed were heavily doctored.[223] She wrote hundreds of notes to editors and hundreds of letters to newspapers to place self-promoting paragraphs in the public domain about her dress, her meetings with titled dignitaries, her causes—for which she became a laughing stock.[224] As late as 1956, more than thirty years after her death, Cyril Connolly, with a characteristic sneer about the looks of a female author, epitomized the hostility she could provoke: "She was both unbearable and unreadable, and her little, stupid face, like a bulldog in ectoplasm, would hardly be televised."[225] She argued with and alienated almost everyone who helped her or cared for her. Critically and personally, she did not just raise hackles, she excited violent hatred.

Yet despite some of the most hostile reviews—after which she announced that she would no longer send out review copies—she was the most successful novelist in Britain from 1893 through to the First World War, and had many fans who were as passionate for her as her enemies were in opposition.[226] She sold around 100,000 volumes a year—by contrast, the lionized

H. G. Wells sold around 15,000. For the literary establishment, the success of Corelli was wondered at, resented, and earnestly discussed. That Queen Victoria herself was known to love Corelli's books added to the problem. The curl of Rebecca West's lip seems to have formed her distaste when she wrote: "Marie Corelli had a mind like any milliner's apprentice."[227] Corelli became the focus of fin-de-siècle anxieties about popular fiction: "Why is she so popular?" was a repeated question.[228] As new educational policies set out to widen the reading public, the question of what should be read "by the broader public" was ineffectually but keenly debated. For every reviewer at the *Westminster Review* who sneered at Corelli, there was a Father Ignatius, who preached in the Portman Rooms on Baker Street with the ringing endorsement, "I say there are thousands upon thousands throughout English speaking Christendom who will bless the pages Marie Corelli has penned."[229]

*Barabbas* was the first major bestseller in Corelli's dizzying career. It tells the story of the Crucifixion of Jesus through the eyes of Barabbas, the condemned criminal released instead of Jesus at the behest of the violent Jewish crowd. Novels in general, as we have seen, resisted the direct description of Jesus or even the Apostles, and avoided the miraculous. The genre of the *Life of Jesus* took on that task with more circumspection and scholarship. Corelli, however, with full-frontal excitement and in slow motion detail, and in the most purple of purple prose, described not just the Crucifixion, but also the very miracles that Gibbon had submitted to such sardonic analysis. For Corelli, the world does literally go dark at the moment of the Crucifixion: "in one breath of time blotted out the face of nature and made of the summer-flowering land a blind, black chaos."[230] Rather bathetically, the citizens hunt for torches to see their way back to the city. She even describes the Resurrection, with angels descending from heaven.

The critical hostility to Corelli was in part because of her willingness to explode the hesitation about representing the divine and the miraculous. Her stylistic abundance—the ever-elegant and amused E. F. Benson, who satirized Corelli in his Lucia novels, called it "a series of geysers continuously exploding"[231]—which coupled with her religious flamboyance, seemed appallingly vulgar to her opponents. She stood against the theological, historiographical, and narratological niceties that had grown up over the century. Her claims to be scholarly were risible—she said she read Greek, Latin, and Hebrew, but she had barely any formal education—and, needless to say, her books had not one footnote or academic excursus. Her popular success was a threat to more than the *amour propre* of the literary establishment.

Barabbas himself dies in a form of saintliness, converted by his awed contact with Jesus, whose Resurrection he witnesses. Judas, even more bizarrely, is exonerated as an idealist who has been tricked by an evil Jewish

priest Caiephas, the lover of his evil sister, Judith Iscariot. Her name, chosen as if Iscariot was Judas's surname, caused hilarity among the scholars. But Corelli needed a love interest. . . . This is all part of a virulently anti-Jewish, anti-priestly, and anti-Catholic agenda, a collocation that should cause little surprise.[232] The awful destiny of the Jews is established early in the book (in a good example of Corelli's overheated prose): "This hideous, withering, irrevocable Curse rose shudderingly up to Heaven—there to be inscribed by the Recording Angel in letters of flame as the self-inflicted Doom of a people."[233] The evil of Caiephas, described with a full physiognomics of physical and moral corruption, is made paradigmatic of the Jewish people. So Jesus is repeatedly separated from his Jewishness in a way that anticipates more consequential theological and political strategies in Germany over the next forty years. Jesus is "so unlike the Jewish race in the fair countenance and dignity of His countenance, the clear yet deep dark blue of His eyes." Even the executioner declares "I would swear his father were never a Jew," and the text supports the claim that he is "not altogether [Jewish]. . . . Mary his mother was of Egypt." [234]

Renan, as so often in the books discussed in this chapter, is the unacknowledged influence here, directly or indirectly. He argued that after visiting Jerusalem, Jesus acts as "a destroyer of Judaism. . . . Jesus was no longer a Jew."[235] Renan's arguments are central to the development of nineteenth-century racism, and led to the claims in German theological writing in particular that Galilee, Jesus's homeland, was not ethnically Jewish because it had been "settled by blond, blue-eyed immigrants fifteen hundred years before the time of Jesus,"[236] and that it was only a malicious Jewish influence that sees Jesus as anything other than a virulent enemy of Judaism—which leads finally and with horrific results to the Nazi-led theological assertion from the heartland of German academia that "It is the greatest lie that the Jews have brought into the world, that Jesus is a Jew."[237] As Wagner's son-in-law, Chamberlain, the racial theorist who had such an influence on Hitler and much of Germany argued already in 1899, "That Christ had not a drop of genuinely Jewish blood in his veins . . . is almost a certainty."[238] Nazi historians were quick to assert a direct genealogical link between Luther and Hitler in their shared perception of the necessary connection between the German spirit and anti-Semitism; Nazi theologians reconstructed the Life of Jesus in remarkably perverse ways.[239] But not only did such extreme academic views have a deep-seated and more complex set of roots, but they also found acceptance in the church not least because of the preparation provided in part by the representation of the Jews and of Jesus in the novels of the nineteenth century. The novels reflect in narrative form the diffusion of challenging theological discussions, and in turn create the conditions of possibility for further change. It hardly needs saying that Corelli is not responsible for the holocaust, but a history

that seeks to explain how anti-Semitism became such a destructive force in Europe needs to take account of how the imaginary of racism develops—and exploring the culture of racism will require recognizing this striking dynamic over time between theological debate, popular fiction, and political change.

Corelli demonstrated her distaste for Catholicism, too. With a nasty twist of the claims of apostolic succession, Peter's denial of Jesus is taken as the origin of papal corruption: "Alas for thee, Peter, that thou too must serve as a symbol. A symbol of error—for on thy one lie, self-serving men will build a fabric of lies on which the Master whom thou hast denied will have no part."[240] Jews and Catholics alike are dismissed in a phrase: "This Crucified Man was against Priestcraft."[241] Corelli had none of the embedded religious affiliations of Kingsley or Newman from earlier in the century, or even of Baring-Gould, her exact contemporary. The over-heated conviction of her lush discourse might seem out-of-date for the 1890s, were it not for her immense and surprising popularity. But Corelli's passion—and her version of the Passion—is best seen as the flip-side of the blanching of stringent commitment that otherwise distinguishes the 1890s in comparison with the 1850s. That is, she offers the thrill of religious excitement but without any bracing theological strictures, and without any apparatus of scholarship. Farrar's *Life of Christ* was attacked for its exuberant and gushing prose, and its "taint of popularity."[242] It offered to many the comfort and reassurance of an embracing account told with the full authority of a respected scholar and divine, to set against the contemporary conflicts of religious belief, which had been exacerbated precisely by theological and historical scholarship. Corelli in turn, dismissed with scorn by the scholarly, offered her readers an emotionally overwhelming experience, which allowed for a sense of intense religious engagement without the intellectual work of theology and without the social awkwardness of public enthusiasm. Corelli's "ecstatic passion and oceanic surrender," her "utopian gesturing towards an ineffable otherness" offered what Rita Felski has nicely called the "popular sublime," not just a "synthesis of scientific knowledge and religious mysticism," but also an emotional exoticism linked to a highly conservative social agenda.[243] One element of this emotional enthrallment of her reading public is Corelli's easy and aggressive deployment of religious prejudice. Here is a perfect example of how high-minded scholarly disagreements and appropriations of the ancient world, and the circulation of long-lasting and socially instrumental stereotypes are part and parcel of the same historicizing discourse about the classical past.

Croly and Corelli were both extremely successful—or extreme and successful—in their modeling of a Christian past in and against Jewish history. Croly's anti-Semitism is both theological and political—an integrated in-

tellectual response to what he perceives as an immediate threat to the Christian constitution of Britain, although it failed to halt the change of legal status for British Jews. Corelli's anti-Semitism, by contrast, sixty years later seems less intellectually grounded and less politically motivated, but is published at a time when the Jewish question has taken a more poisonous turn. *Barabbas* is contemporary with the rise of an aggressive anti-Semitism across Europe in the late 1880s and 1890s, which many scholars have seen as the emotional and social grounding for the horrors of the mid-twentieth century's violent persecution of the Jews—as she also stands in line with England's particular liberal response to the Jewish question, which acts in contrast with the violence of much of Europe.[244] Corelli's lack of a thoroughgoing racist theory can be read as grounding her popularity in England. To this degree, the continuity of the imagery of the Wandering Jew and other stereotypes masks the different political impact and significantly different historical context for each novelist.

Yet for both, the long tradition of seeing the destruction of the Temple as condign punishment for Jewish obstinacy, and as a sign of the failure of Judaism, is joined with an evangelical zeal for spreading the word, to represent the encounter of Jews and Christians in the empire as nothing more or less than the first battle in the long triumphalist war of Christian supersessionism. Since the early Christians spent much time and finally much aggression separating themselves from the Jewish context in which Christianity started, and since the destruction of the Temple, a founding moment in Jewish and Christian religious imagination, also happened in the first century at the hands of the Roman imperial power in Judaea, Jews must play an integral role in the framework of race and nation articulated by the historical novels of the Roman Empire.

So despite the changing political position of the Jews in English political life across the nineteenth century, the representation of Jews in the first centuries in these books at least scarcely escapes the most traditional of stereotypes. In the high liberal tradition, which can be said to find its privileged statement in Arnold's distinction between Hebraism and Hellenism, the Jew as a figure moves between the despised deicide and the transcendent hope of future culture, which finds political expression in Restorationism, though such idealism often stutters and splutters when faced by actual Jewish people, where, as Cheyette notes, race overtakes culture in social stigmatization: even Arnold, with yet another unacknowledged but deliberate echo of Renan, can call Jews, whatever the role of Hebraism in his system, a "petty, unsuccessful, unamiable people, without politics, without science, without art, without charm."[245] We saw in chapter 4 how Wagner's aggressive anti-Semitism could turn this idea of transcendence into an image of willed self-annihilation; *Daniel Deronda* remains the best known example of the lure of Restoration as an idealist political movement. The ambivalent

"semitic discourse," which runs through post-Arnoldian literature into the twentieth century, has been very well analyzed by modern critics, especially Bryan Cheyette. But from Croly's paradigmatic mix of triumphalist recognition of the punishment of the Jews along with a prediction of restoration for a long-suffering people, through to Corelli's evil Jewish plots, in the novels of empire there is a hardening and simplifying of the Semitic discourse. When Jews enter the popular literature of early Christianity and of the Greco-Roman world, we see only the barest traces of the high liberal tradition, even and especially as the nineteenth century ends. The intense intellectual European manipulation of the opposition of Jews and Greeks, say, is indeed strikingly absent from Anglophone novels, and serves to mark how odd Arnold's European-influenced dichotomy between Hellenism and Hebraism, and his association of Hebraism with Protestantism seems within this British context.[246] This racial and national ideological complicity of the novel—or at least of Sunday reading—is nowhere more evident than here. Martin Tupper, the Royal Family's favorite bard, and a man who went fishing with Kingsley, vividly epitomizes this combination of Teutonic imperial and religious fervor, in what are some of his more regrettable lines:

> Break forth and spread over every place.
> The world is a world for the Saxon race.[247]

The clichés of narrative expectation that I discussed in the previous section, and these commonplaces of racial and national thinking, combine to make even the more trivial of novels about the Roman Empire insidious stories through which the citizen of the British Empire experienced a narrative of history, and found a place in the world, a "world for the Saxon race."

## Conclusion: A Christian Empire

It is hard to talk sensibly about the discourse of imperialism in Victorian Britain without considering the image of the Roman Empire, central as it is to the imagining of time and power over others;[248] it is hard to discuss the depiction of Rome without considering the role of Christianity in that depiction, since the early church and its relationship both to Roman power and to modern self-understanding is integral to the most insistent polemics of the middle of the century in particular. Indeed, although modern critics have been keen to see the representation of Rome primarily as a way of modeling empire, we have seen here that in these novels it is Christianity and the role of the past in determining contemporary religious life that is by far the dominant concern of writing about the classical past of the

Roman Empire. Clive Bell wrote dismissively, as the First World War approached: "To compare Victorian England with Imperial Rome has been the pastime of the half-educated these fifty years." But his father-in-law Leslie Stephen, certainly not one of the half-educated, was more precise in his religious focus: "The analogy between the present age and that which witnessed the introduction of Christianity is too striking to have been missed by many observers."[249]

For all of these far-reaching Victorian debates, the numerous novels that are set in the Roman Empire are instrumental. They are instrumental in the performance of the contest over history, and they are instrumental in the circulation of the images and clichés, through which a cultural picture of ancient Rome is formed. To engage with these novels requires an appreciation of the background of Victorian debates over historical consciousness, historical fiction, and the connection between classical scholarship and religious scholarship, two dominant intellectual activities of the academy, which also spread in different ways throughout elite and popular culture in Britain. Classics and theology mattered in Victorian society with an insistence not seen since the sixteenth century and the Reformation. This is a society where a challenging sermon could lead both to a counter-broadside in a pamphlet war or to a riot on the streets (or to polite lack of interest or to an increased audience or . . .); and where at the same time as classical learning could lead to social preferment, classical burlesques could uproariously satirize the war effort. Some of the novels mentioned were hugely popular, with sales in the case of *Ben Hur* in the millions; others were influential among particular groups of readers. It is likely that Wiseman and Newman were bought particularly by Catholic readers; others still were ignored by the public; some flared briefly and passed out of memory. But as a genre—and there was a genre recognized explicitly by readers and reviewers and writers—the novels of the Roman Empire act as the center of a Venn diagram of larger issues: history writing, religious commitment, the value of the classical past.

As such, they provide a peculiarly instructive case for what we have been calling Reception Studies. Roland Barthes famously outlined what he termed "l'éffet du réel," "the reality effect," whereby unnecessary physical details mentioned in passing, along with a background patina of historical figures or places, create a grounding for the realist fiction of the nineteenth century. In these Roman Empire novels, however, we see something further and quite different. The use and abuse of scholarship to locate fiction authoritatively within an appearance of the real is a disruptive and polemical strategy, offering the reader an archaeology of knowledge through which to ground the narrative within a privileged textual or material past. This strategy repeatedly breaks the frame of its own realism with a self-conscious, historically conscious sense of the constructedness of narrative.

The reader is placed as the active heir of the past; the cultural identity of the reader—as English, as Christian, as modern—is set at stake. Thus, many of these stories are explicitly normative and even didactic. One is encouraged not to lose oneself in a good story but to find one's self in it, to see oneself in a toga, however clumsy the gait. This is as far from a "classical allusion" as one can get. The sense of indirectness and complicity, which allusion demands, is replaced with explicit, direct citation; the past is not just a resource for the imagination, but a causal force on the present, as the past explains how things are and should be. There is, then, expressed and explored in the novels a particularly strong understanding of classical heritage or classical tradition, where what is inherited or passed down, like a genetic code, forms a determinative history. The classical past makes the man. Hence, competing views of what it is to be a (religious, English, modern) man make the classical past a scene of contest. Located between the disciplines of classics, history, and theology, disciplines in formation, these novels of the Roman Empire open a distinctive window onto the construction of historical subjectivity in Victorian culture.

These later nineteenth-century fictions of empire, then, with their polemical history of how the modern British Anglican community came to be how it is, constitute a rediscovery and redramatization of the questions Gibbon put in place in the 1770s and 1780s, fueled by the long-running religious turmoil led by figures like Strauss, Renan, Newman. "The novel is the epic of a world forsaken by God," declared Lukacs, famously.[250] His account of the rise of the novel, focused primarily on European examples and articulated from his particular ideological concerns, leads with an overriding teleological force towards realism as the dominant mode of the nineteenth century, in a way that looks back to the artistic debates I outlined in chapters 1 and 2, or to the interest in accuracy in staging discussed in chapter 3—and we have seen many ways in which the dictates of realism redesign the potential of the religious novel, especially where miracles and martyrdom are concerned. The novel's drive toward realism is in itself an integral part of how the generic form of the novel is caught up with conflicts over religion as a dominant representational system, a regime of knowledge. Yet for those in the 1880s, caught between *Ben Hur* and *Robert Elsmere*, or for those tracing the sly and dangerous aesthetics of Pater's *Marius the Epicurean*, or even for those reviling or reveling in Corelli's vision of the Resurrection—no less than readers of Kingsley and Newman in the 1840s—the mind was branded by faith-filled and martyr-led narratives, a world more marked by Providence than God-forsaken. The continuing popularity of Kingsley's *Hypatia*, republished more times in the 1880s than in the 1840s, will stand as an icon for why a nuanced account of secularization and realism in Victorian culture should not forget the continuing impact of the Christian fiction of antiquity.

*Chapter 7*

❖ ❖ ❖ ❖ ❖ ❖ ❖ ❖ ❖ ❖ ❖ ❖ ❖ ❖ ❖ ❖ ❖

# ONLY CONNECT!

## The Life of the Author

In the previous two chapters, we have looked at the intellectual background for the Victorian novels set in the early centuries of Christianity in the Roman Empire, and at the novels as a genre, their strategies of representation, their *topoi* as a style of reception. In this brief final chapter, I want to change the perspective and to reset these cultural productions back into the intellectual lives of their authors, and use this to see something of the social network within which the books emerged and to which they spoke. Each one of the writers and artists who have entered this book could profit from such a treatment, with varying degrees of predictable success according to the state of the archives on their lives. Certain figures have made an appearance across the different disciplines and narratives of this book—Ebers, Renan, Bunsen, from Europe, say—or produced work whose range challenges modern disciplinary boundaries—Jowett's radical theological writing, for example, is almost never considered by classicists who take him as a hero or villain of the Victorian development of classics as a discipline—and this suggests that the richness of the intellectual and social connections of particular Victorian individuals needs an attention that the focus on specific single works often, perhaps inevitably, downplays.

To this end, I have chosen to look first at the rambunctious and pious Charles Kingsley from around the middle of the century, and secondly at the decent and worldly Fred Farrar, less well-known now than Kingsley, but exemplary of the latter years of the Victorian era, and the figure with which I began this section of the book. There, I called Farrar a "hero" of my argument. In part, this was no more than a nod in the direction of the fiction I was about to discuss: he provided an opening focus for my story, a hero in the sense of a leading light (and every story needs a hero). He was also a good example of how novels emerge from within a range of writing about religion and classics, and is paradigmatic in this. (He is certainly not a hero for me in terms of his outlook on life, for all his liberalism and commitment to education.) Now, I want to fill out some of the biographical material that makes Farrar and Kingsley exemplary. But this biographical

perspective has a wider range of implications also, and I would like to stress two of these broader issues here.

The first concerns Victorian biography as a genre. The Victorian biographical turn has been much discussed in recent years, in terms of the sociology of production and in terms of generic form; and the canon of "great biographies" has been profitably challenged and extended by detailed attention both to biographies by women, working class figures, middle-class professionals, and to a wider range of life writing.[1] The two-volume "Life and Letters" became a particularly prevalent Victorian production. Usually written by someone closely linked to the subject—a spouse, a child, a life-long friend—hundreds of these memorials were constructed, usually within a few years of the death of the subject, and almost always written with an air of pious celebration. The emergence of the biography was the public recognition of the significance of the life, the capstone. The focus—again talking very generally—was on the public life of the celebrated figure, and the republication of many letters within the biography both allowed a good portion of the book to be authored by the subject, as it were, and brought even the private life under the aegis of the semi-public exchange of letters, which had all too often been written already with an eye to their broader reading, both by an extended audience within a family and by an imagined posterity. The editing of such "Lives and Letters" reinforced the public and controlled discourse (as we will see shortly with Kingsley's biography by his wife). One key repeated term of the art is "sacred": It is used whenever intimacy or awkwardness is approached too nearly. "This is too sacred" to reveal; these letters are "too sacred" to be intruded upon, and so forth. It marks the reticence that comes with Victorian public discourse, and with it, a particular formulation of the biographical subject in the public domain, a particular sense of the (biographical) self. The high self-control (in all senses) of such volumes was also immediately recognized. "We in England bury our dead under the monstrous catafalque of two volumes (crown octavo)," as Gosse noted sardonically.[2] So Gladstone, a man fully aware of the values of privacy and exposure, dismissed the biography of George Eliot written by the husband of her last years, J. W. Cross, with: "It is not a Life at all. It is a reticence, in three volumes."[3] Carlyle, with a typically memorable turn of phrase, summed up the form: "How delicate, decent is English biography, bless its mealy mouth."[4]

It is within and against this established strain of establishment biography that other genres need to be viewed, both the novel—with its more complex, intimate, and thus more threatening or challenging narratives of selfhood—and history—with its willingness to articulate, explore, and criticize the connections between personality and action. The theory of history as the effect of great men—what Freeman called "the Personal Theory of History"—was promoted and questioned as a grand theory (in contradis-

tinction to other theories). Carlyle's idea of the hero epitomized this model, and it is no surprise that his dictum "History is the essence of innumerable biographies," or, more directly, "The History of the World is but the Biography of Great Men" was echoed endlessly. So Charles Kingsley, in Freeman's eyes, shows how "History is thus turned into a field in which a countless series of biographies finds its place." So, too, in the same strain, Emerson declared: "There is properly no history, only biography."[5] Macaulay's essays set a level for a sharper style of biography as history, based more on classical models of Thucydidean judgment and Tacitean bitterness and paradox. Lytton Strachey's *Eminent Victorians*, an heir to Macaulay in this, was such a brilliant success not only because it debunked the public, formal reticence of his father's generation with witty, psychologically informed revelation, but also because in its generic form it revitalized the essay as a proper form for biography. His willingness to see the private foibles and psychological deformations of his characters offered a different sense of self to the public gaze—a gaze prepared, now, by a long history of psychology as a discipline, and by the novel's interface with it, to pry beneath the surface of public life, and even beneath the exposure of self-representation. Freud's suspicion of willed revelation and his commitment to self-betrayal come after many years of distrust of autobiography as a form.[6]

The very variety of nineteenth-century life writing itself also sets itself against what was recognized with different commitments and complicities to be the standard model. On the one hand, especially after the scandal of Froude's exposure of Carlyle's private life,[7] there was a highly self-aware discussion of the limits and transgressions of discretion. For Gosse, the aim was to find "how to be as indiscreet as possible within the bounds of good taste and kind feeling," while Sir James Crichton-Browne expressed himself more strongly: "But the frank biography has its limits, and has not hitherto been held to include the history of a man's sexual experiences. It has been left to Froude to set a most pernicious example and inflict a stain on English literature. . . ."[8] (The term "inflict a stain" will look too precisely motivated to modern eyes, I fear.) Froude's indiscretion was precisely in "revealing the most sacred privacies of Carlyle's domestic life."[9] This discussion of discretion was at one level about privacy—the "sacred"; at another, about a more class- and gender-based set of criteria. So Sidney Lee, editor of the *Dictionary of National Biography*, and destined to be sharply mocked by Virginia Woolf for his principles of exclusion and inclusion, wrote bluntly: "The life of a nonentity or a mediocrity, however skilfully contrived, conflicts with primary biographical principles."[10] On the other hand, from the first book-length study of biography in English, written by Stanfield in 1813, through to Stephen and Lee, editors of the *DNB*, and Gosse, before the First World War, and to Nicholson and others after, the history of biography as a form became a small (still continuing)

tradition of its own, with a considerable investment in proclaiming the modernity of the contemporary sense of selfhood and biographical exposition.[11] This intellectual discussion of the form—the biography of biography, as it were—together with the celebration of the heroes of the nation and the formation of a sense of community around the prosopography of its distinguished figures, made biography "the devotional literature of Individualism."[12]

Despite the continuing production and continuing circulation of formal biographies in the "Life and Letters" format through the nineteenth century, the range of narratives of the self was extraordinarily varied in Victorian life writing—and the interrelation between different forms of narrative particularly complex to map. At one pole, Carlyle's *Sartor Resartus* is an extraordinary, hilarious, bumptious, and sophisticated take on the *Bildungsroman*, a parodic account that nonetheless had a huge influence on the types of stories of the person that could be told, and acted as a fiction to live by for many a (self-made) man. At another pole, the picture of the internal life of a struggling woman in a novel like *Jane Eyre* was riveting for its very engagement with what so many traditional biographies ignored—and was criticized for being "coarse"—the antonym of "sacred"—precisely because the first-person narrative was intimate and revelatory exactly in the arena where decorum demanded silence and repression. Edmund Gosse's *Father and Son* (1907) took the narrative of a child's development further still with his remarkable portrait of his upbringing amid the Plymouth Brethren, which he constructed as a contrast in temperaments—between his father's intense, evangelical religious commitment and his own questioning, wry, literary sentiment—which becomes a melancholic and funny liberating contrast between the earnest years of the middle of the nineteenth century and the very different feelings of *fin de siècle* and Edwardian London. The son's reminiscences and analysis of his father's and his own maturing feelings paint a retrospective canvas of a culture in change—a narrative of loss that allows history to emerge poignantly from biography. At a further pole still, the invention of the *Dictionary of National Biography* vied with university, school, and newspaper obituaries, other collections of lives, and self-help books (and more besides) in the circulation of snap-shots of how to organize a life, discursively: "The Victorian age was prosopographical."[13] Working class biographies, rarely in contact with literary models, often traced a confessional narrative of conversion: a world in which Parson Lot—or *Alton Locke*—seems particularly at home.[14]

This very variety and sophistication of narratives of the person produce particular modes of indirection—think of Pater's *Marius the Epicurean* as autobiographical fiction (in tension with the biographies of Pater); particular layering of multiform narratives, as in the use of psychological science within novels, multiplying perspectives on (understanding) the self;[15] and

the particular difficulty of appreciating exactly how pointedly the self-placement of a personal narrative is articulated. To what degree can or should a biography in the most traditional form be seen as a refusal of Carlyle's or Brontë's more subtle and intricate discursive strategies—a disavowal? A work such as *Alton Locke* is a good example of the discursive potential of the form of life writing. It appeared first as the autobiography of a tailor, as the title page proclaims, was quickly ascribed to Kingsley, as a barely coded statement of his views known from his public campaigning as Parson Lot, but seen to be based on the life of Thomas Cooper (who wrote his own autobiography twenty or so years later), and its main didactic character was immediately pegged to be a portrait of Carlyle (not least by Carlyle himself). Its fictional narrative interweaves with the real at different levels, and aims to make a public intervention in how lives are lived by offering the narrative of a life. The nineteenth century saw itself, justifiably, as a biographical age, where the sheer profusion of examples of writing the self (and the profusion of models for writing the self) testify to the cultural obsession with personal development and the narrative dynamic of inward change and outward behavior.

What is particularly surprising, however, and a perfect example of what I have been calling the proclamation of modernity, is not just that nineteenth-century writing is so (self-)aware of this generic development and conscious variation, but also that it is seen as an especially modern project, a sign of the times. An English journalist in 1870, Robert Goodbrand, wrote, with an apparently cavalier ignorance of 2000 years of writing: "Until the last hundred years there has been no idea of biography at all. It is a modern attainment, and Goethe and Rousseau have opened the double valves through which the world has arrived at it."[16] Goodbrand is not a distinguished writer, but he does capture a note that runs through many an example of life writing and the commentaries on them. So, Rousseau begins his *Confessions* "I have conceived an enterprise that has no model whatever and that, once accomplished, will have no imitator." So much for Saint Augustine. (Goethe likewise famously noted: "All my works are fragments of a great confession.")[17] Even the classicist Wilamowitz, who certainly knew well the ancient biographical writers from Xenophon to Plutarch to Suetonius, thought that it was only in the nineteenth century that a sense of self had emerged to which the term biography could properly be applied.[18] What links the uncelebrated Goodbrand and the very celebrated Wilamowitz is the perception that a new nineteenth-century understanding of the subject requires and receives a new nineteenth-century genre of life writing.

Now this necessarily truncated version of the development of genres of life writing in the nineteenth century (a full-scale treatment would take us far from my theme here) is designed to emphasize just two basic, general

points so far. That each form of life writing—in narrative strategy and discursive organization—articulates a specific, historically located sense of self, which changes over time and across cultures. A Plutarchan biography is not like a Victorian two-volume life and letters, which is not like a twentieth-century psychological portrait. Each inscribes a sense of self that has a specific cultural purchase. Second, nineteenth-century life writing is especially conscious of these changes and formal possibilities, and again and again thinks of nineteenth-century culture as undergoing a biographical turn.

This, in turn, leads to a third point, however, which does need underlining. The Victorian recognition of the interweaving of a writer's life and work is part of the *reception* of the author as a cultural figure. One particularly relevant example will suffice to make the point. Mrs. Gaskell wrote her biography of Charlotte Brontë shortly after Brontë's premature death. It was one of the first biographies of a female author by a female author. It has proved instrumental in the construction of the myth of the Brontës. Charles Kingsley captures the thrust of Gaskell's impact in a single comment: "*Shirley* disgusted me at the opening: and I gave up on the writer and her books with the notion that she was a person who liked coarseness. How I misjudged her!"[19] Before he had read Mrs. Gaskell's biography, he had one, negative, moralized view of the novels of Brontë; afterward, his appreciation of the novels changed. Brontë's reception is—and has remained—mediated through this carefully rhetorical image, established by Mrs. Gaskell, of Brontë secluded at Haworth, up on the moors, with her sisters, wastrel brother, and domineering father. Life writing is integral to nineteenth-century reception. Pilgrimages to writers' houses start in earnest in this period; the fascination with the author as the guide to the work, its animating spirit, is prevalent. An author's self-representation manipulates the possibilities of this dynamic (as Marie Corelli or Oscar Wilde knew better than most). The expectation of the figuring of the author is written into the letters, prefaces, essays, and fictional narratives of the period. As Roland Barthes wonderfully expressed, not just in "Death of the Author," but in *Roland Barthes / by Roland Barthes* or in *Camera Lucida*, the life of the author has . . . a life of its own. This chapter aims to explore this weaving of the representation of the author, life writing, and the author's texts as part of the process of reception. In neither case will I attempt anything like a full biography. Rather, my aim is to emphasize both the interconnected variety of the writings of each man, and, as Arnaldo Momigliano encouraged nearly fifty years ago now,[20] the interplay between their biography and their intellectual work.

The second major issue can be expressed much more briefly, and concerns our contemporary buzz-word "interdisciplinarity." It seems to me that our very disciplinary boundaries have worked against seeing many an

author and many a work in as full a context as is desirable. In part, this is a question of labels. Kingsley can be called a novelist, or a parson, or a Christian socialist, or the Professor of Modern History at Cambridge (etc.); Farrar has a role as a school teacher, a crusading journalist, a novelist, a divine, a loved and despised religious writer—and so forth. Each label trails its own narrative, and each author has been written into different historical accounts under such labels. In the same way, it is all too rare to see any discussion of *Eric or Little by Little* that also sees Farrar's educational writings or sermons as relevant to the criticism of the novel, despite the fact that *Eric* is a moralizing schoolboy book. This chapter's biographical turn brings together what disciplinary formations tend to separate, in restricted scope, for sure, but as a marker for an ambition toward a more integrated picture of the textual production of the period. Modern disciplinary formation has an instrumental effect on the reception of the writings of the nineteenth century.

These two general issues lead to a third. I have talked repeatedly in this book not just of the representation of antiquity in the nineteenth century, but also of the experience of historicity as a defining characteristic of Victorian culture—knowing oneself to be in an age of progress, marked out as a historical subject. This final chapter will let us see this experience of historicity and its representation as epitomized by two major representative figures of the era.[21]

## Victoria's Historian, Darwin's Parson

It is easy enough to give the basic outline of Kingsley's career, not least because his life story has been told many times, at great length, from his wife's version of his *Life and Letters*, a classic example of this hagiographic genre, through to full-scale modern biographies focusing both on his familial life—with an inevitable modern fascination for his private sexual life—and on his intellectual development.[22]

Kingsley was born in 1819, the same year as Queen Victoria (and George Eliot, Ruskin, Clough, Melville, Whitman), and grew up in a clerical family in the countryside first of Lincolnshire (the fens are the most evocative setting for *Hereward the Wake*) and then in Devon (where *Westward Ho!* starts). His student days were transformational. After two years preparation at King's College, London, where he first came into contact with F. D. Maurice, whom he always regarded as his intellectual father, he came to Cambridge. At Cambridge, like so many earnest young men in the mid-century, he struggled with religion, with sexuality, and with the tension between physical pursuits and a serious, intellectually rigorous Christianity, though he finally worked hard enough to graduate with a distinguished first class

degree. It was while at Cambridge that he met his future wife, Fanny, who is the dominant figure in Kingsley's life and who mediates modern understandings of his life through her editorship of his letters. To her he expressed his spiritual doubts, and it was she who led him, he claimed, to accept fully his Christian faith and purpose. She had been about to enter a Puseyite nunnery, while he was tempted by more sensuous and physical pleasures. Their courtship lasted four years in the face of considerable rather snobbish opposition from her family; for Kingsley, there was no doubt—to have shared a loving gaze with Fanny was "eye wedlock." Each told the story of this courtship as a story of salvation, salvation from the Scylla and Charybdis of asceticism and vicious degeneracy, culminating in the proper bliss of wedded life. Not everyone saw it so. One more disgruntled friend of Froude described Kingsley's passage through university, as "A most vehement, impulsive, stammering, shy, fiery, young Cantab, not without a dash of recklessness, pre-doomed like every other worthy one to the unescapable misery," because he had the "terrible misfortune . . . to meet that peculiar guardian angel of his"—the Tory church "crippled him for life."[23] More charitably, his friend Thomas Hughes described him, even after marriage and ordination, as a "great fullgrown Newfoundland yearling dog," shaking and messing and tumbling over everyone—who nonetheless get pushed into "momentary enjoyment of the tumbling."[24]

Kingsley anguished to Fanny about his physicality. "You cannot understand the excitement of animal exercise to a young man," he wrote, extolling his habits of riding and boxing and walking.[25] He hated the term Muscular Christianity, but it is hardly surprising that it stuck to him.[26] He probably would have preferred Anne Thackeray's praise of his "honest pluck." Before marriage, he also revealed his youthful activities in a letter that Fanny, typically, did not include in the authorized collection: "Darling, I must confess all. You, my unspotted, bring a virgin body to my arms. I alas do not to yours. Before our lips met, I had sinned and fallen. Oh, how low! If it is your wish, you shall be a wife only in name. No communion but that of mind shall pass between us."[27] The strength of sentiment shared throughout the marriage, as well as the pictures which the married Kingsley drew of Fanny and himself, naked, having sex in the fields, or sitting as a naked Greek shepherd and shepherdess in a pastoral bower, suggest that he judged his confession nicely enough—and that they found each other well-suited in their earnest bliss. Both agreed that nakedness brought them closer to God, discussed the wedding night for some time before it took place, and talked to each other of the difficulties of abstinence. Their love letters and Fanny's diary reveal an intimate portrait of expectation and fantasy at odds with the most familiar stereotypes of Victorian ignorance and prudishness.

Kingsley took orders and started life as a country churchman; the couple married in 1844, and in the same year settled into the rectory at Eversley

in Hampshire. From here, Kingsley's career takes a quite untraditional turn. Although he was committed to parish life and to working intently for his flock, he became a figure of national notoriety. First, he became heavily involved in the Chartist movement, and campaigned actively for social change. He was proudly a Christian Socialist, which always tempered his Chartism, when the term evoked a terrifying threat of social upheaval in revolutionary times. At a stormy Chartist meeting, when the church was being attacked for its support of the status quo, Kinglsey impulsively stood and stammered passionately "I am a Church of England pastor—and a Chartist." The rhetorical success of the intervention took years to live down in the circles of preferment. His associate Campbell, bathetically, was reduced to tears of laughter by the stammering announcement, because a colleague took Kingsley to be drunk.[28]

In 1848, he published a verse play, *The Saint's Tragedy*, about Elizabeth of Hungary and her confessor, Conrad of Marburg (in chapter 1, we have already discussed Calderon's picture based on Kingsley's theme and the fuss it caused in the London of 1891). In the play, Elizabeth's desire to help the poor is crushed by the hypocritical institutions of the Catholic Church, and her willingness to go "naked and barefoot through the world, to follow my naked Lord" is the perverted climax of the transformation of a young woman's natural desire into a disturbed asceticism. The play was largely ignored. But F. D. Maurice read it as several stages of its composition, and his criticism and their growing relationship was fundamental to Kingsley's self-awareness: Maurice's plea to regard Christianity and politics as integrally linked was fundamental to Kingsley's intellectual development. (Like Maurice, he worked to "dismiss all faith whatever in the popular doctrine of eternal punishment.") *The Saint's Tragedy* was also picked up appreciatively by Froude and others at Oxford, as part of a backlash against the high church tendencies of the Oxford Movement, and Charlotte Brontë read it in 1851, and wrote to Mrs. Gaskell that it was one of the few books ever to have made her cry.[29] Bunsen praised it to Max Müller. Kingsley's strong anti-Catholic feelings, together with his enthusiasm for political change led by the church, gave real bite to the Christian element in his Christian Socialism, and it makes his own and others' claim that "nothing more dangerous than the Bible" was his "reformer's guide" seem disingenuous to the point of irony.

He also wrote what became famous public letters as "Parson Lot," which expressed horror at "the shameful filth and darkness in which you [the poor] are forced to live crowded together," and called for a liberty further even than the charter promised.[30] He did not much value the electoral reform promised by the charter, but demanded freedom for the poor in a way bound to alienate and upset the classes with which he associated. At this time, he wrote *Yeast*, a rather thin novel in which young men discuss religion earnestly, and in 1850 published a second, much more substantial

novel, *Alton Locke*, which was repeatedly reprinted over the next thirty years. Based on the life of the autodidact Thomas Cooper, with whom Kingsley corresponded, this is a tale of a tailor, who strives to educate himself and is taken up by society as a poet. The book charts the misery of the working classes and the hypocrisy of the upper classes who patronize the young literary figure: it is the novel Parson Lot would write. It marked Kingsley out as a dangerous radical in the eyes of the conservatives, constantly looking over their shoulders after 1848.

Kingsley continued the life of a country parson after these turbulent years, writing some fierce sermons and essays, and in 1853, publishing *Hypatia*, which as we have seen continues the strident anti-Catholicism of *The Saint's Tragedy*. His next novel, however, was written in the fervor of nationalist feeling at the time of the Crimean War. *Westward Ho!*, published in 1855, set at the time of Elizabeth 1, is a bloodthirsty historical adventure in which the English, "replenishing the earth and subduing it for God and the Queen," defeat the evil Catholics of Spain, colonizing and slaughtering as they go. The heroine is saved, swashbucklingly. It was a financial and critical success at the time, and read and given as a school-prize well into the twentieth century (though it is a book that modern readers now generally find abhorrent for its jingoism and easy violence, made more evident by the thinness of the B-movie plot). The move from anti-Catholicism in Alexandria to patriotic anti-Catholicism in England is a change of setting more than any shift in perspective.

In the same year, however, Kingsley also published *Glaucus*, a work of popular natural history, on the zoology of the coastline. Kingsley was both a keen reader of Darwin (he knew and admired Darwin as a man and a scientist) and a passionate enthusiast about the beauties of nature as a sign of God's "handwriting"—many extended and loving descriptions of the natural world are woven through his fiction and other prose. *Glaucus*, he explains, is written to encourage readers to appreciate more intently how the world is "full of ever-fresh health, and wonder, and simple joy, and the presence and the glory of Him whose name is Love."[31] He could be "startlingly dramatic in dealing with sea-slugs."[32] Even here in science's progressive framework, the longing look back toward a heroism of the past is evident: "the qualifications required for a perfect naturalist are as many and as lofty as were required, by old chivalrous writers, for the perfect knight-errant of the Middle Ages; for . . . our perfect naturalist should be strong in body; able to haul a dredge, climb a rock, turn a boulder, walk all day, uncertain where he shall eat or rest; ready to face sun and rain, wind and frost, and to eat thankfully anything, however coarse or meagre; he should know how to swim for his life, to pull an oar, sail a boat, and ride the first horse which comes to hand; and, finally, he should be a thoroughly good shot, and a skilful fisherman; and, if he go far abroad, be able on occasion to

fight for his life."[33] An ideal portrait of the moral character of the naturalist inevitably follows this description of physical perfection: "gentle and courteous . . . brave and enterprising . . . patient and undaunted . . . of a reverent turn of mind" and above all, committed to "the very essence of true chivalry, namely, self-devotion."[34] This is the naturalist as muscular Christian in plucky pursuit of God's truth in nature. The image of the scientist as chivalrous knight somewhat jarringly combines a familiar nostalgic medievalism with a familiar trope of the intellectual on a heroic voyage of discovery.

Kingsley continued to publish at a swift rate. *Heroes* in 1856 retells Greek myths for children—taking the tales of the past and redrafting them as exemplars of heroism. *Two Years Ago* in 1857 offers a hero who is a naturalist and campaigning doctor as well as an adventurer, who triumphs over adversaries at the time of the Crimean war. The mountain scenes in Snowdonia were sufficiently exciting to be recalled as a familiar set-piece for young male readers by General Whitmarsh in *Comrades under Canvas* in 1907, fifty years later; and the hero's drive to eradicate cholera, in a typical Kingsley manner, combines social reform with pugilistic masculinity. The six-point program for Christian Socialism drawn up by "Parson Lot" began ringingly with "Politics according to the Kingdom of God," but included as point 5, "sanitary reform." The hero converts to Christianity only in the last chapter, after an unexplained experience in a Russian jail, but muscular heroism, passion for natural science, family feeling, honesty, and true love for a Christian girl, give a narrative expectation of conversion for which a precise cause is perhaps unnecessary. In 1863, *Water Babies*, the book for which Kingsley remains best known, was published. It is a heavily Christianized allegory of redemption and moral uprightness, where a campaign for cleanliness appears (again) to be as much a moral as a social imperative. In 1864, *Roman and Teuton* put out historical essays outlining Kingsley's theories of nationalism and race, which were so evident in *Westward Ho!* and *Hypatia*. It is at this time, between *Water Babies* and *Hereward the Wake*, that his argument with Newman erupted. In 1866, *Hereward the Wake* told another story of English national heroism, where Hereward's fight against the Normans uses the military adventure story to construct a historical account whereby true Englishness survives the threat of Norman corruption (these arguments are closely related to historians' accounts of British history at the time), and yet, with a surprising though typically Kingsley twist, the hero turns out to fall into failure because he sacrifices the love of his wife for sexual gratification with a beautiful other woman. Surrounding these major productions, a stream of essays, sermons, and poems continued till his death in 1875.

While he maintained this impressive rate of publication, across a series of not very muscular nervous breakdowns, Kingsley and Fanny had four

children, and his career took him away from his daily engagement with the poor of his parish as "a working parson." In 1859, after preaching in Windsor Palace, he was appointed Chaplain to Queen Victoria—moving to the center of the establishment, a place Parson Lot would have seemed to resist inhabiting. The Queen and Prince Albert had a penchant for his historical novels, and on the strength of this he was in 1860 appointed Regius Professor of History at Cambridge, a post he held for nine years. Kingsley was now a public intellectual, lionized by the upper-class young men of the university. In Cambridge, he was a popular lecturer, though his output was often scorned by the up-and-coming professional historians. The criticism became intense and public on occasions: E. A. Freeman, soon to be Regius Professor of History at Oxford, in what was something of a personal campaign against Kingsley, wrote in the *Saturday Review* in 1864, that his appointment was "the strangest": "Other Professors, whether competent or incompetent, had at least some outward and visible connexion with the subjects which they undertook to teach. . . . But the appointment of Mr Kingsley seemed a mere inexplicable freak. . . . He really did not know what historic truth and falsehood meant." He mocked Kingsley's performance in the argument with Newman: "We laughed our laugh at seeing the unfortunate champion of Protestant truth spin round and round like a cockchafer in the strong grasp of the Roman giant." And with a nasty twist of racial thinking, he sneered, "Mr Kingsley is such a Teutonic enthusiast that we think he must be himself sprung of other than Teutonic blood."[35] Kingsley eventually resigned his post. Criticism always got to the sensitive author and campaigner. He not only withdrew his candidacy when he heard that Pusey would oppose his election to an academic honor in Oxford—Pusey's dislike of the heretical *Hypatia* was rumored to be the reason—but also refused to lecture in Oxford ever again. After his resignation from Cambridge, the Queen immediately appointed him Canon at Chester. He traveled to the West Indies, moved finally to take up the post of Canon at Westminster (a working parson no longer), and in the weeks before his death completed his role as international intellectual star by the requisite American lecture tour. He was only fifty-five when he died.

    *Hypatia* is evidently part of Kingsley's consistent engagement with religious and political controversy: Kingsley's anti-Catholicism was the driving force behind his earliest play, *The Saint's Tragedy*, and continued as an integral part of the gung-ho adventure story of *Westward Ho!*, as well as motivating his misfiring argument with Newman. He saw his commitment to home and country as a continuum that supported Anglicanism, Britishness, and anti-Catholicism as mutually reinforcing values. His commitment to the politics of race finds expression in the Goths of *Hypatia* as well as in the essays of *Roman and Teuton*. As a churchman, Kingsley moved from his Chartism-influenced Christian Socialism to a more mainstream

Anglicanism as Canon of Westminster, but never abandoned his commitment to campaigning for social change, or his commitment to his understanding of a full Christian married life. (He was also fiercely against teetotalism.) *Hereward the Wake*'s disastrous marital corruption, distaste for monks, and nationalist military and political adventuring, encapsulate Kingsley's longstanding passions. But at the same time his didactic, sermonizing side also leads not merely to children's books, essays, and homilies, but also to a proselytizing Darwinism: his friendship with Gosse faded away, when Gosse attempted to counter Darwin with the case that God must have planted fossils at the moment of creation. Kingsley sees no gap between his religion and his science—both of which lead to wonder at nature and the desire to comprehend the world, with reverence. Kingsley moves between the earnest circle of religious and political thinkers around Maurice, to the highest social level at the court and at Westminster, to the university world of professional academics, both in science and in history, and, as his letters also reveal, to a more glittery artistic and social world once his novels become a hit (dinner with Dickens, or Bulwer Lytton, who had "a devilish face"). He was great friends with Thomas Hughes, author of *Tom Brown's Schooldays*, whose sporty Protestantism and political campaigning matched Kingsley's own; he knew Bunsen, who brokered the Jerusalem Bishopric between Prussia and England; but he was brother-in-law to Max Müller, the leading Sanskrit philologist and expert in comparative mythology, and also brother-in-law to the polemical historian and notorious religious renegade Froude. (He vehemently disliked and disapproved of Froude's religious doubts, but immediately took him in when Froude was disowned by his family and forced to leave Oxford.) This network of relationships is the social framework in which his extraordinary range of publications and interests takes place. His work comes from, and speaks to the intertwined elite matrices of Victorian political, intellectual, and religious life, and as much as his novels, his campaigning and his parish work reach constantly toward a broader public.

Running through this range of work and relationships, however, is a particular engagement with history. Kingsley writes historical novels that exemplify the genre's tendency to focus on crucial historical junctures in the nation's self-determination: the threat of Spanish and Catholic imperialism to the reign of Good Queen Bess; the invasion of the Normans; and—with some extension of the idea of nation—the origins of Christianity. But he also writes historical essays as the Regius Professor of History. *Hypatia*'s footnotes and scholarly apparatus anticipate the transition between historical fiction and professional historiography. He also writes about zoology—the *longue durée* of natural time—when for some the challenge of natural history was precisely to the temporality of Christianity. Personal time—the development of character, moral, intellectual, religious—is also integral to

*Two Years Ago* in particular, with its contrasting stories of Tom Thurnall, the hero, and his school friend, John Briggs, "an old foe with a new face"; as it is, of course, in *Alton Locke*, where the change of the hero in social status and intellectual attainment is mapped against the pressing need for political change, with *its* sense of history: "self-development" as a sign and symptom of national development.[36] What's more, Kingsley writes about time and change repeatedly in his novels, perhaps most famously in the long fantasy sequence in *Alton Locke* (chapter 36) where the sick and delirious Alton imagines himself growing from the "lowest point of created life" through a full evolutionary narrative—from crab to mylodon to human—in a hybrid dream-world of myth and science: Darwinism, Christian Socialism, developmental psychology, comparative religion, and the Bildungsroman narrative come together in an overwrought narrative of historical change.

If the genre of the historical novel of early Christianity in the Roman Empire opens a distinctive window onto the construction of historical subjectivity in Victorian culture, Kingsley's career reveals a multiform experience of being placed in history and a multiform exploration of writing that experience. History makes the man, not just in the sense that national and religious history forms the subject, nor just in the sense that self-development is a master trope for life writing, nor just in the sense that political activism depends on a sense of historical change, but also in the sense that Kingsley writes and rewrites these pasts as the fullest public expression of who he is and how the present is to be understood.

## The Fight for the Middle Ground

F. W. Farrar was born in Bombay in 1831, where his father was a missionary.[37] He returned to England in 1839, where he passed the rest of his blonde, curly-haired childhood, which he described as idyllic, wandering in nature, and untrammeled by frightening school experiences. Like Kingsley, Farrar went from school first to King's College, London (1847), where he also sat at the feet of Maurice, though without ever developing any political fervor. He proceeded to Trinity College, Cambridge, where he seems to have escaped the anguishes of Kingsley. (His tutor, in full encomiastic mode, writes "To this vigour and earnestness of purpose he united a high and generous spirit and a perfectly blameless character.")[38] He graduated with a first in 1854, continued into a fellowship, which he held while taking up his first post as an assistant schoolmaster at Marlborough. He moved on swiftly to Harrow in 1855, where he taught as a house master for fifteen years, and returned to Marlborough as headmaster in 1871. In 1876, he became Canon of Westminster (after Kingsley had died), and in 1895 he moved to be Dean of Canterbury, where he died in 1903. An exemplary

successful career in public service, then: good university record, leading into the new earnest duty-led style of teaching pioneered by Arnold at Rugby, with an effortless transition into the higher levels of the church, where sermons to the people extended the schoolroom homily, all backed up by a happy marriage with children who loved him, and whose memoirs of their father preserve a saintly image of his life. He even managed to live down without apparent detriment the fact that he had edited *Essays on a Liberal Education*. Where Kingsley was impulsive, prone to bursting into tears, weird to meet and difficult to live with, Farrar cultivated a calm decency, a socially adept niceness.

No schoolmaster can expect unblemished hagiography, however. "This writer, once as a boy, worshipped [Farrar] as his chief hero, till chancing to see the face at close quarters, he was repelled with an instinctive Never More! complete nolo tangere, and strange pity and fear." What he saw was "the high, bold forehead, covered with a thin flesh drawn tightly back, the pale blue eyes gazing fixedly into the ascetic distance, the clenched mouth, clean-shaven, with its thin lips pressed together, and the old man's neck, shrivelled like dry leather, of Dean Farrar, the face of a soul grown petrified in life-long, holy, unflinching, decision to deny the palpably existent and uphold the visibly incredible."[39] To a friend of Froude, distaste for the ostentatious piety and high moral purpose of the establishment churchman, as well as dismissal of his uncritical, unscientific views on the evidence of the Gospels and the writings of the early church, leads to a highly physicalized response. Farrar's support for the "visibly incredible" provokes a visceral reaction to his visual appearance. These contrary descriptions of Farrar's innocence or naïveté, faith, or denial of evidence, strength of character or ascetic petrified holiness, seem two sides of the same coin of Farrar's public self-representation.

Farrar's two novels of the ancient Roman Empire, *Darkness and Dawn*, and *Gathering Clouds*, have already been mentioned as prime examples of classicizing Christian fiction. Both are scholarly, and lead the reader through classical sources and sites. In the case of *Darkness and Dawn*, Farrar is explicit that he has not written "a novel, nor is it to be judged as a novel. The outline has been imperatively decided for me by the exigencies of fact, not by the rule of art."[40] The treatment of Acte also shows how easily the "exigencies of fact" slip into the expectations of stereotypical narrative, however much the book has the appearance of a set of tableaux: the stage is stalked by evilly corrupt Romans, and lost, but redeemable girls. In the case of *Gathering Clouds*, Farrar's dislike of the politics of the church and the corruption of the institutions of power in contrast to the saintly Chrysostom is represented in a far more mellow way than the vitriol of Kingsley in *Hypatia*. We have also already seen in chapter 5 something of the range of Farrar's output—to which can be added a host of sermons, a

Life of St. Paul to follow the Life of Christ, a commentary on Paul's Letter to the Hebrews and on St. Luke, and, in *Seekers After God*, a full-length discussion of how Seneca, Epictetus, and Marcus Aurelius, three ancient philosophers of the empire, reveal a longing for a new morality and understanding of the divine. It is a book that provides the historical theory, as it were, for many a novel's representation of the good pagan as striving toward the light of Christianity. Without feeling any cognitive dissonance, Farrar could denounce the morals of the first century as the morass to which Christianity brought light, and, in the same breath, as it were, cherish the "Christianization" of good pagans, whose philosophy looked toward a higher moral plane.

Farrar, however, also extends Kingsley's model of engagement with writing history—in three main ways. First, as his son and biographer noted, Farrar was an obsessive reader of literature for which he demonstrated an astonishing recall: He quoted from ancient and modern sources regularly in conversation in a tumble of lines and references. This is reflected in his prose, which is repeatedly studded with quotations:

In those days there had long been visible that sure sign of national decadence,

> 'Wealth a monster gorged
> 'Mid starving populations.'
'Huge estates', said Pliny, 'ruined Italy'.[41]

The description of Onesimus's trip through the countryside of Italy is framed as a recognition of "national decadence"—Rome as a way of reflecting on Britain—placing the seeds of the decline and fall of empire early and in economic disproportions. The gap between rich and poor prompts a citation from George Eliot's poem "A College Breakfast Party" from thirteen years earlier (though the source is not named in the text). This is not a random allusiveness. Eliot's poem, based on a trip to Jowett's rooms at Balliol College Oxford, attacks aesthetic High Church Christianity as drawing the worshipper away from true spirituality. Both in the context of Farrar's Protestantism and in the context of Rome's aesthetic beauties in contrast to the humble simplicity of incipient Christianity, Eliot's poem chimes with the novel's agenda. Farrar continues with a prose citation from a named classical source, Pliny, though the point about the economic and social threat of *latifundiae* is a commonplace. Nonetheless, the observation is anchored in a privileged source from antiquity. Farrar's *bricolage* of quotations constructs a continuous past of literature, a lexicon of raided thoughts, which would be called *copia* in classical rhetoric—as if the historical subject could shift between past and present on a tide of literary commentary. Historical narrative here is formulated not as the exigency of *wie es eigentlich gewesen*, but as the cultured reflection of the storyteller.

Second, Farrar is keen to separate the pagan and Christian in the sharp-est terms, in rhetoric replete with a long history of Christian apologetics: "Paganism was to display herself, naked and not ashamed, a harlot holding in her hand the brimming goblet of her wickedness, drunken with the blood of the beloved of God."[42] So, Seneca, for all his claims to be a seeker after God, receives a damning character assessment for his life "dominated by avarice and ambition," in contrast to the first Christians:

> Seneca did little or nothing to make the age more virtuous; the Christians were the salt of the earth. The Pagans fled from despair to suicide; the Christians, in patient submission and joyful hope, meekly accepted the martyr's crown.[43]

It is important for Farrar to be clear on such matters because he had al-ready caused something of a theological storm by preaching five sermons in 1877 in Westminster, qualifying the sense of eternal punishment, sug-gesting that God's infinite mercy might be applied to those even in Hell. His argument was supported by a battery of citations of ancient sources and by an extended discussion of the Greek terms in the Gospel and the Fathers on the afterlife's torments. The sermons were not intended for publication, but the response was sufficiently heated—both in support and in opposition—that Farrar published them as a pamphlet in 1878 (it went through eighteen editions), and then as a book, *Mercy and Judgement*, three years later, to put his case in a more extended and deliberate form. The Bishop of Lincoln amongst others immediately preached counter-sermons against Farrar.[44] Pusey wrote a rather dry volume against the lectures, and corresponded at length with Newman about it.[45] There are more than 125 letters bundled in Farrar's papers, mostly in support of his outspoken stance. Farrar's sermons are indeed strong stuff. "Hell," "Damnation," and "everlasting" are "simply mistranslations," he declares.[46] Even in published form, the passionate eloquence comes across with considerable power. Far-rar's son regards these works as Farrar's most important and long-lasting contribution, and recalls that no one there would ever forget hearing "that clarion voice, ringing through the vast arches of the dim Abbey, amid the hushed silence of the listening throng."[47] (268) Julia Margaret Cameron, for one, recognized the specific intellectual genealogy: "Dearest F.D. Mau-rice, from heaven, he will be most glad."[48] Maurice had lost his professor-ship at London in 1851 for espousing such a doctrine. For Cameron, a quarter of a century later, Maurice, in heaven, could delight in his pupil's defense of his unorthodox view of Hell.

Kingsley writes into *Alton Locke* his story of deep evolutionary time. Far-rar questions the meaning of deep theological time—the very sense of eter-nity. Behind Farrar's historical understanding is not the progress of evolu-tion and the age of geology, but the limits of divine eternity and a moral comprehension of the passing of time. Kingsley emphasizes how the past

gives a determinative picture of how things should now be; Farrar emphasizes how the struggle between darkness and light, the world and the church, is continuous. The two pupils of Maurice, from their different positions in the century's conflicts, express a differently framed experience of historical continuity.

Third and finally, where for Kingsley history makes the man, it could be said that for Farrar education makes the man. He spent a good deal of his life actively engaged not just in teaching, but also in writing and promoting educational books: a Greek grammar, bible commentaries for students. In 1867, he edited the celebrated *Essays on a Liberal Education* and published a pamphlet on the place of classical education in modern society, a hot topic in that year in particular, when Robert Lowe, John Stuart Mill, and Mountstuart Grant Duff also gave widely publicized speeches on the same subject. *Eric*, along with *St Winifred's: or the World of School*, his follow-up schoolboy blockbuster, established the narrative model for schoolboy books for the next century and beyond, even though their particular moral tone was rapidly seen as out of date. Each of his classical novels has stories of educational development within them. The difference between Kingsley and Farrar here is not stark, but one of emphasis. Of course, education is central to *Alton Locke* and *Hypatia*, as history is central to Farrar's *Life of Christ* or *Darkness and Dawn*. But where Kingsley's characters so often find themselves inscribed in a national, racial, ecclesiastical narrative, Farrar's characters often seem to find themselves in the headmaster's study or before the preacher's lectern.

"Only connect!" Farrar spent his life amid the elite of English society, both as a teacher and as a preacher: from Harrow to Marlborough to Westminster to Canterbury. He was a quietly conservative theologian in that he knew Strauss and the critical tradition, but in his work he either sidestepped or silently corrected such tendencies. For more evangelical and more traditional churchmen, however, his writings on eternal punishment were deeply challenging and heterodox. He was not so much middle of the road as positively attacked from both extremes of the spectrum. For the radicals, he was the face of faith over science; for the evangelicals, he was a threat in his use of scholarship to challenge orthodox doctrine. Despite his religious position, he was associated closely with the most active liberal political reforms in education, but did not engage in broader political activity. In 1848, he appeared "modest and gentle" to his fellow students, and far from manning the barricades, he seemed obsessively hard-working on Classics and theology with "an air of asceticism and semi-monkish solitude."[49] He read voraciously and eclectically; he does not seem to have moved in any particularly trendy social set. Yet his work reached an amazingly broad and varied public. The *Life of Christ* sold over 100,000 copies

in his lifetime, and, as we have seen, seems to have reached the reading working man in this country and abroad. *Eric, or Little by Little* sold even more copies, and, like Henty, influenced generations of schoolchildren in its generic, narrative expectations as much as its explicit message. *St Winifred's*, the follow up, was not as successful, but still went through twenty-six editions in Farrar's lifetime. Even his book on *Greek Grammar Rules* went through twenty-two editions, further associating his name with the classroom for many children. His sermons were widely read and discussed in serious religious circles. Farrar's novels of the Roman Empire did not reach such a huge audience as his children's fiction, though *Darkness and Dawn* did go through eight editions. But it is crucial to see how these novels are deeply embedded within Farrar's intellectual world and intellectual career, in their treatment of classical sources, their treatment of religious evidence, in their narrative models, in their social and religious outlook. We have seen how the expectations of genre, the reader's classical education, the religious controversies of the era, the role of history writing in the period, structure the impact of the historical fictions of the Roman Empire. But each novel is also the product of an individual author's engagement with such frames and is received as such: the name of Farrar also prepared an audience for his novels.

In this three-chapter section, I have aimed to bring together three frameworks for understanding Victorian fiction of the Roman Empire, the broadest intellectual, social, and religious background for the genre of historical fiction and specifically historical fiction about the beginnings of Christianity; the development of the genre as a genre and its strategies of representation; and, most briefly, the way in which particular novels are embedded within an individual writer's career—a network of relationships as well as an intellectual development—as an expression of the *experience of historicity*.

It seems to me that each of these frameworks and, above all, the connections between them are necessary for appreciating the work of these novels within Victorian culture. Reception Studies needs to explore this richness of cultural work. It is, of course, possible, and I would say also necessary, to look in a narrow way at how, say, Farrar expands a few sentences of Tacitus to create his fiction of Acte or Pomponia. Farrar's reading of classical sources as a strategy of reception should produce in itself a nuanced and wide-ranging discussion. But the complexity of Victorian engagement with the classical past cannot be appreciated if the analysis remains at that level. Farrar's Acte also speaks to other Actes within the genre, emerges from and speaks to a specific religious and historiographical context, slides between generic, romantic stereotypes and his reading of Tacitus—and is taken up and read within different intellectual and social networks. Reception, that is, needs to be comprehended *between* the generalizing framework of the

Victorian view of the early empire and the author's specific contextualization and strategies of representation; *between* explicit agendas and implicit, stereotypical, inherited models; *between* elite positioning and the circulation of popular images; *between* expert knowledge and the pleasures of fiction. It is in these spaces that the full richness of the cultural work of the Victorian reception of the Classics can be most fully appreciated.

# CODA

❁ ❁ ❁ ❁ ❁ ❁ ❁ ❁ ❁ ❁ ❁ ❁ ❁ ❁ ❁ ❁ ❁ ❁ ❁

In the ultra-trendy art magazine, *The Studio*, a magazine that had run important reviews of Waterhouse's work, some photographs by Wilhelm von Gloeden were published in 1893. Von Gloeden moved from Germany to Sicily in 1878 for his health, where he lived for the last decades of the nineteenth century. He spent his time there taking naked, posed photographs of the local inhabitants. These were sold partly as anthropological studies of the Mediterranean, but mostly as "classical studies"—the Mediterranean body, in the open air. Like Alma-Tadema, he posed his subjects in classical *exedrai* or in the rocky, natural terrain of Sicily. He dressed the boys up in classical garb, and on occasions knotted their hair into Pan's horns (which uncannily anticipate the famous devilish, self-portrait of Robert Mapplethorpe). Where Alma-Tadema's listeners to Homer lounge in Dionysiac release, von Gloeden's boys lie across the marble floor naked, and often embrace, staring into the camera. *The Studio* published the photographs precisely as classical scenes, brought vividly to life by photography, a medium in the 1890s still provocatively novel as a technique in the artistic world.

Most of von Gloeden's negatives were deliberately destroyed during the Second World War by the Italian fascists, in a more brutal and instrumental campaign for social purity than the forces that had been lined up against Poynter, Waterhouse, and the other artists of the Academy in the 1880s. But several dozens of images survive, which have never been out of print, and which are now largely circulated as gay erotica, and, less commonly, as examples in the history of photography. Figure C.1 is a typical picture. A naked young man is posed by a suitably Dionysiac vine. He is lightly embracing a Renaissance bronze statue of a naked athlete, based on classical Greek models. Behind them, there is a wall with Greek-style etchings. The picture suggests that the young man is in contact with the Renaissance and the classical past—classical bodies alive today, a continuity of artistic, physical, and aesthetic form.

Andy Warhol owned this photograph, which he bought at auction. He liked it enough to draw it (figure C.2), with a typical shift of emphasis onto the boy's genitals, and this drawing was used in a volume edited by Roland Barthes, perhaps the most influential modernist theorist of photography, as well as a literary critic of genius, in Paris in the 1980s.

Warhol had a special relationship with the camera. He always carried one in his last years. It forms a link between his obsessive concerns with the

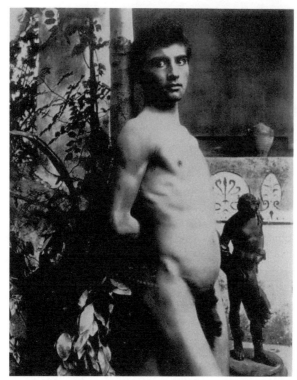

Fig. C.1. Untitled by
Wilhelm von Gloeden
(1856–1931)

world of advertising, with the reproductive capacity of technology, with commercialism, and, above all, with the circulation of icons of celebrity. He used the camera to make art. "I want to be a machine," Warhol famously asserted, and the camera became a central medium through which he constructed his specific anatomy of desire's imagery. Throughout these years, he constantly took Polaroid snaps of his friends having sex (often quite baroque sex, at that); he invited rent boys up to his studio; he persuaded his colleagues to strip in their lunch breaks and masturbate for him. He left thousands of such pictures. But he also made some remarkable art, particularly when he stitched together—literally, with a needle and thread—sets of repeated images.

Warhol, for all his revolutionary novelty and aggressive modernity, produced work in an absolutely conservative artistic tradition. It is not just that he uses classical models, like Waterhouse or Michelangelo, to express his versions of desire or male beauty, but also that in his very use of the camera to explore these areas, he was self-consciously working through a Victorian practice, epitomized by von Gloeden. Warhol's reworking of von Gloeden is a direct link back to the Victorian period.

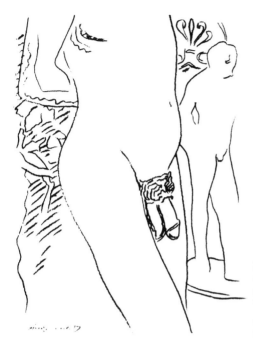

Fig. C.2. *Line Drawing of a von Gloeden Photograph* by Andy Warhol (1928–1987). 2010 The Andy Warhol Foundation for the Visual Arts, Inc. / Artists Rights Society (ARS), New York

Figure C.3 is one of Warhol's studio images, which self-consciously plays with this history of representation. Another perfect Greek body, poised like a statue, but a statue about to step off the plinth. The ripples in the water disturb any Narcissus-like gaze into the reflective mirror of the pond: another joke on the artistic tradition. The body is not-quite-classical in its pose: thrown off kilter by the captured moment of incipient movement. It is a knowing and playful twist both of the lure of the ancient body and of the cliché of using the classical to encode homoerotic desire. This is Warhol having some smart fun with the ideal Greek body and with the artistic tradition he knows he is part of. It is a moment, but there is no story: The joke is just the disruption of the classical iconography. What happens next to the model, or what happened before, is not part of the image's enticement.

Figure C.4, however, is an altogether more sophisticated piece of work. It is one of the stitched works, only recently exhibited for the first time in New York. The subject is one of Warhol's rent boys. There are many other unpublished images of this young man in a single day's sequence of him stripping and posing, now preserved in the Warhol archive. The same chair appears in the studio for many of Warhol's subjects. The boy lolls back naked in the chair, hands folded across his stomach, head thrown back. The four identical images are stitched together. The threads holding

Fig. C.3. *Standing Male Nude* by Andy Warhol. © 2010 The Andy Warhol Foundation for the Visual Arts, Inc. / Artists Rights Society (ARS), New York

the pictures together can be faintly seen in the reproduction at the center of the image.

Now any classical art historian will instantly recognize this icon. It is a modern version of the Barberini Faun (figure C.5)—an image much discussed and copied in the Victorian period. The Faun is a classical version of the transgressive body, flopped out after drink and/or sex, genitals central to the image and our gaze. Warhol takes the classical image of debauchery and updates it for the street life of modern New York.

But the repetition of the image, four together, moves the piece away from a witty joke on an old image. It asks how many Barberini Fauns make up the sexual imagination. What role is there for repetition in the imagery of desire? How different is one hustler from another? How many times do you need to look at the image of the sexualized body? How much are erotic images the repetition of past erotic images? Can you desire without cliché? Without repetition?

Warhol uncovers a buried history within our image repertoire. We are all victims of old love stories. Can you desire without the poses of the old patterns, without those old Greek bodies, those Victorian women, the virgins

Fig. C.4. *Male Nude* by Andy Warhol. © 2010 The Andy Warhol Foundation for the Visual Arts, Inc. / Artists Rights Society (ARS), New York

and the whores? His pictures, like Waterhouse's and Alma-Tadema's, raise an awkward question for the viewer: what do you see when you desire?

Waterhouse showed seven girls from two models in his *Hylas and the Nymphs*, where the youth was being drawn into watery abandon and ravishment; the similarity of the girls is part of the threat of loss of self in the picture. With Warhol, the repetition of the object of desire puts the sexualized

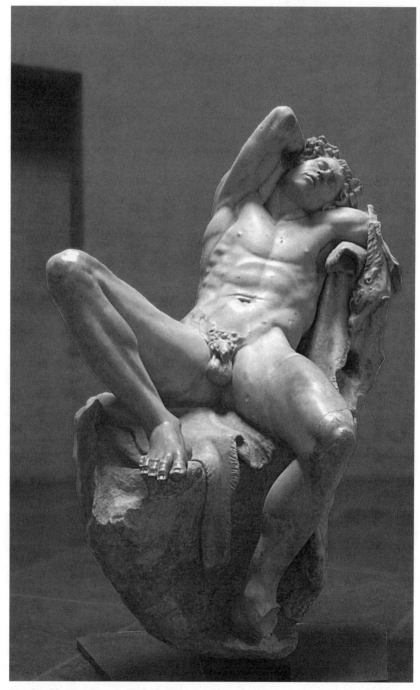

Fig. C.5. Sleeping Satyr or Barberini Faun, marble copy of a bronze original, ca. 200 BC.

body in line with the commodification, commercialization, and circulation of soup cans or the face of Marilyn Monroe. The camera objectifies, as Susanne Kappeler argued with most complete force, but here the camera's repetitions both poses a question about the object of desire as object—and, for many viewers, I expect, rather *de-eroticizes* the encounter, however attractive the young man may seem.

This objectification, or, better, this fetishization of the objectified, is fundamentally connected to a lack of narrative. Where Waterhouse's pictures engaged and enticed and provoked by being a frozen moment of narrative, Warhol's resist narrative. Each image seems to have minimal backstory and no future—there is no poised juncture, as the repetition itself seems to assert. So, even Warhol's movies refuse narrative (movement, even): the excruciatingly long unmoving camera shot of a building; the face of a man experiencing oral sex, where all the action, as in Greek tragedy, is offstage: a silent messenger scene. In place of the story, we have the fetishized, repeated object. With the four images of the naked hustler, unlike the boxes of a cartoon strip, there is no sequencing, no difference, no narrative line. The provocativeness of Warhol's vision stems from combining the realism of the medium of photography with the resistance to the fictions, the narratives, which make up reality.

Yet for all this modernist fascination with the disturbing dynamics of desire and things, Warhol shows a surprising formal continuity between the classical bodies of Victorian art and his modern, repeated photos. More importantly, he lets us see how Victorian appropriations of the classical body to explore the self and male desire continue in the modern imagination. The millions of posters of Waterhouse are the commercial sign of a cultural legacy. Our modern eyes of desire are layered with Victorian images of a Greek world. Gender studies and Reception Studies come together in trying to understand how the past lurks, fragmented, misunderstood, insistent, inside our cultural imagination, inside ourselves as desiring subjects. Victorian desire in classical dress matters because it is with us all, still: our history.

Warhol is an icon of modern pop culture, working within a high modernist tradition. But to see his intimate connection both with Victorian photographic work and with classicizing imagery is not just to discover the richness of his representational technique, but also, more importantly, to uncover the complexity of his ideological positioning, the work of his representational strategies—Warhol's engagement with the past, and the past's dwelling within his art. Such critical labor has been at the heart of this book. I have tried in each section to prevent the familiar and standard teleological narrative of modernism from silencing what were dominant cultural modes of expression in the nineteenth century. My aim has been, on the one hand, to produce a richer cultural history—the growth of secularism,

for example, cannot be properly understood if the power, vibrancy, variety, and insistence of the religious embrace are underappreciated; the art of the 1880 and 1890s in London is not best comprehended as a failed European modernism. On the other hand, my aim has been to explore how reception theory can and should uncover the dangerous complicities and distortions of such teleological history. That a book like *Robert Elsmere*, or, for that matter, *Ben Hur*, should have so restricted a place in our contemporary canon of Victorian fiction does tell a story about the modern academy (as much as about modern taste), and it is a story ripe for interrogation. Above all, through each chapter of the book, I have tried, as with the Barberini Fawn beneath Warhol's, to uncover the pervasive presence of classical antiquity within the proclamations of modernity that are so important to Victorian (historical) self-consciousness.

Victorian culture and classical antiquity has not proved a discrete topic. It has spread across genres, across the divide between high art and popular culture, across the injunctions of cultural memory and cultural forgetting, across elite intellectualizing argument and trivial pleasures, scorn and display—across the boundaries of the Victorian era. It could have spread over many more writers, artists, musicians, and thinkers. But, as Warhol's bodies reveal, the repeated proclamations of modernity through the reinvention of the classical past continue up to our own . . . modernity. What makes the Victorian engagement with antiquity such a fruitful and complex space for study is the overlap of our own complicit use of the Victorian era as a defining past, with the Victorians' multiform appropriations, rejections, and discoveries of the classical past for their own historical self-consciousness. The exercise of classical reception is, finally, finding one's own place in history.

# NOTES

## Introduction. Discipline and Revolution:
## Classics in Victorian Culture

1. Standard biography is Faber (1957).

2. Yeo (2001) on encyclopedias (Enlightenment mainly); on geology and natural science, see, for example, Lightman, ed. (1997); Stafford (1989); and Endersby (2008) on botany.

3. Standard here is Stray (2001).

4. Stephen (1891), as discussed in context by Goldhill (2002) 178–245.

5. See Vasunia (2005) and forthcoming.

6. For Shelley's Greeks, see Wallace (1997) and now Sachs (2010).

7. For these stories in context and with bibliography, see Goldhill (2002) 246–93.

8. See Orrells (forthcoming).

9. See especially Dowling (1994); and most recently Evangelista (2009); also Dellamora (1990); Prins (1999); Gregory (1997).

10. This sentence reflects many conversations with my student, Tatiana Shahir.

11. Rudnytsky (1987); Gere (2002).

12. This intellectual history is further discussed in chapter 5, and there is a fine discussion in Turner (1981). For Wolf's revolutionary influence on nineteenth-century Homeric studies, see the introduction to Wolf (1985).

13. Fine discussion in Turner (1981).

14. Petersen (1970) 592.

15. Ibid., 591. See Sutherland (1990) 106–31. By contrast, in Mrs. Gaskell's *North and South*, a loss of faith is a crucial trigger to the plot, but is given no more content than an unwillingness to sign up again to the 39 articles.

16. Sutherland (1990) 127–28.

17. Detailed figures and discussion in Haig (1984) 27–115; see also McLeod (1996) 14.

18. Eliot (1932) 515.

19. Raphaely (1998).

20. Mallock (1899) 71, 72, 11.

21. Faber (1957) 222–28; recalled as a scandal in Ward (1918). His edition of the Pauline Epistles and, more popularly, his contribution to the notorious *Essays and Reviews*, which was condemned by the church, were major contributing factors. A formal case against him at Oxford for teaching contrary to the tenets of the church was eventually dropped.

22. See Taylor, ed. (2006); Martindale and Taylor, eds. (2004).

23. I am thinking here (of course) of Steiner (1993) and Rood (2004), each differently fascinating.

24. Trippi (2002); Prettejohn, Trippi, Upstone, and Wageman (2008).

25. Sayers (1977) 66.

26. Ruskin (1956–59) I: 82.

27. Martindale (2006) 9.

28. Discussed in more detail with bibliography in Goldhill (2009).

29. Philips *Academy* 1201 (May 11th, 1895) 407; Quilter *Times* (May 4th, 1895) 12.

30. The Metropolitan Museum in New York is a perfect example of this, institutionalized. Its nineteenth-century European art collection displays dozens of fine impressionists, along with van Gogh, moving seamlessly into expressionist work, and so on, but it is quite hard to find any painting—or even any painting of the type—exhibited in the Royal Academy to such huge audiences in the last twenty years of the century.

31. Marx (1926) 19–20.

## Chapter 1. The Art of Reception: J. W. Waterhouse and the Painting of Desire in Victorian Britain

1. See, for example, on education C. Stray (1998); S. Goldhill (2002) 178–246; on culture in general, Turner (1981); Jenkyns (1981); Vance (1997); Clarke, ed. (1989); on art, Jenkyns (1991); on literature, Prins (1999); Dowling (1994); Anderson (1965); on opera, Goldhill (2002) 108–78; Foster (2010), and, less satisfactorily, Ewans (2006)—all with further bibliography.

2. Woolf (1925).

3. See in particular Trippi (2002); Smith, ed. (2001), from both of which I have learned a great deal; and in general the works cited in n28. The catalogue of the first full-scale Waterhouse retrospective is also extremely good: Prettejohn, Trippi, Upstone, and Wageman (2008).

4. This linear engagement of text with text, as it were, has been most developed in Latin studies: see Martindale (1993); Martindale (2005); Martindale and Thomas, eds. (2006); Conte (1986); Conte (1994); Hinds (1998).

5. See Teukolsky (2009) for a good discussion of the relations between intellectual criticism and exhibition spaces.

6. St. Eulalia of Merida, martyred naked (but covered in snow) on December 10, 304, is often and easily confused with St. Eulalia of Barcelona martyred naked (but covered in snow) on February 12, 304. Many, naturally enough, assume there is only one figure behind both sets of stories, especially when the most famous celebration of St. Eulalia of Barcelona, a poem by Quiricus, seventh-century Bishop of Barcelona, is in fact a version of Prudentius's poem on the other St. Eulalia. Barcelona cathedral has some fine reliefs by Bartolemé Ordonez (1519) that show the fully naked Eulalia (of Barcelona) on a bonfire, and a painted altar piece in the cathedral of Palma de Mallorca (c. 1350), which has small pictures of a half-naked Eulalia as well as a large central fully dressed image of the saint. The Catholic Church insists that there are two different figures, and since Waterhouse refers us directly to Prudentius, I will assume that he is referring to Eulalia of Merida only. It is possible that his iconography is influenced by the older, naked forms from Barcelona Cathedral or the cathedral of Palma de Mallorca, though there is no evidence he ever saw them.

7. It is at least possible, though no contemporary commentator makes such a connection, that some viewers may have recalled the story of Eulalia from Foxe's *Book of Martyrs*, where in chapter 2 we read: "Eulalia, a Spanish lady of a Christian family, was remarkable in her youth for sweetness of temper, and solidity of understanding seldom found in the capriciousness of juvenile years. Being apprehended as a Christian, the magistrate attempted by the mildest means, to bring her over to paganism, but she ridiculed the pagan deities with such asperity, that the judge, incensed at her behaviour, ordered her to be tortured. Her sides were accordingly torn by hooks, and her breasts burnt in the most shocking manner, until she expired by the violence of the flames, December, A.D. 303."

8. In general, see Roberts (1993); Malamud (1989); Conybeare (2002); Shaw (1996); Perkins (1995); for the writing on the body with Eulalia, see Goldhill (1999).

9. Perhaps an echo in technique of Caravaggio's extraordinary *The Conversion of St Paul on the Road to Damascus*.

10. See Hobson (2002); Baldry (1917); Trippi (2002). It is striking how little Waterhouse appears in the public and private records of the period, despite his eminence as an artist—especially in contrast with figures such as Poynter, Alma-Tadema, or Leighton.

11. In Logsdail's famous canvas, *The Bank and the Royal Exchange*.

12. *Art Journal* (1893) 125.

13. *Magazine of Art* 8 (1885) 390.

14. *Art Journal* (1893) 125.

15. See Blaikie (1886).

16. Trippi (2002) 66; Kestner (1989). See also Casteras (1987); Psomiades (1997).

17. A huge bibliography could be given. Starting points: Jay (1986); Helmstadter and Lightman, eds. (1990); Snell and Ell (2000), and the further discussion and bibliography in chapter 5.

18. See, for example, Dowling (1994); Prins (1999); Dellamora (1990); Morrison (1996); Potts (1994).

19. See, for example, Vance (1997); and, with a wider historical framework, Edwards, ed. (1999).

20. I have been unable to trace an image of either painting, but from the subjects and the artists' other work, it is extremely unlikely these paintings were other than genre pieces.

21. Kingsley (1853) ch 29. See also Moran (2004). *Hypatia* is discussed in chapter 5. Hypatia, interestingly, is the name chosen by Charles Bradlaugh for his daughter (and future biographist), Hypatia Bradlaugh Bonner: *Charles Bradlaugh: a Record of His Life and Work*, [London, 1902], on which see Rogers [2001]). Bradlaugh, a leading and indeed notorious freethinker, was the defendant with Mrs. Besant in the famous Knowlton case, which tested the limits of the 1865 legal definition of obscenity by publishing a physiological textbook including details of birth control (see for discussion and background Dawson [2007], especially 122–61); and also the first atheist to be elected to Parliament—his inability and unwillingness to take the oath on admission caused a constitutional crisis: see Arnstein (1965). Also, however, Bradlaugh was thrown out of his house at age 16 for his views, and was taken in by the widow of Richard Carlile, a freethinker, who had a daughter Hypatia, with whom

Bradlaugh fell in love—and there was some gossipy scandal about the relationship—see Hypatia Bradlaugh Bonner (1902) 19—and no doubt his first love, also the child of a freethinking family, was in his mind when he named his daughter. Hypatia, the pagan philosopher destroyed by the violence of Christianity, was chosen as a name pointedly by Carlile (see *The Republican* VI [1822] 135–37 cited by Rogers [2001] 153). The name Hypatia may thus be associated in this period with opposition to certain religious institutions (Kingsley) or even religion itself (Bradlaugh).

22. An interesting analysis along these lines is in Moran (2004).

23. Sewell (1845) II: 422.

24. Ibid., I: 192–93.

25. Ibid., I: 344–45.

26. Kingsley (1848) act 1, scene 2.

27. Smith, ed. (2001) 229.

28. Haddo's fuss will be further discussed in chapter 2. See, in general, Smith (1996); also Smith (1999a); Smith (1999b); more generally, Pointon (1990); Nead (1992); Bullen (1998); Pollock (1988).

29. Interestingly, Poynter himself wrote (*Times* 28 May, 1885, 4) "It is obvious, too, that there is no room for drapery in this particular subject; if done at all it should be like the statue [the Esquiline Venus, as discussed later]; the forced introduction of drapery would be a prudery which would increase the evil, if evil there is." It is hard to relate this comment to the two paintings without suggesting that (for whatever reason) Poynter was not consistent in this matter.

30. The responses to this picture are particularly well discussed in Smith (1999b) 202–7. The connection between Poynter's picture and Alma-Tadema's is made explicit by Poynter in *The Times* (May 28, 1885) 4.

31. *The Times* (May 28, 1885) 4.

32. *The Times* (May 20, 1885) 10.

33. On this figure, in general, see the fine study of Smith (1999b).

34. Well discussed with extensive bibliography by Walkowitz (1980).

35. *The Times* (May 23, 1885) 10.

36. *The Times* (May 21, 1885) 6.

37. H. *The Times* (May 25, 1885) 10; H.G.F. Taylor, *The Times* (May 25, 1885) 10.

38. *The Times* (May 23, 1885) 10.

39. Ibid.

40. John Brett, *The Times* (May 25, 1885) 10.

41. *The Times* (May 23, 1885) 10.

42. H. *The Times* (May 25, 1885) 10. He adds two other criteria, an "ideal presentation," and "the observance of certain special artistic conventions as old as Praxiteles," a phrase which, he and others indicate, means concealing the genitals themselves with cloth or plants in paintings, a convention that, as several writers noted, was no longer adequately observed in France (ever the derided other in this debate).

43. See Homer (1992), especially 173–94; Bolger and Cash, eds. (1996); and more generally Fried (1988).

44. Elizabeth was a popular saint, used in children's moral literature (see Mc-Evansoneya (1996) 274–76), and better known from Ambrose de Lisle Phillips's translation of Counte de Montalembert's history, *The Chronicle of the Life of St Elizabeth* (London, 1839). De Lisle Phillips's son, Edwin de Lisle, spoke out in Parlia-

ment against Calderon's picture, calling it "nothing short of obscene and blasphemous and ridiculous," *Hansard* 354 (June 18, 1891) col 798. Liszt's oratorio on Elizabeth was performed in London in 1865 and was well received.

45. James Collinson (a self-flagellating Christian artist) had already painted a "Renunciation of Queen Elizabeth of Hungary"—a restrained image of the fully clothed queen laying aside her crown (now in the Johannesburg Municipal Gallery), and D. G. Rosetti had made three drawings, including one of her naked, kneeling by an altar (Birmingham City Art Gallery 375' 04). But there is no reason to assume that Calderon had seen any of these. See Grieve (1969).

46. Smith (1996). The fullest discussion is McEvansoneya (1996), whose arguments are also rehearsed by Moran (2004).

47. Smith, ed. (2001) 234; Clarke's comments, quoted in Smith, are taken from *The Times*, May 16 and 25, 1891.

48. *The Times* (June 10, 1891) 8—the President of the Royal Academy gracefully but firmly rejected the request in a reply immediately below the Duke's letter.

49. *The Times* (May 20, 1891) 13. For a fine discussion of the accusations of immorality leveled at Darwin and others, see Dawson (2007), who puts Huxley's letter in a broader context 202–3. Dowling (1994) 32–66 puts this anti-Catholic feeling into a useful context of rows over sexual abstinence and marital norms (45): "virulent and widespread . . . anti-catholic feeling . . . involved far more than religious prejudice." See in general Arnstein (1982).

50. On Latin and Greek in the newspapers, see Vandiver (2010) 93–162.

51. *The Times* (May 25, 1891) 8.

52. *Pall Mall Gazette* (May 16, 1891) 1. This is explicitly the explanation for Calderon's picture. The *Athenaeum* ([May 16, 1885] 637) already had worried about his "Andromeda" that "the fair, plump princess is not as Greek as we could wish . . . rather modern than statuesque."

53. *Punch* (May 9, 1891) 227; see also *Fun* ([May 13, 1891] 196) for the same joke. Both are discussed and reproduced helpfully in McEvansoneya (1996) 254–79.

54. *The Times* (July 18, 1891) 11. See *Hansard* 355, col 1522. It is important to note the indications of laughter, which *The Times* includes, to judge the tone of this speech accurately.

55. See Arnstein (1982), on Murphy 88–107; on convents 62–73 and 108–22.

56. See Arnstein (1982), 130–31, who notes that *The Times* declared that this revelation of "diabolical events" in Austrio-Hungary—Elizabeth's kingdom, of course—would "tend to confirm the repulsion with which Protestants regard these institutions."

57. See Casteras (1981); Fletcher (2003). John Nicholas Murphy in his lengthy apologia for convents, *Terra Incognita: The Convents of the United Kingdom* (London, 1873) 2–3, describes visiting the Royal Academy in 1868, where he witnessed the beautiful wife of an Anglican clergyman view the painting "Not a Whit Too Soon," a painting that represented a young nun being saved from the clutches of Catholic clergy by a knight in shining armor, and heard her exclaim loudly "Oh, how dreadful! Why are such things tolerated? Can't the government interfere?" As he left the gallery, he adds, he saw a boy selling cheep copies of *Revelations of a Convent, or the Story of Sister Lucy*, a book of lurid falsehoods. But Harriet Martineau (for example) also wrote a seven-part story, "Sister Anna's Probation," serialized in *Once a Week*

1861–62, where Anna is saved from an unnatural life as a nun by her lover. *Punch*, paradigmatically, images an avaricious and sinister monk luring a rich, young and doll-like girl into a convent (*Punch* 20 [1851] 129). For the previous decade, and worries about connections between the Pre-Raphaelites and the Oxford Movement, see Cooper (1981).

58. *Art Journal* (1849) 167.

59. *The Times* ([April 25, 1885] 10) noted Hypatia's "slender form"—and the inspiration of Kingsley. The *Illustrated London News* ([May 16, 1891] 648) commented on the portrayal of Elizabeth of Hungary that Calderon "can scarcely wish us to believe that the frail girl whom he depicts had been the mother of several children." A close evaluation of the fleshiness of the naked females is encouraged (pruriently?) by such comments.

60. *Pall Mall Gazette*, July 6, 1885; and then on July 7, 8, 9, with comments and discussion almost every day until August 26. Stead was only one of a series of pioneering journalists and reformers to hazard a journey into the slums, and Andrew Mearns's *The Bitter Cry of Outcast London* (1883), which Stead helped promote, was an immediate predecessor, with equally shocking images of the plight of "the abject poor."

61. Bristow (1977) 118–21; Walkowitz (1980) 248–52; Levine (2003).

62. Quilter, *The Times* (May 4, 1895) 12.

63. The sale (Christies, February 19, 2003) was to an anonymous bidder, who has now been confirmed to be John Schaeffer, an Australian business tycoon. *Mariamne* was on exhibition again in Sydney in July 2010.

64. The sketches are conveniently reproduced in Trippi (2002) 54–55 and in the catalogue Prettejohn, Trippi, Upstone, and Wageman (2008) 94–97.

65. Oh, Mariamne! now for thee
The heart for which thou bled'st is bleeding;
Revenge is lost in Agony
And wild Remorse to rage succeeding.
Oh, Mariamne! where art thou?
Thou canst not hear my bitter pleading:
Ah! could'st thou—thou would'st pardon now,
Though Heaven were to my prayer unheeding.

II
And is she dead?—and did they dare
Obey my Frenzy's jealous raving?
My Wrath but doomed my own despair:
The sword that smote her 's o'er me waving—
But thou art cold, my murder'd Love!
And this dark heart is vainly craving
For her who soars alone above,
And leaves my soul, unworthy saving.

III
She's gone, who shared my diadem;
She sunk, with her my joys entombing;
I swept that flower from Judah's stem,

Whose leaves for me alone were blooming;
And mine's the guilt, and mine the hell,
This bosom's desolation dooming;
And I have earned those tortures well,
Which unconsumed are still consuming!

66. Hebbel (1987); Pordage (1673). It is highly unlikely that Hebbel, Pordage, Byron or Waterhouse—or any other Victorian—knew of Cary's play of *Mariam*, the first published play by a woman in English. See Cary (1994).

67. Cf. the catalogue entry for Calderon's picture of Elizabeth, which briefly tells the story of the saint and adds "*See* Dietrich's 'Life of Elizabeth.'"

68. Trippi (2002) 80 and 82.

69. Ibid., 82 lists comments from Bernard Shaw, Harry Quilter and D. S. Mac-Coll on the theatricality of the image.

70. Ibid.

71. Based on the bibliographies collected by Schreckenberg (1968) and (1979), it is fascinating to note that while over 600 articles were written on Josephus between 1801 and 1901 only 46 were in the English language. Josephus was simply not a major concern of the intellectual or scholarly world in England or America. Of these forty-six, the majority (twenty-seven) are in theological journals and concern specific religious matters, and 10 others are on local questions of archaeology. In the same 100 years, however, over 200 separate editions of Whiston's translation of Josephus were published, including over 50 in London alone (and, e.g., 26 in Philadelphia)—excluding 33 undated editions. Clearly, very many copies of Josephus in translation were in circulation. I intend to discuss the Victorian reception of Josephus in more detail elsewhere, but these figures immediately indicate how carefully "the educated audience" needs to be calibrated. I suspect that many more clergy (and others) owned copies of Josephus for reference and/or status, rather than reading Josephus through.

72. "Mr Waterhouse, whose few pictures have made their mark, is fond of antiquity, but goes to something else than ordinary classical sources," noted *The Times* (April 30, 1887) 10.

73. Hinds (1998) 31: The emphasis on "entire" is mine.

74. His *Lady of Shalot* is perhaps more instantly recognizable to scholars as it has been so popular for book covers and as an illustration of Tennyson's poem.

75. See Auerbach (1982); Dijkstra (1986).

76. See, for a general if rather rosy placement of Beardsley in Victorian culture, Zatlin (1990).

77. See Laqueur (2003) especially 192–239.

78. "I admit, of course, the existence of sexual excitement terminating even in nymphomania, a form of insanity that those accustomed to visit lunatic asylums must be fully conversant with." Acton (1857) 133: nymphomania is the threatening extreme that helps authorize his well-known normative assertion that "there can be no doubt that sexual feeling in the female is in the majority of cases in abeyance." So in the *Westminster Review* (1850) 456, it is declared that "Women's desires scarcely ever lead to their fall"—that is, women very rarely become prostitutes/are seduced out of sexual feelings, although—and here's how the patriarchal system

holds together, even in a critical piece such as this—after they have experienced sex, then their dormant desires may take over. On Acton and the context of male anxiety, see, for example, Hall (1991);  Haller and Haller (1974); Weeks (1981); Peterson (1986) 569–90; Sigsworth and Wyke (1972); Nead (1988); Walkowitz (1980); and in particular Levine (2003)—each of which is corrective to and indebted to the seminal work of Marcus (1964).

79. "At this point a certain suspicion of mine became a certainty. The use of 'Bahnhof' ['station'; literally, 'railway-court'] and 'Friedhof' ['cemetery'; literally, 'peace-court'] to represent the female genitals was striking enough in itself, but it also served to direct my awakened curiosity to the similarly formed 'Vorhof' ['vestibulum'; literally, 'fore-court'] - an anatomical term for a particular region of the female genitals. This might have been no more than mistaken ingenuity. But now, with the addition of 'nymphs' visible in the background of a 'thick wood', no further doubts could be entertained. Here was a symbolic geography of sex! 'Nymphae', as is known to physicians though not to laymen (and even by the former the term is not very commonly used), is the name given to the labia minora, which lie in the background of the 'thick wood' of the pubic hair. But any one who employed such technical names as 'vestibulum' and 'nymphae' must have derived his knowledge from books, and not from popular ones either, but from anatomical textbooks or from an encyclopaedia - the common refuge of youth when it is devoured by sexual curiosity. If this interpretation were correct, therefore, there lay concealed behind the first situation in the dream a phantasy of defloration, the phantasy of a man seeking to force an entrance into the female genitals." S. Freud, "Fragment from the analysis of a case of hysteria," *S.E.* 7:99. In fact, the use of "nymphae" in English may not be as restricted as Freud suggests: A. Smith writing to Darwin (March 26, 1867, DAR 85: A103–A105) talks of the "lengthened nymphae" of Hottentot women; Waitz (1863) 106 also talks of Hottentot "*nymphae*" as a distinctive anatomical feature. Smith was a retired army surgeon and writing privately to a biologist, but Waitz, although he was interested in "psychophysiology," was writing for a general audience.

80. Groneman (2000); Rousseau (1982); on the ancient world, see M. Maaskant-Kleibrink (1980), and, more generally, Dean-Jones (1992).

81. For a modern version of such a view, see Wood (1981) who writes (144): "Waterhouse's Circes and Sirens are not evil and destructive monsters like those of Gustave Moreau and the European Symbolists. Rather they lure and entrap their victims by their wistful beauty and mysterious sadness, as if they cannot help what they are doing, and rather regret it."

82. "Mr J. W. Waterhouse's Painting 'Hyllas and the Nymphs,'" *The Studio* 10 (1897) 243–47, quotations from 244 and 247.

83. Phythian (1905) 54. The threat of realism was precisely articulated in the debate in *The Times* in 1885 over the Royal Academy's exhibition and its paintings of nude women: "Why, my dear 'goody' and my dear young lady, if painters were photographers neither you nor any decent man or woman could stay in Burlington House ten minutes." *The Times* (May 25, 1885) 10: to look at a photograph of a naked person is self-evidently unacceptable because of its realism.

84. Kestner (1989).

85. Spielmann (1908) 7; *Art Journal* (June 1897) 178; Baldry *The Studio* 10 (1897).

86. Sketchley (1909) 8.

87. The central image of the piece is also taken from classical sources—the Minotaur and the labyrinth—though, unlike in the classical myth, where both boys and girls were offered in tribute, in Stead's report the victims are all female. Campaigners for purity were as attracted by the language of the classical world as were the artists they campaigned against.

88. Acton (1857) 23.

89. John Ruskin *Works* 17: 213–14.

90. *As You Like It* II.1.

91. There is also a suggestion that the soldier at the far right of *Mariamne*, usually cut off in reproductions, also is a self-portrait. His friend, Logsdail, who also worked in the Primrose Hill studios, painted Waterhouse into one of his most famous images, *The Bank and the Royal Exchange* (on the bus, as noted earlier), and also used Esther, Waterhouse's wife, for the adult in *St Martin's in the Field*.

92. Trippi (2002) 110.

93. Kestner (1989) 232 thinks that Odysseus is in the painting, presumably the most emphatic male figure, but there is no evidence for this. (He repeats the same assertion in Kestner (1995): 61–62.)

94. Armstrong (1891). Kestner (1989) 42 usefully lists twenty British Circes between 1884 and 1912.

95. See Harrison (1887) 133–36, which illustrates ancient Sirens in the form Waterhouse paints. The *Pall Mall Gazette*, May 2 (1891) 2 notes "Some hypercritical spectators have asked how the Sirens managed to 'do' their black hair, as they are furnished only with claws," a joke they repeated May 22, 2.

96. John Ruskin *Works* 17: 211–12.

97. Baldry (1917) 2–15.

98. See Schmalz's *Faithful unto Death or Christianos ad Leones* (private collection 1888); or Lefebvre's *La Vérité* (Musée d'Orsay, 1870); *Chloe* (Young and Jackson Hotel, Melbourne, 1875), *La Cigalle* (National Gallery of Victoria, 1872)—particularly direct in its pornographic invitation.

99. Kestner (1989) 14.

100. It was striking and disappointing to see how dismissive most of the reviews of the London retrospective exhibition were—trotting out, as they did, no more than the inherited views of Waterhouse.

## Chapter 2. The Touch of Sappho

1. It is already listed as *Sappho and Alcaeus* in Dircks (1910).

2. The names are taken from Sappho's own poetry: see fragments 16 (Anactoria) 8, 49, 96, 131 (Atthis); 22, 95 (Gongyla); 82a (Gyrinno[s]). For a text and wonderful translation of Sappho (with good notes also), see Carson (2002).

3. These pictures are reproduced and discussed in Barrow (2001), now the standard first port of call on Alma-Tadema.

4. See Stewart (2006), lavishly illustrated. His reading (152–54) of Francisco di Zurbarán's *Saint Romanus of Antioch* (1638) is, however, bizarrely misguided because the Latin of the inscription is wholly misunderstood, as his interpretation of

Charles Allston Collins's *Convent Thoughts* (1851) misses the provocation of the biblical quotation included in the frame (169). It is significant that this painting was exhibited at the height of the anti-Catholic scares: see Casteras (1981) 170–3; Fletcher (2003) 299–301.

5. For the hairy shorts in antiquity, see, conveniently illustrated in Bérard, ed. (1989), a pot that may be the source for Alma-Tadema here.

6. This story was made popular by Jean-Jacques Barthélemy in his *Voyage de jeune Anacharsis en Grèce* (1788), who based his claim on the fragmentary *Marmor Parium* which said that Sappho fled Mytilene and went to Sicily. He states that this must have been because of her political involvement with Alcaeus against the tyrant. This is discussed by DeJean (1989) 158–60.

7. DeJean (1989) 153. George Ebers thinks the picture is inspired by a poem of Hermesianax, quoted in Athenaeus *Deipnosophists* 13 598b, which simply states "You know how many revels Lesbian Alcaeus enjoyed as he sung and played his yearning love for Sappho." For Georg Ebers, see chapter 6, pp. 232–33. It is interesting to see an Egyptologist and novelist also involved with writing the life of this major classicizing artist.

8. DeJean (1989) 190.

9. DeJean (1989) charts this most fully. See also Williamson (1995) 8–12 and in general the fine collection of essays in Greene, ed. (1996).

10. A wine cooler now attributed to the Brygos Painter [Munich 2416]. Both figures are named on the pot.

11. Bullen (1998); Nead (1988); Pointon (1990); Pollock (1988); Smith (1999a); Smith (1999b); and especially Smith (1996).

12. On Haddo's attempted legislation, see Smith (1996) 30–32.

13. Swanson (1990) 52.

14. Smith (1999a) 202–7 is particularly good on responses to this painting in context.

15. Stirling (1926) 63–64. He also comments that "*Punch* was evidently a little staggered."

16. Jenkyns (1991) 125–28.

17. See Smith (1999b) on "the British Matron."

18. DeJean (1989); Prins (1999); see also in general (from a huge bibliography) Porter and Hall (1995); Gillman (1985); Bland and Doan, eds. (1998).

19. Typical is this comment of Meynell (1887) 15: "His subjects, as a general rule, are in no sense connected to the feelings; they are the learned revivifications of the past, delighting only in their scholarly accuracy."

20. Swanson (1977) still feels the need to regret the shocking anachronism of the furniture. The Victory is based on a table-stand from Pompeii, with a lectern added.

21. It is used on the cover of Prins (1999), and has had a certain brief flurry of notoriety from that in Sappho studies at least. Moreau did a series of prints of Sappho on the rocks, leaping and lying dead at the bottom, and there are several other pictures on this theme—a genre to the extent that Daumier did a lovely cartoon of Sappho being forced unwillingly over the cliff by a heaving Eros.

22. "Heroides" 15.31–5. The authenticity of this poem does not affect its importance for the tradition of representations of Sappho.

23. See Nead (1988).

24. Brinton (1900). It is discussed well by Prins (1999) 187–88.

25. Brinton (1900) 509–10.

26. I have excluded from this survey prints of an erotic/pornographic nature where Sappho is in a sexual embrace with another woman, of which the most well–known is probably *Songe de Sapho* by Girodet-Triason, conveniently reproduced in Reynolds (2003) fig 3, p64, who discusses such images, 53–67. I have also not included such images as the frontispiece of Blin de Sainmore's *Lettre de Sappho à Phaon* (1766), where Sappho languishes on a sea-shore like Ariadne and is supported by a female companion (conveniently reproduced in DeJean (1989) fig 2, p144). Nor a painting such as Angelica Kaufman's *Sappho Inspired by Love*, where Cupid rests a hand on Sappho's shoulder. Klimt has a drawing of Sappho with her daughter near her, but not quite touching. One could say that both the pornographic images and the images of Sappho as a deserted or inspired lover would add to the erotic expectations of the Alma-Tadema picture. In each case, the touch is a significant moment.

27. See Adams (1977–78); Crow (1995) 262–64.

28. See Schnapper (1980) 268–70. The painting is now in the Hermitage.

29. Johnson (1993) 245–46.

30. See Johnson (1993) 244–47 "compelling in its strangeness"; Crow (1995); Adams (177–78).

31. Sappho does mention an Eirana (fr 91; 135) who is implausibly linked with Erinna the poet, who almost certainly lived at least 200 years after Sappho: see Williamson (1995) 18–19.

32. On Solomon's career, see Davis (1999); Donaghue (1995) 38–39; Reynolds (1984); Cruise (1995); and the brief but salient comments of Dellamora (1990) 170–71.

33. Pater praised him in print—anonymously but very recognizably: "a young Hebrew painter"—three years after his disgrace [reprinted in *Greek Studies* (London, 1922) 42]. The description of Solomon's painting of Dionysus included this "homosexual code" (Donoghue [1995] 39): "the sea-water of the Lesbian grape become somewhat brackish in the cup."

34. Cited in McCormack (1991) 28.

35. Prins's chapter on Swinburne and Sappho is particularly good (Prins [1999] 112–73). See also Dellamora (1990) 69–85.

36. National Archaeological Museum in Athens, 1260.

37. See Østermark-Johansen (1999).

38. See Mathieu (1994) 72–79: The quotations are translated by me, and the critics quoted are Désiré Laverdant, and Maxime du Camp, cited 78. Moreau's own comments are taken from *L'Assembleur de rêves: écrits complets de Gustave Moreau*, ed. P-L. Mathieu (Fontfroide, 1984) 60.

39. For Stück's work and references to the contemporary response to it, see Voss (1973).

40. See Auerbach (1982).

41. *Punch* May 14 (1881) 226.

42. Ibid., 217.

43. *The Times* June 6 (1881) 4.

44. *Fortnightly Review* 29 (1881) 689–703; *Athenaeum* 2782 April 30 (1881) 597; *Daily Telegraph* April 39 (1881) 5; *Magazine of Art* (1881)

45. *The Nation* Sept 16 (1886): 237–38. It is an anonymous review of Georg Ebers's biography of Alma-Tadema (see earlier n7).

46. *AJP* 34 (1913): 106–7.

47. For the story, see fn 3 earlier.

48. *The Athenaeum* 2792 (1881) 597.

49. For the importance of Wharton, see Prins (1999) 52–73.

50. Patrick (1912) 100.

51. Ibid.

52. Gosse *Fortnightly Review* 29 (1881) 692 "something of a *précieuse*"; *The Athenaeum* 2792 April 30 (1881) 597: "it may be that the painter intended a little satire in importing to her garments and her air something that is *précieux*, while it is refined and dignified." The tension in the response here is again in evidence.

53. This identification is also made by Helen Zimmern in the *Art Journal* special supplement (1886) 22, reprinted in Singleton, ed. (1912).

54. This and the remaining quotations in this paragraph come from *Daily Telegraph* April 30 (1881) 5.

55. *Magazine of Art* 4 (1881) 309; *Art Journal* (1883) 66; *Art Journal* Special Supplement (1886) 22 [by Helen Zimmern]; *Schreiber's Magazine* 18 (1895) 670; all comment on the coloring of the sky and sea, but make no comment on the dynamic of the central figures.

56. Reynolds (2003) 81.

57. The reproductions are conveniently listed by Swanson (1990) 213–14.

## Chapter 3. Who Killed Chevalier Gluck?

1. For Gluck's biography, see Howard (1991), who translates Gluck's extant letters and many of the documents relevant to his life; Einstein (1936).

2. He wrote two brief factual public letters to *Mercure de France* (Lesure [1984] 96–99; 100–101): an early statement of principle (Lesure [1984] 8–10), and one rather more sarcastic rejoinder to La Harpe (Lesure [1984] 271–75). But despite his interest in publicizing his operas, he found the rows tedious and allowed others to argue his case.

3. Lesure (1984) 10. Compare J. von Sonnenfels's review of January 5, 1768 (translated in Howard [1991] 82–83): "the limits of all national styles are too narrow for him. From the music of all nations he has made a music for himself—or rather he has plundered Nature for all the sounds of true expression." The final turn to nature as the source of true expression is typical of the Enlightenment—and helped the theorists turn back to the early Greeks who were closer, more in touch with nature.

4. Leclerc (1796) 10.

5. Ibid., 22: "Following Plato's example we will exclude all purely instrumental music." "A military march," he declares (23), "however well characterized, does not adequately determine ideas." He makes the general point (n12 p60): "The ancients, much more aware than the moderns on all moral influences, had this idea about

music: that all novelty introduced into song presages a change in the State, and that one cannot touch the laws of music without touching the laws of government: that was the opinion of Plato and of Cicero." (He regularly justifies his proposals as being "according to the example of the Greeks.") Leclerc also made (and published) formal proposals for the organization of marriage in the new revolutionary state, and presented opinions on a range of public issues in the Assembly.

6. Johnson (1995) 142.

7. See Staiger (1989) 48. In the famous preface to *Alceste*, the great statement of Gluck's operatic reform, Gluck declared his primary aim to be the search for "a beautiful simplicity." The preface is usefully translated in Howard (1991) 84–85.

8. Einstein (1936) 49 asserts that they met, but I have found no corroborating evidence.

9. See Lesure (1984).

10. See Rushton (1972): "Gluck's *Iphigénie en Tauride* is perhaps the most brilliant *pasticcio* ever produced" (430).

11. See Rushton (1992); Cumming (1995).

12. Brown (1991) is essential here. See also Heartz (1995); Heartz (2004); and the excellent Rosen (1997).

13. On this history of dance, see Alm (1976); Angiolini (1763); Betzwieser (2000); Cohen (2000); Cyr (1995); Franko (1993); and Morelli, ed. (1996);

14. Brown (1991) 143. John Weaver in London too aimed to re-create dance "in imitation of the PANTOMIMES of the Ancient Greeks and Romans": see Brown (1991) 146.

15. On Calzabigi, see Marri, ed. (1989); Ricci (1965) 631–44. Casanova described him as: "Well aware of the main chance, versed in financial preparations, familiar with the commerce of all nations, learned in history, *bel esprit*, poet and great lover of women," Jacques Casanova de Seignalt *Histoire de ma vie*, ed. F. Brockhaus (Paris, 1960–62) vol. V 28 (cited by Einstein [1936] 64 and Howard [1991] 57).

16. See Hortschansky, ed. (1989); Paduano (1989); Rosen (1997); Thomas (2002); Heartz (2004), each with further bibliography.

17. See Segal (1989), and for a brief prehistory of Orpheus in opera Barsham (1981b); Tomlinson (1995), and with more intellectual flamboyance, Abbaté (2001) 1–54.

18. See Calzabigi's letter to the imperial chancellor Prince Kaunitz (March 6 1767), translated in full in Howard (1991) 78–80: "*Orfeo* went well because we discovered Guadagni, for whom it seemed tailor-made, and it would have fared disastrously in other hands" 80.

19. Noverre (1930) 93–97. For general background, see Heartz (2004) 257–70; Woodfield (2001).

20. On Quinault, see Thomas (2002) s.v. Quinault, especially 36–9.

21. Calzabigi's letter to the imperial chancellor Prince Kaunitz (March 6, 1767), translated in full in Howard (1991) 78–80.

22. Calzabigi's letter to the imperial chancellor Prince Kaunitz (March 6, 1767), translated in full in Howard (1991) 78–80.

23. See Cave (1988), especially the early chapters.

24. Lesure (1984) 10.

25. The dedication to Louis XV on the score of *Iphigénie en Aulide*, usefully translated in full in Howard (1991) 119–20.

26. This is taken from the fine memorial to Gluck written by Olivier de Corancez, editor of the *Journal to Paris*, who recalled how Gluck had explained that he "had noticed that all the Greek poets who wrote hymns for temple scenes followed the rule of making a certain metre predominate in their odes." *Journal de Paris* (August 24, 1788) 1021–23 (translated in Howard [1991] 245–49).

27. Rosen (1997) 172.

28. Lesure (1984) 164.

29. Ibid., 70.

30. Ibid., 312.

31. Ibid., 245.

32. Rolland (1774), cited in Howard, ed. (1981) 106.

33. See Alm (1996); Betzwieser (2000); Cohen (2000); Cyr (1995).

34. *Encylcopédie* vol. 2 1448.

35. Lesure (1984) 70.

36. *Wienensches Diarium* 82, October 13, 1762 (Wednesday supplement).

37. Angiolini (1783) 18.

38. On Noverre see especially Lynham (1950); also Noverre, C. (1882).

39. *Introduction to the Ballet des Horaces or little answer to great letters of the Sieur Angiolini* cited and translated by Lynham (1980) 75–76.

40. Arthur Murphy *Life of Garrick* (London, 1801) cited by Lynham (1980) 34.

41. For a wonderful description of the affair published in the *Journal Etranger* (December 1755), see Lynham 36–39.

42. On the relation between performers and the London audience in the eighteenth century, see Wanko (2010).

43. Noverre (1807) vol. I, 359.

44. Ibid.

45. Ibid. (1930) 27.

46. de Cahusac (2004) [Lecomte, Naudeix, and Laurenti] 3. The most bizarre claim of de Cahusac is that Agamemnon left a *dancer* with his wife, Clytemnestra, to watch over her morals and encourage her toward glory. He cites Athenaeus as his source (I. 14b). Athenaeus, like Homer, whom one would have expected to be cited, uses the term *aoidos*, "bard." De Cahusac also claims that anyone who has only read the sources in translation may not have understood this properly! He concludes rather finely with a moral for his story: "Maris qui partez, emmenez avec vous le danseur" (82). As Pepys shows, having a dancing master in your house was not always perceived as a way of preserving morals—as amusingly retold by Tomalin (2002) 149–55.

47. Noverre (1930) 2—although he did note the influence of de Cahusac and Diderot (Noverre [1930] 164–66).

48. Ibid., 97.

49. Ibid., 32.

50. Ibid., 21.

51. Ibid., 2.

52. See, in particular, Vincent-Buffault (1991) and Johnson (1995). In general, also, Mullan (1990).

53. Grimm, *Correspondence Litteraire* July 1760.

54. Ibid.

55. Vincent-Buffault (1991) 69.

56. And a changing sense of the audience in the Victorian era where, it is claimed, "The demands of public life forbade men the outbursts of sensibility and emotion which might give power into the hands of the observer" (Vincent-Buffault [1991] 245). In fact, many Victorian men did cry publicly, though only at certain types of scene.

57. See Johnson (1995) 9–34. "Virtuosi of the lorgnettes" 29.

58. Johnson (1995) 34.

59. La Morlière, J. R. de *Angola: Histoire Indienne*, 2 vols., Paris 1746 vol. I, 69, cited by Johnson (1995) 31.

60. Lesure (1984) 108.

61. *Correspondance des amateurs musiciens*, April 27, 1804, 256.

62. Johnson (1995) 60.

63. Ibid., 82. By contrast, Calzabigi in 1778 attacks the ignorance and tastelessness of the Italian spectators: "How could one want to present a Greek tragedy in front of such a deranged audience?" Ricci (1965) 636.

64. Lesure (1984) 63.

65. Boyé (1779), cited and translated in Lippman (1986) 289.

66. Noverre *Preface to Agamemnon Vengée* (Vienna, 1772), translated in Noverre (1782) vol III.

67. Kämpfer in C. Cramer *Magazin der Musik* 1 (1783) 561–64, translated in Howard (1991) 226–27. Compare the description of J. Mannlich "Mémoires sur la Musique à Paris à la Fin du Régne de Louis XV," ed. H. Weiss, *La Revue Musicale* 15 (1934) 163, translated in Howard (1991) 110–12, who notes "Gluck's conduct of rehearsals soon became the talking-point of Paris."

68. Tiersot (1930) 355.

69. Lesure (1984) 63.

70. Ibid., 46.

71. Ibid., 146.

72. Einstein (1930) 116.

73. Lesure (1984) 297.

74. Ibid., 331. Tiersot (1930) 356 calls La Harpe a "ridiculous, spiteful and bigoted pedant."

75. Lesure (1984) 365.

76. Ibid., 389.

77. Launay, ed. (1973) I, 764.

78. Quoted as an anecdote by La Harpe, *Correspondence Littéraire*, 6 vols. (Paris 1804–7) vol. 1, 25.

79. See Corancez, *Journal de Paris* (August 24, 1788) 1021–23, translated in Howard (1991) 243–49 (anecdote on 243–44).

80. Cited by Tiersot (1930) 354.

81. Heartz (2004) 264.

82. See Tiersot (1930); Thomas (2002) 207–12; "*Orfeo* seems to be constructed as if in answer to the pleas of Diderot." Heartz (2004) 268.

83. *Mercure de France* (1772) 169–74, reproduced in Lesure (1984) 1–7 and translated in Howard (1991) 102–5. See, in general, Müller-Blattau (1995); Cumming (1995).

84. The libretto of *Iphigénie en Aulide*, translated in Howard (1991) 109.

85. Zinzendorf's diaries have been well used by Link (1991), especially for the later years of the century. She notes (489) that in 1781 for "possibly the most important state event to take place during Joseph's reign," *Iphigénie en Tauride, Orfeo*, and *Alceste* were staged in a great triple bill. For Gluck in Zinzendorf, see also the rather pedestrian Breunlich (1989).

86. Lesure (1984) 167.

87. La Harpe, J-F. *Lycée, ou cours de littérature ancienne et moderne*, 16 vols. in 19 (Paris, 1799–1805) vol. 12, 205 cited and set in context by Thomas (2002) 39.

88. Racine (1995) 510.

89. Excellent discussion of the ending and its change in Rushton (1992).

90. Lesure (1984) vol. II, 120–21.

91. Thomas (2002) 283.

92. Carlson (1988) 18.

93. Boullée (1953) 61.

94. Thomas (2002) 283.

95. See Vidal-Naquet (1990) 211–35.

96. Grimm *Correspondance Littéraire* VI: 170–71 (January 1, 1765).

97. Ibid., XI: 12.

98. *Chronique de Paris* (December 12, 1790) 1, 383—also told in Johnson (1995) 110.

99. I have taken this story from Johnson (1995) 116.

100. *Journal de l'Empire* (February 21, 1811) 2.

101. Jouhard (1809) 331.

102. Cairns (1989–99) II, 635. See also Everist (2001) for this decline.

103. Ellis (1995) 80.

104. *Révue et Gazette Musicale* 47 (November 20, 1859) 385 [Léon Durocher].

105. "The origins of Berlioz's musical aesthetic are in the Michaud article on Gluck" Cairns (1989–99) vol. I, 82.

106. Cairns (1989–99) is the authoritative biography of Berlioz. See also Bloom (1998). And, of course, Berlioz's own memoirs (Berlioz [1970]).

107. Cairns (1989–99) vol. 1, 137.

108. Ibid., 490; vol. II, 654 [*Cosima Wagner's Diaries* trans. G. Skelton, New York 1978 vol. II, 179].

109. Cairns (1989–99) vol. II, 582–83.

110. See Berlioz (1915). Background to this journalism in Murphy (1988) and Ellis (1995). Everist (2001) is excellent on the development of Berlioz's critical writing in the context of the changing status of Gluck from the 1820s onward.

111. Cairns (1989–99) 77–78.

112. Ibid., 627.

113. The full letter is quoted in Cairns (1989–99) vol. I, 405.

114. Cairns (1989–99) vol. II, 735.

115. Berlioz (1915) 15.

116. Ibid., 105, 81.

117. A performance of *Alceste* in 1861 was praised by some (and contrasted positively and polemically with *Tannhaüser* by the journalist Monnais in 1866 as part of

an attack on new music and a defense of the classical), but never received the huge support and press coverage of *Orphée*, which ran for 138 performances by 1863.

118. Henry Chorley (1926) [1862] 237. On Chorley, see n125.

119. See Waddington (1975); Fitzlyon (1964) 345–56; Kendall-Davies (2003) is not completely reliable.

120. "He loves me much, I know it—he loves me only too much! But that would make a long story to tell you—and it is all too new still—I still feel too agitated to be able to write about it. Perhaps I have already said too much." Viardot (1916) 40. She wrote with such candor often to Rietz, to whom she confessed she did not love her husband, although he loved her (1915) 548. Berlioz's visits certainly seemed to upset her: "The sight of this man, a prey to such physical and mental anguish, so unhappy in spirit, so touched by the kind reception we gave him, torn by horrible tortures of the heart, the violence of the efforts which he makes to hide them, the ardent soul bursting its bounds of clay . . . the vast tenderness that overflows in his gaze, in his least words; all this, I say, wrings my heart." (1916) 42.

121. Cairns (1989–99) 639.

122. BM Add. Ms 41, 191 33bis. cited in Waddington (1975) 395.

123. *Ménestrel* 727, no. 51, November 20, 1859, 403. He added of the second act "il est tout entire dans Virgile" and, in the full flow of his rhetoric, declares that Gluck "seems to radiate the tenderness of the soul of Euripides" (402).

124. Letter to his sister, 1860 quoted in full in Barrington (1906) vol. II, 52–53.

125. Chorley (1926) [1862] 237. Chorley, music critic for the *Athenaeum*, was a good friend of Dickens and Browning, and much respected by Mendelssohn, though he became seen as old-fashioned and silly, especially when his distaste for Wagner stood out against the trend. Ernest Newman edited his papers in 1926, however. Newman recognized something of a kindred spirit in Chorley at one level: Chorley had been adopted as a youth by a Quaker family, and was self-taught—and, like Newman, who significantly had changed his name to "Ernest Newman"—self-fashioned. Newman also described Chorley in terms that provide a fascinating backdrop for the passion of his description of Viardot (Chorley [1926] xiv): "All his life through he had a pathetic longing for sympathy and understanding. He had two love affairs, both of them unfortunate; his solitary proposal of marriage was rejected. His position in the musical world and his honesty of speech brought him many annoyances and insults, and made him the object of many a malicious intrigue." See Viardot's reaction to him (following on p. 110).

126. Viardot (1916) 46.

127. Several reviews are helpfully collected in La Laurencie (not dated) 131f. Fouquet (1992) 196 writes "The cultural context of 1859 would almost guarantee the successful restoration of *Orphée*: the interest in antiquity fostered by the imperial regime, and manifested by numerous archaeological explorations and by the institution of educational policies that affirmed the value of ancient civilizations and of teaching dead languages, was in accord with the interest in the effect on the sensibilities of the contralto voice." Each element Fouquet specifies is true, but even in combination these reasons do not sufficiently explain why *Orphée* specifically was such a success.

128. Letter to his sister, 1860 quoted in full in Barrington (1906) vol. II, 52–53.

129. Barrington (1906) vol. II, 53. Viardot (1916) 52—the performance was on July 12, while another performance of *Orphée* with Fr. Csillag of Vienna played at Covent Garden. The latter was a complete flop, and, as Viardot recorded with satisfaction, when the audience at Lord Dudley's heard her, they could not imagine it was the same music being performed.

130. Viardot (1915) 538.

131. See Hall and Macintosh (2005) 438–42.

132. Ibid., 316–430 (with further bibliography).

133. In fact, Gluck had been parodied already in his own time: see Brown (1999), and La Laurencie (not dated) 76–79.

134. Berlioz (1916) 9, 25. See also Fauquet (1992) especially 197.

135. Berlioz, Letter to Emile Perrin, January 10, 1855, cited by Fauquet (1992).

136. Berlioz wrote furiously against a review of Scudo who suggested he had introduced ophicleidae into a concert performance of an act of *Iphigénie*: see Cairns (1989–99) vol. II, 211–14. Cairns, in defense of his hero Berlioz, seems to dislike Scudo thoroughly.

137. Although reviewing in nineteenth-century Paris was a deeply compromised business, as the journals were owned by publishing houses that also published the music and had a vested interest in praising their own composers (and criticizing their rivals), nonetheless reviewing a production with which the reviewer had been so involved, stretches even those boundaries of complicity. See Ellis (1995) for a detailed study of reviewers' complicity, and Everist (2001) for Berlioz on Gluck.

138. *Ménestrel*, January 23, January 30, February 6, February 13, February 20, 1859. This series of articles may have helped prepare the way for the revival later in the year.

139. Cairns (1989–99) vol. II, 764.

140. Hoffmann (1969) 58.

141. Ibid., 59.

142. Wagner (1983) 337.

143. See below, ch. 4, especially pp. 131–33.

144. Ibid.

145. Wieland Wagner also changed the ending of *Orphée* in 1953: a family commitment to a tragic ending. Wolf Siegfried Wagner in turn was heavily involved with the production of *Orphée* at Wexford in 1977, but this was controversial, in as much as it was, only for the rather heavy-handed symbolism of its staging.

146. "Artemis, whom I had introduced into the action. . . ," Wagner (1983) 337–38.

147. Riehl (1891) 161–62.

148. Wagner (1983) 339.

149. Ibid., 337.

150. Ibid. (1894)—with Grey (1988) and for this in a wider context Grey (1995).

151. See especially Goldhill (2008) with further bibliography; also Goldhill (2002) 160–66; most recently, Foster (2010), with a good discussion of Wagner's debt to Hegel.

152. Naumann (1894) vol. 4, 852.

153. Ibid., 838.

154. Ibid., 844.

155. Ibid., 845.

156. Ibid., 830.

157. Berlioz (1918) 126.

158. *Daily News* (May 14, 1890).

159. *Guardian* (May 21, 1890).

160. Newman (1895) 189.

161. I have discussed this cultural event at length in Goldhill (2002) 108–77.

162. *The Times* (February 19, 1910).

163. Goldhill (2002) 108–77.

164. Ibid. At the same time, 1910–12, Puccini too became a lightening rod for arguments about Italian national identity, as Wilson (2007) has explored well.

165. Paradigmatic is Robert Hartford, who calls Gluck "old sober-sides," *The Musical Times* 133, no. 1787 (1992) 38.

166. *Ménestrel* 727, no. 51 (November 20, 1859) 403.

## Chapter 4. Wagner's Greeks: The Politics of Hellenism

1. The best guide is now Carnegy (2006), with full further bibliography.

2. See Goldhill and Osborne, eds. (1999) for the idea of ancient Greece as a "performance culture."

3. Austin (1975); Goffman (1969); (1975); Turner (1969); (1982); Schechner (1988).

4. This linear engagement of text with text, as it were, has been most developed in Latin studies: see Martindale (1993); Conte (1986); Conte (1994); Hinds (1998).

5. Fricke (1990) 94.

6. Wagner (1892–99) I. 32.

7. Wagner (1911).

8. Foerster-Nietzsche, ed. (1921) 125.

9. Ibid., 126.

10. Wagner (1911) 415.

11. On Droysen's Greeks and Jews, see Momigliano (1970) 147–61. A full treatment of Droysen's impact is still needed.

12. See earlier pp. 112–16. Lincoln (1999) and Hall (1997) have good background on German and Greek links. See also Gossman (2003) and the seminal Butler (1935).

13. Wagner (1911) 412.

14. See Hegel (1948) 324–25; Nietzsche (1967) VII. 3: 412–13 (August–September 1885 fr 41 [4])—discussed in Goldhill (2000) 1–7; Riehl is cited in Gossman (1994) 11.

15. See Silk and Stern (1981); Ruehl (2003); Foerster-Nietzsche, ed. (1921).

16. Wagner, C. (1977) vol. II, 551–52.

17. Mack (1976) 16–17 + plates 60–67.

18. Standard work is Ewans (1982); for earlier accounts, see Braschowanoff (1910); Wilson (1919); and Schadewaldt (1999), which is discussed later; also Lloyd-Jones (1986) 126–42; Magee (2000) 83–101.

19. For the Hegelian structuring, here too see Foster (2010).

20. Most detailed is Ewans (1982).

21. Baldick (1987) 41.

22. Lloyd-Jones (1986) notes well (140–42) how alien this is to any sense of Greek tragedy's idea of the gods.

23. Goldhill (2002) 160–66.

24. Deathridge (2008). Lloyd-Jones (1986) 126 and McGee (2000) 96 go for "turgid" (McGee blames Hegel for the rise in incomprehensible prose). In general, see Grey (1995) for a more positive engagement.

25. Wagner (1892–99) I. 168: I have changed Ashton Ellis's translation from "communistic" to "communal": The importance of community in Wagner's prose here needs emphasizing.

26. Ibid., 35. Foster (2010) is good on the repeated flower imagery in Wagner's Hellenism.

27. Wagner (1892–99) I. 53.

28. Ibid., II. 190.

29. "Brünhilde is the Antigone of the *Ring of the Niebelung*. She acts from a feeling which is not quelled by the consciousness of what she will have to suffer as a punishment from the representative of the state for disobedience," Irvine (1897) 182.

30. Wagner (1892–99) II. 191–92.

31. Ibid., I. 135–36.

32. Ibid., 58.

33. Ibid., III. 80

34. Ibid., 82–83.

35. Ibid., 100.

36. Ibid.

37. Ibid.

38. Borchmeyer (1992) 174; see also in general Borchmeyer (1991).

39. Deathridge (1992) 223. Deathridge (2008) ch 13 has some excellent comments on Wagner's racism.

40. Irvine (1897) 32.

41. Shaw (1906).

42. Magee (2000). For such strong denials of anti-Semitism in the music or dramas, see also Borchmeyer (1991) and (1992).

43. Hanisch (1992) 189–90—he is quoting Thomas Mann.

44. Deathridge (1999) 136.

45. Wagner (1892–99) IV. 155–56.

46. Deathridge (2008) 163.

47. Letter of November 22, 1881. Strobel (1936–39) III: 229–30. Translation from Deathridge (2008) 163.

48. Wagner (1892–99) IV. 43. Cf. V. 331.

49. Hall (1997).

50. Deathridge (1999) 137.

51. The best short general account of the production is now found in Carnegy (2006) 69–106.

52. Spencer, ed. (1976) 230.

53. Skelton (1976) 10.

54. As told by Gustav Adolph Kietz: Barth, Mack, and Voss, eds. (1975) 228–29.

55. Porges (1880) 142.

56. See Fricke (1906) 40, translated in Fricke (1990), (1991). Fricke (1991) 27 found Wagner's attempts to direct kissing particularly funny: "the diminutive composer suddenly hanging from the neck of the much taller Niemann, so that the latter could scarcely keep his balance, while Wagner's toes were barely touching the ground." For the development of Wagner as Regisseur in the nineteenth-century context, see now the excellent Carnegy (2006); see also Srocke (1988).

57. Fricke (1991) 42.

58. Fricke (1991). Fricke thought the dragon scene "as arranged by Wagner . . . is bound to look ridiculous," even or especially if all the dragon had arrived [(1991) 41; but when he actually saw the dragon he "whispered to Doepler: 'Hide the thing away, where no one will ever find it! Get rid of it. This dragon will be the death of us.'" [(1991) 42].

59. Quoted in Skelton (1976) 130. In fact, her diary reveals her to be particularly unhappy with Doepler's costumes, especially in their first forms: "I am much grieved by [Doepler's models], revealing as they do an archaeologist's fantasy . . . it is all mere pretence," and then, when he balked at her suggestions, "The costumes are reminiscent throughout of Red Indian chiefs and still bear, along with their ethnographic absurdity, all the marks of provincial tastelessness" [Wagner, C. (1978–80) vol. I, 915, 917].

60. See Ashman (1992); Mack (1976). It is particularly telling to compare Appia's eventually influential response to Wagner: see now (with further bibliography) Carnegy (2006) 175–207.

61. Möhr (1876) 65.

62. Bennett (1877) 79. Bennett, whose reviews were first published in the *Daily Telegraph* in 1876, was one of the first critics to compare the *Ring* to the *Oresteia*. He did not like the spectacle of the *Rheingold* (97): "It is the vulgar bustle and glare of a pantomime 'opening.'" For a full range of audience response, see Großman-Vendrey (1977–83).

63. On the sets, see Baumann (1980); Bauer (1982); Mack (1976). On the costumes, see Zeh (1975).

64. Hegel (1975) II. 1057 writes, for example, "The story of Christ, Jerusalem, Bethlehem, Roman law, even the Trojan war have far more present reality for us than the affairs of the Niebelungs which for our national consciousness are simply a past history, swept clean away with a broom. To propose to make things of that sort into something national for us or even into the book of the German people has been the most trivial and shallow notion."

65. See Baumann (1980) 188–91.

66. Schama (1996).

67. Nonetheless, in the second act of *Rheinmaidens* at least, one critic did see "a serene Greek landscape"—the *Musikalisches Wochenblatt*, quoted by Srocke (1988) 77.

68. Porges (1880) 144.

69. Goldhill (2002) esp. 94–8. See Field (1981).

70. Hitler (1972) 17.

71. See Spotts (2002) 223–63, who singles out A. Kubizek (1954) as particularly egregious.

72. Wagner, N. (1998) 157. See also McGee (2000) 367 for a brief account of Winifred's relationship with Hitler, which started long before his rise to power: she provided him in prison with the writing materials with which *Mein Kampf* was composed. For a full and fine account, see Hamann (2005).

73. To Arno Breker, as recorded by Breker (1970) 123 and cited by Spotts (2002) 255.

74. "Strange to say, it was not considered that there could be a more honourable occupation than designing Wagner sets for Hitler's Bayreuth," quoted in Wagner, N. (1998) 107. There is an absolutely damning account of Wieland's engagement with Hitler and the Nazis, along with a stirring treatment of Winifred, in the excellent Hamann (2005).

75. Wagner, N. (1998) 236.

76. Ibid., 112.

77. Wieland Wagner, quoted in Wagner, N. (1998) 13.

78. Carnegy (2006) 290.

79. Zeh (1975) 87—words of a critic of the production.

80. It was Oliver Taplin who first told me the story of how Schadewaldt had cut off Fraenkel in 1934 before the war because Fraenkel was Jewish, and tried—and spectacularly failed—to regain his friendship after the war. Schadewaldt sent a gift of a book to Fraenkel with the inscription that he was *memor* of their former association. Fraenkel returned it with the two words *et ego*. See now Flashar (2005a), Flashar (2005b).

81. Wagner, N. (1998) 233. Her story of the New Festival is neatly told (233–59), though strongly colored by her ambivalent feelings about her parents. Spotts (1994) 200–247 preserves more distance.

82. One notable exception is Weiner (1995); compare Rose (1992) or the otherwise balanced Katz (1986), who do not mention Hellenism. Typical in (shocking) silence is Lee (2003). Weiner (1995) 16 gives a list of major Wagnerians of the twentieth century who ignore Wagner's anti-Semitism—where he notes the exceptional case of Zelinsky, and offers a history of the issue. Magee (2000) and Borchmeyer (1991) are paradigmatic when they keep their chapters on Greek tragedy and on anti-Semitism far distant from each other. Adorno (1981) is seminal here. The recent study of Foster (2010) is also sensitive on this issue.

## Chapter 5. For God and Empire

1. For Farrar's biography, see Farrar (1904).

2. *Spectator* (July 11, 1874) 886–87. See also *Quarterly Review* 138 (January, 1875) 177–206; *London Quarterly Review* 43 (October, 1874) 241–44; *The Athenaeum* (June 27, 1874) 856–58; *British Quarterly Review* 60 (July 1874) 281–83; Farrar replied briefly: Farrar (1875). "The terms 'florid' and 'exuberant' have been reiterated *ad nauseam* by every journalist," Farrar (1904) 194.

3. On street violence, see, from the political angle, Royle (2000); Wright (1988); Belchen (1996); McWilliam (1998)—each looking back to the seminal Thompson (1963). On religious violence, see especially Paz (1992), with the background in Arnstein (1992); Wheeler (2006); the Victorian discourse on crowds starts with le Bon in France (translated into English in 1896); Mackay (1841) has been suggested

to be the beginnings of English discourse on crowd psychology, but it is really an anthology of follies.

4. See especially John Keble and Isaac Williams *Tract LXXX* "Reserve in Communicating Christian Knowledge."

5. *The Athenaeum* (June 27, 1874) 857, 858.

6. The discussion of Strauss is extensive: see Harris (1973), Frei (1985), Larsen (2004) 43–58; and in a broad context Pals (1982) 19–58.

7. See Massey (1983), for the best account of the political reception of Strauss in Germany. In England, Strauss was published both in the *Poor Man's Guardian* and in a People's Edition, and was regularly cited in Free Thinking circles.

8. " . . . at any rate for the moment": Ruge (1886) I. 304.

9. Reimarus is particularly important; see, for example, Ziolkowski (2004) 67–71.

10. See Ziolkowski (2008) especially 93.

11. Pals (1982) 37.

12. Tulloch (1864) 3. Renan's influence will recur throughout this chapter, particularly with Mrs. Humphry Ward, Walter Pater, and Matthew Arnold.

13. See Pals (1982) 39–50.

14. Ibid., 47.

15. *The Month* 4 (June 1866) 564.

16. *Westminster Review* 102 (October 1874) 515.

17. *Athenaeum* (June 27, 1874) 857.

18. Farrar (1904) 302–12, a chapter entitled "Bread Upon the Waters."

19. For general background, see Turner (1975); MacKenzie (1984) 199–26; Richards, ed. (1989) (and Richards [1989]); Castle (1996); Holt (2008) (on flogging 113–56); and with a wider scope, Green (1980). The importance of Locke as a philosophical mentor behind the history of children's literature is beautifully articulated by Lerer (2008) 104–28.

20. Partial bibliographies can be found in Goodrich (1900); Faries (1923); Nield (1929); Kelly (1968).

21. For introductions to this huge topic, each with further bibliography, see Larsen (2004); Brown (2008); Hilton (1986); Wheeler (2006); Bebbington (1989); Sanders (1942); Vance (1985); Toon (1979); Jay (1986); Helmstadter and Lightman, eds. (1990); Snell and Ell (2000); and of course Chadwick (1966); see also later for further detailed treatments of particular topics.

22. Withrow (1883) 231.

23. Gray (1897). For a selection of other history books and novels on this theme, see Lysons (1860), (1861); Taylor (1859); Mercier (1886); Price (1876); Greer (1900); Wrey Savile (1861); Tucker (1880); discussed later on pp. 209–12.

24. On Pomponia Graecina, see pp. 209–12.

25. Gray (1897) xxxi, 32, xxxiv. Not all nationalist historians made such claims, of course: see, for example, Wright (1857) who has no problem with the standard story of Augustinian conversion and reaches (353) "the unavoidable conclusion that Christianity was not established in Roman Britain."

26. Henty (1893) 191–93. Shakespeare's *Cymbeline* lurks behind here—and contemporary models of Romanization; see Hingley (2008), especially 316.

27. Bernal (1987), (1991), (2001) most recently discussed, with bibliography of the criticisms, in Orrells, ed. (forthcoming).

28. Fundamental background and further bibliography in Turner (1981), Stray (1998), Stray, ed. (1998); Jenkyns (1981, 1991); Dowling (1994); Goldhill (2002)—with more general discussion in Rothblatt (1968, 1976); Roach (1991).

29. For the complexity of the Roman Empire as a model, see especially Vance (1997), Hingley (2000), and Sachs (2010), and further works cited in the following.

30. Macaulay (1826) 346.

31. See Jann (1985) 141–69.

32. Ward (1888) 411 [ch 32]. See also later pXXX.

33. Rubery (2009) has interesting and relevant remarks on the interaction of newspapers and fiction in this period.

34. On film versions of antiquity, see especially Wyke (1997); also Joshel, Malamud, and McGuire, eds. (2001); Cyrino (2005); Winkler (2004, 2006); Scodel and Bettenworth (2009); also Babington and Evans (1993) on biblical epics.

35. Goodrich (1900); Faries (1923); Nield (1929).

36. Wolff (1977); Levine (1968).

37. From Lukacs (1969) onward: see, for example, the English-speaking discussion of Victorian historical fiction: Chandler (1970); Fleishman (1971); Simmon (1973); Rance (1975); Sanders (1978); Shaw (1983); Chapman (1986); Orel (1995); Maitzen (1998); McCaw (2000).

38. Rhodes (1995) is the fullest treatment. See also Riikonen (1978). The short articles of Jenkyns (1995) and Turner (1999) are more critically satisfying, though each limits himself to a brief discussion of the most familiar novels.

39. Slee (1986) gives an institutional history; see also Jann (1985) 215–33.

40. As late as 1873, History was still part of the faculty of Law at Cambridge and had only two endowed posts (Slee [1986] 55–85).

41. Oliphant (1876) 636.

42. From a huge bibliography, see, for example, Parry (2006); Mandler (2006); Hall, McLelland, and Rendall, eds. (2000).

43. From a huge bibliography, see, for example, Bowler (1989); Jann (1985); Culler (1985); and with a more general theoretical perspective, Koselleck (1985, 2002); Fritzsche (2004); Lowenthal (1985).

44. From a huge bibliography, see, for example, Mellman (2007); Chandler (1970); Burrow (1981); MacDougal (1982); Smiles (1994); Girouard (1981).

45. On Gibbon and his reception, see Womersley (1997) (useful collection of primary sources); McCloy (1933); Womersley (2000); and the magisterial and exhaustive Pocock (1999–2005). Momigliano (1966) 40–55 sensibly uses German historiography to place Gibbon's work in a context.

46. Gibbon (1995) 470.

47. Ibid., 470 fn70.

48. See Farrar (1868).

49. Gibbon (1995) 510.

50. Ibid., II. 446–47; ch 16.

51. Acte, Eckstein (1889); Seneca, Westbury (1890), Eckstein (1889); Domitian's wife, Baring-Gould (1898); Antinous: Ebers (1881).

52. Gibbon (1995) 512.

53. Ibid., 577. This and the previous passage were particularly criticized in the eighteenth century by Chelsum, see Womersley (1997) 20–23; Womersley (2000) 23.

54. Excellent discussion in Bruce Mullin (1996). Edwin Abbott, broad church headmaster of City of London School, who wrote two novels of the early Roman Empire (Abbott [1878], [1882]), also wrote an attack on Newman on miracles (Abbott [1891])—a career that nicely parallels the more distinguished Farrar.

55. On healing, see Bruce Mullin (1996) 83–107.

56. Mrs. Humphry Ward *Robert Elsmere* (1901) 342 [ch 26]. She is, of course, of the Arnold family. . . . On *Robert Elsmere*, see also later pp. 189–90.

57. See Harris (1999), on which these comments on Lourdes are based.

58. Lasserre (1869), fascinatingly discussed by Harris (1999) 177–209, who also notes that the more critical work of Cros (who challenged the miracles) was not finally published until 1957.

59. For the lambasting, see earlier nn6 and 7; for the lampoon, see, for example, Whately (1819), a much republished pamphlet over the next forty years and more, which parodically used Straussian techniques to prove that Napoleon did not exist. Whately also published the standard textbook on philosophical logic, which added weight to his squib.

60. Bulwer Lytton (1834) xii, 307: page numbers are given from the 1905 Funk and Wagnall edition, illustrated by C. H. White.

61. On Bulwer's politics, see Snyder (1995).

62. Withrow (1883) 49–50.

63. *British Quarterly Review* 18 (1853) 160; Kingsley (1853) xi/xvi cites Gibbon both as "a sneerer" and as an authority; see Kingsley, vol. II, 156–59; Newman (1890) 126 (sermon preached May 27, 1832 in Oxford): "one of the masters of a new school of error"; and Newman disliked Millman's *History of the Jews* because of "the irreverent scoffing Gibbon-like tone" (Newman [1891] II: 299).

64. [Brown] (1843) 14—he acknowledges the copying in a footnote. Faries (1923), followed by Riikonen (1978), wrongly attributes the novel to one Ellen Pickering.

65. R. L. Edgeworth in a letter to the Board of Education (*Reports from the Commissioners of the Board of Education in Ireland, 1809–12* (reprinted 1813) third report, appendix 10: 109.

66. Niebuhr (1875) 2.

67. Ibid., 75.

68. Ibid., 81.

69. See Thirlwall (1936), a less hagiographic biography than many. Thirlwall was not an easy man to like: "The repellent picture of Thirlwall conceived by most of his clergy and by casual acquaintances is true—but incomplete," summarizes Thirlwall (1936) 170. For the connection between the evangelicals and the Jerusalem Bishopric, see Lewis (2010).

70. Barrow (1829) 8.

71. Hare (1829).

72. On Grote, see Demetriou (1999); Calder and Trzaskoma, eds. (1996); and the elegant, nicely old-fashioned biography of Clarke (1962); Momigliano (1952).

73. Freeman (1856) 172. On Freeman, see Momigliano (1966).

74. Turner (1981) 213–63. Grote's philosophical writing was less widely read—it was deeply discussed at the university level but never reached the audience of the histories. However, his combination of relativism and utilitarianism could easily be

seen as a challenge to Christian ethics: "In most instances a believer entirely forgets that his own mind is the product of a given time and place, and a conjunction of circumstances always peculiar, amidst the aggregate of mankind for the most part narrow" *Plato* II: 361. It was precisely a recognition of such historical contingency that led Robert Elsmere in Mrs. Ward's novel to doubt the stories of the early church.

75. Macaulay (1871) 7: 683.

76. Bulwer-Lytton (1852) 38.

77. Turner (1981) 212.

78. Ibid., 214.

79. Ibid., 215.

80. *British Quarterly Review* 18 (153) 126. Phillpotts was sufficiently nasty to justify such a remark: a belligerent, ambitious, Tory party hack, with a cruel streak. See the regrettably dull biography of Davies (1954) (who calls him the "mitred termagent" 385), which records his litigiousness in great detail. Phillpotts appears, thinly disguised, as Henry Grantley in Trollope's *The Warden*.

81. Burrow (1981) 39.

82. See Levine (1968); McKelvey (2000).

83. Macaulay (1828) 331–32, 365.

84. Ibid., 365.

85. Ibid., 367.

86. See the excellent McKelvey (2000) for general discussion and bibliography.

87. Macaulay (1842), preface to "Horatius."

88. *Lays of Rome* Preface.

89. See Gange (forthcoming) for discussion and bibliography, which extends the work of Turner (1981) 135–86.

90. Turner (1981) 142.

91. Pusey (1854) 62.

92. Withrow (1883) 38.

93. Church (1893) 522. Church, the former Professor of Latin at University College, London, became a prolific writer of historical fiction for children, as well as tales from classical texts. On the history and background of advice for female writers in periodicals, see Fraser, Green, and Johnston (2003) 38–39.

94. Saintsbury (1894) 410.

95. Matthews (1914) 26.

96. Lewes (1846) 35.

97. Ibid.

98. Allison (1845) 346.

99. Ibid., 341.

100. Stephen (1874) 241.

101. Stoddard (1900) 84.

102. For Scott's sales, see Bautz (2007), who is indebted to the seminal St. Clair (2004).

103. Saintsbury (1894) 329; Lewes (1846) 48.

104. Gibbon (1907) 304–5.

105. See Goode (2003) for discussion and further bibliography. For the historical development of the antiquary as a figure, see Levine (1986) and, in France, the less satisfactory Blix (2009) 28–47.

106. Brown (1980) is good on the eighteenth-century tradition of mocking anti-quaries in Scotland, as a background to this representation.

107. Goode (2003) 75. In general, see Ferris (1991).

108. Macaulay (1826) 323.

109. Hugo (1979) 1. 61. Blix (2009) ch 5 is good on the parallel French historical and fictional problem of making whole the fragments of the ancient record.

110. Collins (1850) preface.

111. Farrar (1892) 292.

112. Carlyle (1925) 79.

113. See for discussion and bibliography Goldhill (forthcoming), and the other essays in the volume Gange and Ledger-Lomas, eds. (forthcoming). See also Challis (2008); Hingley (2000); Gere (2009).

114. See Gange (2009) and Gange (forthcoming).

115. Harris (2003) 246.

116. Fowles (1977); Byatt (1990). For the best discussion, see Kaplan (2007) 85–118, who would add Faber (2003).

117. Archaeological metaphor is particularly strong in Freud, and in modernism, as Cathy Gere (2009) has brilliantly explored; and he bought a copy of the Gradiva frieze for his office, after writing this essay. In his essay, Freud does seductively re-call how he too had once thought a woman, a patient, was a dead woman *rediviva* (Downey [1993] 248), a temporary delusion like Hanold's. But there is more self-aggrandizement than self-analysis in Freud's essay.

118. Freud *SE* 9: 7–95. Jensen and Freud are usefully paired in Downey (1993).

119. Gautier (1914) 216. For Gautier in context, see the scattered comments in Blix (2009). Gautier's ballet criticism was obsessed with classical Greek bodies in a way that anticipates *Gradiva*: see Clark (2001).

120. Hofmannsthal (1952) 180–81, discussed further in Goldhill (2002) 144–45. "The ancient world is a particularly good ground for finding ghosts," comments Evangelista (2009) 81 on aestheticism's interest in classical ghosts.

121. Gautier (1914): "I feel like quoting Latin, as they do in the newspapers."

122. See Stray (1998); Stray, ed. (1998); Dowling (1994); Goldhill (2002) 178–245.

123. Church (1893) 521.

124. Bulwer Lytton (1834) preface.

125. Ibid.

126. Ibid.

127. *Westminster Review* 83 (1865) 490.

128. See Stanley (1990); Thorne (1999); Porter (2004); and on Palestine specifically, Tibawi (1961); Perry (2003). I have discussed the gap between missionary self-representation and their activities in Jerusalem in Goldhill (forthcoming b).

129. Mrs. Humphry Ward to Mandell Creighton March 13, 1888, a letter published in Peterson (1970) 591. See also Lightman (1990). On Mrs. Humphry Ward, see the excellent Sutherland (1990).

130. Newman (1983) 132: Much of Section V, from which this is taken, is concerned with the relation of antiquity and the *via media* of Newman's religious position before his conversion to Rome.

131. Mrs. Humphry Ward, quoting another correspondent to her friend, Mere-dith Townsend: Petersen (1970) 592. An American liberal nicely defined her book

as an "antidote to *Ben Hur*," on which, see the following pp. 215–18 (Petersen [1970] 593).

132. For vicars voting on compulsory Greek, see Raphaely (1998).

133. Collins (1850) 243.

134. See Pearl (2010) for general introduction and bibliography, which replaces, for example, Davies (1955); see also Colbert (1997) for the connection with art; Hartley (2001), for the technical treatises; Tytler (1982) discusses the long influence of Lavater in the novel but surprisingly does not mention race; Eastlake (1852) gives a useful snapshot of the *status quaestionis* from mid-century.

135. Franklin (2003) notes the importance of Arnold *pere* but does not explore it.

136. The plot of *Phra* enacts a desideratum of Gibbon (ch xxxiii): "If it were possible, after a momentary slumber of two hundred years, to display the *new* world to the eyes of a spectator who still retained a lively and recent impression of the *old*, his surprise and his reflections would furnish the pleasing subject of a philosophical romance."

137. Arnold (1890) 57, 242. Anticipating much modern criticism, Phra comments (340): "Vague fancies began to form within my mind and . . . began to egg me on *to write myself*."

138. Ward (1918) 167.

## Chapter 6. Virgins, Lions, and Honest Pluck

1. Brown (2004) 34.

2. Quoted in Moneypenny and Buckle (1910–20) V: 348.

3. Mitchell (2003) states that Bulwer himself vainly claimed to be "perhaps the vainest man who ever lived," but the reference he gives is wrong and I have been unable to trace this remark in Bulwer's writing.

4. Ray (1945–46) III: 181.

5. Thackeray (1834) 725.

6. Oddly, Rosina called him "pupps" in her letters (when fond), and he signed himself as "puppy" to her "poodle."

7. [Kingsley] (1850) 111.

8. See for a brief typical satire Mrs. Bulwer Lytton (1838); also Lytton, R. (1994); Lytton, R. (1839); for the row, see Devey (1887); Lytton, V. (1948); Mitchell (2003); Cobbold (2004).

9. *Westminster Review* 83 (1865) 479, 468. Another, really vicious review in *Fraser's Magazine* 16 (1837) 347–56; [Donne] (1838), worthy, dull, long review; [Sandford] (1837) largely in praise, but concluding (177): "Mr Bulwer is not yet *talented*."

10. *Athenaeum* (February 26, 1842) 182.

11. Leavis (1932) 164.

12. Kingsley (1850) 111.

13. Dedicatory Epistle to *Zanoni* (1845), discussed by Brown (2004) 33. See also Schor (2004) for Bulwer on the Public.

14. Oliphant (1855) 223.

15. And *contra*: "The *philosophy* of Mr Bulwer will, on enquiry, be found quite as far from truth and probability as the wildest fiction of Romance" Thackeray (1834)

725; "In almost all his novels there are one or more gentlemen with a morbid propensity for apostrophizing the heavenly bodies, and talking sham philosophy about the true and the beautiful": *Cornhill Magazine* 27 (1873) 350.

16. Ruskin (1893) 34: This is a piece of rather embarrassing juvenilia. Bulwer's writing are said to be (32) "full of an entangled richness of moving mind, glittering with innumerable drops of rosy and balmy and quivering dew, instinct with a soft, low, thrilling whisper of thought" (and so on).

17. Ruskin (1956–59) I: 82. *Modern Painters* was published only three years later.

18. Briullov's painting *Last Days of Pompeii* was a particular hit in Rome at the time.

19. Bulwer Lytton (1834) 3.

20. Ibid., 24.

21. Ibid., 19.

22. Ibid., 540.

23. Ibid., 540.

24. Ibid., 541.

25. Ibid., 541.

26. Ibid., 541.

27. Ibid., 51.

28. Ch 8, 134.

29. Ibid., 1. A potential counter example is the famous sentry who never left his post, a Victorian fantasy that spoke to ideals of duty: see Behlman (2007).

30. Ibid., 16.

31. Ibid.

32. Ibid., 176.

33. This quotation is from Gerald Massey's 1881 poem "Ancient Egypt." There was in the last decades of the nineteenth century—despite Martin Bernal's claims—already an active movement which saw Egypt in particular as the origin of Western culture, especially among spiritualists like Massey (who started life as the son of a boatman and left school at eight, only to rise through his poetry and his friendship with F. D. Maurice, before becoming something of a social outcast as a Druid and a spiritualist).

34. Bulwer Lytton (1834) 51.

35. Ibid., 174.

36. Ibid., Bk 2, ch 8.

37. Ibid., Bk 2, ch 8 [133].

38. Ibid., 308, 350.

39. Ibid., 141.

40. See Taylor (1834), who had a significant influence on Darwin, and thanks to David Gange for the story of Oakham Gaol.

41. Ibid., 202.

42. Ibid., 202.

43. It is not therefore easy to agree with Turner (1999) 175 "Within the novel there was nothing problematic about the Christian faith itself."

44. Bulwer Lytton (1834) 309.

45. Bk 4, ch 4 [253].

46. Bk 4, ch 4 [254].

47. Jenkyns (1995) 143.

48. Bulwer Lytton (1834) 210. There is a high philosophical tradition (Hume is perhaps the most relevant predecessor) making a similar claim about unchanging human nature.

49. Ibid., 134.

50. Ibid., 135. See also Schor (2004).

51. Bulwer Lytton (1834) 543. On Spurzheim, see Colbert (1997), Davies (1955), Hartley (2002), Pearl (2010)—discussed in relation to Bulwer in Goldhill (forthcoming b) with further bibliography.

52. See Goldhill (forthcoming b)

53. Ibid., 198.

54. [Brown] (1843) 16.

55. Turner (1999) 174. See also, from an extensive bibliography, Arnstein (1992); Bebbington (1989); Chadwick (1966); Helmstadter and Lightman, eds. (1990); Hilton (1986); Larsen (2004); Paz (1992).

56. Newman (1868) x.

57. Gibbon (1995) 945–46.

58. See Prickett (2000); Dorman (1979); Downes (1972). For broader discussion of Kingsley's life and works, see ch. 7.

59. Kingsley (1853) preface xiv [page numbers from 1895 pocket edition].

60. Ibid., xii.

61. Ibid., xiv.

62. Ibid., xii.

63. Ibid., xiii, my emphasis. This view of the Teutons was widespread in the mid-century, but, as MacDougall (1982) 129 nicely notes "Not much was heard in England about Teutonic excellence after World War 1." Lincoln (1999) is good on the background here; also Young (1995); Olender (1992); and, from a French perspective Todorov (1993).

64. Collins (1850) 370, 371. On the barbarian as a trope in French political thought in the nineteenth century, see Blix (2009) 216–26.

65. Ibid., 50.

66. Kingsley (1853) preface xiii–xiv.

67. See Brown (2008).

68. Kingsley (1853) preface vii.

69. Ibid., xvi.

70. Ibid., xv.

71. Ibid., ch 30: 476.

72. Ibid., preface xiv.

73. Ibid., xv.

74. See Chitty (1974); Prickett (1996); Lankewish (2000); Maynard (1993).

75. Turner (1999) 179.

76. See Hyamson (1971). General background in Bar-Yosef (1998); Goldhill (forthcoming a).

77. Kingsley (1853) ch 27: 425.

78. See Offelman (1986).

79. Kingsley (1853) ch 27: 424.

80. Wiseman (1854) 152.

81. Ibid., 235.

82. Ibid., 236.

83. Ibid., 217.

84. See Litvack (1993).

85. Newman (1855) 359–60.

86. Ibid., 360.

87. On Lysons senior, see Hingley (2008) 247–54.

88. Lysons (1860) 20. This is based on Tacitus *Annals* xiii 32.

89. Mercier (1886).

90. Grover (1867) 221, 223; see also Grover (1868). He is arguing against Wright (1857) 356.

91. See, for example, Charles (1869) 21. For the archaeological background, see Hingley (2008) 147–48, 247–54. Wright (1857) 353 coolly noted Tertullian's rhetoric for what it is.

92. See, for example, Church (1903); Sienkewicz (1897); Farrar (1892); Webb (1904); de Mille (1867).

93. See Henry (1789) 124—the historian cited by Scott, see earlier p. 180.

94. Henderson (1903) 344.

95. Poste (1853) 393–95.

96. Prichard (1854) 302–4; Williams (1844) 60.

97. Ruskin (1894) 91–93: Ruskin cites Henry (1789).

98. Timpson (1849) 14; Edmondson (1913) (the Bampton Lectures at Oxford); Williams (1848) 51–53 (sympathetically reviewed in *Blackwoods* (1849) 487–90); Hassell (1872) 34 (from an evangelical missionary perspective); Howorth (1885) 131–32 (better known as a geologist, of course, but a serious historian, too); Bigg (1905) 107–8 (also lectures at Oxford). Carpenter (1900), from the center of the church hierarchy, does not mention Pomponia, but does suggest that "we must think . . . of our British ancestors as largely Christian" 8.

99. Conybeare and Howson (1860)—the seventh edition—vol. 2: 474 and 484–85; Lewin (1890)—the fifth edition—vol. 2: 243, 392–97. Lewin, who wrote the standard work on trust law, also argued that Claudia was the daughter of Cogidunus, and must have been the ward of Pomponia.

100. Harnack (1878) 263. The same piece is reprinted in *Dickinson's Theological Quarterly* 4 (1878): 573–97.

101. Lampe (2004) 196.

102. Conybeare (1903) 257 (my italics)—an SPCK volume; this is not F. C. Conybeare, the professor of theology at Oxford, but the (other) theologian J. W. Conybeare who published standard commentaries on Paul, and well received essays and sermons.

103. Giles (1847) 194–96.

104. Alexander (1853) 105–7—a book for the Religious Tract Society.

105. Rhodes (1995) 138.

106. Kingsley (1864b) 217. The accusations of Catholic willing immorality with regard to truth-telling/lying were a commonplace of the popular "escaped nun's" narrative, and an association with such popular polemics may have helped fuel the disagreement of Kingsley and Newman: see Griffin (2004).

107. Letter in Trinity College Library, cited by Thirlwall (1936) 203. By contrast, Thirlwall himself, Hare's friend, wrote in retrospect many years later, that

Newman's "craving for truth was strong in proportion to the purity of his life and conscience" Thirlwall (1936) 207.

108. *Saturday Review* (April 9, 1864): 446.

109. *Nation* (September 14, 1867).

110. Eliot (1856) 457. The contrast between missionary rhetoric and missionary success is well examined by Tibawi (1961), Stanley (1990), Thorne (1999), and Porter (2004)—and already recognized in the extraordinary novel of Rickett (1893) ch 1: "Paul admitted to his own heart that little real work had been done, but he wrote his report and made up the statistics."

111. Webb (1891) 33. Tucker (1880) has a similarly crass tale of Druid conversion; see also Sedgwick (1904); Spurrell (1904); [anon] (1843); Crake (1876) (with the historically later tale of Crake [1889] and its textbook support of Crake [1888]—a typical career of history/fiction/children's books).

112. Charles (1856) 29 [reprinted in New York, 1865].

113. Henry James worrying about Charles's depiction of Wesley wrote in *The Diary of Kitty Trevelyan*: "We are all of us Protestants, and we are all of us glad to see the Reformation placed in its most favourable light, but as we are not all of us Methodists, it is hard to sympathize with a lady's *ex parte* treatment of John Wesley. Our authoress does not claim to be more than superficial, and it were better not to touch Methodism at all than to handle it superficially." *Nation* (September 14, 1867).

114. Coleridge (1903); also Dennis (1992) 183, of *The Heir of Redclyffe* specifically: "imbued with Tractarian principles."

115. *The Christian Year* sold nearly 300,000 copies.

116. (1833) 135 (not in praise).

117. Anstice published in the 1830s, but died young (1808–36). He was still being read in the 1890s, as Housman testifies, writing to Pollard, October 25, 1890: "I don't think I admire your fluent friend Anstice as much as you do." Earlier praise for Anstice: *Athenaeum* (1833) 789.

118. Purcell (1957); see also Baring-Gould (1923, 1925).

119. Crucial background to this remark in Levine (1986).

120. Baring-Gould (1888) vi.

121. Baring-Gould (1925) 227.

122. Purcell (1957) 118.

123. He published the story of its writing several times himself, and it is told most amusingly by McKee (1947) 166–67: see *The Youth's Companion* (February 2, 1893) 57, "I had no convictions about God or Christ"; also *Harper's Weekly* (March 6, 1866); *Detroit Journal* (October 10, 1885); *Syracuse Journal* (April 2, 1903).

124. Nonetheless, *Ben Hur* took a while to become a success. In the first seven months, it sold only 2,800 copies, and was roundly criticized by almost all the reviewers who noticed it: "I protest as a friend of Christ, that He has been crucified enough already, without having a Territorial Governor after Him." Cited in McKee (1947) 172, with other remarks, 172–73. Wallace was Governor of New Mexico when *Ben Hur* was published.

125. The figure of 20,000,000 (scarcely believable), based on box office receipts, is offered by McKee (1947) 180–88, along with the anecdote of the race in Boston.

126. Wallace (1880) 428.

127. Ibid., 64.

128. Ibid., 130.

129. Ibid., 65.

130. Ibid., 205, 206.

131. Ibid., 73.

132. Ibid., 279.

133. Ibid., 97.

134. My translation. For the problems of this verse, see in general Kermode (1979).

135. Wallace (1880) 406.

136. Mathew 27.48; Mark 15.36; John 19.29.

137. Wallace (1880) 422.

138. Farrar (1874) 629.

139. See earlier n133.

140. It is odd that Culler (1985) 262 calls *Marius the Epicurean* "one of the last" of these novels; even odder that Simmons (1973) 61 calls Kingsley and Newman "the tail end of one tradition, the final playing out of a cycle going back in somewhat different form to the Waverly novels."

141. See Duclaux (1925) 351; Culler (1985) 261–70.

142. For the variety of autobiographical form and its discussion in Victorian prose, see Fleishman (1983) and Saunders (2010).

143. Pater (1885) II, 224. The chapter is entitled "Anima Naturaliter Christiana." See Dahl (1973).

144. Exemplary reflections are to be found in Benson (1906) 89–116, who is good on the relation between the "languid, highly perfumed, luscious, over-ripe" prose (113) and the "introspective, even morbid" (110) "personal, almost autobiographical impress" (91) of the novel. See also Williams (1989), who in an excellent discussion slips into performing the doubt; "Marius becomes a Christian at the end of the novel" (180); "At his death, he is no converted Christian" (232). See also Bloom (1971a) 193–94; Evans (1973) 344–51.

145. As recorded by his tutor, Cape, cited in Culler (1985) 261.

146. Pater (1885) II, 110.

147. Ibid., 113–14.

148. Ibid., 114.

149. Ibid., 118.

150. Ibid., 117.

151. Ibid., 126. Cf. Baring-Gould (1888).

152. See Williams (1989) 191.

153. Bloom (1971a) 188; Williams (1989) 179.

154. Williams (1989) 180–81.

155. Ibid., 193.

156. Peterson (1986) and especially Evangelista (2009). I have benefited from discussions with Yopie Prins and Stefano Evangelista on this.

157. Pater (1885) I, 56.

158. Ibid., 92.

159. Ibid., 93.

160. See Scodel and Bettenworth (2009).

161. Sienkiewicz (1897) 1–2.

162. Ibid., 229. Sienkiewicz, a Polish nationalist, in his novel *The Knights of the Cross* is strongly anti-Teutonic, which may help explain why this view of the fat Germans is so different from the standard picture, based on Tacitus, of German physical prowess. Both Lygia and Ursus come from an area of Eastern Europe associated with ancient Poland.

163. Sienkiewicz (1897).

164. Fararr (1892) 499.

165. Wiseman (1854) 108.

166. See Behlman (2007).

167. Henty (1893) 175.

168. Stobart (1912) 3.

169. Locke (1878) 9.

170. Henty (1893) 383. This must slightly qualify MacKenzie's judgment (1984) 211: "He condemned miscegenation" (true though it is where Africa and Asia are concerned).

171. Henty (1893) 383. An interview in *Home Messenger* 12 (1903), cited in Arnold (1980) 20.

172. On the ancient sources for Vestal Virgins, see Beard (1980) with Beard (1995).

173. Farrar (1892) 283.

174. Davis (1900) preface 6. See also Sienkewicz (1897) 415.

175. See Elsner and Masters, eds. (1994).

176. Gibbon (1995) 530; and Renan (1873) 158–59, who (n5) doubts any religious jealousy between Poppaea and Acte, on the grounds that Acte's Christianity cannot be proved—but his suggestion of a rivalry between Acte and Poppaea occurs in several novels. Cf. 545 for Renan's anti-Semitism is full flight. Both Gibbon and Renan base their remarks on Josephus *de vit. sua* 13-6 and *Ant. Jud* 20: 189–96, who notes that through the intercession of Aliturus, a Jewish actor, and Poppaea, some Jewish priests were released. On the sources, see Smallwood (1959). Perowne (1958) 104, who had been involved in the British Mandate administration in Jerusalem, is typical of continuing misplaced certainty when he declares that Poppaea "was known to be favourable to Judaism, of which she may well have been a secret adherent." Perowne's father (who edited Thirlwell's papers) and grandfather were each Bishop of Winchester, and he had an evangelical background (though he was gay and had a *mariage blanc* with Freya Stark). For Poppaea called a Jew in standard theological commentaries, see (for example) Lewin (1890) 242, a view supported by Conybeare and Howson (1860).

177. Eckstein (1889) I, preface i.

178. Ibid., II, 284.

179. The rather poor critical studies of Renault have all focused on her sexuality at the expense of her sense of history: Wolfe (1969); Dick (1972); Huberman (1997) 73–88; as does her biography, Sweetman (1993).

180. See Hopkins (1983) 1–30; Barton (1993); Wiederman (1992); Kyle (1998). Augustine *Confessions* VI, viii (13) for Alypius.

181. On literary crowds, see the rather thin Plotz (2000); Barrows (1981); on historical background: Richter (1981); Rudé (1981), each with extensive bibliogra-

phies to what has become a major topic in social history, as well as social psychology from Le Bon and Canetti onward.

182. *Childe Harold* Canto 4, 141.

183. On Byron's influence on popular classicism, see Roessel (2002).

184. Sienkwewicz (1897) 497–501.

185. Surprisingly, the novels of Whyte Melville might have a frisson of impropriety, which the ancient world could so easily cultivate: Elizabeth Johnes, the young epistolary *inamorata* of the old Thirlwall, wrote privately, "I happened to mention the *Gladiators*, for instance, in company with Whyte Melville's other novels, and no less than four people held forth on it being questionable reading." Thirlwall (1936) 170.

186. See especially Arnold (1980); also Turner (1975); Mackenzie (1984) 199–226; Eldridge (1996).

187. Henty (1884) 11.

188. White (1918) 56, 62.

189. Plutarch *Numa* 10.4.

190. White (1918) 108. This may be an echo of *Jane Eyre*: "if she struck me with that rod, I should get it from her hand; I should break it under her nose."

191. Ibid., 105.

192. Compton-Rickett (1893) ch xv, a book read mainly as an example of how Darwinism fostered novels such as *Tarzan*, within, that is, the history of colonialism and science fiction. Compton-Rickett was a Liberal MP who also wrote *The Christ That Is To Be: a Latter-Day Romance*.

193. White (1918) 175. See Koven (2006).

194. On Ebers, see Fischer (1994); also Marchand (2007).

195. On German Orientalism, see Lincoln (1999); Marchand (2009); Irwin (2006); on German political involvement, Trumpener (1968) and in particular Schöllgen (1984) which remains essential; see also Pick (1990); Scheffler (1998); Hagen (2004); Anderson (2007); McKeekin (2010); with Müller (1991) for the endgame.

196. Ebers (1881) II, 167, 175.

197. Ibid., 289.

198. Ibid., 287.

199. See Waters (1995) for a context for this. Lankewish (2000) is too thin to be persuasive.

200. Hausrath (1880) 220.

201. Ibid., 222.

202. Ibid., 253.

203. Ibid., 359.

204. Cheyette (1993) is standard on the literature. But see also Bar-Yosef (1998); Goldhill (forthcoming a) on engagement with the Holy Land itself.

205. Withrow (1883) 136.

206. Westbury (1890) II, 120.

207. Withrow (1883) 191.

208. Whyte-Melville (1863) 102.

209. Herring (1861) 5.

210. Ibid., 26.

211. Gaskell (1997) [1857] 272. It is part of Gaskell's agenda to emphasize this wish, a fact perhaps not appreciated sufficiently by Gerin (1967) 367 and Fraser (1988) 307–8, and certainly not by Gordon (2008) 192–200.

212. *Don Juan* 11.57.

213. Croly (1822) v–vi.

214. Croly (1848). Gosse, who never quite understood why he was made each night to pray for the restitution of Jerusalem to the Jews, recalls that Croly was the one novelist his fiercely evangelical father remembered with pleasure, before all novels were banned in the house, but that his mother refused even to open such a work of fiction: Gosse (2005) [1907] 27, 44–45.

215. Croly (1837) 6—a pamphlet that announces it has gone into 17,000 copies. Oddly, Ruskin early on also seemed to think that "the source of evil is the Emancipation Act of 1829" according to Culler (1985) 163.

216. Croly (1901) 551, 552.

217. Croly (1828) I, 66.

218. Ibid., III, 394; II, 180.

219. Ibid., I, 214.

220. See for example: Webb (1841) (another "last days" title); Brewsher (1875); Henty (1888); Farmer (1895); Kingsley, F. (1905); Miller (1908). See for some discussion, Burstein (2003) 333–342.

221. Cited Bullock (1940) 115.

222. Masters (1978) 169. Federico (2000) 162–86 is good on the reception of Corelli.

223. Pre- and post-doctoring images in Federico (2000) 14–52; wonderful publicity picture of her with the Stratford on Avon Boat Club in Bullock (1940) 137. [Stuart-Young] (1906) 680 called her "The greatest genius of self-advertisement produced by our century."

224. Full details in Masters (1978), whose work is essential despite being not particularly sympathetic to his subject; Bullock (1940) is hamstrung by not discussing her relationship with Bertha Vyver (who was still alive); Ransom (1999) offers rather naïve support for Corelli; far more nuanced and interesting is Federico (2000), who correctly analyzes the continuing gender bias in writing on Corelli.

225. Cited from *The Sunday Times* in Masters (1978) 8. See [Stuart-Young] (1906) for a good example of published hostility at the time: his mixture of sexism, snobbery, and personal attack is typical of the criticism of Corelli.

226. See, for example, Adcock (1909) for published lionization.

227. West (1928) 321.

228. Taken in this case from [Stuart-Young] (1906) 681.

229. Cited by Masters (1978) 144. Father Ignatius, a charismatic lecturer, was an eccentric—and a nightmare for those who opposed the Oxford Movement. A Protestant, Benedictine Monk, he lectured to raise funds for his monastery in Llanthony, Wales. He became a *cause célèbre* when he was prosecuted, successfully, for kidnapping, after a young man came to his monastery for comfort and spiritual guidance. There are two hagiographic biographies that revel in his combination of "Gothic Revival, Oxford movement, Romanticism, Evangelicism and neo-Medievalism": Attwater (1931) [citation from 11]; the Baroness de Bertouch (1904). Calder-Marshall (1962) is more critical.

230. Corelli (1894) 154.

231. Benson (1940), cited in Masters (1978) 13, and used as an epigraph by Federico (2000).

232. See Wallis (1993) 171–82; Feldman (1994) 48–71; Burstein (2003).

233. Corelli (1894) 57.

234. Ibid., 55, 78, 237. For the background, see Cheyette (1993), and especially Heschel (2009).

235. Renan (1864) 206–7. Arvidsson (2006) 107 argues that Renan was not motivated by anti-Semitism, although he was racist and wrote phrases that "resound with pure anti-Semitism." Unfortunately, he tries to argue that Renan couldn't be anti-Semitic because he worked with Jews. Todorov (1993) is more nuanced about the place of Renan in French thinking on race. Tal (1975), especially 279–89 on Chamberlain, gives good background for the effect of Renan on German thinking; see also Olender (1992); and more generally Lincoln (1999) for the connections between racial thinking and philology. Césaire (1972) 16 is characteristically sharp when she quotes a paragraph and comments: "Hitler? Rosenberg? No, Renan."

236. Tal (1975) 277. Renan (1864) 96 had argued: the "North [Galilee] alone has made Christianity"; on Renan and geographical determinism, see Moxnes (2001).

237. A 1940 catechism cited by Heschel (2009) 127. Grundmann, a major player in the Aryan Jesus movement, claimed Mary was not a Jew and that Jesus's father was a Roman named Panther (an old Rabbinic slur): Heschel (2009) 155.

238. Chamberlain (1911) I: 211.

239. Brilliantly uncovered by Heschel (2009) with full bibliography.

240. Corelli (1894) 188–89.

241. Ibid., 183.

242. Gosse, cited in Bullock (1940) 75.

243. Felski (1995) 115–44 (citations from 120, 132, 143)—one of the best studies of Corelli, though it does not treat *Barabbas*.

244. Interestingly debated in Cheyette and Marcus, eds. (1998); Cheyette and Valman, eds. (2004); and Feldman (1994)—each with an extensive bibliography to a much discussed issue.

245. Arnold (1968) 199, which echoes Renan (1896) 64: "A race, incomplete by its very simplicity, having neither plastic arts, nor rational science, nor philosophy, nor political life, nor military organization." For Renan's influence on Arnold, see Faverty (1951) 169. On Arnold's German sources, and a good discussion of philhellenism and anti-Semitism, see Grossman (1994).

246. I have learned a great deal here from Miriam Leonard, whose book on the topic is forthcoming.

247. First published in a short-lived journal called the *Anglo-Saxon* in 1850, and much cited since, perhaps most tellingly by Appiah (1992) 47. For his association with Kingsley, see Martin (1960) 193.

248. See Vance (1997); Hingley (2000); Sachs (2010); Mills (1856) xxi stands out from the crowd when he insists that Greece "afford[s] no basis of comparison on which any practical political inferences, either to condemn or to justify our present system, can be reasonably founded" and Rome "affords a precedent still less applicable." He is writing specifically on colonialism, and the need to dismiss the power of the classical precedent is also testimony to its status as commonplace. Bell (2006)

makes an interesting but finally unconvincing argument to distinguish between proponents of greater Britain and other theorists.

249. Bell (1958) 137; Stephen (1893) 353. See Betts (1971); Taylor (1991) 13.

250. Lukacs (1978) 88, where the translation is "abandoned by God"; the more often cited version is taken from Watt (1957) 84. Since the work in particular of Tucker (2008) and also Dentith (2006), it is impossible to maintain the triumphalist account of the rise of the novel (based on Hegel) that Lukacs and Bachtin both offer, at least to the degree that it depends on the disappearance of epic and the idea of the epic as dependent on a single, coherent world picture—a view that modern scholars of Virgil, Milton, and many other epic poets have fundamentally challenged.

## Chapter 7. Only Connect!

1. For a representative sample of work, each with further bibliographies, see Gagnier (1991); Amigoni (1993); Amigoni, ed. (2007); Peterson (1986); Fleishman (1983); Marcus (1994); Gay (1995); Broughton (1999); Homans (1986); Corbett (1992); Vincent (1981); and especially Saunders (2010).

2. Gosse (1901) 195.

3. Benson (1930) 97.

4. Carlyle (1925).

5. Carlyle (1830) 62, (1993) 26; Emerson (1841) 153; Freeman (1864) 10.

6. Fleischman (1983) is still useful on the variety of autobiographical forms and their bad faith, disavowals, and self-deceptions.

7. See, for example, Broughton (1999) 83–172, with further bibliography.

8. Gosse (1962) [1903] 104; Crichton-Browne (1903) 1498.

9. Crichton-Browne (1903) 1498: He goes on (1501) to call Carlyle "every inch a man," and to ask "Is the splendid virility of his writing to count for nothing?" which testifies to the worry of Broughton (1999) about exactly what is at stake in this debate about impotence.

10. Lee (1911) 10. On Lee, see White (1984). Woolf is typical of the "new biography" in her self-justifying scorn at "the Victorians."

11. Stanfield (1813); Stephen (1898–1902); Goss (1901, 1962); Lee (1911); Nicholson (1924); see Altick (1965); Marcus (1994). Dilthey and Misch are particularly important for the German case, and, fascinatingly, Misch (1907) was translated into English as late as (1950): see Marcus (1994) and Guthenke (forthcoming). I have discussed these issues to my great benefit with Constanze Guthenke.

12. Collini (1991) 195.

13. Booth (1991) 41.

14. See in particular Vincent (1981) for the English sources.

15. See Shuttleworth (1996) with Taylor and Shuttleworth, eds. (1998).

16. Goodbrand (1870) 20. He does of course know of Plutarch.

17. Dilthey (Rickman, ed. [1976]: 213) more sensibly lists Augustine, Rousseau, and Goethe as typical examples of autobiography as reflection on life.

18. Wilamowitz (1972) [1907] 123–24; on which, see Guthenke (forthcoming).

19. Cited in Martin (1959) 108.

20. Momigliano (1966).

21. Representative—but in no way should either man be regarded as a "typical Victorian" as Martin (1959) 15 calls Kingsley.

22. Kingsley (1877); Pope-Hennesy (1949); Martin (1959); Chitty (1974); Klaver (2006) are the most important contributions, the latter two with extensive bibliographies.

23. Kelly (1907) 38, 42.

24. Martin (1959) 120.

25. Cited Chitty (1974) 55–56.

26. See Vance (1995). Muscular Christianity was also linked to Carlyle's philosophy: "Does Mr Carlyle recognize the Philosophy of Force dressed up by Mr Kingsley?," Leslie Stephen *Tait's Edinburgh Magazine* 25 (1858) 100.

27. Cited in Chitty (1974).

28. Martin (1959) 109.

29. Gaskell (1997) 367.

30. Reprinted in Kingsley (1877).

31. Kingsley (1855a) 157.

32. Pope-Hennesey (1949) 2.

33. Kingsley (1855a) 34.

34. Ibid., 35–36.

35. Freeman (1864) 446–47. On Freeman, see Momigliano (1970) 197–208.

36. Kingsley (1850b) 34.

37. Farrar (1904) is the only biography.

38. Farrar (1904) 47.

39. Kelly (1907) 43–44.

40. Farrar (1892) vi.

41. Farrar (1895) 265.

42. Ibid., 482.

43. Ibid., 506.

44. Wordsworth (1878); Cosens (1878); Lowry (1878); Goodfellow (1878); Endean (1878); [Anon] (1878); also Harvey (1883); Tomlinson (1895)

45. Pusey (1880).

46. Farrar (1878) 78.

47. Farrar (1904) 268.

48. Cited Farrar (1904) 277.

49. The reminiscences of Edwin Arnold, father of the author of *Phra the Phoenician*, reprinted in Farrar (1904) 26–35.

# BIBLIOGRAPHY

❀ ❀ ❀ ❀ ❀ ❀ ❀ ❀ ❀ ❀ ❀ ❀ ❀ ❀ ❀ ❀ ❀ ❀ ❀ ❀

Abbaté, C. (2001) *In Search of Opera*, Princeton.
Abbott, E. (1878) *Philochristus: Memoirs of a Disciple of the Lord*, London.
—— (1882) *Onesimus*, London.
—— (1891) *Philomythus, an Antidote against Credulity: a discussion of Cardinal New-man's Essay on Ecclesiastical Miracles*, London.
Acton, W. (1873) *The Functions and Disorders of the Reproductive Organs*, London.
—— (1968) *Prostitution*, ed. P. Fryer, London [orig. London, 1857].
Adams, B. (1977–78) "Painter to Patron: David's Letters to Youssoupoff about the *Sappho, Phaon, and Cupid*," *Marsyas* 19: 29–36.
Adcock, A. (1909) "Marie Corelli: A Record and an Appreciation," *Bookman* 26: 59–78.
Adorno, T. (1981) *In Search of Wagner*, trans. E. Livingstone, London.
Alexander, W. L. (1853) *The Ancient British Churches, being an Enquiry into the His-tory of Christianity in Britain prior to the Establishment of the Heptarchy*, London.
Allison, A. (1845) "The Historical Romance," *Blackwood's Edinburgh Magazine* 58: 341–56.
Alm, I. (1996) "Pantomime in seventeenth-century Venetian theatrical dance" in Morelli, ed. (1996).
Altick, R. (1965) *Lives and Letters: A History of Literary Biography in England and America*, New York.
Amigoni, D. (1993) *Victorian Biography: Intellectuals and the Ordering of Discourse*, Hemel Hemsptead, UK.
——, ed. (2006) *Life Writing and Victorian Culture*, Aldershot, UK.
Anderson, M. L. (2007) "'Down in Turkey, far away': Human Rights, the Armenian Massacres, and Orientalism in Wilhelmine Germany," *Journal of Modern History* 79: 80–111.
Anderson, W. (1965) *Matthew Arnold and the Classical Tradition*, Ann Arbor, MI.
Angiolini, G. (1783) *Lettere di Gasparo Angiolini a Monsieur Noverre sopra i balli pan-tomimi*, Milan.
—— (1996) "Preface to 'Le Festin de Pierre,'" in Gluck (1966).
[anon] ["the translator of 'Margaret or the Gold Mine'"] (1843) *The Priestess, an Anglo-Saxon tale, or The Early Tales of Christianity in Britain*, London.
[anon] (1873) "The Late Lord Lytton as a Novelist," *Cornhill Magazine* 27 (1873): 345–54.
[anon] (1878) *Eternal Punishment: a Critique on Canon Farrar's "Eternal Hope,"* London.
Appiah, A. (1992) *In My Father's House: Africa in the Philosophy of Culture*, London.
Armstrong, W. (1891) "Briton Riviere: His Life and Work," *Art Journal* 1891: 1–32.
Arnold, E. L. (1890) *The Wonderful Adventures of Phra the Phoenician*, London.

Arnold, G. (1980) *Held Fast for England: G. A. Henty Imperialist Boys' Writer*, London.

Arnold, M. (1965) *Culture and Anarchy*, ed. R. Super, Ann Arbor, MI.

———(1968) *Dissent and Dogma*, ed. R. Super, Ann Arbor, MI.

Arnstein, W. (1965) *The Bradlaugh Case: A Study in Late Victorian Opinion and Politics*, Oxford.

———(1992) *Protestant versus Catholic in Mid-Victorian England: Mr. Newdegate and the Nuns*, Columbia, MO.

Arvidsson, S. (2006) *Aryan Idols: Indo-European Mythology as Ideology and Science*, Chicago.

Ashman, M. (1992) "Producing Wagner," in Millington and Spencer, eds. (1992).

Attwater, D. (1931) *Father Ignatius of Llanthony: A Victorian*, London.

Auerbach, N. (1982) *Women and the Demon: Life of a Victorian Myth*, Cambridge, MA.

Austin, J. L. (1975) *How to Do Things with Words*, 2nd edition, Oxford.

Babington, B. and Evans, P. (1993) *Biblical Epics: Sacred Narrative in the Hollywood Cinema*, Manchester, UK.

Baldick, C. (1987) *In Frankenstein's Shadow: Myth, Monstrosity and Nineteenth-Century Writing*, Oxford.

Baldry, A. Lys (1917) "The Late J. W. Waterhouse," *The Studio* (June, 1917): 2–15.

Baring-Gould, S. (1888) *Our Inheritance: an Account of the Eucharist Service in the First Three Centuries*, London.

———(1897) *Perpetua*, London.

———(1898) *Domitia*, London.

———(1923) *Early Reminiscences 1834–64*, London.

———(1925) *Further Reminiscences 1864–94*, London.

Barnard, E. (1790) *The New, Comprehensive, Impartial and Complete History of England: From the Very Earliest Period of Authentic Information, to the End of the Present Year*, London.

Barringer, T. and Prettejohn, E., eds. (1999) *Frederick Leighton: Antiquity, Renaissance, Modernity*, New Haven, UK.

Barrington, Mrs. R. (1906) *Life, Letters and Works of Frederick Leighton*, 2 vols., London.

[Barrow] (1829) "Review of Granville's *Travels*," *Quarterly Review* 39: 1–41.

Barrow, R. J. (2001) *Lawrence Alma-Tadema*, London.

Barrows, S. (1981) *Distorting Mirrors: Visions of the Crowd in late nineteenth-century France*, New Haven, CT.

Barsham, E. (1981a) "Berlioz and Gluck" in Howard, ed. (1981).

———(1981b) "The Orfeo Myth in Operatic History," in Howard, ed. (1981).

Barth, H., Mack, D. and Voss, E., eds. (1975) *Wagner: A Documentary Study*, London.

Barthes, R. (1986) "Death of the Author" in *The Rustle of Language*, trans. R. Howard, New York: 49–55.

———(1993) *Camera Lucida: Reflections on Photography*, trans. R. Howard, London.

———(1995) *Roland Barthes / by Roland Barthes*, trans. R. Howard, London.

Barton, C. (1993) *The Sorrows of the Ancient Romans*, Princeton.

Bar-Yosef, E. (1998) *The Holy Land in English Culture 1799–1917*, Oxford.

Bashant, W. (1995) "Singing in Greek Drag: Gluck, Berlioz, George Eliot," in Blackmer and Smith, eds. (1995).

Batstone, W. (2006) "Provocation: The Point of Reception Theory," in Martindale and Thomas, eds. (2006): 14–20.

Bauer, O. (1982) *Richard Wagner: Die Bühnenwerke von der Uraufführung bis Heute*, Frankfurt am Mein, Berlin, Vienna.

———, ed. (1976) *1876 Bayreuth 1976: 100 Jahre Richard-Wagner-Festspiele*, Munich.

Bauman, T. and McClymonds, M., eds. (1995) *Opera and the Enlightenment*, Cambridge.

Baumann, C-F. (1980) *Bühnentechnik im Festspielhaus Bayreuth*, Munich.

Bautz, A. (2007) *The Reception of Jane Austen and Walter Scott: A Comparative Longitudinal Study*, London.

Beard, W. M. (1980) "The Sexual Status of Vestal Virgins," *JRS* 70 (1980): 12–27.

——— (1995) "Re-reading (Vestal) Virginity," in Hawley and Levick, eds. (1995): 21–43.

Bebbington, D. (1989) *Evangelicalism in Modern Britain: A History from the 1730s to the 1980s*, London and New York. 132–69.

Behlman, L. (2004) "Burning, Burial, and the Critique of Stoicism in Pater's *Marius the Epicurean*," *Nineteenth-Century Prose* 31.1: 133–69.

——— (2007) "The Sentinel of Pompeii: An Exemplum for the Nineteenth Century," in Coates and Seydl, eds. (2007): 157–70.

Belchen, J. (1996) *Popular Radicalism in Nineteenth-Century Britain*, Basingstoke, UK.

Bell, C. (1958) *Art*, New York.

Bell, D. (2006) "From Ancient to Modern in Victorian Imperial Thought," *The Historical Journal* 49.3: 735–59.

Bennett, J. (1877) *Letters from Bayreuth Descriptive and Critical of Wagner's Der Ring des Niebelungen*, London.

Benson, A. C. (1906) *Walter Pater*, London.

Benson, E. F. (1930) *As We Were*, London.

——— (1940) *Final Edition*, London.

Bérard, C., ed. (1989) *A City of Images: Iconography and Society in Ancient Greece*, trans. D. Lyons, Princeton.

Berlioz, H. (1915) *Gluck and His Operas*, trans. E. Evans, London.

——— (1918) *Mozart, Weber and Wagner*, trans. E. Evans, London.

——— (1970) *The Memoirs of Hector Berlioz*, trans. D. Cairns, London.

——— (1996) *Critique Musicale*, 5 vols., eds. H. Robert Cohen and Y. Gérard, Paris.

Bernal, M. (1987) *Black Athena: The Afroasiatic Roots of Classical Civilization*, vol. I, London.

——— (1991) *Black Athena: The Afroasiatic Roots of Classical Civilization*, vol. II, London.

——— (2001) *Black Athena Writes Back: Martin Bernal Responds to His Critics*, Durham, NC.

Bertouch, B. de (1904) *The Life of Father Ignatius, O.S.B., the Monk of Llanthony*, London.

Betts, R. (1971) "The Allusion to Rome in British Imperialist Thought of the Late Nineteenth and Early Twentieth Centuries," *Victorian Studies* 15: 149–59.

Betzwieser, T. (2000) "Musical Setting and Scenic Movement: Chorus and *Choeur Dansée* in Eighteenth-Century France," *Cambridge Opera Journal* 12: 1–28.

Bigg, C. (1905) *The Church's Task Under the Roman Empire*, Oxford.

Blackmer, C. and Smith, P., eds. (1995) *En Travesti: Women, Gender Subversion, Opera*, New York.

Blaikie, J. (1886) "J. W. Waterhouse A.R.A.," *Magazine of Art* 9: 1–6.

Bland, L. and Doan, L., eds. (1998) *Sexology in Culture: Labelling Bodies and Desires*, Cambridge.

Blix, G. (2009) *From Paris to Pompeii: French Romanticism and the Cultural Politics of Archaeology*, Philadelphia.

Bloom, H. (1971) "The Place of Pater: *Marius the Epicurean*," in Bloom (1971b): 184–94.

——— (1971b) *The Ringers in the Tower: Studies in Romantic Tradition*, Chicago and London.

Bloom, P. (1998) *The Life of Berlioz*, Cambridge.

———, ed. (1992) *Berlioz Studies*, Cambridge

Bolger, D. and Cash, S., eds. (1996) *Thomas Eakins and the Swimming Picture*, Fort Worth, TX.

Bonner, H. B. (1902) *Charles Bradlaugh: A Record of His life and Work*, London.

Booth, A. (2001) "Men and Women of the Time: Victorian Prosopographies," in Amigoni, ed. (2001): 41–66.

Borchmeyer, D. (1991) *Richard Wagner: Theory and Theatre*, trans. S. Spencer, Oxford.

——— (1992) "The Question of Anti-Semitism," in Müller, Wapnewski, and Deathridge, eds. (1992).

Boucé, P., ed. (1982) *Sexuality in Eighteenth-Century Britain*, Manchester.

Boullée, E. L. (1953) *Boullée's Treatise on Architecture: A Complete Presentation of the Architecture, Essai sur l'art, which Forms Part of the Boullée Papers (Ms. 9153) in the Bibliothèque Nationale*, ed. Helen Rosenau, Paris

Bowler, P. (1989) *The Invention of Progress: The Victorians and Their Past*, Oxford.

Boyd, M., ed. (1992) *Music and the French Revolution*, Cambridge.

Boyé (1779) [Louis Lefébure] *L'Expression musicale, mise au rang des chimères*, Amsterdam.

Bradstock, A., Gill, S., Hogan, A., and Morgan, S., eds. (2000) *Masculinity and Spirituality in Victorian Culture*, New York.

Braschowanoff, G. (1910) *Richard Wagner und die Antike*, Leipzig.

Breker, A. (1970) *Paris, Hitler et Moi*, Paris.

Breunlich, M. (1989) "Gluck in den Tagebüchen des Grafen Karl von Zinzendorf," in Croll and Woitas, eds. (1989).

Brewsher, Mrs. M. (1875) *Zipporah, the Jewish maiden*, London.

Brinton, C. (1900) "Queen Victoria as an Etcher," *The Critic* (June): 501–10.

Bristow, E. (1977) *Vice and Vigilance: Purity Movements in Britain since 1700*, Dublin.

Broughton, T. L. (1999) *Men of Letters, Writing Lives: Masculinity and Literary Auto/biography in the Late Victorian Period*, London.

Brown, A. (2004) "Bulwer's Reputation," in Christensen, ed. (2004): 29–37.

Brown, B. A. (1989) "Marie Theresa's Vienna," in Zaslaw, ed. (1989).

——— (1991) *Gluck and the French Theatre in Vienna*, Oxford.

——— (1996) "Elementi di classicismo nei balli viennesi di Gasparo Angiolini," in Morelli, ed. (1996).

——— (1999) "*Les Rêveries Renouvelées des* Grecs: Fracture, Function, and Performance Practice in a Vaudeville Parody of Gluck's *Iphigénie en Tauride* (1779)," in Schneider, ed. (1999).

Brown, I. (1980) *The Hobby-Horsical Antiquary: A Scottish Character 1640–1830*, Edinburgh.

[Brown, J. W.] (1843) *Julia of Baiae or the Days of Nero*, New York.

Brown, S. (2008) *Providence and Empire 1815–1914*, Harlow.

Bruce Mullin, R. (1996) *Miracles and the Modern Religious Imagination*, New Haven, UK.

Bullen, J. (1998) *The Pre-Raphaelite Body*, Oxford.

Bullock, G. (1940) *Marie Corelli: The Life and Death of a Best Seller*, London.

Bulwer Lytton, E. (1834) *The Last Days of Pompeii*, London.

—— (1852) "Outlines of the Early History of the East. Lecture delivered at the Royston Mechanics Institute, Thursday June 3rd, 1852," London.

Bulwer Lytton, Mrs. E. (1838) "Artaphernes the Platonist: a Supper at Sallust's," *Frazer's* 18: 513–20.

Burrow, J. (1981) *A Liberal Descent: Victorian Historians and the English Past*, Cambridge.

Burstein, M. (2003) "Protestants against the Jewish and Catholic Family, c. 1829 to c. 1860," *Victorian Literature and Culture* 31: 33–57.

—— (2005) "Reviving the Reformation: Victorian Women Writers and the Protestant Historical Novels," *Women's Writing* 12: 73–84.

Butler, E. (1935) *The Tyranny of Greece over the German Imagination*, Cambridge.

Byatt, A. S. (1990) *Possession: A Romance*, London.

Cairns, D. (1989–99) *Berlioz*, 2 vols., London.

Calder, W. M. and Trzaskoma, S., eds. (1996) *George Grote Reconsidered*, Hildesheim, Germany.

Calder-Marshall, A. (1962) *The Enthusiast: An Enquiry into the Life, Beliefs and Character of Rev. Joseph Leycester Lyne, alias Fr. Ignatius, O.S.B., Abbot of Elm Hill, Norwich, and Llanthony, Wales*, London.

Canetti, E. (1962) *Crowds and Power*, New York.

Carlson, M. (1988) "The Theatre as Civic Monument," *Theatre Journal* 40.1: 12–32.

Carlyle, T. (1830) "On History" in *Centennial Memorial Edition*, 26 vols., London, vol. 16.

—— (1925) *Carlyle's Essay on Sir Walter Scott*, ed. A. Smith, London.

—— (1993) *On Heroes and Hero Worship*, eds. M. Goldberg et al., Berkeley, CA.

Carnegy, P. (2006) *Wagner and the Art of the Theatre*, New Haven and London.

Carson, A. (2002) *If Not, Winter: Fragments of Sappho*, New York.

Cary, E. L. (1994) *The Tragedy of Mariam: The Fair Queen of Jewry*, ed. Weller, B. and Ferguson, M., Berkeley, CA.

Casteras, S. (1981) "Virgin Vows: The early Victorian artists' portrayal of nuns and novices," *Victorian Studies* 24: 157–84

—— (1987) *Images of Victorian Womanhood in English Art*, Rutherford, Madison, Teaneck, London and Toronto.

Castle, K. (1996) *Britannia's Children: Reading Colonialism through Children's Books and Magazines*, Manchester, UK.

Cave, T. (1988) *Recognitions: A Study in Poetics*, Oxford.

Césaire, A. (1972) *Discourse on Colonialism*, trans. J. Pinkham, New York.

Chadwick, O. (1966) *The Victorian Church*, 2 vols., London.

Challis, D. (2008) *From Harpy Tomb to the Wonders of Ephesus*, London.

Chamberlain, H. S. (1900) *Richard Wagner*, trans. G. Ainslie Hight, London.

——— (1911) *The Foundations of the Nineteenth Century*, 2 vols., trans. J. Lees, London.

Chandler, A. (1970) *A Dream of Order: The Medieval Idea in Nineteenth-Century English Literature*, London.

Chapman, R. (1986) *The Sense of the Past in Victorian Literature*, London and Sydney.

Chard, C. (2007) "Picnic at Pompeii: Hyperbole and Digression in the Warm South," in Coates and Seydl, eds. (2007): 115–32.

Charles, E. R. (1856) *The Cripple of Antioch*, London.

——— (1869) *Sketches of Life in England in the Olden Time*, London.

Cheyette, B. (1993) *Constructions of "the Jew" in English Literature and Society: Racial Representation 1875–1945*, Cambridge.

Cheyette, B. and Valman, N., eds. (2004) *The Image of the Jew in European Liberal Culture 1789–1914*, London and Portland.

Chitty, S. (1974) *The Beast and the Monk: A Life of Charles Kingsley*, London.

Chorley, H. (1926) *Thirty Years' Musical Recollections*, ed. E. Newman, New York and London.

Christensen, A., ed. (2004) *The Subverting Vision of Bulwer Lytton*, Newark.

Church, A. J. (1893) "The Historical Novel," *Atalanta* 6: 520–22.

——— (1901) *To the Lions*, London.

——— (1903) *The Burning of Rome*, London.

Clark, M. (2001) "Bodies at the Opéra: Art and the Hermaphrodite in the Dance Criticism of Théophile Gautier," in Parker and Smart, eds. (2001): 237–53.

Clarke, G. W., ed. (1989) *Rediscovering Hellenism: The Hellenic Inheritance and the English Imagination*, Cambridge.

Clarke, M. L. (1962) *George Grote, a Biography*, London.

Clifford, J., ed. (1962) *Biography as an Art*, London.

Coates, V. and Seydl, J., eds. (2007) *Antiquity Recovered: The Legacy of Pompeii and Herculaneum*, Los Angeles.

Cobbold, D. L. (2004) "Rosina Bulwer Lytton: Irish Beauty, Satirist, Tormented Victorian Wife, 1802–1882," in Christensen, ed. (2004): 147–58.

Cohen, S. (2000) *Art Dance and the Body in French Culture of the Ancien Régime*, Cambridge.

Colbert, C. (1997) *A Measure of Perfection: Phrenology and the Fine Arts in America*, London and Chapel Hill, NC.

Colli, G. and Montinari, M. (1988) *Friedrich Nietzsche: Werke. Kritische Gesamtausgabe*, Munich and Berlin.

Collini, S. (1991) *Public Moralists: Political Thought and Intellectual Life in Britain 1850–1930*, Oxford.

Collins. W. (1850) *Antonina*, 3 vols., London.

Conte, G. (1986) *The Rhetoric of Imitation: Genre and Poetic Memory in Virgil and Other Latin Poets*, ed. C. Segal, Ithaca, NY.

——— (1994) *Genres and Readers*, trans. G. Most, Baltimore.

Conybeare, C. (2002) "The Ambiguous Laughter of St. Lawrence," *Journal of Early Christian Studies* 10: 175–202.

Conybeare, J.W.E. (1903) *Roman Britain*, London.

Conybeare, W. and Howson, J. (1860) *The Life and Epistles of St Paul*, 7th ed., 2 vols., London.

Cooper, R. (1981) "The Relationship between the Pre-Raphaelite Brotherhood and Painters before Raphael in English Criticism of the 1840s and 1850s," *Victorian Studies* 24: 405–38.

Coote, H. C. (1878) *Romans of Britain*, London.

Corbett, M-J. (1992) *Representing Femininity: Middle-Class Subjectivity in Victorian and Edwardian Women's Autobiographies*, Oxford and New York.

Corelli, M. (1894) *Barabbas: A Dream of the World's Tragedy*, London.

Cosens, C. (1878) *A Few Thoughts on Eternity*, London.

Crake, A. (1876) *The Camp on the Severn*, London.

—— (1888) *Stories from Old English History*, London.

—— (1889) *The Doomed City or the Last Days of Durocina*, London.

Crichton-Browne, J. (1903) "Froude and Carlyle: The Imputation Considered Medically," *British Medical Journal*, 27 June: 1498–1502.

Croll, G. and Woitas, M., eds. (1989) *Gluck in Wien: Wien 12–16th November, 1987*, Kassel, Basel, London and New York.

Croly, G. (1822) *Catiline: a Tragedy, with Other Poems*, London.

—— (1829) *Salathiel: A Story of Past, Present and Future*, London.

—— (1837) *England, the Fortress of Christianity*, London.

—— (1848) *The Claims of Jews Incompatible with the National Profession of Christianity*, London.

—— (1901) *Tarry Thou Till I Come*, introduction by General Lew Wallace, New York and London.

Cros, L. (1957) *Histoire de Notre-Dame de Lourdes*, 3 vols., ed. F. Cavallera, Paris.

Crow, T. (1995) *Emulation: Making Artists for Revolutionary France*, New Haven, UK.

Culler, A. (1985) *The Victorian Mirror of History*, New Haven, UK.

Cumming, J. (1995) "Gluck's Iphigeneia Operas: Sources and Strategies," in Bauman and McClymonds, eds. (1995).

Cyr, M. (1995) "The Dramatic Role of the Chorus in French Opera: Evidence for the Use of Gesture 1660–1770," in Bauman and McClymonds, eds. (1995).

Cyrino, M. (2005) *Big Screen Rome*, Oxford.

Dahl, C. (1973) "Pater's Marius and Historical Novels in Early Christian Times," *Nineteenth Century Fiction* 28: 1–24.

Dahlhaus, C. (1976) "Was Schillers Mißverständnis 'zu Thränen gerührt'? Eine Erwiderung," *Die Musikforschung* 29: 72–73.

—— (1989) "Ethos und Pathos in Gluck's *Iphigenie auf Tauris*," in Hortschansky, ed. (1989).

Davies, G. (1954) *Henry Phillpotts, Bishop of Exeter. 1778–1869*, London.

Davies, J. (1955) *Phrenology, Fad and Science: A 19th-Century American Crusade*, New Haven, UK.

Davis, W. (1999) "The Image in the Middle: John Addington Symonds and Homo-erotic Art Criticism," in Prettejohn, ed. (1999).

Davis, W. S. (1900) *A Friend of Caesar*, New York.

Dawson, G. (2007) *Darwin, Literature and Victorian Respectability*, Cambridge.

Dean-Jones, L. (1992) "The Politics of Pleasure: Female Sexual Appetite in the Hippocratic Corpus," *Helios* 19: 74–78.

Deathridge, J. (1992) "A Brief History of Wagner Research," in Müller, Wapnewski, and Deathridge, eds. (1992).

——— (1999) "Wagner, the Greeks, and Wolfgang Schadewaldt," *Dialogos* 6: 133–40.

——— (2008) *Wagner: Beyond Good and Evil*, Berkeley, CA.

de Cahusac, L. (2004) *La Danse ancienne et modern ou traité historique de la danse*, eds. N. Lecomte, L. Naudeix, and J-N Laurenti, Paris.

Decugis, N. and Reymond, S. (1953) *Le Décor de théâtre en France du moyen age à 1920*, Paris.

DeJean, J. (1989) *Fictions of Sappho*, Chicago.

Dellamora, R. (1990) *Masculine Desire: The Sexual Politics of Victorian Aestheticism*, Chapel Hill, NC.

Demetriou, K. (1999) *George Grote on Plato and Athenian Democracy*, Berlin.

de Mille, J. (1867) *Helena's Household: A Tale of Rome in the First Century*, New York.

Dentith, S. (2006) *Epic and Empire in Nineteenth-Century Britain*, Cambridge.

Devey, L. (1887) *Life of Rosina, Lady Lytton*, London.

Dick, B. (1972) *The Hellenism of Mary Renault*, Carbondale and Edwardsville, IL.

Dijkstra, B. (1986) *Idols of Perversity: Fantasies of Feminine Evil in Fin-de-Siècle Culture*, Oxford.

Dircks, R. (1910) "The Later Work of Sir Lawrence Alma-Tadema O.M. R.A. R.W.S.," *The Art Journal* Christmas Special Edition.

Donoghue, D. (1995) *Walter Pater: Lover of Strange Souls*, New York.

Donne, W. (1838) "The Rise and Fall of Athens," *British and Foreign Review* 7: 36–85.

Dorman, S. (1979) "*Hypatia* and *Callista*: The Initial Skirmish between Kingsley and Newman," *Nineteenth Century Fiction* 34: 173–93.

Dowling, L. (1985) "Roman Decadence and Victorian Historiography," *Victorian Studies* 28: 579–607.

——— (1994) *Hellenism and Homosexuality in Victorian Oxford*, Ithaca, NY.

Downes, D. (1972) *The Temper of Victorian Life: Studies in the Religious Novels of Pater, Kingsley, and Newman*, New York.

Downey, H. (1993) *Gradiva by Wilhelm Jensen; and Delusion and Dream in Wilhelm Jensen's Gradiva by Sigmund Freud*, Los Angeles.

Duclaux, M. (1925) "Souvenirs sur Walter Pater," *La Revue de Paris* 32: 351.

Dumas, F. G., ed. (1908) *Franco-British Exhibition Illustrated Review: British Fine Art Section*, London.

Eastlake, Lady E. (1851–52) "Physiognomy" *Quarterly Review* 90: 62–91.

Ebers, G. (1871) *The Egyptian Princess*, trans. E. Grove, London.

——— (1881) *The Emperor*, 2 vols., trans. W. Gottsberger, New York.

——— (1885) *Serapis*, Stuttgart.

——— (1892) *Per Aspera: A Thorny Path*, trans. C. Bell, London.

Eckstein, E. (1889) *Nero*, 2 vols., trans. C. Bell and M. Safford, New York.

Edmondson, G. (1913) *The Church in Rome in the First Century*, London.

Edwards, C., ed. (1999) *Roman Presences: Receptions of Rome in European Culture, 1789–1945*, Cambridge.

Einstein, A. (1936) *Gluck*, London.

Eldridge, C. (1996) *The Imperial Experience: From Carlyle to Forster*, London.

Eliot, G. (1856) "Silly Novels by Lady Novelists," *Westminster Review* 66: 442–61.

Eliot, T. S. (1932) *Selected Essays*, London.

Ellis, K. (1995) *Music Criticism in Nineteenth-Century France: La Revue et Gazette musicale de Paris, 1834–80*, Cambridge.

Elsner, J. and Masters, J., eds. (1994) *Reflections of Nero: Culture, History, and Representation*, London.

Emerson, R. W. (1841) "History," in Ziff, ed. (1982): 149–74.

Endean, J. (1878) *What is the Eternal Hope of Canon Farrar?*, London.

Endersby, J. (2008) *Imperial Nature: Joseph Hooker and the Practices of Victorian Science*, Cambridge.

Evangelista, S. (2009) *British Aestheticism and Ancient Greece: Hellenism, Reception, Gods in Exile*, Basingstoke, UK.

Everist, M. (2001) "Gluck, Berlioz, and Castel-Blaze: The Poetics and Reception of French Opera," in Parker and Smart, eds. (2001): 86–108.

Ewans, M. (1982) *Wagner and Aeschylus: The Ring and the Oresteia*, London.

——— (2006) *Opera from the Greek: Studies in the Poetics of Appropriation*, Aldershot, UK.

Faber, G. (1957) *Jowett*, London.

Faber, M. (2003) *The Crimson Petal and the White*, Edinburgh.

Faries, R. (1923) *Ancient Rome in the English Novel*, Philadelphia.

Farmer, L. (1895) *The Doom of the Holy City*, New York.

Farrar, F. (1858) *Eric: or Little by Little, a tale of Roslyn School*, London.

——— (1862) *St Winifred's*, Edinburgh.

——— (1866) *Greek Grammar Rules: drawn up for the use of Harrow School*, London.

——— (1868) *Seekers After God: Seneca, Epictetus and Marcus Aurelius*, London.

——— (1874) *Life of Christ*, London.

——— (1875) "A Few Words on the Life of Christ," *Macmillan's Magazine* 31: 463–71.

——— (1878) *Eternal Hope: Five Sermons Preached in Westminster Abbey, November and December 1877*, London.

——— (1879) *Life and Work of St Paul*, London.

——— (1892) *Darkness and Dawn*, London.

——— (1895) *Gathering Clouds*, London.

——— (1903) *Three Sermons, preached in the Cathedral Church of Christ, Canterbury*, London.

——— (1904) *The Life of Frederic William Farrar*, London.

Farrar, F., ed. (1867) *Essays on a Liberal Education*, London.

Fauquet, J-M. (1992) "Berlioz's version of Gluck's *Orphée*," in Bloom, ed. (1995).

Faverty, F. (1951) *Mathew Arnold, The Ethnologist*, Illinois.

Fearenside, C. (1900) "Historical Novels and Their Uses in Teaching," *The School World* 2: 404–7.

Federico, A. (2000) *Idol of Suburbia: Marie Corelli and Late Victorian Literary Culture*, Charlottesville, VA and London.

Feldman, D. (1994) *Englishmen and Jews: Social Relations and Political Culture*, New Haven, UK.

Felski, R. (1995) *The Gender of Modernism*, Cambridge, MA.

Ferris, I. (1991) *The Achievement of Literary Authority: Gender, History and the Waverly Novel*, Ithaca, NY.

Field, G. G. (1981) *Evangelist of Race: The Germanic Vision of Houston Stewart Chamberlain*, New York.

Fischer, H. (1994) *Der Ägyptologe Georg Ebers: eine Fallstudie zum Problem Wissenschaft und Öffentlichkeit im 19. Jahrhundert*, Ägypten und Altes Testament 25, Wiesbaden.

Fiske, S. (2008) *Hereteical Hellenism: Women Writers, Ancient Greece, and the Victorian Popular Imagination*, Athens, Ohio.

Fitzlyon, A. (1964) *The Price of Genius: A Life of Pauline Viardot*, London.

Flashar, H. (2005a) *Schadewaldt, Wolfgang.* in *Neue Deutsche Biographie*. Bd. 22: 495–96, Berlin.

——— (2005b) "Biographische Momente in schwerer Zeit" in Szlezák, ed. (2005).

Fleishman, A. (1971) *The Historical Novel: Walter Scott to Virginia Woolf*, Baltimore.

——— (1983) *Figures of Autobiography: The Language of Self-Writing in Victorian and Modern Britain*, Berkeley, CA.

Fletcher, R. (2003) "'Convent Thoughts': Augusta Weber and the Body politics of the Victorian Cloister," *Victorian Literature and Culture* 31: 295–313.

Foerster-Nietzsche, E., ed. (1921) *The Nietzsche-Wagner Correspondence*, New York.

Forster, J. (1966) *The Life of Charles Dickens*, 2 vols., ed. A. Hoppé, London and New York.

Foster, D. (2010) *Wagner's Ring Cycle and the Greeks*, Cambridge.

Fowles, J. (1977) *The French Lieutenant's Woman*, London.

Franklin, J. J. (2003) "The Counter-Invasion of Britain by Buddhism in Marie Corelli's *A Romance of Two Worlds* and H. Rider Haggard's *Ayesha: the Return of She*," *Victorian Culture and Literature* 31: 19–42.

Franko, M. (1993) *Dance as Text: Ideologies of the Baroque Body*, Cambridge.

Fraser, H., Green, S., and Johnston, J. (2003) *Gender and the Victorian Periodical*, Cambridge.

Fraser, R. (1988) *Charlotte Brontë*, London.

Freeman, E. (1856) "Grote's *History of Greece*," *North British Review* 25: 141–72.

——— (1864) "Mr Kingsley's Roman and Teuton," *Saturday Review* April 9: 446–48.

Frei, H. (1974) *The Eclipse of Biblical Narrative: A Study in Eighteenth- and Nineteenth-Century Hermeneutics*, New Haven, UK.

——— (1985) "David Friedrich Strauss" in Smart et al. eds. (1985): 215–60.

Friang, M. (2008) *Pauline Viardot au Mirroir de sa Correspondance*, Paris.

Fricke, R. (1990) "Bayreuth in 1876," trans. S. Spencer, *Wagner* 11.3: 93–109; 134–150.

——— (1991) "Bayreuth in 1876," trans. S. Spencer, *Wagner* 12.1 25–44.

Fried, M. (1988) *Realism, Writing and Disfiguration: Thomas Eakins and Stephen Crane*, Chicago.

Fritzsche, P. (2004) *Stranded in the Present: Modern Times and the Melancholy of History*, Cambridge, MA.

Gagnier, R. (1991) *Subjectivities: A History of Self-Representation in Britain, 1832–1920*, Oxford.

Galian, J. (2003) "Christians, Infidels, and Women's Channeling in the Writings of Marie Corelli," *Victorian Literature and Culture* 31: 83–97.

Gange, D. (2009) "Odysseus in Eden: Gladstone's Homer and the Idea of a Universal Epic," *Journal of Victorian Culture* 14:190–206.

Gange, D. (forthcoming), Cambridge.

Gange, D. and Ledger-Lomas, M. eds. (forthcoming) "Troy" in *Cities of God*, eds. D. Gange and M. Ledger-Lomas (forthcoming).

Gaskell, E. (1997) [1857] *The Life of Charlotte Brontë*, London.

Gauthier, T. (1914) *Madmoiselle Dafné, La Toison d'Or, Arria Marcella, Le Petit Chien de la Marquise*, Paris.

Gay, P. (1995) *The Bourgeois Experience from Victoria to Freud: The Naked Heart*, New York.

Gere, C. (2002) *Psyche's Labyrinth: Minoan Archaeology and Modern Prophecy 1900–1945*, Cambridge (PhD).

——— (2009) *Knossos and the Prophets of Modernism*, Chicago.

Gerin, W. (1967) *Charlotte Brontë: The Evolution of Genius*, Oxford.

Gibbon, E. (1995) *The History of the Decline and Fall of the Roman Empire*, ed. D. Womersley, London.

Gilbar, G., ed. (1990) *Ottoman Palestine 1800–1914*, Leiden, The Netherlands.

Gildenhard, I. and Ruehl, M., eds. (2003) *Out of Arcadia*, BICS Supplement 79, London.

Giles, J. A. (1847) *History of the Ancient Britons from the earliest Period to the Invasion of the Saxons*, London.

Gillman, S. (1985) *Difference and Pathology: Stereotypes of Sexuality, Race, and Madness*, Ithaca, NY.

Girouard, M. (1981) *The Return to Camelot: Chivalry and the English Gentleman*, New Haven, UK.

Gissing, G. (1904) *Veranilda*, London.

Gluck, C. W. (1966) *Don Juan/Semiramis/Ballets, Pantomimes von Gasparo Angiolini*, ed. R. Engländer, Basel, Paris, London, New York.

Goffman, E. (1969) *The Presentation of Self in Everyday Life*, Harmondsworth.

——— (1975) *Frame Analysis: An Essay on the Organisation of Experience*, London.

Goldhill, S. (1999) "Body/Politics: Is There a History of Reading?" in *Contextualizing Classics: Ideology, Performance, Dialogue*, eds. T. Falkner, N. Felson, D. Konstan, Lanham, MD: 89–120.

——— (2002) *Who Needs Greek? Contests in the Cultural History of Hellenism*, Cambridge.

——— (2008) "Wagner's Greeks: the Politics of Hellenism," in Revermann and Wilson, eds. (2008).

——— (2009) "Cultural History and Aesthetics: Why Kant Is No Place to Start Reception Studies," in Hall, ed. (2009).

——— (forthcoming a) "The Victorian Discovery of Jerusalem," in Gange and Ledger-Lomas, eds. (forthcoming).

——— (forthcoming b) "A Writer's Things: Edward Bulwer Lytton and the Archaeological Gaze."

Goldhill, S. and Osborne, R., eds. (1999) *Performance Culture and Athenian Democracy*, Cambridge.

Goodbrand, R. (1870) "A Suggestion for a New Kind of Biography," *Comparative Review* 14: 20–28.

Goode, M. (2003) "Dryasdust Antiquarianism and Soppy Masculinity: The Waverley Novels and the Gender of History," *Representations* 82: 52–86.

Goodfellow, A. (1878) "Farrar and Cox versus Dr. Thomson on Hell and Everlasting Punishment unscriptural and unreasonable. A reply to the Rev. A. Thomson D.D.," London.

Goodrich, A. (1900) *Topics of Greek and Roman History*, London.

Gordon, L. (1995) *Charlotte Brontë: A Passionate Life*, London.

Gosse, E. (1901) "The Custom of Biography" *Anglo-Saxon Review* viii: 195–208.

—— (1962) [1903] "The Ethics of Biography," in Clifford, ed. (1962): 113–19.

—— (2005) [1907] *Father and Son: A Study in Two Temperaments*, Stroud.

Gossmnan, L. (1994) "Philhellenism and Anti-Semitism: Matthew Arnold and His German Models," *Comparative Literature* 46: 1–39.

Gray, A. (1897) *The Origin and Early History of Christianity in Britain: From Its Dawn to the Death of Augustine*, London and New York.

Gregory, E. (1997) *H.D. and Hellenism: Classic Lines*, Cambridge.

Gregory, F. (1992) *Nature Lost? Natural Science and the German Theological Tradition of the Nineteenth Century*, Cambridge, MA.

Green, M. (1980) *Dreams of Adventure, Dreams of Empire*, London.

Greene, E., ed. (1996) *Re-reading Sappho: Reception and Transmission*, Berkeley, CA.

Greer, M. (1900) *Christianity in England before Augustine*, London.

Grey, T. (1988) "Wagner, the Overture, and the Aesthetics of Musical Form," *Nineteenth-Century Music* 12: 3–22.

—— (1995) *Wagner's Musical Prose: Texts and Contexts*, Cambridge.

Grieve, A. (1969) "A Notice on Illustrations to Charles Kingsley's *The Saint's Tragedy* by Three Pre-Raphaelite Artists," *The Burlington Magazine* 111: 291–93.

Groneman, C. (2000) *Nymphomania: A History*, New York.

Großmann-Vendrey, S. (1977–83) *Bayreuth und dis deutschen Presse*, 4 vols., Regensburg.

Grover, J. W. (1867) "Pre-Augustine Christianity in Britain: as indicated by the discovery of Christian Symbols," *Journal of the British Archaeological Association* 23: 221–30.

—— (1868) "On a Roman Villa at Chedworth," *Journal of the British Archaeological Association* 24: 129–35.

Guthenke, C. (forthcoming) "'Lives' as Parameter: The Privileging of Ancient Lives as a Category of Research around 1900," *Ramus* (forthcoming).

Hagen, G. (2004) "German Heralds of Holy War: Orientalists and Applied Oriental Studies," *Comparative Studies of South Asia, Africa, and the Middle East* 24.2: 145–62.

Haig, A. (1984) *The Victorian Clergy*, London.

Hall, C. (1991) *Hidden Anxieties: Male Sexuality 1900–1950*, Cambridge.

Hall, C., McLelland, K., and Rendall, J., eds. (2000) *Defining the Victorian Nation: Class, Race, and Gender, and the Reform Act of 1867*, Cambridge.

Hall, D., ed. (1994) *Muscular Christianity*, Cambridge.

Hall, E., ed. (2009) *Reception Theory and Performance*, Oxford.

Hall, E. and Macintosh, F. (2005) *Greek Tragedy and the British Theatre 1660–1914*, Oxford.

Hall, J. (1997) *Ethnic Identity in Greek Antiquity*, Cambridge.

Haller, J. and Haller, R. (1974) *The Physician and Sexuality in Victorian America*, New York.

Hamann, B. (2005) *Winifred Wagner: A Life at the Heart of Hitler's Bayreuth*, trans. A. Bance, London.

Hanisch, E. (1992) "The Political Influence and Appropriation of Wagner," in Müller, Wapnewski, and Deathridge, eds. (1992).

Hansen, E. (1997) *Decadence and Catholicism*, Cambridge, MA.

Hare, J. (1829) "A Vindication of Niebuhr's *History of Rome* from the charges of the *Quarterly Review*," Cambridge.

Harnack, A. (1878) "Christianity and Christians at the Court of the Roman Emperors before the Time of Constantine," *Princeton Review* 54: 239–80.

Harris, H. (1973) *David Friedrich Strauss and His Theology*, Cambridge.

Harris, Robert (2003) *Pompeii*, New York.

Harris, Ruth (1999) *Lourdes: Body and Spirit in the Secular Age*, Harmondsworth.

Harrison, J. (1887) "The Myth of Odysseus and the Sirens" *Magazine of Art* 10: 133–36.

Hart-Davies, R., ed. (1962) *The Letters of Oscar Wilde*, London.

Hartley, A. (1977) *The Novels of Charles Kingsley: A Christian Social Interpretation*, Folkestone.

Hartley, L. (2001) *Physiognomy and the Meaning of Expression in Nineteenth-Century Culture*, Cambridge.

Harvey, A. (1883) *Good the Final Goal of Ill, or, the Better Life Beyond; four letters to the Ven. Archdeacon Farrar by a layman*, London.

Hassell, J. (1872) *From Pole to Pole, being the History of Christian Missions in All Countries of the World*, 2nd ed., London.

Hausrath, A. [G. Taylor] (1880) *Antinous: a Historical Romance of the Roman Empire*, trans. J.D.M., London.

Hawley, R. and Levick, B., eds. (1995) *Women in Antiquity: New Assessments*, London.

Heartz, D. (1995) *Haydn, Mozart, and the Viennese School 1740–1780*, New York.

———— (2004) *From Garrick to Gluck: Essays on Opera in the Age of the Enlightenment*, Hillsdale, New York.

Hebbel, F. (1987) *Herodes und Mariamne*, ed. E. Purdie, Oxford.

Hegel, G. (1948) *Early Theological Writings*, trans. T. Knox and R. Kroner, Chicago.

———— (1975) *Aesthetics: Lectures on Fine Art*, 2 vols., trans. T. Knox, Oxford.

Helmstadter, R. and Lightman, B., eds. (1990) *Victorian Faith in Crisis*, London.

Henderson, B. (1903) *The Life and Principate of the Emperor Nero*, London.

Henry, R. (1789) *The History of Great Britain from the First Invasion of It by the Romans under Julius Caesar*, 2nd ed., Dublin.

Henty, G. (1884) *With Clive in India or The Beginnings of Empire*, London.

———— (1888) *For the Temple*, London.

———— (1893) *Beric the Briton*, London.

Herring, R. (1861) *A Few Personal Reflections of the Late George Croly LLD*, London.

Heschel, S. (2009) *The Aryan Jesus*, Princeton.

Hilton, B. (1986) *The Age of Atonement: The Influence of Evangelicalism on Social and Economic Thought 1785–1865*, Oxford.

Hindmarsh, D. (2005) *The Evangelical Conversion Narrative: Spiritual Autobiography in Early Modern England*, Oxford.

Hinds, S. (1998) *Allusion and Intertext: Dynamics of Appropriation in Roman Poetry*, Cambridge.

Hingley, R. (2000) *Roman Officers and English Gentlemen: The Imperial Origins of Roman Archaeology*, London.

———— (2008) *The Recovery of Roman Britain, 1586–1906: A Colony So Fertile*, Oxford.

Hitler, A. (1972) *Mein Kampf*, trans. R. Manheim, London.

Hobson, A. (1980)  *The Art and Life of J. W. Waterhouse RA*, London.

Hoffmann, E.T.A. (1969) *Selected Writings of E.T.A. Hoffmann*, Vol. 1, ed. and trans. L. Kent and E. Knight, Chicago.

Hofmannsthal, H. von (1952) *Selected Prose*, trans. M. Holtinger, and T. and J. Stern, New York.

Holt, J. (2008) *Public School Literature, Civic Education and the Politics of Male Adolescence*, Farnham, UK.

Homans, M. (1986) *Bearing the Word: Language and Female Experience in Nineteenth-Century Women's Writing*, Chicago.

Homer, W. (1992) *Thomas Eakins: His Life and Work*, New York, London, Paris.

Hopkins, K. (1983) *Death and Renewal*, Cambridge.

Hortschansky, K., ed. (1989) *Christoph Willibald Gluck und die Opernreform, Wege der Forschung* 613, Darmstadt.

Hoselitz, V. (2007) *Imagining Roman Britain: Victorian Responses to a Roman Past*, Woodbridge, UK.

Howard, P. (1981) "From 'Orfeo' to 'Orphée,'" in Howard, ed. (1981).

——— (1991) *Gluck: An Eighteenth-Century Portrait in Letters and Documents*, Oxford.

———, ed. (1981) *C. W. Gluck. Orfeo*, Cambridge.

Howorth, H. (1885) "Christianity in Roman Britain," *Transactions of the Royal Historical Society* 2: 117–72.

Huberman, R. (1997) *Gendering Classicism: The Ancient World in Twentieth-Century Women's Historical Fiction*, Albany, New York.

Hugo, V. (1979) *La Légende des siecles*, 2 vols., Paris.

Hurst, I. (2006) *Victorian Women Writers and the Classics: The Feminine of Homer*, Oxford.

Hyamson, H. (1971) *British Projects for the Restoration of the Jews*, Leeds, UK.

Irvine, D. (1897) *Wagner's Ring of the Niebelungs and the Condition of Ideal Manhood*, London.

Irwin, R. (2006) *For Lust of Knowing: The Orientalists and Their Enemies*, London.

Istel, E. (1931) "Gluck's Dramaturgy," *Musical Quarterly* 17: 227–33.

Jann, R. (1985) *The Art and Science of Victorian History*, Columbus, Ohio.

Jay, E. (1986) *Faith and Doubt in Victorian Britain*, London.

Jenkyns, R. (1981) *The Victorians and Ancient Greece*, Oxford.

——— (1991) *Dignity and Decadence*, London.

——— (1995) "Late Antiquity in English Novels of the Nineteenth Century," *Arion* 3: 141–66.

John, J. and Jenkins, A., eds. (2000) *Rethinking Victorian Culture*, London.

Johnson, D. (1993) *Jacques-Louis David: Art in Metamorphosis*, Princeton.

Johnson, J. (1995) *Listening in Paris. A Cultural History*, Berkeley, CA.

Joshel, S., Malamud, M., and McGuire, D., eds. (2001) *Imperial Projections: Ancient Rome and Modern Popular Culture*, Baltimore.

Jouhard, P. (1809) *Paris dans le XIXm siecle, ou Réflexions d'un observateur*, Paris.

Kaplan, C. (2008) *Victoriana: Histories, Fictions, Criticism*, Edinburgh.

Kappeler, S. (1986) *The Pornography of Representation*, Cambridge.

Katz, J. (1986) *The Darker Side of Genius: Richard Wagner's Anti-Semitism*, London.

Kelly, M. (1907) *Froude. A Study of His Life and Character*, London.

Kendall-Davies, B. (2003) *The Life and Work of Pauline Viardot-Garcia: The Years of Fame 1836–63*, Amersham, UK.

Kermode, F. (1979) *The Genesis of Secrecy: On the Interpretation of Narrative*, Cambridge, MA.

Kerr, J. (1989) *Fiction against History: Scott as Story-Teller*, Cambridge.

Kestner, J. (1989) *Mythology and Misogyny: The Social Discourse of British Classical Subject Painting*, Madison.

—— (1995) *Masculinities in Victorian Painting*, Aldershot.

Kingsley, C. (1848) *Saint's Tragedy: or, The True Story of Elizabeth of Hungary, Landgravine of Thuringia, Saint of the Romish Calendar*, London.

[Kingsley, C.] (1850) "Sir E. B. Lytton and Mrs Grundy," *Fraser's* 41: 98–111.

Kingsley, C. (1850b) *Alton Locke: tailor and Poet: an Autobiography*, London.

—— (1853) *Hypatia; or New Foes with an Old Face*, London.

—— (1855a) *Glaucus: or the Wonders of the Shore*, London.

—— (1855b) *Westward Ho!*, London.

—— (1856) *Heroes, or, Greek Fairy Tales for my Children*, London.

—— (1857) *Two Years Ago*, London.

—— (1858) *Andromeda and Other Poems*, London.

—— (1863) *Water Babies*, London.

—— (1864a) *Roman and the Teuton*, Cambridge.

—— (1864b) "Review of Froude's *History of England*, vols. vii–viii," *Macmillan's Magazine* IX: 211–24.

—— (1864c) "What, then, Does Dr. Newman Mean? a reply to a pamphlet recently published by Dr Newman," London and Cambridge.

—— (1866) *Hereward the Wake: "Last of the English,"* London.

—— (1877) *Charles Kingsley: His Letters and Memories of His Life*, 2 vols., ed. F. Kingsley, London.

Kingsley, F. (1905) *Tor, a Streetboy of Jerusalem*, Chicago.

Kintzler, C. (1991) *Poétique de l'opéra francais de Corneille à Rousseau*, Paris.

—— (2004) *Théâtre et opera à l'age classique: une familière étrangeté*, Paris.

Kinze, S. (1989) "Christoph Willibald Gluck, oder: Die 'Natur' des musikalischen Dramas," in Hortschansky, ed. (1989).

Klaver, J. (2006) *The Apostle of the Flesh: A Critical Life of Charles Kingsley*, Leiden, UK.

Klinger, K. (1989) "Gluck und der aufgeklärte Absolutismus in Österreich" in Hortschansky ed. (1989).

Koselleck, R. (1985) *Futures Past: on the Semantics of Historical Time*, trans. K. Tribe, Cambridge, MA.

—— (2002) *The Practice of Conceptual History: Timing History, Spacing Concepts*, trans. T. Presner et al., Stanford, CA.

Koven, S. (2006) *Slumming: Sexual and Social Politics in Victorian London*, Princeton.

Kubizek, A. (1954) *Young Hitler: the Story of Our Friendship*, trans. E. Anderson, London.

Kyle, D. (1998) *Spectacles of Death*, London.

Laclaux, M. (1925) "Souvenirs sur Walter Pater," *Révue de Paris* 32: 339–58.

La Laurencie, L. (not dated) *Orphée de Gluck*, Paris.

Lampe, P. (2004) *From Paul to Valentinus: Christians at Rome in the First Two Centuries*, Philadelphia.

Lankewish, V. (2000) "Love Among the Ruins: The Catacombs, the Closet, and the Victorian 'Early Christian' Novel," *Victorian Literature and Culture* 28: 239–73.

Laqueur, T. (2003) *Solitary Sex: A Cultural History of Masturbation*, New York.

Larsen, T. (2004) *Contested Christianity: The Political and Social Contexts of Victorian Theology*, Waco, TX.

Lasserre, H. (1869) *Notre-Dame de Lourdes*, Paris.

Launay, D., ed. (1973) *La Querelle des bouffons: texte de pamphlets avec introduction, commentaries et index*, 3 vols., Geneva.

Leavis, Q. (1932) *Fiction and the Reading Public*, London.

Leclerc, J-B. (1796/Year 4) *Essai sur la propagation de la musique en France: sa conservation et ses rapports avec le gouvernement*, Paris.

Lee, M. O. (2003) *Athene Sings: Wagner and the Greeks*, Toronto and Buffalo, NY.

Lee, S. (1911) *Principles of Biography*, Cambridge.

Lerer, S. (2008) *Children's Literature: A Reader's History from Aesop to Harry Potter*, Chicago.

Lesure, F. (1984) *Querelles des Gluckistes et des Picinistes*, 2 vols., Geneva.

Levine, G. (1968) *The Boundaries of Fiction: Carlyle, Macaulay, Newman*, Princeton.

Levine, P. (1986) *Amateur and Professional: Antiquarians, Historians, and Archaeologists in Victorian England, 1838–1886*, Cambridge.

——— (2003) *Prostitution, Race and Politics: Policing Venereal Disease in the British Empire*, New York and London.

Lewes, G. (1846) "Historical Romance," *Westminster Review* 45: 34–50.

Lewis, D. (2010) *The Origins of Christian Zionism: Lord Shaftesbury and Evangelical Support for a Jewish Homeland*, Cambridge.

Lewin, T. (1890) *The Life and Epistles of St Paul*, 5th edition, 2 vols., London [1851].

Lightman, B. (1990) "*Robert Elsmere* and the Agnostic Crises of Faith," in Helmstadter and Lightman, eds. (1990): 283–311.

———, ed. (1997) *Victorian Science in Context*, Chicago.

Lincoln, B. (1999) *Theorizing Myth: Narrative, Ideology and Scholarship*, Chicago.

Lindemann, D. (1983) *Intellectual roots of Nazism: A Study of Interpretations*, Ann Arbor.

Link, D. (1991) *The National Court Theatre in Mozart's Vienna: Sources and Documents 1783–92*, Oxford.

Lippman, E. (1986) *Musical Aesthetics: a historical reader*, 3 vols., New York.

Litvack, L. (1993) "*Callista*, Martyrdom, and the Early Christian Novel in the Victorian Age" *Nineteenth Century Contexts* 17: 159–73.

Lloyd-Jones, H. (1986) *Blood for the Ghosts: Classical Influences in the Nineteenth and Twentieth Centuries*, London.

Locke, W. (1878) *Stories of the Land We Live In; or England's History in Easy Language*, London.

Lowenthal, D. (1985) *The Past is a Foreign Country*, Cambridge.

Lowry, E. (1878) "The sayings of the Lord Jesus Christ Concerning the World To Come," London.

Lukacs, G. (1969) *The Historical Novel*, trans. by H. and S. Mitchell, Harmondsworth, UK.

—— (1978) *The Theory of the Novel*, trans. A. Bostock, London.

Lynham, D. (1950) *The Chevalier Noverre: Father of Modern Ballet*, New York.

Lyons, J. (1995) "The barbarous ancients: French classical poetics and the attack on ancient tragedy," *MLN* 110.5: 1135–47.

Lysons, S. (1860) *The Romans in Gloucestershire, and the results of their residence in this county considered in a historical, social, and religious point of view: embracing the very interesting question, whether or not we owe our early Christianity to our intercourse with them, and whether St. Paul himself preached in Britain, and possibly at Gloucester: a lecture, delivered at Gloucester, before the Literary and Scientific Society, and the Gloucester Association for Young Men*, London.

—— (1861) *Claudia and Pudens: or the Early Christians in Gloucester*, London.

Lytton, R. (1839) *Cheveley or a Man of Honour*, London.

—— (1994) *A Blighted Life*, London.

Lytton, V. (1948) *Bulwer-Lytton*, 2 vols., London.

Maaskant-Kleibrink, M. (1980) "Nymphomania," in Blok and Mason, eds. (1980): 275–96.

Macaulay, T. (1828) "The Romance of History. England by Henry Neale," *Edinburgh Review* 47: 331–67.

—— (1866) *Works*, ed. G Trevelyan, London.

McCaw, N. (2000) *George Eliot and Victorian Historiography: Imagining the National Past*, Basingstoke.

McCloy. S. (1933) *Gibbon's Antagonism to Christianity*, London.

MacDougall, H. (1982) *Racial Myth in English History. Trojans, Teutons and Anglo-Saxons*, Montreal, Hanover, and London.

McEvansoneya, P. (1996) "'A Libel in Paint': Religious and Artistic Controversy around P. H. Calderon's 'The Renunciation of St. Elizabeth of Hungary,'" *Journal of Victorian Culture* I: 254–79.

McKelvey, W. (2000) "Primitive Ballads, Modern Criticism, Ancient Scepticism: Macaulay's *Lays of Ancient Rome*," *Victorian Literature and Culture* 28: 287–309.

MacKenzie, J. (1984) *Propaganda and Empire: The Manipulation of British Public Opinion 1880–1960*, Manchester, UK.

McKeekin, S. (2010) *The Berlin-Baghdad Express: The Ottoman Empire and Germany's Bid for World Power 1898–1918*, London.

McLeod, H. (1996) *Religion and Society in England, 1850–1914*, Basingstoke.

McWilliam, R. (1998) *Popular Politics in Nineteenth-Century England*, London.

Mack, D. (1976) *Der Bayreuther Inszenierungsstil*, Munich.

Magee, B. (1968) *Aspects of Wagner*, New York.

—— (2000) *The Tristan Chord: Wagner and Philosophy*, New York.

Maitzen, R. (1998) *Gender, Genre, and Victorian Historical Writing*, New York and London.

Malamud, M. (1989) *A Poetics of Transformation: Prudentius and Classical Mythology*, Ithaca, NY.

Mallock, W. H. (1899) *Tristram Lacy, or The Individualist*, London.

Marchand, S. (1996) *Down from Olympus: Archaeology and Philhellenism in Germany, 1750–1970*, Princeton.

—— (2007) "Popularizing the Orient," *Intellectual History Review* 17: 175–202.

—— (2009) *German Orientalism in the Age of Empire: Religion, Race, and Scholarship*, Cambridge.

Marcus, L. (1994) *Auto/biographical Discourses: Theory, Criticism, Practice*, Manchester, UK.

Marcus, S. (1964) *The Other Victorians*, New York.

Marri, F., ed. (1989) *La figura e l'opera di Ranieri de' Calzabigi*, Florence.

Martin, R. B. (1959) *The Dust of Combat: a Life of Charles Kingsley*, London.

Martindale, C. (1993) *Latin Poetry and the Hermeneutics of Reception*, Cambridge.

—— (2005) *Latin Poetry and the Judgement of Taste*, Cambridge.

—— (2006) "Thinking Through Reception," in Martindale and Thomas, eds. (2006): 1–13.

Martindale, C. and Taylor, A. B., eds. (2004) *Shakespeare and the Classics*, Cambridge.

Martindale, C. and Thomas, R., eds. (2006) *Classics and the Uses of Reception*, Oxford.

Marx, K. (1926) *The Eighteenth Brumaire of Louis Bonaparte*, trans. E. and C. Paul, London.

Mason, M. (1998) *The Making of Victorian Sexuality*, Oxford.

Massey, M. C. (1983) *Christ Unmasked: The Meaning of* The Life of Jesus *in German Politics*, Chapel Hill, NC.

Masters, B. (1978) *Now Barabbas Was a Rotter: The Extraordinary Life of Marie Corelli*, London.

Mathieu, P-L. (1994) *Gustave Moreau*, Paris.

Matthews, T. B. (1914) *The Historical Novel and Other Essays*, New York.

Maynard, J. (1993) *Victorian Discourses on Sexuality and Religion*, Cambridge.

Mellman, B. (1991) "Claiming the Nation's Past: The Invention of an Anglo-Saxon Tradition," *Journal of Contemporary History* 26: 575–95.

Mercier, Mrs. J. (1886) *By the King and Queen: a Story of the Dawn of Religion in Britain*, London.

Meynell, W. (1887) *The Modern School of Art*, 4 vols., London.

Miller, E. (1908) *City of Delight, a Love Drama of the Siege and Fall of Jerusalem*, Indianapolis, IN.

Millington, B. and Spencer, S., eds. (1992) *Wagner in Performance*, New Haven and London.

[Millman] (1836) "Review: 'Reminiscences of an intercourse with George Berthold Niebuhr, the Historian of Rome' by Francis Lieber," *Quarterly Review* 55: 234–50.

Mills, A. (1856) *Colonial Constitutions*, London.

Misch, G. (1907) *Geschichte de Autobiographie*, 8 vols., Leipzig.

Mitchell, L. (2003) *Bulwer Lytton: The Rise and Fall of a Victorian Man of Letters*, London and New York.

Möhr, W. (1876) *Richard Wagner und das Kunstwerk der Zukunft im Lichte der Bayreuther Aufführung betrachtet*, Cologne.

Mole, T., ed. (2010) *Romanticism and Celebrity Culture 1750–1850*, Cambridge.

Momigliano, A. (1952) "George Grote and the Study of Greek History," *Inaugural Lecture, University College, London*, London.

—— (1966) *Studies in Historiography*, London.

—— (1970) *Studies on Modern Scholarship*, ed. G. Bowersock and T. Cornell, Berkeley, CA and London.

Moran, N. (2004) "The Art of Looking Dangerously: Victorian Images of Martyrdom," *Victorian Literature and Culture* 32: 475–93.

Morelli, G., ed. (1996) *Creature di Promoteo: il ballo teatrale dal divertimento al dramma*, Florence.

Morrison, J. (1986) *Winckelmann and the Notion of Aesthetic Education*, Oxford.

Mullan, J. (1990) *Sentiment and Sociability: The Language of Feeling in the Eighteenth Century*, Oxford.

Müller, J. L. (1991) *Islam, Gihad ("Heilige Krieg") und Deutsches Reich: Ein Nachspiel zur Wilhelminischen Weltpolitik im Maghreb, 1914–1918*, Frankfurt.

Müller, U. (1992) "Wagner and Antiquity" in Müller, Wapnewski, and Deathridge, eds. (1992).

Müller, U., Wapnewski, P., and Deathridge, J., eds. (1992) *Wagner Handbook*, Cambridge, MA.

Müller-Blattau, J. (1989) "Gluck und Racine," in Hortschansky, ed. (1989).

Murphy, J. N. (1873) *Terra Incognita: The Convents of the United Kingdom*, London.

Murphy, K. (1988) *Hector Berlioz and the Development of French Music Criticism*, Ann Arbor, MI.

Naumann, E. (1894) *The History of Music*, special edition, 5 vols., trans. F. Praeger, ed. Rev. Sir F. Gore Ouseley, London, Paris, New York, Melbourne [first published in English 1884, in German 1880].

Nead, L. (1988) *Myths of Sexuality: Representations of Women in Victorian Women*, Oxford.

——— (1992) *The Female Nude: Art, Obscenity, and Sexuality*, London and New York.

Newman, E. (1895) *Gluck and the Opera: a Study in Musical History*, London.

Newman, J. (1855) *Callista*, London.

——— (1890) *Fifteen Sermons Preached Before the University of Oxford between 1826 and 1843*, new ed., London.

——— (1891) *The Letters and Diaries of John Henry Newman during His Life in the English Church*, 2 vols., ed. A. Mozley, London.

——— (1983) *Apologia pro Vita Sua*, New York [1864].

Nicholson, H. (1928) *The Development of English Biography*, London.

Niebuhr, B. G. (1844) *The History of Rome from the First Punic War to the Death of Constantine*, 2 vols., ed. L. Schmitz, London.

——— (1875) *Niebuhr's Lectures on Roman History*, trans. H. Chepmell and F. Demmler, London.

Nield, J. (1929) *A Guide to the Best Historical Novels and Tales*, 5th edition, London.

Nietzsche, F. (1967-) *Werke. Kritische Gesamtausgabe*, 15 vols., eds. G. Colli and M. Montinari, Berlin.

Noverre, C. (1882) *The Life and Works of the Chevalier Noverre*, London.

Noverre, J. G. (1782) *The Works of Monsieur Noverre*, 3 vols., trans. by AN, London.

——— (1807) *Lettres sur les arts imitateurs en general et sur la dance en particulier*, 2 vols., Paris.

——— (1930) *Letters on Dancing and Ballets*, trans. C. Beaumont, London.

Offelman, L. (1986) "Kingsley's *Hypatia*: Revisionism in Context," *Nineteenth Century Literature* 41: 87–96.

Olender, M. (1992) *The Language of Paradise: Race, Religion and Philology in the 19th Century*, Cambridge, MA.

Oliphant, M. (1855) "Bulwer," *Blackwood's Edinburgh Magazine* 77: 223.

[Oliphant, M.] (1876) "Review of Trevelyan's Life and Letters of Lord Macaulay," *Blackwood's* 119 (May, 1876): 614–37.

Orel, H. (1995) *The Historical Novel from Scott to Sabatini—Changing Attitudes to a Literary Genre 1814–1920*, Handsmill.

Orrells, D., ed. (2010) *African Athena: New Agendas*, eds., D. Orrells, K. B. Gurminder, K. B., and T. Roynon, Oxford.

Østermark-Johannsen, L. (1999) "The Apotheosis of the Male Nude: Leighton and Michaelangelo," in Prettejohn, ed. (1999).

Paduano, G. (1989) "La riforma di Calzabigi e Gluck e la dramaturgia classica," in Marri, ed. (1989).

Parker, R. and Smart, M. (2001) *Reading Critics Reading: Opera and Ballet Criticism from the Revolution to 1848*, Oxford.

Parry, J. (2006) *The Politics of Patriotism: English Liberalism, National Identity and Europe, 1830–1886*, Cambridge.

Pateman, R. (2002) *Chaos and Dancing Star: Wagner's Politics, Wagner's Legacy*, Lanham.

Pater, W. (1885) *Marius the Epicurean*, 2 vols., London.

Patrick, M. M. (1912) *Sappho and the Island of Lesbos*, London.

Paz, D. (1992) *Popular Anti-Catholicism in Mid-Victorian England*, Stanford, CA.

Pearl, S. (2010) *About Faces: Physiognomics in Nineteenth-Century Britain*, Cambridge, MA.

Pelikan, J. (1987) *The Excellent Empire: The Fall of Rome and the Triumph of the Church*, San Francisco.

Perkins, J. (1995) *The Suffering Self*, London and New York.

Perry, Y. (2003) *British Mission to the Jews in Nineteenth-Century Palestine*, London and Portland, OR.

Peterson, J. (1986) "Dr. Acton's Enemy: Medicine, Sex, and Society," *Victorian Studies* 29: 569–90.

Peterson, L. (1986) *Victorian Autobiography: The Tradition of Self-Interpretation*, New Haven, UK.

Peterson, W. (1970) "Mrs. Humphrey Ward on 'Robert Elsmere': Six New Letters," *Bulletin of the New York Public Library* 74: 587–97.

Phillips, C. (2004) "The Historical Context of *Athens: Its Rise and Fall*," in Christiansen, ed. (2004): 133–46.

Phythian, J. (1905) *Handbook of Painting*, Manchester, UK.

Pick, W. (1990) "Meissner Pasha and the Construction of Railways in Palestine and Neighbouring Countries," in Gilbar, ed. (1990): 179–218.

Plotz, J. (2000) *The Crowd: British Literature and Public Politics*, Berkeley.

Pocock, J.G.A. (1999–2005) *Barbarism and Religion*, 4 vols., Cambridge.

Pointon, M. (1990) *Naked Authority*, Cambridge.

Pollock, G. (1988) *Vision and Difference*, London.

Pordage, S. (1673) *Herod and Mariamne: a tragedy*, London.

Porges, H. (1880) "Die Bühnenproben zu den Bayreuther Festspielen des Jahres 1876," *Bayreuther Blätter* (May 1880): 141–44.

Porter, A. (2004) *Religion versus Empire? British Protestant Missionaries and Overseas Expansion 1700–1914*, Manchester, UK.

Porter, R. and Hall, L. (1995) *The Facts of Life: The Creation of Sexual Knowledge in Britain 1650–1950*, New Haven, UK.

Poste, B. (1853) *Britannic Researchs or New Facts and Rectifications of Ancient British History*, London.

Potts, A. (1994) *Flesh and the Ideal: Winckelmann and the Origins of Art History*, New Haven, UK.

Prettejohn, E., ed. (1999) *After the Pre-Raphaelites: Art and Aestheticism in Victorian Britain*, Manchester, UK.

Prettejohn, E., Trippi, P., Upstone, R., and Wageman, P. (2008) *J. W. Waterhouse 1849–1917: The Modern Pre-Raphaelite*, London.

Price, T. C. (1876) *The Introduction of Christianity into Britain*, London.

Prichard, T. L. (1854) *The Heroines of Welsh History*, London.

Prickett, S. (1996) *Origins of Narrative: The Romantic Appropriation of the Bible*, Cambridge.

Prickett, S. (2000) "Purging Christianity of Its Semitic Origin: Kingsley, Arnold, and the Bible," in John and Jenkins, eds. (2000): 63–79.

Prins, Y. (1999) *Victorian Sappho*, Princeton.

Psomiades, K. (1997) *Beauty's Body: Femininity and Representation in British Aestheticism*, Stanford, CA.

Purcell, W. (1957) *Onward Christian Soldier: A Life of Sabine Baring Gould, Parson, Squire, Novelist, Antiquary*, London.

Pusey, E. (1854) *Collegiate and Professorial Teaching and Discipline in Answer to Professor Vaughan's Strictures*, Oxford and London.

——— (1880) *What is of Faith as to Everlasting Punishment?: In reply to Dr Farrar's Challenge in His "Eternal Hope" 1879*, Oxford.

Racine, J. (1995) *Théâtre complet*, eds. Morel, J. and Viala, A., Paris.

Rance, N. (1975) *The Historical Novel and Popular Politics in Nineteenth-Century England*, London.

Ransom, T. (1999) *The Mysterious Marie Corelli, Queen of Victorian Bestsellers*, Thrupp, Stroud.

Raphaely, J. (1998) "Nothing but Gibberish and Shibboleths? The Compulsory Greek Debates, 1870–1919," in Stray, ed. (1998): 71–94.

Ray, G., ed. (1945–46) *The Letters and Private Papers of William Makepeace Thackeray*, 4 vols., Cambridge, MA.

Reed, J. (1996) *Glorious Battle: The Cultural Battles of Victorian Anglo-Catholicism*, London.

Renan, E. (1873) *L'Antechrist*, Paris.

——— (1896) *Studies in Religious History: History of the People of Israel and Religion of Antiquity*, trans. W. Thomson, London.

Revermann, M. and Wilson, P., eds. (2008) *Performance, Reception, Iconography: Studies in Honour of Oliver Taplin*, Oxford.

Reynolds, M. (2003) *The Sappho History*, London.

Reynolds, S. (1984) *The Vision of Simeon Solomon*, Stroud, UK.

Rhodes, R. (1995) *The Lion and the Cross: Early Christianity in Victorian Novels*, Columbus, OH.

Ricci, C. (1965) *I Teatri di Bologna nel secolo xvii e xviii*, Bologna.

Richards, J. (1989) "With Henty to Africa," in Richards, ed. (1989): 73–106.

Richards, J., ed. (1989) *Imperialism and Juvenile Literature*, Manchester, UK.

Richter, D. (1981) *Riotous Victorians*, Athens and London.

Ricket, J. Compton (1893) *The Quickening of Caliban: a Modern Story of Evolution*, London.

Rickman, H., ed. (1976) *Wilhelm Dilthey: Selected Writings*, Cambridge

Riehl, W. (1891) *Kulturgeschichtliche Charakterköpfe*, Stuttgart, Germany.

Roach, J. (1991) *A History of Secondary Education in England 1870–1902*, London.

Roberts, M. (1993) *Poetry and the Cult of the Martyrs*, Ann Arbor, MI.

Rogers, H. (2001) "In the Name of the Father: Political Biographies by Radical Daughters," in Amigoni, ed. (2001): 145–63.

Rood, T. (2004) *The Sea! The Sea! The Shout of the Ten Thousand in the Modern Imagination*, London.

Rose, P. L. (1992) *Wagner: Race and Revolution*, London.

Rosen, C. (1997) *The Classical Style: Haydn, Mozart and Beethoven*, 2nd edition, London.

Rothblatt, S. (1968) *The Revolution of the Dons: Cambridge and Society in Victorian Britain*, Cambridge.

—— (1976) *Tradition and Change in English Liberal Education: An Essay in History and Culture*. London.

Rousseau, G. (1982) "Nymphomania, Bienville, and the Rise of Erotic Sensibility," in Boucé, ed. (1982): 95–119.

Rowell, G. (1974) *Hell and the Victorians: A Study of Nineteenth-Century Theological Controversies Concerning Eternal Punishment and the Future Life*, Oxford.

Royle, E. M. (2000) *Revolutionary Britannia: Reflections on the Threat of Revolution in Britain 1789–1848*, Manchester, UK.

Rubery, M. (2009) *The Novelty of Newspapers: Victorian Fiction after the Invention of the News*, Oxford.

Rudé, G. (1981) *The Crowd in History: A Study of Popular Disturbances in France and England, 1730–1848*, London.

Rudnytsky, P. (1987) *Freud and Oedipus*, New York.

Ruehl, M. (2003) "*Politeia* 1871: Nietzsche *contra* Wagner on the Greek State," in Gildenhard and Ruehl, eds. (2003).

Rushton, J. (1972) "*Iphigénie en Tauride*: The operas of Gluck and Piccinni," *Opera and Letters* 53: 411–30.

—— (1992) "'Royal Agamemnion': the two versions of Gluck's *Iphigénie en Aulide*," in Boyd, ed. (1992).

Ruskin, J. (1893) *Three Letters and an Essay, 1836–1841*, London.

—— (1894) *Veronia and Other Lectures*, London.

—— (1956–59) *The Diaries of John Ruskin*, 3 vols., ed. J. Evans and J. Whitehouse, Oxford.

Sachs, J. (2010) *Romantic Antiquity: Rome in the British Imagination, 1789–1832*, Oxford.

Sadler, H., Scheffler, T., and Neuwirth, A., eds. (1998) *Baalbek: Image and Monument 1898–1978*, Beirut.

Saintsbury, G. (1894) "The Historical Novel," *Macmillan's* 70: 256–64, 321–30, 410–19.

Sanders, A. (1978) *The Victorian Historical Novel 1840–80*, London.

Sanders, C. (1942) *Coleridge and the Broad Church Movement*, Durham, NC.

[Sandford, D.] (1837) "Athens: its Rise and Fall," *The Edinburgh Review* 132: 151–77.

Saunders, M. (2010) *Self Impression: Life-Writing, Autobiografiction, and the Forms of Modern Literature*, Oxford.

Sayers, D. L. (1977) *Wilkie Collins: A Critical and Biographical Study*, ed. E. Gregory, Toledo, Ohio.

Schadewaldt, W. (1970) *Hellas and Hesperien*, Zurich.

—— (1999) "Richard Wagner and the Greeks," *Dialogos* 6: 108–40.

Schama, S. (1996) *Landscape and Memory*, London.

Schechner, R. (1988) *Performance Theory*, revised and expanded edition, London and New York.

Scheffler, T. (1998) "The Kaiser at Baalbek: Tourism, Archaeology, and the Politics of the Imagination," in Sadler, Scheffler, and Neuwirth, eds. (1998): 13–49.

Schnapper, A. (1980) *David: Témoin de son temps*, Friburg, Germany.

Schneider, H., ed. (1999) *Timbre et Vaudeville: zur Geschichte und problematic einer Populären Gattung im 17. und 18. Jahrhundert*, Hildesheim, Zürich, New York.

Schöllgen, G. (1984) *Imperialismus und Gleichgewicht: Deutschland, England und die orientalische Frage*, Munich.

Schor, E. (2004) "Lions of Basalt: Buler, Italy, and the Crucible of Reform," in Christensen, ed. (2002): 116–132.

Schreckenberg, H. (1968) *Bibliographie zu Flavius Josephus*, Leiden, Germany.

—— (1979) *Bibliographie zu Flavius Josephus Supplementband*, Leiden, Germany.

Scodel, R. and Bettenworth, A. (2009) *Whither Quo Vadis? Sienkiewicz's Novel in Film and Television*, Malden, MA, Oxford, and Chichester.

Sedgwick, S. (1904) *A Daughter of the Druids*, London.

Segal, C. (1989) *Orpheus, the Myth of the Poet*, Baltimore.

Seiler, R. (1980) *Walter Pater: The Critical Heritage*, London.

Sewell, Rev. W. (1845) *Hawkstone: a Tale of and for England in 184-*, 2 vols., New York and London.

Shaw, B. (1906) *The Perfect Wagnerite: A Commentary on the Niblung's Ring*, London.

—— (1996) "Body/Power/Identity: Passions of the Martyrs," *Journal of Early Christian Studies* 4: 269–312.

Shaw, H. (1983) *The Forms of Historical Fiction: Walter Scott and His Successors*, Ithaca, NY.

Shuter, W. (1997) *Rereading Walter Pater*, Cambridge.

Shuttleworth, S. (1996) *Charlotte Brontë and Victorian Psychology*, Cambridge.

Sienkewicz, H. (1897) *Quo Vadis*, trans. S. Binion and S. Malevsky, London.

Sigsworth, E. W. and Wyke, T. J. (1972) "A Study of Victorian Prostitution and Venereal Disease," in Vicinus, ed. (1972): 77–99.

Silk, M. and

Stern, P. (1981) *Nietzsche on Tragedy*, Cambridge.

Simmons, J. (1973) *The Novelist as Historian: Essays on the Victorian Historical Novel*, The Hague and Paris.

Singleton, E., ed. (1912) *Modern Paintings as Seen and Described by Great Writers*, New York.

Skelton, G. (1976) *Wagner at Bayreuth: Experiment and Tradition*, 2nd edition, London.

Sketchley, R. (1909) "J. D. Waterhouse R.A.," *Art Annual: The Art Journal Christmas Number*, London.

Slee, P. (1986) *Learning and a Liberal Tradition: The Study of Modern History in the Universities of Oxford, Cambridge and Manchester*, Manchester, UK.

Smart, N. et al., eds. (1985) *Nineteenth-Century Religious Thought in the West*, Cambridge.

Smiles, S. (1994) *The Image of Antiquity. Ancient Britain, and the Romantic Imagination*, New Haven, UK.

Smith, A. (1996). *The Victorian Nude: Sexuality, Morality and Art*, Manchester.

—— (1999a) "Nature Transformed: Leighton, the Nude and the Model," in Barringer and Prettejohn, eds. (1999): 19–48.

—— (1999b) "'The British Matron' and the Body Beautiful," in Prettejohn, ed. (1999): 217–39.

Smith, A., ed. (2001) *Exposed: The Victorian Nude*, New York.

Snell, K. and Ell, P. (2000) *Rival Jerusalems: The Geography of Victorian Religion*, Cambridge.

Snyder, C. (1995) *Liberty and Morality: A Political Biography of Edward Bulwer Lytton*, New York.

Spencer, S., ed. (1976) *Wagner 1976: A Celebration of the Bayreuth Festival*, London.

Spielmann, M. (1908) "The British Art Section," in F. G. Dumas, ed. *Franco-British Exhibition Illustrated Review: British Fine Art Section*, London.

Spotts, F. (1994) *Bayreuth: A History of the Wagner Festival*, New Haven, UK.

—— (2002) *Hitler and the Power of Aesthetics*, London.

Spurrell, H. (1904) *At Sunrise*, London.

Srocke, M. (1988) *Wagner als Regisseur*, Munich and Salzburg.

Stafford, R. (1989) *Scientist of Empire: Sir Roderick Murchison, Scientific Exploration and Victorian Imperialism*, Cambridge.

Staiger, E. (1989) "Glucks Bühnenkunst," in Wartschansky, ed. (1989).

Stanfield, J. F. (1813) *Essays on the Study and Composition of Biography*, London.

Stanley, B. (1990) *The Bible and the Flag: Protestant Missions and British Imperialism in the Nineteenth and Twentieth Centuries*, Leicester, UK.

St. Clair, W. (2004) *The Reading Nation in the Romantic Period*, Cambridge, UK.

Steen, M. (2007) *Enchantress of Nations. Pauline Viardot: Soprano, Muse and Lover*, Cambridge.

Steiner, G. (1993) *Antigones*, London.

Stephen, J. K. (1891) *The Living Languages: A Defence of the Compulsory Study of Greek at Cambridge*, Cambridge.

Stephen, L. (1870a) "Mr Mathew Arnold and the Church of England," *Fraser's Magazine* n.s. II (October, 1870): 414–31.

—— (1870b) "Athletic Spats and University Studies," *Fraser's Magazine* n.s. II (October, 1870): 691–704.

—— (1879) *Hours in a Library* (3rd Series), London.

—— (1893) *An Agnostic's Apology and Other Essays*, London.

—— (1898–1902) *Studies of a Biographer*, 4 vols., London.

Stewart, G. (2006) *The Look of Reading: Book, Painting, Text*, Chicago.

Stirling, A. (1926) *The Richmond Papers*, London.

Stobart, J. C. (1912) *The Grandeur that was Rome*, London.

Stoddard, F. (1900) *Evolution of the English Novel*, London and New York.

Stoll, A. and Stoll, K. (1975) "Affekt und Moral: zu Glucks *Iphigenie auf Tauris*," *Die Musikforschung* 28: 305–11.

Stray, C. (1998) *Classics Transformed: Schools, Universities, and Society in England 1830–1960*, Oxford.

Stray, C., ed. (1998) *Classics in the 19th and 20th Century Cambridge: Curriculum, Culture and Community (PCPS Supplement 24)*, Cambridge.

Strobel, O., ed. (1936–39) *König Ludwig II und Richard Wagner. Briefwechsel*, 5 vols., Karlsruhe, Germany.

Strohm, R. (1995) "Sinfonia and Drama in Early Eighteenth-Century Opera Seria," in Bauman and McClymonds, eds. (1995).

[Stuart-Young, J.] (1906) "A Note on Marie Corelli by Another Writer of Less Repute," *Westminster Review* 167: 680–92.

Sutherland, J. (1990) *Mrs Humphry Ward: Eminent Victorian, Pre-eminent Edwardian*, Oxford.

Swanson, V. (1977) *Sir Lawrence Alma-Tadema: The Painter of the Victorian Vision of the Ancient World*, London.

——— (1990) *The Biography and Catalogue Raisonné of the Paintings of Sir Lawrence Alma-Tadema*, London.

Sweetman, D. (1993) *Mary Renault: A Biography*, New York.

Szlezák, T. A., ed. (2005) *Wolfgang Schadewaldt und die Gräzistik des 20. Jahrhunderts*. Hildesheim (Spudasmata, Bd. 100).

Tal, U. (1975) *Christians and Jews in Germany: Religion, Politics, Ideology in the Second Reich*, trans. N. Jacobs, Ithaca, NY.

Taylor, A. B., ed. (2006) *Shakespeare's Ovid*, Cambridge.

Taylor, I. (1859) *Ancient Christianity*, London.

Taylor, J. B. and Shuttleworth, S., eds. (1998) *Embodied Elves: An Anthology of Psychological Texts, 1830–1890*, Oxford.

Taylor, M. (1991) "Imperium et Libertas: Re-thinking the Radical Critique of Imperialism during the Nineteenth Century," *Imperial and Commonwealth History* 19: 1–23.

Taylor, R. (1834) *Diegesis: Being a Discovery of the Origins, Evidences and Early History of Christianity*, London.

Teukolsky, R. (2009) *The Literate Eye: Victorian Art Writing and Modernist Aesthetics*, Oxford.

Thackeray, W. (1834) "Highways and Low-Ways: or Ainsworth's Dictionary with Notes by Turpin," *Fraser's* 9: 724–38.

——— (1838) "Mr Yellowplush's Ajew" *Fraser's Magazine* 18: 195–200.

Thirlwall, J. C. (1936) *Connop Thirlwall: Historian and Theologian*, London.

Thomas, D. (2002) *Aesthetics of Opera in the Ancien Régime*, Cambridge.

Thompson, J. (1963) *The Making of the English Working Class*, London.

Thorne, S. (1999) *Congregational Missions and the Making of Imperial Culture in Nineteenth-Century England*, Stanford, CA.

Tibawi, A. (1961) *British Interests in Palestine 1800–1901*, Oxford.

Tiersot, J. (1930) "Gluck and the Encyclopedists," *Musical Quarterly* 16: 336–57.

Timpson, T. (1849) *British Ecclesiastical History Including the Religion of the druids, the Introduction of Christianity into Britain, and the Rise, Progress and Present State of Every Denomination of Christianity in the British Empire*, 2nd ed., London.

Todorov, T. (1993) *On Human Diversity: Nationalism, Racism and Exoticism in French Thought*, trans. C. Porter, Cambridge, MA.

Tomalin, C. (2002) *Samuel Pepys: The Unequalled Self*, London.
Tomlinson, G. (1995) "Pastoral and Musical Magic in the Birth of Opera," in Bauman and McClymond, eds. (1995): 7–20.
Tomlinson, J. (1895) *A Review of Canon Knox-Little's "Answer to Archdeacon Farrar,"* London.
Toon, P. (1979) *Evangelical Theology 1833–1856: A Response to Tractarianism*, London.
Trippi, P. (2002) *J. W. Waterhouse*, London and New York.
Trumpener, U. (1968) *Germany and the Ottoman Empire, 1914–1918*, Princeton.
Tucker, C. [A.L.O.E.] (1880) *Daybreak in Britain*, London.
Tucker, H. (2008) *Epic: Britain's Heroic Muse, 1790–1910*, Oxford.
Tulloch, J. (1864) *The Christ of the Gospels and the Christ of Modern Criticism: Lectures on M. Renan's "Vie de Jesus,"* London.
Turner, E. (1975) *Boys Will Be Boys*, London (rev. ed.).
Turner, F. (1981) *The Greek Heritage in Victorian Britain*, New Haven, UK.
——— (1999) "Christians and Pagans in Victorian Novels," in Edwards, ed. (1999).
Turner, V. (1969) *The Ritual Process Chicago*, Chicago.
——— (1982) *From Ritual to Theater*, New York.
Tytler, G. (1982) *Physiognomy in the European Novel: Faces and Fortunes*, Princeton.
Vance, N. (1985) *The Sinews of the Spirit: the Ideal of Christian Manliness in Victorian Literature and Religious Thought*, Cambridge.
——— (1997) *The Victorians and Ancient Rome*, Oxford.
Vandiver, E. (2010) *Stand in the Trench, Achilles: Classical Receptions in British Poetry of the Great War*, Oxford.
Vasunia, P. (2005) "Greek, Latin, and the Indian Civil Service," *Cambridge Classical Journal* 51: 35–71.
——— (forthcoming) *Greece, Rome and the British Empire*, Oxford.
Viardot-Garcia, P. (1915) "Pauline Viardot-Garcia to Julius Rietz (Letters of Friendship)," *Musical Quarterly* 1: 526–59.
——— (1916) "Pauline Viardot-Garcia to Julius Rietz (Letters of Friendship)," *Musical Quarterly* 2: 32–60.
Vicinus, M., ed. (1972) *Suffer and Be Still*, Bloomington, IL.
Vidal-Naquet, P. (1990) *La Démocratie grecque vue d'ailleurs*, Paris.
Vincent, D. (1981) *Bread, Knowledge and Freedom: A Study of Nineteenth-Century Working Class Autobiography*, London.
Vincent-Buffault, A. (1991) *The History of Tears: Sensibility and Sentimentality in France*, Basingstoke and London.
Voss, H. (1973) *Franz von Stück: Werkkatalog der Gemälder*, Munich.
Waddington, P. (1975) "Pauline Viardot-Garcia as Berlioz's Counsellor and Physician," *Musical Quarterly* 59: 382–98.
Wagner, C. (1977) *Die Tagebücher*, eds. M. Gregor-Dellin and D. Mack, Munich.
——— (1978–80) *Cosima Wagner's Diaries*, 2 vols., eds. M. Gregor-Dellin and D. Mack, trans. G. Skelton, London.
Wagner, N. (1998) *The Wagners: The Dramas of a Musical Dynasty*, trans. E. Osers and M. Downes, London.
Wagner, R. (1894) "Gluck's Overture to 'Iphigeneia in Aulis,'" in *Richard Wagner's Prose Works*, trans. W. Ellis, vol. III, 153–66, London.
——— (1983) *My Life*, trans. A. Gray, ed. M. Whittall, Cambridge.

—— (1892–99) *Richard Wagner's Prose Works*, 8 vols., trans. W. Ashton Ellis, London.

—— (1913) *Opera and Drama*, trans. E. Evans, London.

Waitz, T. (1864) *Introduction to Anthropology*, trans. J. F. Collingwood, London.

Walkowitz, J. (1980) *Prostitution and Victorian Society: Women, Class and the State*, Cambridge.

Wallace, J. (1997) *Shelley and Greece: Rethinking Romantic Hellenism*, Basingstoke, UK.

Wallis, F. (1993) *Popular Anti-Catholicism in Mid-Victorian Britain*, Leicester, UK.

Wanko, C. (2010) "Patron or Patronised? 'Fans' and the Eighteenth-Century English Stage," in Mole, ed. (2010): 209–26.

Ward, Mrs. H. (1888) *Robert Elsmere*, London.

—— (1918) *Writer's Recollections*, London.

Ware, W. (1837) *Letters from Palmyra*, London.

Waters, S. (1995) "'The Most Famous Fairy in History': Antinous and Homosexual Fantasy," *Journal of the History of Sexuality* 6: 194–230.

Watt, I. (1957) *The Rise of the Novel: Studies in Defoe, Richardson, and Fielding*, Berkeley, CA.

Webb, Mrs. J. Peploe (1841) *Naomi: or the Last Days of Jerusalem*, London.

—— (1867) *Pomponia: or The Gospel in Caesar's Household*, Philadelphia.

Weeks, J. (1977) *Coming Out: Homosexual Politics in Britain, from the Nineteenth Century to the Present*, London

—— (1981) *Sex, Politics, and Society: The Regulation of Sexuality Since 1800*, London.

Weiner, M. (1995) *Richard Wagner and the Anti-Semitic Imagination*, London and Lincoln, UK.

West, R. (1928) *The Strange Necessity: Essays and Reviews*, London.

Westbury, H. (1890) *Acte*, London.

Whately, R. (1819) *Historic Doubts Relative to Napoleon Bonaparte*, Dublin.

Wheeler, M. (2006) *The Old Enemies: Catholic and Protestant in Nineteenth-Century English Culture*, Cambridge.

White, C. (1984) "The Biographer and Edward VII: Sir Sidney Lee and the Embarrassments of Royal Biography," *Victorian Studies* 27: 301–19.

White, E. L. (1918) *The Unwilling Vestal*, New York.

Whyte-Melville, G (1863) *The Gladiators*, London.

Wiederman, T. (1992) *Emperors and Gladiators*, London.

Wilamowitz, U. (1972) Review of Georg Misch (1907) in *Kleine Schriften* vi: 120–27, Berlin and Amsterdam.

Williams, C. (1989) *Transfigured World: Walter Pater's Aesthetic Historicism*, Ithaca, NY.

Williams, J. (1844) *The Ecclesiastical Antiquities of the Cymry: or the Ancient British Church, its History, Doctrine, and Rites*, London.

—— (1848) *Claudia and Pudens: An Attempt to Show How Claudia Mentioned in St. Paul's Second Epistle to Timothy Was a British Princess*, London.

Williamson, M. (1995) *Sappho's Immortal Daughters*, Cambridge, MA.

Wilson, A. (2007) *The Puccini Problem: Opera, Nationalism and Modernity*, Cambridge.

Wilson, P. (1919) *Wagner's Dramas and Greek Tragedy*, New York.

Winkler, M. (2004) *Gladiator: Film and History*, Oxford.

—— (2006) *Spartacus: Film and History*, Oxford.

Wiseman, J. (1854) *Fabiola*, London.

Withrow, W. (1883) *Valeria, the Martyr of the Catacombs. A Tale of Early Christian Life in Rome*, London.

Wolf, F. A. (1985) *Prolegomena to Homer*, trans. by A. Grafton, Princeton, NJ.

Wolfe, P. (1969) *Mary Renault*, New York.

Wolff, R. L. (1977) *Gains and Losses: Novels of Faith and Doubt in Victorian England*, New York and London.

Womersley, D. (1997) *Religious Scepticism: Contemporary Responses to Gibbon*, Bristol.

—— (2000) *Gibbon and the* 'Watchmen of the Holy City': The Historian and His Reception 1776–*1815*, Oxford.

Wood, C. (1981) *The Pre-Raphaelites*, London.

Woodfield, I. (2001) *Opera and Drama in Eighteenth-Century London: King's Theatre, Garrick and the Business of Performance*, Cambridge.

Woolf, V. (1925) *The Common Reader*, London.

Wordsworth, C. (1878) *On the Duration and Degrees of Future Rewards and Punishments*, London.

Wrey Saville, B. (1861) *Introduction of Christianity into Britain*, London.

Wright, D. G. (1988) *Popular Radicalism: The Working Class Experience 1780–1880*, London.

Wright, T. (1857) *The Celt, the Roman and the Saxon: a History of the Early Inhabitants of Britain, down to the Conversion of the Anglo-Saxons to Christianity*, London.

Wyke, M. (1997) *Projecting the Past: Ancient Rome, Cinema and History*, London.

Yeo, R. (2001) *Encyclopaedic Visions: Scientific Dictionaries and Enlightenment Culture*, Cambridge.

Young, R. (1995) *Colonial Desire: Hybridity in Theory, Culture and Race*, London.

Zaslaw, N., ed. (1989) *The Classical Era from the 1740s to the end of the 18th Century*, Basingstoke and London.

Zatlin, L. (1990) *Aubrey Beardsley and Victorian Sexual Politics*, Oxford.

Zeh, G. (1975) *Das Bayreuther Bühnenkostüm*, Munich.

Zelinsky, H. (1976) *Richard Wagner—ein deutsches Thema*, Frankfurt.

Ziff, L., ed. (1982) *R. W. Emerson: Selected Essays*, Harmondsworth.

Ziolkowski, T. (2008) *Clio the Romantic Muse: Historicizing the Faculties in Germany*, Ithaca, NY.

# INDEX

❀  ❀  ❀  ❀  ❀  ❀  ❀  ❀  ❀  ❀  ❀  ❀  ❀  ❀  ❀  ❀  ❀  ❀  ❀

Note: Page numbers in bold italics indicate illustrations; "pl." refers to the color plates.

classical works, 34; and Victorian classical education, 188; Victorian gender norms or stereotypes, 43, 54, 81, 227, 231

Germany: Egyptology and, 232–33; Gluck and German identity, 115–16; imperialism and, 140; nationalism in, 112–16, 115–16, 123, 133–34, 136, 138; Roman/Goth opposition, 158; Wagner and construction of German Hellenism, 10, 12, 89, 111, 115–17, 125–31, 133, 140, 146

Gerôme, 31–32

Giles, John Allen, 210

gladiatorial games, 226–29; *A Roman Holiday* (Rivière), *pl. 16*

*Glaucus* (Kingsley), 254–55

Gluck, Christoph Willibald Ritter von: accuracy and classicism in works of, 45, 99–100, 116; audience as influence on creative process of, 89; Berlioz and "reinvention" of, 12, 89–90; Berlioz revival of *Orphée* by, 104–10; British receptions of, 95–96, 110, 116–17; collaboration and, 90–97; early career and reputation of, 90–91; emotional response to works of, 12, 15; French cultural mediation of classical sources, 100–101; French reception of works of, 15, 100–101, 106–10, 111; as "German," 115–16; and happy endings, 101; and idealized ancient world, 90; innovation and operas of, 92; modernity and, 17; as Orpheus figure, 111–12; as "revolutionary" artist, 87–88, 93, 95–96, 100, 105, 116; Strauss and, 90, 99, 101, 119, 122–23; Wagner and "reinvention" of, 89–90, 115

Gluck, works of: *Alceste*, 92–94, 96, 100, 101; *Don Juan*, 91, 95; *Iphigénie en Aulide*, 88, 93, 100–101, 103, 104, 115; *Iphigénie en Tauride*, 88, 90, 119–22; *Orphée*, 88, 89, 100, 108–10, 116–17

Goodbrand, Robert, 249

Gosse, Edmund, 78, 257; on life writing, 246, 247, 248

Gothic literature, 200

*Götterdämmerung*: set designs by Hoffman, *138*; set designs by Neumann, *139*

*Gradiva* (Jensen), 185, 299n117

Greece or the Greeks: in Bulwer Lytton's *The Last Days of Pompeii*, 195–06; and democracy or freedom, 3, 5–6, 174; Germans as "Greek," 116–17, 127, 130;

Greek/Roman opposition, 195, 196, 197, 225. *See also* Hellenism

Green, John R., 159

Grote, George, 5, 163–64, 172, 173–74, 176, 297n74

Guadagni, Gaetano, 92, 95–96, 106

Hacker, Arthur, 60, *61*

Haddo, George Gordon, Lord, 33–34, 69

Hall, Jonathan, 134

Hanisch, E., 133

Harris, Robert, 184, 187

Harry Potter Effect, 225, 229–31

Hausrath, Adolf (George Taylor), 233–34

Hédouin, P., 111

Heine, Heinrich, 78

Hellenism: Gluck's neoclassical, 115–16, 122–25; Hebraism and, 241; homosexuality and, 4–5; nationalism and, 18, 122, 133–34, 146; and performance, 125–26; philhellenism, 4, 82, 146; Romantic, 4, 89, 111; twentieth-century politics and, 126; Wagner's construction of German Hellenism, 10, 12, 89, 111, 115–17, 125–31, 133, 140, 146

helplessness, 29–30

Henty, G. A., 158–59, 224–25, 229, 232, 263

*Hereward the Wake* (Kingsley), 206, 251, 255, 257

*Heroes* (Kingsley), 255

high/popular cultures, relationship between, 15

Hinds, Stephen, 52

historical fiction: American audiences and, 215–23; anti-Catholicism in, 203–6, 212; archaeological stance and, 170, 176, 182–85, 189, 194, 201–2, 209–10, 214, 216–17; audience for, 160, 177, 179, 212, 214–15, 218, 223, 227, 232, 237, 243; Bulwer Lytton and genre of, 170, 183, 188–89, 194–95, 200–202, 216; Christian characters in, 223–24 (*see also* conversion to Christianity in *under this heading*); Christian Gospels appropriated by authors of, 217; as classical education, 188; conversion to Christianity in, 212, 219, 223, 227, 233–34, 255; crisis of faith in, 6–8, 162, 169, 189–90; critical reception of genre, 177–79; frame breaking/frame maintenance in, 184–87, 243–44;

352   INDEX